PICASSO

The Real Family Story

Olivier Widmaier Picasso

PICASSO

The Real Family Story

Prestel

Munich · Berlin · London · New York

Documentary research was carried out by Élisabeth Marx

Translated from the French by Bernard Wooding (pp. 7–88), David Radzinowicz Howell (pp. 89–122), Ruth Hemus (pp. 123–202), Robert McInnes (pp. 203–84), Jonathan Dickinson and Steven Rogers (285–339)

© Prestel Verlag
Munich · Berlin · London · New York, 2004
© for the works illustrated and photographs: see p. 343
© for the French edition: Éditions Ramsay, Paris 2002

The Library of Congress Cataloguing-in-Publication
data is available; British Library Cataloguing-in-
Publication Data: a catalogue record for this book is
available from the British Library; Deutsche Bibliothek
holds a record of this publication in the Deutsche
Nationalbibliografie; detailed bibliographical data can
be found under: http://dnb.ddb.de

Front cover: Pablo Picasso (Photograph: Edward Quinn
Archive. Zurich-Berlin-New York: Scalo Publishers)

Prestel books are available worldwide. Please contact
your nearest bookseller or one of the following
Prestel offices for information concerning your local
distributor:

Prestel Verlag
Königinstrasse 9, 80539 Munich
Tel. +49 (89) 38 17 09-0; Fax +49 (89) 38 17 09-35

Prestel Publishing Ltd.
4 Bloomsbury Place, London WC1A 2QA
Tel. +44 (020) 7323-5004; Fax +44 (020) 7636-8004

Prestel Publishing
900 Broadway, Suite 603, New York, NY 10003
Tel. +1 (212) 995-2720; Fax +1 (212) 995-2733
www.prestel.com

Edited by Christopher Wynne
Editorial assistance: Michele Schons

Design and production: Matthias Hauer
Typesetting: Setzerei Vornehm, Munich
Origination: ReproLine Mediateam, Munich
Printing and binding: Kösel, Altusried

Printed in Germany on acid-free paper

ISBN 3-7913-3149-3

Contents

*"Exceptional geniuses are
not there to please the fainthearted."*

Charles Baudelaire

Introduction

For me, Pablo Picasso was born on April 8, 1973. Yes, my grandfather was born the day he died.

Up until then he did not exist—either in my dreams or in reality. He existed only on walls, which meant he was very present but at the same time very abstract. People talked to me about him from time to time, but I never saw him.

At high school, my friends all had grandfathers they often saw on Sundays. I didn't, but strangely it was not something I missed. They had family photos; I had family portraits—of my mother as a child, of my grandmother lost in thought—and painted objects that were called "still lifes," even though I didn't really understand how a coffee pot or a piece of bread could be alive or dead.

On April 8, 1973, everything changed. All this "still life" started to move!

It was a Sunday afternoon and, as on most Sundays, after lunch, my mother, Maya, my sister, Diana, who was still a baby, and myself aged around ten were watching a film on television. My father Pierre had gone out with Richard, my younger brother.

At the end of the film, a special news flash came up. I knew that meant there had been a catastrophe, a terrorist attack, or the death of someone famous. A monotonous voice, with no pictures, declared: "The painter Pablo

Picasso died this morning in his house on the Côte d'Azur at the age of ninety-two. He is regarded as the artist who invented twentieth-century art."

Normal programs resumed, but it was as if the sound had been turned off in the living room. I felt nothing, aside from a confusing sense that they had just been talking about someone that I was supposed to know well ... without knowing him. It was like feeling hot and cold at the same time. I was at the heart of the story, but at the same time outside it.

I looked at my mother, who, without saying a word, got up from her armchair, and walked quietly, mechanically, to the telephone in the next room. She dialed the number of her brother, Paulo, who lived at Boisgeloup, a property in Gisors near Paris that I knew. I caught her saying: "Hello Paulo, it's Maya. Have you heard from Papa?" Paulo replied, she told me afterwards, that he had called him the day before and that he had seemed very tired. But that was all.

It was clear that Paulo hadn't heard the news. My mother couldn't bring herself to tell him about the news flash. They spoke a bit more and then she hung up. I heard a few days later that he was told the news following a brief phone call from the Côte d'Azur. Paulo came back to Paris and bumped into the concierge of his building at the bottom of the stairs: "Oh! Monsieur, your poor papa!" Then he left for Orly airport to catch a plane so that he could go to Mougins.

April 8, 1973.

Things would never be the same again.

The next few days were a mystery for me. Normally, when someone dies, the whole family comes together to pay their respects around the deceased. My grandfather's body had traveled during the night from Mougins, a pretty village in the hills above Cannes in the Alpes-Maritimes, to Vauvenargues, a few kilometers from Aix-en-Provence, where I learned that he owned a château. Good, I thought: we live in Marseille, it will make things easier for my mother.

But strangely, there was no funeral—at least not in the sense that my classmates understood it when they lost one of their grandparents. Would we, the grandchildren, have to go to the funeral? I was a bit frightened, because it would have been my first time.

Nothing happened. My mother went away for a day. I heard on the radio that Pablo Picasso had been buried a few days after his "arrival" at Vauvenargues, in the presence of Jacqueline, his last wife, and Paulo. But what about my mother? Why didn't they mention her? On the grave, they had placed a statue of his that had been inspired by my grandmother, Marie-Thérèse, which surprised me. I knew that my grandfather had had several

partners—something that had made a big impression on me—and I thought they had all been his wives. How dignified for a widow to agree to step aside for one of her predecessors. What a tribute!

A few days later I woke up to a much less romantic reality and a more fitting pragmatism. The front pages announcing the death of the Great Master and retracing his exceptional artistic career, the revelations about his hasty burial and the photos of his grave, and the official tributes lamenting his loss were followed by speculation about his inheritance. There was talk of hundreds of millions of francs, of real heirs and potential heirs. Picasso's children were mentioned and photos of them shown, while pointing out that some of them could not be his heirs.

Seen through a child's eyes, this all seemed very complicated: wasn't there a will tucked away somewhere? Had Pablo wanted to cut some people out of his estate? What on earth could my mother and the others have done to deserve being disinherited? And the others?

Little by little I began to fit the pieces of this huge puzzle together in my mind. I discovered there was a legitimate son, Paul, who my mother had always called Paulo, and then the other children—Maya, my mother, and Claude and his sister Paloma, my uncle and aunt, who I had probably seen only once or twice since I was born. These "others" were presented as Picasso's "natural" children, who had not been recognized by him. But then why had he painted them? Were they or were they not his children? What a mess! In any case, "not recognized" according to the press meant that they were not his children. So Picasso was not my grandfather!

And yet we had all those photos at home showing Pablo and Maya, Maya and Paulo, and all the children together. And there were all those books that I had leafed through, with Pablo surrounded by his boys and girls on the beach, in Cannes and Vallauris, photographed by his closest friends. I learned, thanks to the press, the meaning of the word *adultérin* used to describe these three famous descendants of Picasso. I looked in the dictionary: "Illegitimate" meant born of adultery. But what adultery was this, because my grandfather had married all his "wives," or so I thought? Who were Maya, Claude, and Paloma the children of? Why did Paulo talk to our mother of "their" joint father, calling her "my sister"? And where did these works in our home come from?

I discovered about my own family by reading articles. I slowly learned about the complexities of life—and about the very unjust law of the time that my grandfather had broken free of.

Out of love.

His love in the face of the law.

With his death, the mystery surrounding Picasso suddenly deepened. My grandfather's inheritance went far beyond the twentieth-century art that he was supposed to have invented. Money had the strange effect of heightening the colors in his canvases. Each familiar object now had its price. I no longer looked at the works on the walls with the same casualness. I admired them as if our apartment had become a museum, full of objects that had suddenly become untouchable. The large painting in the dining room, *Maya au Tablier rouge*, which already seemed large to me in its beautiful gilt wooden frame, seemed to have doubled in size!

Above all, I learned that my mother, Claude, and Paloma had registered a request for recognition of filiation a few months before their "father" died. Why did they leave it so late? How is it possible that Picasso's four children could have been discussed in public for two decades and then, suddenly, three of them should be denied this blood relationship? I read Pablo's dedications—"To my darling daughter," "To Maya"—on the portraits that my mother owned. How could this reality be called into question? And everyone was talking about the reform of 1972. What was this? I didn't understand anything about it, except that apparently there had been a before and an after 1972. And that changed everything. A few months later, Pablo would officially have become their father. Except that he had died at the beginning of 1973.

The future father was already dead.

The next year was full of what the press called the "necessary" judiciary procedures concerning the "legal" recognition of "natural" filiations. Maya, Claude, and Paloma were officially the children of their father. It seemed normal that my mother should become the daughter of her father, and yet it seemed so complicated. Then came the regular meetings between heirs and lawyers, which my mother attended. A new life began. There were some tensions, which were blown out of proportion by certain journalists, but which were trivial if my mother was to be believed: there was no reason for me to worry. In 1976 and 1977, agreements concerning the sharing of the inheritance were signed. The magazine *L'Express* splashed across its front cover the title "1,251,673,200 new francs: The Inheritance of the Century"—and even that figure was well below the true one—together with a black-and-white photo of Pablo Picasso by Irving Penn, revealing to everyone in my school that I now belonged to a different world.

In the end, the skill of the lawyers, the collaboration of the state in preparing the famous *Dation*,[1] and, in a way, the good will of the heirs made

1 Payment of inheritance tax through the handing over of works of art or collector's items.

possible what was, all things considered, a quick settlement for such an important affair artistically and financially. There only remained the problem of handling the moral aspect, together. The Succession Picasso gave way to the Indivision Picasso.

Of this period I still remember my mother telling me about the endless inventories, calculations, choices, and selections. My grandfather, that mischievous and inventive stranger, had generated a vast database. Each inventoried work had a number (or numbers) and an estimated value. At school I had become a curiosity—as if I had won a medal or a prize. I was Picasso's grandson! I would forever be "different."

It was also at this time that my first vocation emerged: law. By the eighth grade, my mind was made up. I had observed the ways and customs of the legal people working on the Succession—the administrator, auctioneers, notaries, tax advisers, and bailiffs. I had accompanied my mother to several meetings, which I watched in silence. I liked the intellectual game that consisted of constructing rational arguments based on the law to support a position or oppose that of someone else. It was like jousting or a game of chess. So I decided to be a knight. I also liked discussion, gathering information, the process of achieving a necessary consensus. I liked the idea of general good sense prevailing in the face of individual obstructiveness.

Art, on the other hand, seemed a very hazardous and solitary enterprise, very unsuited to my character, and taking it on would unfortunately have been rather ridiculous in view of the comparison that would inevitably have been made with my illustrious grandfather. Artistic talent was not transmitted genetically, I felt. I believed more in the influence of the environment. Although I didn't know it at the time, the artistic atavism that I denied possessing would reveal itself through other channels.

Life returned to normal. The Succession had been settled, the *Dation* exhibited in 1979, the Indivision set up.[2] The Musée Picasso in Paris was inaugurated in 1985 by François Mitterrand: Picasso's work became an official monument and Pablo was venerated like an eternal god by his grateful homeland.

Then, around the mid-1980s, the famous "revelations" came to light.

Thanks to the legions of experts, contemporaries, biographers, friends, and even former partners, all archaeologists of the Picasso continent, we already knew so much about my grandfather that it seemed difficult to find anything new to say about him. But after the period of official celebrations

2 The *Indivision Picasso* means that the five current heirs have joint ownership of intellectual property rights attached to the work, name, and image of Pablo Picasso, such as reproduction rights. See the Website www.Picasso.fr.

and scholarly decodings, of books and exhibitions, came the period of criticism—the period of the inquisition: the work was not allowed to speak for itself; its originality had to stem from a feeling of guilt; its creator could not be innocent. Such an exceptionally atypical man had to be a pervert, who enacted his vices through his art! His intolerable art!

The Nazis had already put degenerate art—of which Picasso, in their eyes, was the most illustrious representative—in the dock. Now a new trial in absentia had begun.

Instead of analyzing how he was different, people spoke of his indifference—toward others. The artist was suddenly distinguished from the man. The former was clad in the matador's costume, the latter in a sinister black cape. His work was set aside so that genius could be compared with "normality." In my view, this was not so much lacking relevance as lacking context: the contexts had been forgotten. He was imputed with premeditated malice, unfailing meanness, a propensity for controlling and humiliating people—frequent sadism. All of this was a far cry from my mother's happy memories!

It is true that in 1933 Fernande Olivier,[3] his first official partner at the beginning of the century, had recounted their bohemian years. She described the man and his friends in a light, nostalgic tone that reflected their mutual incomprehension. Pablo was furious and, encouraged by his entourage, had attempted in vain to buy the publication rights. It is also true that the book published in 1965 by Françoise Gilot,[4] his postwar partner and mother of Claude and Paloma, had painted a picture of a private Picasso who was a very complex person. In my view, it resulted in a lot of fuss over nothing. But the minutely detailed chronicle of Picasso's everyday life and their private love life, even though very restrained, was felt as a betrayal by the painter, whipped into a frenzy by a new overexcited entourage. In Pablo's eyes, Françoise had crossed the Rubicon of their secrets. He sued, but lost.

He would have been better off feigning indifference. The emotion generated by the whole affair had aroused suspicion, and created a precedent. The gate remained open, allowing the wolves to enter.

In the 1980s, the mood was much more radical and simplistic: Picasso was a "creator," of course, but was just as much a "destroyer"—in this instance, not of artistic academicism. The "affair" of the Succession added grist to the mill of malicious gossip. It was now known that there was a lot of money at

3 Olivier, Fernande, *Picasso et ses amis*, Paris 1933. See also Olivier 1964 and 1996.
4 Gilot and Lake 1964.

stake. The American Arianna Stassinopoulos-Huffington[5] set things rolling in 1988, when she created a sensation. On the basis of her reputation as an author of books for the "general public," she was commissioned to write a popular biography for the American public. She had all the ingredients and she knew the marketing plan, she simply had to build her text around a leitmotiv, using exaggeration and drawing on a long tradition of representing gossip as the truth.

She formed a team of researchers, conducted numerous interviews—and made extensive use of Françoise Gilot's book. She delved more deeply into Picasso's private life. She departed from the conventional artist's biography, incorporating a good deal of scandalous material. She selected the reservations and criticisms expressed in interviews and the most trivial of disrespectful comments. However, she did mention Picasso's great artistic phases.

In the 1960s, there had not been much response to Françoise Gilot's book because at the time the media was not yet the fourth estate; but the book by the American received worldwide promotion targeting a public supposedly hungry for celebrity subjects. At the time, I was a long way from the world of Picasso, but the book's success proved to me that my grandfather was still at the top of the pantheon of celebrities, fifteen years after his death. Before even questioning the veracity of the contents, I saw the bitterness of my mother, who felt she had been betrayed by the author. Officially, this woman had come to Paris as a tourist and my mother had agreed, over a cup of tea, to reply to her innocuous questions. Her interviewer did not take any notes at all. And my mother had no idea that her answers were actually part of a prewritten script. Moreover, she did not know that her interviewer was a specialist.

It is true, the biographer, either in person or via her assistants, had met a large number of witnesses, and probably sought to corroborate her facts. But she did not turn up at these interviews in a state of innocence: she was advancing towards the goal that she had set herself. She proceeded by means of ingenious "copy and paste" tactics, to use computer language. And she used a kind of magnifying glass effect. She sorted the ingredients and kept only the spiciest, fitting them into the mold that she had created—even if it meant spicing up the recipe even more. However, it has to be said that most of the artistic and historical information, taken from reference works and often usefully supplemented, testifies to the scope of the work undertaken.

Picasso the creator was self-evident, but from a commercial point of view, it was necessary to have Picasso the destroyer. Everything was slanted in

5 Stassinopoulos-Huffington 1988.

this direction, with the addition of a dash of blood and a lot of sensational-ism—without which this would have been just one more art book sitting on the shelves, rather than a bestseller.

It worked. Arianna acquired a new feather in her biographer's cap, with the innocent assent of everyone: this was an "authorized" biography, to use the term beloved of American publishing.

The moral of the story was changing. Picasso the genius was also a mon-ster. The man who deconstructed art had to destroy beings. It makes for a more satisfying story.

This "biography" followed a book that had appeared the previous year, *Bitter Legacy*, by the American Gerald McKnight.[6] This relatively short book attempted to describe my grandfather's inheritance, but failed to untangle the legal complexities of the affair. The author drew on a few brief interviews with some of the heirs, and rumors gleaned from a few people who had been close to Picasso, as well as from an increasingly distant entourage. The book was also full of mistakes in the spelling of names, places and the roles of different people. Furthermore, some people had talked nonsense. Let's just say the chief merit of this book was that it offered Stassinopoulos-Huffington a source of quotations that were useful to her thesis.

The promotion of these books in the international press encouraged people to try and go one better. I discovered at this time how unfair some people were with my grandfather. I got the measure of this cowardice, which involved attacking a dead man who cannot defend himself. However, diffi-cult as it was, I concluded that the best response was silence, because reply-ing would simply have thrown the lies into greater relief.

Between Françoise Gilot's very measured account and the American-style "screenplay" biography, the way was paved for a film version. All Holly-wood producers had to do was use one or the other to concoct a highly fic-tional two-hour film about, a very famous artist, a satanic Don Juan who stunned his conquests before devouring them.

The problem was that they had to dramatize ninety-two years of exis-tence, so to hell with historical truth. The scriptwriters made a compilation of what they regarded as the spiciest details of my grandfather's love life. But Picasso's irascibility was exaggerated, his talk became arrogant, his actions labored, and the encounters between wife, partners, and mistresses invented

6 McKnight 1987.

to spice up the story and portray him as a wrestling umpire reveling in bouts between women. The eminent American director James Ivory and his associate Ismael Merchant set to work. To get permission to include reproductions of original works by Picasso, they sent their script to my uncle, Claude Picasso.[7] Not surprisingly, he objected, arguing that his official position, above and beyond any personal feelings he might have, prevented him from accepting the liberties taken with the true facts of Picasso's life and work. So he forbade them from reproducing and representing works by Pablo Picasso in their film.

That ought to have led to the abandonment of the project. But not at all. The film was made with similar works by an American painter of the 1950s and 1960s, sticking faithfully to the original screenplay.

Despite the immense talent of actors such as Anthony Hopkins (as Pablo) and Natasha McElhone (as Françoise Gilot), the enterprise was a commercial flop.

I met Ismael Merchant in 1995 at the Hôtel Raphaël in Paris. He wanted me to intercede with my uncle. While I understood his excitement at bringing Picasso's life to the screen, I was determined to persuade him that he had an obligation with regard to historical truth.

I remember being impressed by his charisma and his desire to "compromise." However, I knew how much this word, in American legislation, can result in different opinions—particularly by the producer, in this instance the major company Warner Brothers, which asserts its absolute right to a final cut, a right which always carries more weight than the moral right of the director.

Because he drew on Françoise Gilot's book in particular, the screenwriter had assumed he would have the agreement of her son Claude. Merchant was to be bitterly disappointed: although I had approached Claude in a spirit of conciliation, the latter remained adamant—and with good reason. *Surviving Picasso* was made without any reproductions of the master's canvases, and opened in 1996 to coincide with the exceptional exhibition "Picasso and the Portrait" (in April at the Museum of Modern Art, New York, and in September at the Grand Palais, Paris). But whereas the exhibition celebrated the artist, the film showed a vile and sadistic man. Picasso spent more time in it grumbling about his friends and relatives, who were always at his beck and call, than working and creating.

Despite meticulous direction, which succeeded well in recreating the Côte d'Azur of the postwar period, the film suffered from having mediocre characters. There was no magic or genius. It presented prosaic, everyday

7 Claude Picasso was appointed administrator of the *Indivision Picasso* in 1989.

life, with two-dimensional characters who were supposed to be portraying extraordinary people.

It was all a hoax, and the public was not deceived, despite considerable publicity and a launch in every country, despite the prestigious cast and a catchy title. The box office did not quake, Anthony Hopkins went from playing Picasso to playing Nixon, and life went on.

But Pablo Picasso the man had suffered again. His bad reputation had become firmly established.

I became filled with a sense of injustice. I felt I was at a crossroads, between the long lines of visitors to the Grand Palais, who waited for hours in the rain for a few moments of emotion, and the few viewers of *Surviving Picasso*, astonished by such a disappointing "reality." On the one hand, the film attempted to make those coming out of the exhibition think that the artist was a bad guy. On the other hand, those who had seen only the film without glimpsing even the hint of a work would be likely to conclude that the exhibition was not worth wasting time on.

I will pass over in silence the articles which confirmed that this Picasso was a nasty manipulator, a fact that hadn't been reiterated often enough. Some of the journalists had simply contented themselves with copying the press releases.

Our family chose to react with indifference. We slumped a bit more under the insult. But it was pointless to add scandal to the situation, something those marketing the film were hoping for, or get embroiled in an interminable lawsuit in California. Personally, though, I was furious.

It was at this point that my cousin, Marina, the daughter of Paulo (Pablo's first son), revealed her vision of Picasso. Along with her half-brother Bernard, she was the co-heir of her father, who died in 1975. Since 1980, Marina had been living in Switzerland, choosing—nobody knew why—to have nothing to do with our family—something she had every right to do, of course. But that did not give her the right to say bad things without justification.

She tirelessly reiterated that she was "Picasso's only legitimate granddaughter." Fair enough. In 1995, she published a first book, *Les Enfants du bout du monde*,[8] which set out to describe her personal experiences. Half the book is devoted to her personal journey and to the prolonged psychotherapy that she had to follow in order to accept, as she put it, her status as an heir. The other part, to her immense credit, described the creation of

8 Marina Picasso 1995.

the charitable organization that she financed in Vietnam, and her adoption of two Vietnamese children.

This first portrait of our grandfather that she presented was not very flattering. I found it all the more surprising in that Marina, although born in 1950, described several afternoons spent with him when she was a child. Despite her young age, she apparently remembered a few anecdotes that were the source of some very bitter definitive judgments.

I saw this as the result of her therapy, which must have led her to brood endlessly on these few brief moments in the hope of finding reasons for her unhappiness. One detail had astonished me, however: two of the photographs reproduced in the central section were captioned: "Pablo Picasso and his granddaughter Marina" and "Pablo Picasso with Pablito and Marina." In fact, as was publicly known, they showed "Picasso and his daughter Paloma" and "Pablo Picasso with his son Claude and his grandson Pablito" —Marina's elder brother, who died in 1973. Was this a mistake? If so, what about the text? Did it too contain errors?

Unfortunately, as it did not contain any accounts by others or any precise dates, it was difficult for me to corroborate any of the few facts related. I remember feeling confused. I firmly believed that we, Picasso's descendants, had an obligation to be precise with regard to the historical truth. To this end, we had to be above reproach if we wanted to talk about the life or work of our grandfather, even partially.

Otherwise, it would be better if we said nothing.

When, in late 1994, as a producer, I decided to create the first CD-ROM devoted to Pablo Picasso, I forced myself to follow this principle. The work demanded a commitment to excellence and, in order to achieve this, an ambitious team.

I knew the limits of my own abilities. I found the perfect co-producer to take care of the technical side of things and worldwide distribution. In my uncle Claude Picasso, we had the ideal editorial consultant. As well as combining knowledge with personal memories about Pablo Picasso's work and life, he was also enthusiastic about new technology. We assembled an outstanding team and in September 1996, following a marathon of work, we presented an exhaustive catalogue of an exceptional body of work. It was the ideal museum spread over more than two thousand interactive pages.

We decided that everything should center on the work. The work would form the link between biographical references and the events of each era explored. We were seeking a harmonious balance that would enable us to appeal to the uninitiated and reassure aficionados.

Asked whether I had any desire to supplement this work by writing a book about my grandfather, I replied that I saw no need for one. I naturally wanted to avoid treading on the toes of my mother, Maya, or my uncle Claude. They were Picasso's children and, moreover, they possessed genuine artistic legitimacy. I preferred to limit myself to this single multimedia work, which was more in tune with my generation.

This experience had already enabled me to put Pablo Picasso's creative genius into perspective in the face of the bitter statements put forward in the books and the film described above. With a touch of Manichaeism, I believed that good could triumph over bad, justice over injustice—or at any rate, accuracy over inaccuracy.

In this respect, I would be enormously disappointed.

At the end of 2001, the second of my cousin Marina's books was published, *Grand-Père*.[9] And there I was thinking she had said everything she had to say in the first one! The title led one to expect a nostalgic account—even if the memories must have been very few in number—an intimate portrait, if it was true that they were close, or at the very least some sort of appreciation. But there was neither nostalgia nor appreciation. In September 2001, at a time when blind, fanatical terrorism was striking the world, Marina "remembered" that for her Picasso was a genius, yes, but "the genius of evil." My grandfather, our grandfather, had just died a second time.

When interviewed by journalists, I used the phrase "shooting at the coffin." It is so easy to do when you know the accused cannot defend himself anymore. The collateral damage was enormous: her dead father, Paulo, her mother, Émilienne, on life support, and many others. And there were so many inaccuracies, which were assuredly more attention-grabbing. And yet, despite the inevitable deluge of articles promoting it in the press, the book did not fulfill its promise as a bestseller. The problem, no doubt, was that the first book, which appeared in 1995, was already sufficient on the subject, and that this second one gave the impression of being a new "cut and paste" job. Furthermore, despite Marina's benevolent declaration that it was not her aim to say bad things about Picasso, it was filled with a succession of statements about our grandfather that I regarded as offensive. It also contained some strange alterations. Once again, it had no dates or comments by anyone else, and it had the same photograph of Pablo and Paloma incorrectly captioned. Seen in the context of those famous fourteen years of analysis, many of her comments were not taken seriously and some people concluded that it would perhaps be a good thing for her to stop biting the hand that fed her.

9 Marina Picasso and Louis Vallentin, *Grand-Père*, Paris 2001. See also Marina Picasso and Vallentin 2002.

At the time, I felt real compassion for my cousin Marina, probably because of the way she had needlessly cut herself off from our family. None of us had ever done anything to harm her. On the contrary, everyone had always tried to maintain good relations. This book had revealed to me her difficult daily life with her mother, Émilienne, and the occasional awkward moments with her father, Paulo. It occurred to me that this book should have been called *Maman, Papa, Grand-père*, in view of the relative importance of each person's memories and responsibilities. It was Marina's personal story, but in reality some protagonists had only minor roles, while other, essential figures had strangely disappeared. And the script seemed very thin to me. Why? There is no justification for turning our grandfather into a villain, a manipulative monster who spent most of his time looking for punch-bags. I am afraid that this bad book demonstrates the failure of the much publicized therapy. Too much therapy kills therapy.

A year before this, in the autumn of 2000, I had been contacted again about writing a book. I decided it would be an interesting opportunity to go in search of this grandfather and to meet those who had actually known him while there was still time. It would be a chance to bring his day-to-day existence, with its ups and downs, both big and small, back to life in a new form. Indeed, these fortunate people, few in number today and in many cases very old, enabled me to live with Pablo Picasso for a few hours. They brought back to life for me those times of work or relaxation that they had experienced with my grandfather. Many had never spoken about him before, or at least had never talked with a member of the family. Using my knowledge of law to help me understand the various legal issues, I wanted this task to be conducted as rigorously as an inquiry, with a journalist's objectivity and a detective's perceptiveness. I wanted to ask the difficult questions, gather information, and double check the facts. So I set to work. What I had thought of as research turned into an exciting search—the search for an individual. I hope in the coming chapters to present an image that matches the truth and, as far as is possible, to lay a new stone in the edifice of our knowledge about Picasso. Not another shovelful of dirt on his tomb. In that respect, I feel I have been faithful to a fitting sense of gratitude.

Like it or not, we descendants of Picasso are united by our destiny. We are also responsible for safeguarding a memory, because we all share in the pride and advantages it brings. But that does not prevent us from being ourselves, and from being respectful of the truth, even if it hurts sometimes. We can smile through gritted teeth. In the final analysis, that is why I decided to write this book.

I am sure that my grandfather was not an easy man. His work certainly isn't easy. I must be honest enough to recognize that some people may have suffered as a result of his choices or mistakes. Were they victims or themselves guilty? Are we always able to break free? My grandfather was the painter of freedom; some of those close to him understood this, while others did not. Did Picasso put them in a situation of constraint? He is no longer here to explain his actions. Others have had a go. That is why I decided to write this book.

I have not attempted to write a biography in the traditional sense. That was not my aim. Apart from anything else, I have too much respect for the work of art historians like Pierre Daix,[10] Josep Palau i Fabre,[11] William Rubin,[12] John Richardson,[13] and Christian Zervos,[14] who have devoted part of their lives to the task. There are many other eminent figures, friends, or enthusiasts of Picasso, such as Marie-Laure Bernadac and Christine Piot,[15] Brassaï,[16] Pierre Cabanne,[17] Brigitte Léal,[18] Jean Leymarie,[19] Fernand Mourlot,[20] Patrick O'Brian,[21] Roland Penrose,[22] Werner Spies,[23] Antonina Vallentin,[24] to name a few. Nor should we forget photographers like Man Ray, David Douglas Duncan, Lucien Clergue, Edward Quinn, André Villers, and Roberto Otero. Their passion for my grandfather and their painstaking research command respect. Neither do I wish to deal here with Picasso's work, which has been the subject of thousands of books and exhibition catalogues rich in material. The CD-ROM devoted entirely to his work, put together with the help of numerous enthusiasts, bears modest witness to the principle of objectivity that I set for myself.

I would like this book to explore a third avenue, that of Pablo Picasso the man. I didn't know him in daily life, but this daily life that I did not have

10 Pierre Daix has written more than ten books together with numerous articles on Pablo Picasso. For a selection of these see the Bibliography.
11 Palau i Fabre 1981.
12 For Rubin's works see the Bibliography.
13 For Richardson's works see the Bibliography.
14 For Zervos'works see the Bibliography.
15 Bernadac and Piot 1986.
16 Brassaï 1999.
17 Cabanne 1977.
18 Léal 1996.
19 Leymarie 1962, and *Picasso: Métamorphoses et unité*, Geneva 1971.
20 Mourlot 1970.
21 O'Brian 1976.
22 Penrose 1957; Penrose 1958.
23 Werner Spies, *Sculptures by Picasso, with a Catalogue of the Works*, New York 1971; *Picasso: Pastelle, Zeichnungen, Aquarelle*, Stuttgart 1986.
24 Vallentin 1957.

access to intrigues me. I had the privilege not only of having met many historic witnesses, but also of having benefited from a unique vision as spectator within my own family. So I decided to look into the rumors and uncertain memories, partial or "reconstituted," even if it meant denouncing them with the aid of proofs. I turned back the clock with those who really knew Pablo, by meeting them or consulting their writings, if they are verifiable. These were people who shared these moments of happiness or doubt, people my grandfather confided in, people who were present in his everyday life, at his death, or at other events still little known. They were old enough to understand, to have retained vivid memories and coherent assessments. Thus the true story of an exceptional man and his legacy took shape before my eyes. The story of a grandfather, of our grandfather, of my grandfather.

The following pages paint the portrait of a man, with all his strenghts and defects, his encounters, his conquests, his partners, his children, his friends, his family, his doubts, his fears, his regrets, and his certainties, his commitments, his unique audacity, his fidelity, his infidelity, his moments of happiness, and, on occasion, his arguments and his bouts of anger. And everything was imbued with an insolence that came from constant questioning and ceaseless work.

This whole quest has been a real initiation for me, and I would like to share it with everyone, particularly those who saw in my grandfather only an alleged "dark side of power." I risked discovering things that had been left unsaid, things that history had forgotten, but that is the risk of every exploration. And its honor. For me, as a grandson, it is like abolishing the time that separates us. And even though it is not possible to bring someone back to life, at least I have worked on his memory. I have accomplished my duty with regard to his memory.

I know my task is a hazardous one and that people will be unforgiving of any lapses. Since I demand great rigor in other people, I am obliged to exercise great vigilance in my own work. I have spoken of an obligation to historical truth. I hope that this book will be an example of this. I have consulted numerous legal documents and found official archives lying dormant under half a century of dust that shed light on everything and everyone. Picasso belongs a little to his family and a lot to others. More than thirty years after his death, not a day goes by without his life or work being talked about, without an anecdote in an interview, a record auction sale, a successful exhibition bringing back his memory. It all fascinates and inspires me. If that were not the case, I would no longer be myself. I decided a long time ago to be Picasso's grandson. It's a real blessing. Thank you grandfather!

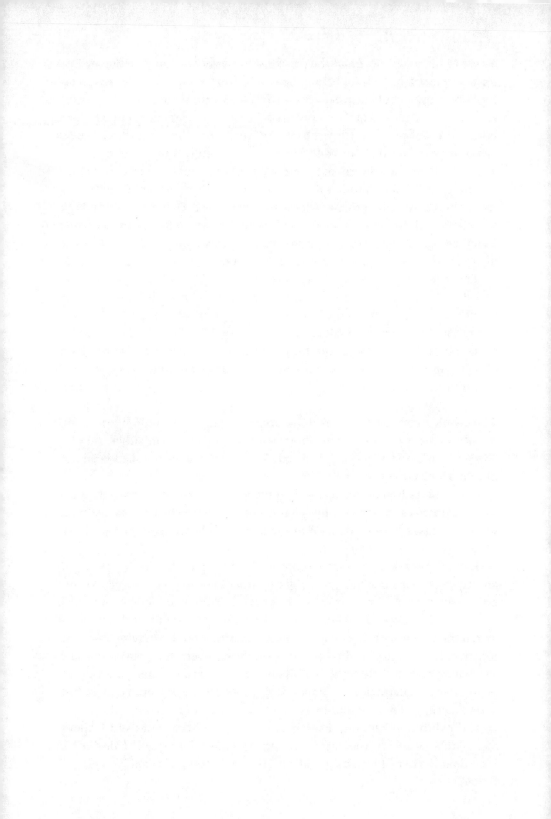

Women

"I do not seek, I find!"[1]

Pablo Picasso

My grandfather was a Sun King, a fixed point in the firmament, around whom women moved like planets in perpetual orbit, sometimes coming closer, other times drifting further away—assuming that he had not banished them to burn out at the far end of the universe.

Legend has it that Picasso was one of the most seductive men of the twentieth century. Yet he scarcely possessed the traditional attributes of the type. He was short—around five feet five inches—stocky and heavy set. Once asked whether he was lacking anything in life, he replied: "Yes, another two inches!" However, he made up for this lack of stature elsewhere.

He dressed elegantly, particularly from 1915, when he started to make more money, and for the next twenty years in what his friends jokingly called his "duchess period." In the early 1930s, the photographer Cecil Beaton, who was expecting to photograph a wild bohemian in a messy studio, saw Picasso arrive wearing an elegant navy blue suit with a silk tie in his immaculate French Regency-style apartment in the rue la Boétie. This tailor-made smartness, worthy of London's famous Savile Row, was a visible sign of his wealth and his entrance into a new world. Even after he had abandoned this ostentatious elegance, he retained right up to the end of his life a personal style (as in the famous sailor's pullover and shorts of the post-

1 Pablo Picasso, "Lettre sur l'Art," in *Ogoniok*, Moscow, no. 20, May 16, 1926.

war period), and a certain coquettishness (evident in his propensity for combining various materials, such as velvet and tweed, and of colors and prints).

He listened a lot without necessarily talking. But as soon as he started to speak, his enthusiasm and charm proved irresistible, qualities that were of particular appeal to women. With a piercing look and a few direct, incisive words, he could usually obtain the favor he desired.

He had an increasing number of affairs as time went by. The large brown lock of hair that fell across his determined forehead had disappeared at the beginning of the 1940s. By this time, it was a Picasso haloed with thin gray hair who aroused women's fantasies, and undoubtedly male jealousy—even though some husbands literally offered up their wives to the master's "affection," although often in vain. The gaze remained dark, penetrating, attentive, disturbing in its conviction, hypnotizing. To it he added a way with words—accompanied in the beginning by a certain shyness, and, more instinctively, a penchant for the cutting remark, the trenchant comment.

Picasso's love life was the *sine qua non* of his work. Even when his hand was guided by political considerations alone, as in *Guernica*, it was always the woman or feminine influences of the moment, sometimes competing ones, that gave human form to the figures in the work.

Women were to Picasso what paint is to the brush: inseparable, essential, fatal.

My grandfather produced the twentieth century's most extraordinary portraits of women, oscillating between the purest classicism and the most controversial deconstruction. In every instance, he listened only to his instinct —and his love. This love was essential and ever present, even if, each time, its object was different. Picasso loved, loved like a madman, furiously seeking the woman who would feed his art, his life, his dream of eternity. He made each new companion undergo an initiation, an emotional and artistic test, to seduce, reassure, and restrain her, to draw from her inspiration and creativity, which he exhausted before ineluctably abandoning her and recommencing the same game with another woman—and then another. Very few could withstand it.

What they gained from it was immortality. The painter who knows how to glorify a woman's gaze forever on his canvas possesses a powerful weapon. My grandfather knew the aura he had. Despite an affable, endearing demeanor, he had the eye of the Minotaur, strong and tender at the same time, seductive and implacable, imperious and tamed, capable of the best and the worst.

An artist who was into everything, a gambler who always won, a fickle womanizer, an unfaithful husband, and polygamous lover, known wherever

he went, he possessed what many men dreamed of: love, sex, fame, money, power, and the artist's gift. These were eternal themes that recur in his work. *Forever and ever. Amen.* This was the "mass." God's name was Picasso. His women were saints, in some cases converts, in others veritable expiatory offerings. But the apostle traveled a long road, and was often crucified, before being eternally sanctified.

Whether I visit an exhibition or read an art book about my grandfather, I find it inconceivable that such a body of work could have been created without love—without other people. I believe those who see his work as the product of an egoist are mistaken: what made him so unique was that his raw, living materials were love and humanity. In a television interview he gave in the 1960s, he declared that the most important thing was to love and that, if there was no one left to love, he would have loved anything—"even a door handle."

He had a passion for other people. Without them, his work would be empty, empty of lines, of pencil, of paint—and empty of meaning. My grandfather had a great need for affection and every day he demanded hard proof, emotional proof. He saw the world through his painting, but he also saw painting through others. The Málaga of his childhood was a world of devoted women. Surrounded by his mother, his sisters, and his aunts, he was the child king. Attention and affection went without saying. Did he understand that he had to show similar attention and affection in return? It is by no means certain! The daily life of this pampered boy demanded nothing of the kind. Even his indifference to school did not incur the wrath of either his father or his mother. The latter, Doña María, idolized him; his father, Don José, had understood the inexplicable.

Pablo had demonstrated a precocious aptitude for drawing and, thanks to the unconditional support of his father, who was a professor at the School of Fine Arts, and of his uncle, his childhood misdemeanors were forgiven because of his artistic genius. After having observed his entourage, after having captured to perfection pigeons and the bulls at the bullfights that his father took him to see, he experienced for the first time in 1894, at the age of thirteen, the turmoil of love. It was the first time he'd been wounded.

The family left Málaga, in southern Spain, settling in 1891 in La Coruña, a wind- and rain-swept coastal town in the north of the country. There Pablo fell in love with a pupil in his class, Angeles Mendez y Gil, who came from a bourgeois family. In the drawings that he gave her, he intertwined his initials with hers, as he would do with my grandmother Marie-Thérèse at the end of the 1920s. They had a secret love affair under the noses of their respective families, but hers found out and disapproved so strongly of this idyll with a boy of humble extraction that they sent the young girl away to

another town. That was the end of the infatuation. The adolescent was heartbroken and his pride was grievously wounded.

After the hell of the Atlantic coast, the Ruiz Blasco y Picasso family eventually settled in the Mediterranean paradise of Barcelona. It was there that Pablo had his first sexual encounters before the age of fifteen. When he entered the School of Fine Arts (called La Lonja by the students, or Llotja in Catalan), he got to know a classmate, Manuel Pallarès, who became a friend for life (Pablo died in 1973, Pallarès in 1974).

Pallarès, who was five years older, took Pablo with him on his rounds of the bars and brothels, immersing him at an early age in the harsh realities of life. Pablo thus went from unbridled romanticism to the crudest sensuality.

These first experiences—fleeting affairs or cheap sexual encounters—would give him a lifelong fascination with physical love, a symbol of life and youth, the energy and prevalence of which are captured in his erotic works.

In 1897, he left for Madrid to study at the Academy of San Fernando. His absences from the academy and his nocturnal escapades soon led his benefactor, his uncle Don Salvador, to cut off his allowance. But his father continued to send some money for him to get by on and to pay for his room. Pablo's period of abject poverty had begun.

To make matters worse, he fell ill, either with scarlet fever or the consequences of his wild lifestyle. With empty pockets and circles under his eyes, he returned to Barcelona to be with his family again and then left with his alter ego Pallarès for the village of Horta de Ebro (today Horta de Sant Joan), the place from which Pallarès' family came. Picasso was intending to convalesce there and build up his strength, while Pallarès was taking refuge from being drafted into the army (Spain was then at war with the United States).

At this time, Horta was a large village with more than two thousand inhabitants. It was reached by road and then footpath. For Picasso, who had only ever known the city, it was fascinating to discover peaceful agricultural life amid almond and olive groves, small pastures, and barren landscapes.

The locals he encountered there were used to hard work, sacrifice, and solidarity. It was there that he learned how to forge relationships with other people and things. No matter how successful and wealthy he later became, he remained true to this simplicity and would never forget that it had contributed to the undoubted contentment of the inhabitants of Horta down the centuries.

The two friends stayed there for nearly eight months, exploring the surrounding hills and mountains. They had also gone there to paint. Pablo and Manuel lived simply, sleeping under the stars or in caves, every two or three

days receiving supplies brought by Salvador, Manuel's younger brother. Pablo's father had sent some canvases on stretchers and paints for his son.

All these details—and there are many more—about Pablo's experiences in Horta and the surrounding region were exhaustively recounted by the historian Josep Palau i Fabre in a first encyclopedic book.[2] Fabre used the account of these key moments given to him by Picasso and, above all, Pallarès. However, a different version is given by American biographer Arianna Stassinopoulos-Huffington[3]—and her alone. Stassinopoulos-Huffington, referring to an interview with Françoise Gilot in the 1980s,[4] claims that a third person, a young gypsy, accompanied Pablo and Manuel. "The gypsy was five years younger than Pablo and was also a painter; the three of them spent a large part of the day painting.... Together they watched the daily miracle of dawn and took long walks.... Theirs became a burning friendship.... Pallarès, suddenly displaced and excluded, took his revenge later when he omitted any mention of the gypsy from his account of Pablo's life in Horta. The way Pallarès told the story, just he and Pablo explored Horta; the way Pablo told it, on the only occasion when he talked about his passionate friendship, it was always he and the gypsy.... Pablo was in love— with the gypsy and with the world."[5]

The biographer is here making subtle allusions to a passionate homosexuality. And the most astonishing thing is that these dreamed up "revelations" have a strange flavor of puritanical disapproval. There should be no beating about the bush in this matter.

But let us return to serious matters. As a result of my research, during which I looked at all the biographical sources and accounts, I can assert that this encounter, which Françoise Gilot herself does not mention in any of her own books, has not been corroborated by anyone. John Richardson refers to the influence of the gypsies in the following terms: "[In Málaga] in the shadow of the Alcazaba were the shacks of 'Chupa y Tira,' where beggars and gypsies 'sat de-lousing one another in the sun among whiffs of orange flower and drying excrement [and] children up to the age of twelve ran naked.' The neighborhood was called 'Chupa y Tira' (Suck and Throw) because 'the people were so poor,' Picasso told Jaime Sabartès,[6] 'that all they could eat was a chowder made with clams. And all their backyards were filled with clamshells which they had thrown out of their windows after having sucked

2 Josep Palau i Fabre, *Picasso vivo (1881–1907)*, Barcelona: Ediciones Poligrafa, 1980, chapter V (La Horta de Ebro).
3 Stassinopoulos-Huffington 1988.
4 Françoise Gilot, Pablo's companion until the autumn of 1953. They met in May 1943.
5 Stassinopoulos-Huffington 1988, pp. 41–42.
6 Jaime Sabartès was a Spanish friend of Picasso's. He became his secretary in 1935.

out … their very souls.' Picasso's love for *cante jondo* originated in the 'Chupa y Tira.' But that was not all the gypsies taught him. Unbeknownst to his family, he learned not only how to smoke but how to smoke with a cigarette up his nostril; he also learned how to dance rudimentary flamenco. 'There was no end to the tricks I learned from the gypsies,' he would say mysteriously."[7]

In Horta that year, 1898, in addition to these very innocent pleasures, Pablo painted the portrait of a young naked gypsy, which Josep Palau i Fabre has examined carefully.[8] The gypsy is painted in the purest academic style of the time. Like the models used in the school, he is naked, and his serious face brings to mind another portrait of a gypsy also painted in Horta. This work is unquestionably in the tradition of that done by the students of the San Fernando Academy.

John Richardson describes how a young gypsy painter, Fabián de Castro, stayed at the Bateau-Lavoir.[9] De Castro, who might have been the famous "gypsy" from Horta ("Fabián is presumably the gypsy painter with whom Picasso is supposed to have had an affair"),[10] slept on the floor in the same room as Picasso, but as Richardson says, "there is no evidence or likelihood of a sexual relationship."[11]

What a godsend this supposed homosexual experience in the hills around Horta is for an ill-intentioned biographer. The unverifiable scene took place in the mountainous desert of the Catalan back country in 1898(!), and the two protagonists, Pablo and Pallarès, are both dead. Despite all the exhaustive research on more conventional subjects, there is nothing like an "exotic" touch to "spice up" a biography.

Far be it for me to dispute the possibility that Picasso might have been curious about his sexual identity—in our day and age, such behavior is commonplace. But it is a bold step indeed to conclude that he fought throughout his life against his "natural" attraction. Equally bad is the biographer's innuendo about Braque, her laborious description of Picasso's turn-of-the-century homosexual friends, such as the dealer Manyac and the poet Jacob, and her dubious questions about "his own confused sexuality."[12] "Were the relentless brothel rounds and the red-blooded masculinity an expression of his volcanic lust, or did they hide a deeper conflict?"[13] she goes on, deftly allowing uncertainty to persist.

7 Richardson, vol. 1, 1992, p.27.
8 Palau i Fabre 1996.
9 A dilapidated building housing studios in Montmartre (Paris), where Pablo lived on and off at the beginning of the twentieth century.
10 Richardson, vol. 1, 1992, p.296.
11 Ibid. p.296.
12 Stassinopoulos-Huffington 1988, p.67.
13 Ibid., p.67.

Picasso, then, is supposed to have had many heterosexual relationships in order to conceal (from himself) his deep predilection for men. What a titanic struggle! What a painful battle that must have been, to spend seventy years endlessly painting, drawing, sculpting women, in thousands of works! What a superhuman task it was, to have four children with three very different women! Although there are a few naked men among the drawings, none of them is free from academicism, and, as Pierre Daix remarked to me: "If every time a painter paints a naked young man we must conclude that he is a pederast...".

But what about the erotic frescoes he painted on the walls of the small two-room apartment of his friend Jaime Sabartès in Barcelona in 1904? Pablo was inspired to paint these frescoes, mostly in blue, by the proto-surrealist book *Les Chants de Maldoror* by Lautréamont, and a pornographic novel, *Gamiani*, attributed to Musset. The frescoes showed a naked couple engaging in passionate frolics beneath a hanged Moor with an erection.

These paintings, done in the course of an evening, were quickly erased. Sabartès recounted the anecdote to the American historian William Rubin, and no one concluded as a result that Picasso had a particular attachment to the poor Moor. By executing the most licentious drawing possible, Pablo doubtless wanted to poke fun at the very academic art school that he could see from the window of the room.

There is nothing in any of Picasso's erotic work that suggests an interest in male homosexuality. However, like a lot of heterosexuals, he enjoyed, *a contrario*, the sight of lesbian love-making that the young boarders at the brothels of his youth often offered him, and which he reproduced in many sketches of the period.

It is a fact that Picasso was heterosexual. And that was the problem for many women! Was he homosexual? There is a lack of reliable testimony. Was he a zoophile because he was fond of a little goat in the 1950s and a sheep at the end of his life?

Enough. Picasso had homosexual friends, and, even though he lived in less tolerant times, he would have defended them. Suffice it to say, if he was homosexual, it was no doubt through his lesbian leanings.

His need for affection really made itself felt after the Barcelona period and his first stay in Paris at the beginning of the twentieth century, a time when he was alone and very poor. At this point, Pablo was the very archetype of the broodingly handsome man. Well built and strikingly Latin, he provoked strong reactions. He did more than just stare at a woman, his interest went beyond her appearance: he would penetrate her, rape her with his eyes, and provoke an emotional response that, unconsciously or not, he would take advantage of.

GERMAINE (1881–1948)

During his first trip to Paris in October 1900 in the company of his friend and co-tenant in Barcelona, Carles Casagemas, he visited the Exposition Universelle, and stayed with one of their friends, the Catalan painter Isidre Nonell (whom he had met at the El Quatre Gats café in Barcelona), at 49, rue Gabrielle in Montmartre. Soon after, they moved to the Bateau-Lavoir at 13, rue Ravignan. There they joined a whole community of Catalan émigrés, including Casas, Utrillo, Fontbona, Isern, Pidelaserra, and Junyent.

At the Bateau-Lavoir, they got to know two young women, Odette and Germaine. The latter became Casagemas's girlfriend. A laundress and model for painters in Montmartre, she frequented this community of young people and, although married, she was not prudish. Casagemas had high hopes for their relationship, which was too platonic for his liking.

However, things quickly took a turn for the worse between them. Germaine didn't want their relationship to be taken as anything other than simple friendship. Casagemas, for his part, imagined a love affair that didn't exist. The reality of the situation made him more depressed by the day. One evening, in front of Odette, Pallarès, and the Catalan sculptor Manolo, Casagemas took a revolver out of his pocket and fired it at Germaine.

John Richardson recounts the incident as follows: "Thanks to Pallarès's intervention, the bullet missed, but the explosion knocked Germaine to the ground. Concluding that he had killed the woman he loved, Casagemas put the gun to his head, and crying out 'Et voilà pour moi!,' shot himself in the right temple."[14] Pierre Daix (drawing on the exhaustive study by Palau i Fabre) provides the following details, and confirms how strikingly attractive Germaine was: "According to the recollections of Pallarés, Germaine, disappointed in Casagemas's impotence and hysteria, had decided before returning to Paris to leave him, and to be safe, had even chosen to go back to the home of her husband Florentin. That was the cause of the tragedy. When Picasso returned to Paris in June 1901 and moved to 130 ter, boulevard de Clichy, in the heart of the Spanish community, his friend Manolo had become Germaine's official lover, but Picasso quickly replaced him and communicated the news via a comic strip addressed to Miquel Utrillo in Barcelona, in which he showed Manolo's jealousy and drew himself in bed with Germaine, confronted by an angry Odette."[15]

14 Richardson, vol. 1, 1992, pp. 180–81.
15 Daix 1995, p. 392.

Pablo seemed very proud of this conquest, even though Germaine had been the focus of his despairing friend's hopes. Perhaps he was trying to get closer to him, to his soul, by sharing a fondness for the same woman? By succeeding where Casagemas had failed?

The Bateau-Lavoir period was, in terms both of lifestyle and painting, a time of exchange and experimentation. A spirit of frivolity prevailed, at odds with the general puritanism of the time. My grandfather and his friends were part of an art movement with a worldwide impact that they could hardly have foreseen, and that prefigured many other liberation movements. Years before any real moral emancipation took place, they freed their desires.

Emotion, by nature curious and changeable, was the wellspring of their creative impulse, which was marked by freedom and the rejection of academicism. Pablo had numerous affairs and depicted them as so many conquests. Several of his models, who merely posed or else had fleeting relationships with him, are represented in this way, for example Jeanne and a certain Blanche, whose names are associated with brief but intense affairs.

Later, he would say of these ephemeral women: "To begin with, you are only interested in painting them. But then you go on to something else…." And he did go on to something else—time and again.

MADELEINE

In the course of his nomadic love life, Pablo saw Germaine on several occasions, during his trips to Paris in 1902 and 1904, but at that time he was also seeing another model, Madeleine, whom he had met at Le Lapin Agile, the famous cabaret in Montmartre.[16] In 1904, he was even thinking of taking things further and having a child with her.

We know little about this relationship. For Pierre Daix, "The gap in knowledge is doubtless due to the fact that at the time of their affair, only Max Jacob could have known about it;[17] now, he always kept secret his friend's [Pablo's] affairs, which must have exacerbated his jealousy.

16 Previously known as *Le Lapin à Gill*, after André Gill who, in 1872, had painted a rabbit on the sign on the front of the cabaret (originally called the *Cabaret des Assassins*).

17 Max Jacob (1876–1944), French poet. He had been one of Pablo's best friends since 1901. He introduced him to French culture. When Pablo arrived in Paris, these two "bohemian companions" shared a room. Their rather complicated relationship was punctuated by periods of both deep affection and incomprehension. Max Jacob was homosexual and disliked Pablo's affairs. The latter illustrated Jacob's first book, published by Kahnweiler, *Saint Matorel*, in 1910. Along with Guillaume Apollinaire and Jean Cocteau, Jacob was a witness at Pablo Picasso's marriage to Olga Khokhlova in 1918. They grew apart around the beginning of the 1920s, even though their friendship continued until the death of Jacob, who was deported to Drancy in 1944.

Apollinaire[18] and Salmon[19] were not yet close friends of Picasso and the latter, no doubt fearing that Fernande [Olivier], who claimed to be 'Mrs. Picasso' and also his first mistress, would be irritated, revealed the existence of Madeleine only after Fernande's death, in order to avoid any comments on her part. It is probable that his friends in the Spanish colony knew about it, but they too were good at the keeping of secrets."[20]

When it came to affairs of the heart, my grandfather learned early on that discretion was his best ally. Not because he had decided to have lots of affairs or took his conquests lightly. But, even after clear-cut separations, he always maintained a bond, even if it was a purely artistic one. At the moment a new relationship was beginning, another was continuing.

FERNANDE OLIVIER (1881–1966)

Fernande was born on June 6, 1881, the same year as Pablo. Her real name was Amélie Lang. She had married a brutal man by the name of Paul-Émile Percheron, a shop assistant, in 1899. It was a forced, unhappy marriage. Exasperated by this violent man, she quickly left him to go and live with a certain Laurent Debienne, a sculptor in Montmartre. She earned a living posing for various painters. Fernande became a well-known and colorful figure in the Butte Montmartre, which was still a village at the time.

She met Pablo in the summer of 1904. She lived in the Bateau-Lavoir and one evening, during a big storm, they bumped into each other under the little entrance porch. She took refuge at his place.

18 Guillaume Apollinaire (1880–1918), French modernist poet and art critic. He possessed a rich classical culture and was regarded as the theoretician of the "esprit nouveau." He published poetry collections such as *Alcools* and *Calligrammes*. A literary and artistic activist, he contributed to the *Mercure de France* and *Paris Journal,* and founded the periodical *Les Soirs de Paris.* He met Picasso at the end of 1904 at the Bateau-Lavoir. According to Sabartès, his arrival transformed Picasso's life "in terms of his culture, his imagination and his intelligence." They became good friends, regularly discussing painting and literature. Both were part of a circle of friends that included Georges Braque, Marie Laurencin, Douanier Rousseau (in whose honor Picasso organized a famous banquet in late 1908), and many other Cubist painters. He wrote an article on Picasso in *La Plume* at the time of an exhibition of Pablo's work at the Galerie Serrurier (1905), and an essay entitled "Les Peintres cubistes" (1913). Thanks to their regular correspondence. Apollinaire's friendship with Pablo continued during World War I while Apollinaire was at the front. He died of Spanish flu on November 9, 1918.

19 André Salmon (1881–1969), French poet and writer. He was introduced to the "Picasso gang" at the Bateau-Lavoir at the end of 1904 by the sculptor and painter Manolo, and remained a close friend of Pablo's until 1937. Their friendship ended when Salmon agreed to become a war correspondent in Spain for *Le Petit Parisien,* an openly pro-Franco newspaper. They never saw each other again, something Pablo deeply regretted, despite his resentment.

20 Daix 1995, p. 543.

She was simple and spontaneous, and far from prudish. Their relationship began with this first storm. But Fernande was also "involved with the Spanish painter Joachim Sunyer, who, if he is to be believed, introduced her to physical love. These intermittent relations with Picasso lasted for more than a year."[21] In the beginning, Picasso was still involved with Madeleine, and used to see Fernande intermittently. He also had a brief relationship with Alice Princet, who would later become the wife of the painter Derain.

It is difficult to unravel the tangle of amorous liaisons, but they testify to a genuine joie de vivre, despite the indescribable poverty that was the daily lot of this artists' community.

The Bateau-Lavoir was an old "ramshackle building made mostly of wood, zinc, and dirty glass, with stove-pipes sticking up haphazardly."[22] It had a single lavatory with one cold water tap serving thirty studios. But it was always possible to drink at the little fountain in the place Ravignan. This tumbledown place was filled with dreadful odors of mildew, cat's pee, and paint. In winter the place was freezing, and in summer it was a furnace —not unlike Madrid.

Pablo lived in a state of complete destitution, possessing only a simple bed base and an old trunk that served as an armchair. He never forgot these lean years: even when he had a fortune so huge that even he did not know what it was worth, he remained a simple and frugal man who used the deprivation he had experienced in the past as a yardstick to measure the requests that he was continually bombarded with. Some people have dared to create from this moderation a legend—totally false—that Picasso was an avaricious man, but we shall return to this later.

Fernande came to live with him at the beginning of 1905. In her book of memoirs, she describes these happy but impoverished times with nostalgia. "I wonder whether Picasso still remembers the young friend who sat for him so often, who at one time could not leave the house for two whole months because she hadn't any shoes. Does he remember those winter days when she had to stay in bed because there was no money to buy coal to heat the icy studio? ... Then there were the days when we were obliged to fast, and the piles of books bought at the little bookshop in the Rue des Martyrs: sustenance which I found essential, since Picasso, out of a sort of morbid jealousy, forced me to live like a recluse. But with some tea, books, a couch, not much housework to do, I was very, very happy."[23]

It is difficult to avoid seeing the possessive jealousy that Pablo inflicted on Fernande as a foretaste of his attitude later to my grandmother, Marie-

21 Ibid., p. 646.
22 O'Brian 1976, p. 124.
23 Olivier 1964, p. 17.

Thérèse. It is also hard to avoid thinking of the time that Pablo suggested to Françoise Gilot that she live hidden away, permanently, in the little apartment above his studio in the rue des Grands-Augustins, like a cloistered dove in a love nest. Marie-Thérèse, confined in one cage after another, but always at the center of their secret garden, submitted willingly to this kind of existence. Françoise's wings were much too big for his tiny aviary on the top floor.

This behavior may have been evidence of a sublimated instinct for collection on the part of Picasso. Or it might have been an echo of the anxiety of the adolescent from whom the little Angeles had been so unjustly taken away, a tragedy that he never wanted to experience again. Or perhaps it was a confusion between the image captured on the canvas and the captive woman in life.

Fernande and Pablo's material situation improved from November 1905, when the American collector Leo Stein and his sister Gertrude began to take an interest in his work. It improved further in May 1906, when the famous dealer Ambroise Vollard acquired around twenty canvases, all major works. Vollard had not bought anything from Pablo since 1901—their first exhibition had been a critical but not popular success, but Vollard had strongly disliked the painter's Blue Period. This unexpected windfall enabled the lovers to take a little trip to Spain. First to Barcelona, to meet his Catalan friends who had stayed at home, then to Gósol, where a delighted Picasso painted frenziedly.

Gósol, an isolated Catalan village that could be reached only by mule, brought back memories of his stay in Horta de Ebro. Throughout his life my grandfather loved returning with his partners to the places of his youth: he went to Barcelona with Olga, then with Marie-Thérèse (in what was his last trip to Spain), and to Montmartre and the rue la Boétie with Françoise. He attempted to get them to see that he was the product of his past, and to accept it. He wanted them to allow that part of him should remain a "free zone" that they would not have access to.

At this time, Picasso devoted himself mainly to his work and, under the influence of Fauvism, which had caused a scandal at the Salon des Indépendants in 1905 with the exhibition of canvases by Cézanne, Derain, Matisse, and Braque, he again used generous amounts of color. He drew lots of nudes, his first attempts at representing desire. Thus in spring 1906, he painted *Nu à la chevelure tirée* (Nude with long Hair) and *Nu à la draperie* (*Nude with Drapery*).

Sculpture and tribal art were a revelation to Pablo, who introduced hatching and partitioned surfaces in his work.

Fernande, for her part, looked after everyday matters and doesn't seem to have taken much interest in her companion's artistic experiments.

As for Fernande, she was interested in a young Dutch painter, Kees van Dongen, who had just moved to the Butte. She posed naked for him, which aroused Picasso's jealousy, making him furious. Convinced that he had been betrayed, he told her they were splitting up. Alerted by Fernande, Gertrude Stein doubted the theatrical sincerity of this separation. She was proved right: three months later the couple returned to their life together.

While Fernande was doing everything she could to get Pablo's attention, the latter was totally absorbed in his work, at the risk of letting their relationship die completely. But that would always be the case with Picasso. Work above all else was the artist's creed. Nothing and no one could distract him from his work.

During Fernande's absence, Pablo finally synthesized all the studies that he had undertaken since autumn 1906. He was inspired by Gauguin and his Tahitian women with their massive shapes, and by his visits to the Musée de l'homme, the haven of primitive art. A long series of preparatory drawings culminated in the completion in June 1907 of the emblematic painting of modern art, *Les Demoiselles d'Avignon*, turning him into the creator that the new century was waiting for.

And yet the painting was not shown in public until nine months later. Only a few fortunate people got to see the work in his studio. Most of them were unimpressed, sniggering and making fun of it, even Leo Stein, Derain, Apollinaire, and Braque, who made the following remark: "In spite of your explanations, your painting looks as if you wanted to make us eat tow, or drink gasoline and spit fire." Fernande doesn't even mention the big picture in her memoirs! Only Gertrude Stein seemed to understand it's significance and to realize what a historic moment it was.

A certain Daniel-Henry Kahnweiler, a German art dealer, experienced the epiphany of his young career at this time. Meeting this Picasso, about whom a German colleague had spoken to him, for the first time, he discovered simultaneously the artist and the masterpiece of modern art. He became Pablo's official dealer.

He began by buying a few important canvases. Picasso and his companion's standard of life improved. Pablo embarked on a stimulating collaboration with Braque, a dialogue that would last until 1914, resulting in what would come to be known as Cubism.

Fernande possessed two essential qualities: she liked their artist friends and she knew how to organize the house to receive them. Despite Pablo's all-consuming passion for his work, which took up more and more time and space, and despite his horror of routine, the couple enjoyed receiving close friends. The poets Guillaume Apollinaire, André Salmon, and of course Max Jacob, together with many other painters, were regulars at the rue Ravignan.

This bohemia, which Picasso often missed later on, gradually gave way to a small, excessively formal Parisian society made up of artists, intellectuals, painters, and writers.

Picasso was already suffocating. During the summer of 1908, he rented a small house forty kilometers from Paris, at la rue-des-Bois, near Creil. He moved in with Fernande and his dog and cat, which was about to have kittens. Fernande wrote: "We ate our meals in a room that smelled like a stable and were lulled to sleep by the gentle murmur of sounds from the forest. We got up late, having slept through all the noises from the farmyard, which had been awake since four in the morning. A succession of friends came to visit Derain and his pretty wife also came.... Then Max Jacob came and spent several days with us, and Apollinaire and other friends too."[24]

This temporary isolation in the countryside would be repeated in the future: in Fontainebleau with Olga, at the Château de Boisgeloup in the Eure and Le Tremblay-sur-Mauldre with Marie-Thérèse, and at Ménerbes with Françoise.

Pablo returned to Paris for the Salon d'Automne (which had been founded in 1903 and which he had taken an interest in since 1905). There he discovered the works that Braque had produced in the summer at L'Estaque, near Marseille. The critic Louis Vauxcelles spoke vividly of his "shamelessly simplified, contorted metallic figurines." Braque, he said, "despises form and reduces everything—landscape, places, houses and people—to geometric forms, to cubes."

Cubism was born, but the founding act remained those still secret *Demoiselles d'Avignon*.

In November 1908, Pablo got to know the famous custom's official Rousseau. He organized a memorable banquet to celebrate his purchase of Rousseau's canvas *Portrait de femme* at Père Soulié's gallery. Pablo kept this portrait for the rest of his life.

This banquet was probably the emblematic event at the Bateau-Lavoir for its spontaneous artists. For me, it is evidence of the enormous sympathy that my grandfather could feel for someone who had genuinely touched him. Pierre Daix recalls that "it was a custom at the time to organize such festivities to celebrate different events, in the realm of literature or art (prizes, birthdays, later the recovery of the war wounded like Braque and Apollinaire). The banquet took place in Pablo's studio at the Bateau-Lavoir. Fernande had deployed her talents as a hostess and received the whole 'Picasso gang.'"[25]

24 Olivier 1996, pp. 217–18.
25 Daix 1995, p. 655.

During the summer of 1909, Pablo took Fernande to Spain again. After stopping off briefly in Barcelona to see his family, they spent their vacation at the famous Horta de Ebro. The Catalan landscapes inspired him to paint new Cubist landscapes, in what has been called "Cézannian Cubism," in which both objects and the background are treated in the same way and on the same ground, in facets, prisms, and cubes. The colors are very close to those used by Cézanne—who was *the* emotional touchstone for Picasso—in his landscapes and still lifes.

At Horta, he met up with the few friends he had made during his first voyage, including, of course, Manuel Pallarès. Fernande fell ill and Pablo suddenly became odious, the first symptom of his phobia of illness and death. Fernande confided in a letter to Gertrude Stein that she published later in her memoir, *Loving Picasso*: "I sometimes have an unbearable pain in my kidneys and in my side, which makes me feel as if I'm about to drop dead …. Pablo is no help. He doesn't know what's going on and he's too selfish to want to understand … that it's largely because of him that I've been brought to this. He threw me into complete confusion this winter. I know all this is neurotic…. What's to be done? If I'm unhappy it makes him angry…. Pablo would let me die without noticing the condition I'm in."[26]

Pablo could not accept that Fernande was ill. He raged, on principle, against illness. He was unable to control this revulsion. Death had taken his little sister Conchita, but as a child was he aware of the full meaning of the tragedy? For him, illness was death. This obstinate rejection would quickly become, for no logical reason, a chronic fear. Later, more than the loss of loved ones, it was the passing of time, linked to disease, that tormented him. In the end, the two merged in the recurring health problems of Jacqueline, his last companion, and the approach of his own death. Is death not the final obstacle to passing time?

Why did Fernande have to fall ill here in Horta, in this Eden of bliss and happiness? Was it a bad omen? For this man full of superstitions, everything assumed exaggerated and irrational proportions.

Furthermore, that summer Pablo was worried by a rumor of a riot in Barcelona. He would have liked to be there. At the time, news traveled slowly. Two key aspects of his personality took shape: fear of disease, an early warning sign of the worst, and an interest in politics, surpassing all the rest.

Pablo and Fernande returned to Paris in September and moved out of the Bateau-Lavoir and into a comfortable new apartment at 11, boulevard de Clichy. Bohemia had lost its natural setting, and the lovers became bourgeois, as Fernande recounts: "We slept in a bedroom on a low bed with heavy

26 Olivier 1996, pp. 243–44.

square copper bedposts.... Our meals were served by the maid, wearing a white apron, in the dining room, which, although small, was very bright.... An antique cherry wood sideboard took up the whole length of one wall."[27]

Fernande quickly became a real little bourgeois Parisian again, reveling in the everyday comfort that she had access to once again. Pablo ordained that his studio should not be cleaned without his agreement. His need for personal reassurance through a "comfortable" life clashed with his continual need to create, which obliged him to transcend all that he had gained through his new-found status.

This thirst for innovative experimentation was the perpetual driving force behind his creativity. While Fernande dreamed of children and an orderly life, her companion was methodically deconstructing conventional art and inventing modern art. Fernande sometimes had difficulty in understanding his intense dedication to his work and was unhappy about it.

The excessively conventional lovers gradually grew apart from each other. The years 1910 and 1911 were marked by a growing lack of understanding between them. Pablo continued to flirt with non-conformism by fleeing the everyday: he drew, created feverishly, innovated, and was already parting company with his era. He could not step back from his painting. It was the only thing he could see now.

He met up with the leading figures of the time at the Café de l'Ermitage on the boulevard Rochechouart. In the autumn of 1909, he got to know the Polish painter Marcoussis and, more importantly, his companion Éva Gouel.

It was love at first sight. Destiny was fixed in a single exchange of looks. Pablo featured his new conquest in his works, gradually replacing his official love with the one he was still hiding. Nevertheless, Fernande and Pablo spent the summer of 1910 in Cadaqués, in the south of France, where he rediscovered some echoes of his Spain in the landscape and in the people of the region. He enjoyed the delights of the neighboring Pyrenees and meeting other artists who were on vacation. The idyll with Fernande had had its day, but she remained the "official woman." Fernande had some affairs, observing bitterly that Pablo no longer showed the same enthusiasm for her. She rediscovered the habits of a liberated woman, sometimes even in public. By now, Pablo was past caring. By the autumn, only Éva counted and this trend was reinforced the following year.

In 1912, he once again rented a studio in the Bateau-Lavoir, on the grounds that he had a large-scale project and needed space. In reality, he carried on his secret relationship with Éva there. Fernande guessed this and took the

27 Ibid., p. 253.

initiative, noisily leaving Pablo for someone else. "We know this thanks to a note from Picasso to Braque," as Pierre Daix recounts. "Fernande went off with Umbaldo Oppi. The dog Frika was taken in by Germaine Pichot. Kahnweiler was instructed to retrieve works and material from the boulevard de Clichy, from where Picasso moved out late September to go and live with Éva at 228, boulevard Raspail."[28]

In June 1912, things became definitive. Marcoussis, abandoned by Éva, published a satirical drawing in *La Vie parisienne* to put an end to their relationship. It showed Pablo dragging Éva with a ball and chain, while Marcoussis jumps for joy.

Éva and Pablo were already a long way away, in Céret. Germaine and Ramon Pichet went there with Fernande to convince Pablo to leave Éva. But the passionate lovers left Céret in time and settled in Sorgues.

Pablo thus rediscovered the artist's life that inspired him so much. From now on he would be living a spontaneous passion, without pretension, routine, or rules—and without having to worry about everyday life anymore. Money came in regularly. Éva understood Pablo and stimulated him in his work at the very time he was exploring Synthetic Cubism. He shared his energy with his mistress.

In Sorgues, the "refugees" were joined by Braque and Marcelle, the woman he had just married. Life was going well. The dialogue between the two artists resumed, centering in particular on African art. The two couples visited Marseille and the surrounding region.

A new chapter in Pablo's life had begun.

His existence had become a succession of vacillations between conformism and bohemianism, between academicism and freedom, between mastery and audacity. Each mutation, each "period" was greeted with jubilation, and an almost immediate rejection of any attempt at pigeonholing him.

Fernande went out of his love life forever. He did not hear anything more about her until the early 1930s, when her memoirs were published.

However, he never forgot the help that she had given him in difficult times and he in turn helped her in the 1950s, when she was almost homeless.

Out of friendship and courtesy, he revealed his relationship with the notorious Madeleine only after Fernande's death, on January 26, 1966.

ÉVA GOUEL (1885–1915)

Éva Gouel's real name was Marcelle Humbert. It would appear that she met my grandfather at the end of 1909 at the Café de l'Ermitage, where, follow-

28 Daix 1995, p. 312.

ing his move to the boulevard de Clichy with Fernande, he often used to go for discussions with his "futurist" friends.

According to Pierre Daix, "she was the antithesis of Fernande physically and in life. Small, slim, undoubtedly intelligent, she liked neither a bohemian lifestyle, nor extravagance and was able to provide Picasso with regular habits, her talents as a cook and the peace of mind that he needed."[29]

The "Éva period" was a happy one. Madly in love, Pablo gave joyful expression to his happiness. Symbolically, she was everywhere. The joy of this love comes through in his work. Her initials and name, and her nickname of "Ma Jolie"—the title of a popular tune of the period—appeared in his paintings, which became more colorful in this period leading up to the first collages. In the autumn of 1912, the couple was living together on the boulevard Raspail in Montparnasse: Pablo thus left Montmartre and moved to his new lover's neighborhood.

This was the beginning of an idyllic period, as he would later recall.

The following summer Braque created his first *papiers collés*, incorporating pieces of painted paper into his canvases. Pablo enthusiastically followed in his footsteps, adding various materials, notably wood, glue, rope, and sand. He wrote to his friend: "I've been using your latest papery and dusty methods." They had just paved the way for collages and all the constructions and accumulations so widely used in art today.

In December 1912, true to his "pilgrimages," Pablo took Éva to Céret again, then to Barcelona, to show her the city of his origins and to introduce her proudly to his Catalan friends. The ritual was beginning all over again.

When they returned, the couple resumed their blissful daily life. In the spring of 1913, they went back to Céret. Juan Gris, a friend and also a competitor of Pablo's (and, as it happens, another of the artists represented by Kahnweiler), visited them, as did Max Jacob. Picasso's little world ran smoothly—for a few months at least.

The year 1913 was a terrible one. Don José, Picasso's father, died at the beginning of May. Pablo encountered death on his path and lost his only master, the only one he was intent on surpassing. This death added to Pablo's pessimism and reinforced his fatalism.

Hardly had he returned from the funeral in Barcelona than he fell ill with typhoid (or, more probably, dysentery), which left him bedridden for a month and nearly killed him. Then the first symptoms of Éva's illness appeared. On top of all this, there were the first premonitory signs of a large-scale conflict in Europe.

29 Daix 1995.

Éva was still at the heart of his work: *Female Nude "J'aime Éva"* (autumn 1912) was followed by *Woman in an Armchair* (late 1913–14), *The Painter and His Model*, and *Portrait of a Girl*, painted in the summer of 1914 during a peaceful stay in Avignon. In Paris, Pablo began a new social life with Éva and started to become a celebrity.

War broke out: Braque and Derain left for the front, as did an enthusiastic Apollinaire, delighted to be "fit for service." Spain was neutral in this conflict, so Pablo stayed behind with the wives of friends who had gone into combat—and, fortunately, with Éva.

For a few weeks, Éva had been complaining of pains. Cancer of the throat was diagnosed. The disease was spreading. A letter from Pablo to Apollinaire, dated February 1915, reveals that Éva had been in a nursing home for a month and that she was undergoing a first operation. Her health deteriorated continuously throughout the spring, and still further in the summer. And to complete this dark picture, Braque was seriously injured in the head that same spring. Pablo was overcome with grief, and terribly alone. In an attempt to save Éva, he went from hospital to hospital. All the beds were occupied by the war wounded. Éva spent her last weeks in a clinic in Auteuil and died on December 14, 1915.

In most of the biographies of my father, Éva has been described as the "great love of his life," and she was certainly the source of his greatest despair. Destabilized, Pablo talked of making a home with her, of getting married and having children. He wanted to accomplish what he had sketched out with Fernande, but with tenderness and understanding. Disease had shattered this dream of eternity and Pablo had trouble recovering from the blow.

On the other hand, the fleetingness of this love added to its brilliance: Pablo did not pursue the inspiration that Éva had offered him to the end, and their love affair, emotionally and artistically, was doomed to remain an unfinished masterpiece.

Pablo, who was in despair, attempted to take his mind off things through new conquests, brief affairs. In his confused state, he even went as far as to propose, but without conviction or success. These successive affairs involved Gaby Lapeyre (who became Mme de Lespinasse), Irène Lagut, a neighbor and attentive confidant of the rue Schoelcher, where he had moved to with Éva in 1912, Elvira Paladini (known by the nickname of You-You), and a certain Émilienne Pâquerette, the fashionable model who found in Picasso the ideal complement to her image as a high-profile woman. Pablo juggled these four liaisons, more or less simultaneously, throughout 1916 and early 1917.

In October 1916, in order to flee the obsessive memory of Éva, he moved out of the rue Schoelcher and went to live in Montrouge. He assiduously frequented La Rotonde, the bar that had become fashionable since intellectuals and artists had migrated from Montmartre to Montparnasse. He made new friends, such as Marie Vassiliev. The most important of these was Jean Cocteau, a frenetic young poet and socialite whom he had met in late 1915. The future author of *La Machine infernale* was the ideal key to unlocking this great world, and he opened up new horizons in Pablo's life and work. Cocteau, excited about his new friend and demonstrative enough to harbor hopes—in vain—of being painted as a harlequin, introduced him to Eugenia Errazuriz.

Born in 1860, of Chilean origin, Madame Errazuriz was a patron of the arts and a prominent member of Parisian high society, of which Serge Diaghilev, "the inventor" of the Ballets Russes, was a leading figure. She had the same mother tongue as Pablo and served as his guide, introducing him into cosmopolitan high society circles. Pablo thus met Étienne de Beaumont, who, together with his wife, was an eminent figure at leading society events in Paris. In October 1916, Pablo was invited to the memorable Babel evening party, organized by the couple.

A new life had begun—his "duchess" period, to use the term of his friend Max Jacob and adopted by his friends of old.

Olga Khokhlova (1891–1955)

At the beginning of 1917, Cocteau persuaded Pablo to work on the set for *Parade*, his one-act ballet. He wanted to bring together the most prominent artists of the times on this project: the composer Erik Satie, the choreographer Léonide Massine, Serge Diaghilev's Ballets Russes troupe, Pablo Picasso for the set, drop curtain, and costumes, and himself, of course.

This was the catalyst that Picasso was waiting for. For several months he had been living what he regarded as a dull life, one that was emotionally and artistically empty. He went to Rome to see Diaghilev and his dancers, and made the acquaintance of a twenty-six-year-old dancer named Olga Khokhlova.[30] According to Michael C. Fitzgerald, "she was no neophyte in the theatrical world. She had joined the Ballets Russes in 1911, at the age of twenty, to participate in Diaghilev's first independent season. The daughter of Stéphane Khokhlova, a colonel in the Imperial Russian military and his

30 In many books the name is spelled "Khoklova," and, more rarely, "Kokhlova" or even "Koklova." However, the correct spelling is "Khokhlova." This is the one that appears on all official documents, such as those relating to Pablo and Olga's divorce proceedings and the Succession Picasso. The name is often misspelled—even her granddaughter, Marina, has used the spelling "Kokhlova" in the writings she has published.

wife, Lidia Vinchenko, she had already trained in the private St. Petersburg studio of a respected ballet master, Yevgenia Povlovna Sokolova, but this was her first professional position. Although Olga never became a prima ballerina, she was far from neglected by Diaghilev's choreographers."[31]

Arianna Stassinopoulos-Huffington introduces Olga in a particularly dramatic way. Nobody has since sought to correct this vitriolic description of the woman Pablo fell in love with: "She had left home at 21 to join the Diaghilev Ballet and devote herself to dancing. Her talent was too small to compensate for the fact that by ballet standards she had started too late, but Diaghilev liked to include in his company girls from a higher social class even if they were not very good at dancing. Olga Khokhlova was, above all, average: an average ballerina, of average beauty and average intelligence, with average ambitions to marry and settle down. For Picasso, who had tried prostitutes, bisexual models, flamboyant bohemians, tubercular beauties and black girls from Martinique, Olga was so conventional in every way as to be positively exotic."[32]

In biography after biography, the reservations about Olga mount up, offering a caricature of the young woman. Nobody in Pablo's love life has caused so much controversy. And the violence of the separation in 1935, reinforced by the "official" aspect of the divorce procedure, subsequently had an adverse effect on Olga's image, to the extent that people trended to forget all that was happy about the relationship in the beginning.

Was it her reserve and her good manners that attracted Pablo? Was it her Russian origins, a paradoxical mix that combined the excitement of the Bolshevik revolution with the prestige of the tsarist empire that was crashing down? Olga is a mystery, both as a person and for what she represents. It is of no importance that she did not become the dancer she hoped to be: she had many other goals, which only Pablo would enable her to accomplish. For his part, he had artistic objectives that she would help him achieve. Their apparent incompatibility forged a truly complementary relationship.

Pablo followed the troupe to Paris, Madrid, and Barcelona, where he presented his new conquest to his mother, who advised Olga not to marry her son. "I do not think," she is supposed to have said, "that any woman could be happy with him." And Abuelita ("little grandmother") similarly warned her beloved son that on no account should he marry this woman.[33] Diaghilev, for his part, told Pablo: "She's Russian, marry her!"

31 Michael C. Fitzgerald, "Neoclassicism and the Portraits of Olga Khoklova," in Rubin 1996, p. 303.

32 Stassinopoulos-Huffington 1988, p. 147.

33 Pablo announced his marriage to Olga in a letter to his mother, Doña María, one month after the ceremony, on July 12, 1918.

There were many pressures on the couple. Pablo began playing his usual subtle game of seduction with Olga, using his most powerful weapon: his painting. In Barcelona, the Russian Olga became Hispanic, and wore a mantilla. The portrait, in a Pointillist style, appears to be a marriage request. Painted to make Olga part of the Spanish lineage, the representation satisfied the model—and Doña María, who kept the work in Barcelona.

The "Olga period" marked a return to a Neoclassical style. In Rome, Pablo was dazzled by the historic city, the monumental architecture, and the statuary. For him, the majesty of the setting and the simple life of the locals went hand in hand. He developed a passionate interest in the ruins of Pompeii. Hurting from the death of Éva, frustrated by brief affairs, he rediscovered the pleasures of a quiet life that was restful for the soul and the heart. He was surrounded by talented people. The fine weather and the general good humor were also conducive to inspiration. The creative work with Diaghilev and the business of seducing Olga stimulated his delight in life. It was a renaissance—a new life.

His return to Barcelona, and to his family, marked the end of his journey as a young man. It was time to have a family. Olga aspired to a bourgeois, high society life, very much in the tradition of her education, and Picasso was at the forefront of cultural life in Paris. She would be able to make the right impression.

When the company left Barcelona, Olga stayed with Pablo, intelligently giving up a career that she had already fulfilled to the best of her ability for a more promising life as a wife, although she later appeared in a few dance performances, the last of which was in 1922. In late November 1917, they moved into Pablo's studio in Montrouge. Olga took charge of the home. From now on, life was ordered and polished. Farewell bohemia, that fertile muse that was now unwelcome. This is how Stassinopoulos-Huffington describes this change: "But Olga cared nothing about art except as something to decorate an apartment, was revolted by bohemianism and was too firmly controlled to allow herself to be swept off her feet by animal magnetism. Also she was a performer, and her narcissism matched his. So she responded to his advances because he was important in her own immediate world, someone substantial enough to have been chosen by the legendary Diaghilev as the designer for *Parade*. And she responded with caution and calculation."[34]

There are very few eyewitness statements about Olga, and curiously they describe either a cold person who attracted little in the way of comment, or an explosive character who was strongly criticized, particularly when Pablo

34 Stassinopoulos-Huffington 1988, p.148.

sought a divorce in 1935. My feeling is that she was the product of her education, fettered by rules and constraints. Olga's personality was formed in a mold of respectability. In a sense, her life eluded her.

In the 1920s, in the wake of World War I and the Russian Revolution, the world changed forever. The revolution in art was paralleled by changes in morals and in French society. Olga dreamed of a world that no longer existed and, unfortunately, she chose the candidate who was least suited to these dreams, and, above all, the least docile. She was won over by his appearance. In her eyes, Picasso was a man who could rival Cocteau and Diaghilev for elegance. His Spanish accent excused her own Russian accent. He courted her. The image accorded with her code of good behavior. She was ignorant of all the rest, in particular the workings of his creative genius and his inner suffering.

It has to be said that Pablo was curious to get to know high society and he seemed ready to make the same sacrifices as many other men to win a young woman of the highest social standing. In any case, he was prepared to give it a go. He liked things to take their course. He had met Cocteau, Eugenia, Diaghilev, and Olga: it must all have a meaning. Hadn't chance already pleasantly surprised him? But Olga had also demonstrated that she was independent: she had chosen at a late age, against the wishes of her own family, the profession of dancer, which was not at all highly regarded in her milieu, and she lived an unusual life for a young woman who came from a good family.

From the beginning of their perfectly proper relationship, Pablo chose to draw Olga with all the respect that she demanded: above all, she wanted to be able to recognize herself. In his portraits of her she is pensive, almost absent, with very regular features. Pablo cleaned up his life, and he almost cleaned up his art.

Pablo and Olga married on July 12, 1918, at the time of the last murderous death throes of a world war, at the Russian church in rue Daru. The witnesses were Jean Cocteau, Max Jacob, and Guillaume Apollinaire.

The euphoria of the marriage did not last long. Even during the earliest days of their honeymoon at Biarritz at the home of his dear friend Madame Errazuriz, Pablo did not display the enthusiasm expected of a young husband. Had he made a mistake in not keeping Olga as a lover? During what was meant to be their honeymoon, Eugenia introduced him to his future dealers Georges Wildenstein and Paul Rosenberg (the brother of Léonce, also a dealer, with whom Pablo had already worked). But he was bored. He wrote to his friends, in a subdued mood, to tell them of his daily activities: he made pencil sketches, he decorated a bedroom in the house—nothing

very exciting. In his letter to Apollinaire, however, he admitted: "I am not very unhappy."

Back in Paris, Olga and Pablo decided to find a new apartment. Olga wanted to receive people and their home at Montrouge, although now clean and tidy, was unsuitable and not presentable enough. Paul Rosenberg found the ideal setting, at 23, rue la Boétie in the eighth *arrondissement* in Paris, next door to his luxurious gallery. The Champs-Élysees neighborhood was already prestigious, with its fur shops, art galleries, and *hôtels particuliers*. After Montmartre and Montparnasse, Pablo was once again surrounded by creators—but well-established creators with money in the bank.

Extensive work was done on the apartment, and it took so long that Olga persuaded Pablo to move to the Hôtel Lutetia on boulevard Raspail in the sixth *arrondissement*—still close to Montparnasse and Saint-Germain-des-Prés, on the left bank of the Seine, but on the edge of the sumptuous *hôtels particuliers* of the seventh—to receive their acquaintances properly. She also wished to put some distance between them and his artist friends. "Pablo frequents the smart neighborhoods," the latter used to say bitterly.

Eventually, Pablo decided to rent the apartment in the rue la Boétie, on the fifth floor, to use as his studio. He thus divided his time between the impeccable reception apartment, lavishly decorated by Olga (the one that the photographer Cecil Beaton was surprised to discover), and the studio where he organized, or rather disorganized, "his bohemia." Thus for a while he reconciled the contradictions of their respective aspirations. However, society life gradually got the upper hand. There were endless dinners, soirées, and galas, while Pablo attempted to continue working.

At the beginning of 1919, he left with Olga for London. They stayed there nearly three months so that Pablo could work on the drop curtain for a new ballet, *Tricorne*, with Diaghilev and Massine. They were still invited everywhere. Pablo was not indifferent to the praise or the lure of fame. And Olga provided an elegant accompaniment to this triumph. When the newly-weds went on vacation to Saint-Raphaël in August, they joined the high society circuit on the Côte d'Azur.

In February 1920, Pablo created the set and costumes for *Pulcinella*, which was presented by Diaghilev the following May at the Opéra de Paris. He now exhibited his paintings at the gallery of Paul Rosenberg, who provided him with a very comfortable income. Daniel-Henry Kahnweiler, back in Paris after the war (France had confiscated his collections during the conflict as "possessions of the enemy"), opened a new gallery on rue Astorg and immediately offered to exhibit his works. Pablo took advantage of this opportunity to put the two dealers in competition with each other. As a result, his reputation and his income continued to grow. Rosenberg was in the

strongest position however, since, with his associate Wildenstein, he promoted Pablo in the United States, thereby ensuring his future universal success.

The couple returned to Saint-Raphaël the following summer, and Olga became pregnant. At last! The happy event gave new impetus to their relationship. Pablo rediscovered his vitality and creativity. And also his affection for Olga. The birth of a son, Paul, on February 4, 1921, marked a new step for Pablo, a father at the age of forty. Olga's pensive face became, on his canvases, that of a mother attending to her child. The full force of Picasso's artistic experimentation was channeled into tenderness. Numerous Mother and Childs appeared, particularly in July 1921, when the couple settled in Fontainebleau with the baby. When he painted such dazzling works as *Three Women at the Well* and *Three Musicians*, he produced two versions. He hinted at an unsuspected dimension to Olga, distorted but transfigured. His wife's features may have been transmuted, but the intensity of their emotions was captured on canvas. Their trips, particularly the one to Rome, the solidly built dancers, the bathers he had seen by the sea, reminiscent of those he saw in his childhood by the bathing huts of La Coruña, and Olga's pregnancy all inspired him to paint monumental forms. This was the "period of the giants."

Besides, he was troubled by the works that Renoir produced in his last years, large numbers of which he saw at Rosenberg's: Pablo indirectly adopted the curving, generous forms explored by the Impressionist painter. Renoir's women retained their colors, while those of Picasso were austere and pensive. Picasso thus linked classicism and modernism. He was pursuing a new avenue that, already, signaled the end of the Cubist period and, simultaneously, the bohemian period of his life. Wasn't he aiming to enter the museum?

In July 1922, during a stay in Dinard with Olga, his work evolved toward a more pronounced "rendering of movements." "These deformed figures playing ball or skipping are set in the joyful, free atmosphere of a beach."[35] The psychological aspect of the portraits became stronger, and the sources of inspiration became more varied. Olga's face became blurred.

Back in Paris at the end of the summer, Pablo executed the set for Cocteau's free adaptation of *Antigone*, presented at the Théâtre de l'Atelier. For her part, Olga continued organizing their social life, accompanied more than ever by her husband. Pablo was not indifferent to the charm of these

35 Catalogue of the auction "Les Picasso de Dora Maar," October 27–28, 1998, held in Paris by the PIASA auction group and Maître Mathias, estate of Madame Markovitch (known as Dora Maar), at the Maison de la Chimie.

evenings during the Roaring Twenties, the crazy years that saw both the reconstruction of Europe and the beginnings of the rise of fascism—and the regulars at these wild parties were all future clients.

However, as one party followed another, they started to lose their attraction. Their marriage was nothing more than a facade revolving around endless social events and the maintaining of appearances. The frivolous eclipsed the essential, their social life took precedence over their relationship.

During these society events, Pablo met Gerald Murphy and his wife, Sara, who were Americans from Boston. He was a painter, she a brilliant socialite. Picasso found her very beautiful and particularly entertaining. The Murphys, whose friends included many writers and artists, gave high society life an intellectual slant. Picasso, excited by this whirl of minds, joined the couple at Cap-d'Antibes in the summer of 1923, staying at the Hôtel du Cap, which was now open in the summer. They were joined by the Beaumonts, Gertrude Stein, and her companion Alice B. Toklas. Doña María, visiting France for the first time, noticed how respectable her son had become.

The beautiful Mrs. Murphy doubtless liked Pablo's originality, but did she like the man? That summer, Picasso worked on various studies for the *Bathers*, painted the *Pan-Pipes,* and portrayed Olga looking pensive and distant. What is she thinking of, anyway? All that she had dreamed of but had not received? Her regrets or hopes? The couple did not talk to each other much.

He worked increasingly with photography. He had been interested in this medium for several years, and would analyze the way a print reproduced reality, with its variations of gray tones and its recreation of depth of field. Olga, Paulo, Diaghilev, and, a few years earlier, Apollinaire were thus immortalized in silver salts, then reproduced, with the aid of photos, in paintings or drawings.

In 1924, Pablo worked on Léonide Massine's ballet *Mercure*, followed by Serge Diaghilev's *Train bleu*. In total, since 1916, he had participated in eight theater or dance productions. Olga was not pleased to see this past that she had given up coming back to haunt her at regular intervals. With her, it was an obsession. She also attempted to erase Pablo's past, tearing up letters from Apollinaire in which he talked about Fernande, or making a scene in front of a dumbfounded Gertrude Stein.

Like *Parade*, *Mercure* caused a scandal. Even a polite Pablo remained a perpetual subversive, much to the delight of the radical intellectual movements—foremost of which, from 1920, were the Dadaists.

These anarchists of creativity—the very word "dada" appealed to Pablo —recalled the daring innovations of his youth in Barcelona. The Dada group, led by the poet Tristan Tzara, included eminent activists like Paul

Éluard, Louis Aragon, and André Breton, as well as the artists Francis Picabia and Max Ernst. However, much as they admired Picasso's *papiers collés*, they incorrectly believed that he was creating "commercial" Cubism, when in fact he had already gone far beyond this. Their mistake was doubtless due to the fact that the dealer Kahnweiler presented works to buyers some time after they were created, so the public was always lagging a few steps behind.

However, the ballet *Mercure*, this time, provoked vigorous protests on the part of the Surrealists, who had just separated from the Dadaists and were led by Breton. They did not protest about Picasso's set, which was in line with their concept of art, but about the soirée given by Comte de Beaumont for the benefit of Russian refugees, enemies of the Bolshevik revolution.

Picasso, as it happens, had known Breton since 1918. In June 1924, the Surrealists collectively paid homage to Pablo to disassociate him from the scandal of *Mercure*. Wasn't Picasso the precursor, the first one to free himself through Cubism and collages, the first to break free of academic conventions? Wasn't he curious about chance?

In the summer, at Juan-les-Pins, Pablo enjoyed painting his son Paul, now known as Paulo, in different costumes, in a final classical temptation. But he was drawn to the Surrealist wave. Perhaps it provided him with reassurance about the course he had chosen. Pablo, older than his grateful disciples, did not want to be outdone. For André Breton, "The dearest aim of the Surrealists, now and in the future, must be the artificial reproduction of the ideal moment when a man is prey to a particular emotion." Pablo, who shared this view, put it into practice in a new approach to his work. The appearances of things and beings disappeared. He rediscovered the philosophy of his late lamented friend Apollinaire—the inventor of the word "Surrealist."

Meanwhile, Olga was thinking about the next soirée....

In 1925, Olga, Paulo, and Pablo left for the Côte d'Azur again, a ritual that had become wearying. Even Olga seemed to be forcing herself. The soirées resumed, almost inexorably, most often at Monte Carlo. Pablo's inner conflict became more acute. He had thought it through and realized that he was totally wasting his time, while an artistic and intellectual revolution was taking place elsewhere, without him.

Small talk inspired a veritable dread in Picasso. Hence his taste, later on, for abrupt declarations. He saw that Olga was a prisoner of this high society life. Pablo was already no longer actively involved. He wanted to take part in the struggle for ideas. He had to take a lead again.

Life with Olga deteriorated irremediably. She was fully aware that she was losing her husband. She wanted him to be interested in her again. Had

she understood too late? They argued every day. Instead of looking for the reasons for their disagreements, she rejected them. They were beyond her comprehension. She had already given up demanding an explanation for Pablo's absences when he returned home. Later she would oppose the divorce, by all means possible, even to the extent of sacrificing her physical and mental health to her obstinacy. She simply did not want to be a divorced woman. It was not acceptable.

In the autumn of 1925, despite his previous decision never to take part in group exhibitions, Pablo agreed to appear in the first Surrealist exhibition, at the Galerie Pierre in Paris. The fashion designer and collector Jacques Doucet[36] lent his *Demoiselles d'Avignon*, who were now the mothers of modern art, even though they had been created back in 1907. Picasso met a number of new artists there, and he became a "contemporary artist" again. In a masterstroke, he completed *The Dance*, a large canvas that marked a definitive break with his Neoclassical period. There followed *The Kiss*, a scandalous, extremely erotic work that is indecipherable and yet unambiguous, which he would keep all his life.

So he drew a line under his years of socializing, not because he did not enjoy them at the time, but because they weakened him, castrated him almost.

In January 1925, a young man, Christian Zervos, created a little-known periodical about modern art, *Les Cahiers d'Art*, devoting his first articles to Pablo. He offered to create a catalogue raisonné of his work. An ongoing dialogue between them started up, and almost every week Zervos photographed works from the past and work in progress, and continued to do so until he died in 1970. This laborious enterprise, often too costly for him, resulted in thirty-three volumes of key importance, unprecedented in the history of art. And yet even these do not include all of Picasso's work.

For the summer of 1926, Pablo, Olga, and Paulo, accompanied by a cook and a governess, moved into the villa La Haie Blanche at Juan-les-Pins. The troubled couple still accepted high society invitations on the Riviera.

The following October, the small Picasso family left for Barcelona. But these few weeks in Catalonia cut off from the outside world convinced Picasso that a change in his life was necessary.

36 On the advice of André Breton at the end of 1921, Jacques Doucet immediately bought the canvas on credit. *Les Demoiselles d'Avignon* was sold in 1937 by his widow to Jacques Seligman for 150,000 francs (approximately $ 82,200 today), then purchased for $28,000 by the Museum of Modern Art in New York thanks to a private donation of $10,000 and the sale of a canvas by Degas, *Le Champ de course*. It was the first time that the museum had sold one of its works (the purchase did not become official until April 1937, after the sale of the Degas). In 1990, at the time of the exhibition "Picasso and Braque: Pioneering Cubism," the work was valued at "at least" 500 million francs. Today its value is incalculable.

Despite the political situation of the period, with the coming to power of the Spanish military dictatorship, the dawning of European fascism, and the spread of communism, Pablo was no longer a revolutionary, but a dull, forty-five-year-old bourgeois.

A few months later, an unexpected solution appeared: Pablo found a heaven-sent refuge, and Olga a miraculous stay of execution.

MARIE-THÉRÈSE WALTER (1909–1977)

She was unquestionably the person who reawakened Pablo's creative power. She also reawakened Pablo the lover. On Saturday, January 8, 1927, in the late afternoon, Pablo saw a young woman through the windows of the Galeries Lafayette. He followed her with his eyes, waited for her to come out, and went up to her with a big smile. "Mademoiselle, you have an interesting face. I would like to paint your portrait." He added: "I have a feeling that we will accomplish great things together." "I am Picasso," he said by way of introduction, pointing to a large book in Chinese or Japanese in which he was featured. "I would like to see you again. Meet me on Monday at 11 at Saint-Lazare metro station."[37]

Marie-Thérèse Walter, my future grandmother, had just met the man of her life. Picasso was reborn.

She had no idea who this Picasso was, but she noticed his superb red and black tie, which she would later keep for the rest of her life: "In the past, young women did not read the newspapers. The name Picasso did not mean anything to me. It was his tie that interested me. And he charmed me …"

Marie-Thérèse would also keep a small calendar for 1927 in a red leather Hermès folder, accompanied by a lock of Picasso's hair and a self-portrait on a small piece of paper, which confirmed the symbolism that he attached to the year 1927.[38]

Marie-Thérèse turned up at the rendezvous. The strange man was there. "I went there for no special reason, by chance, because he had a kind smile," Marie-Thérèse recounted half a century later. "He took me to a café for lunch, then to his studio. He looked at me. He looked at my figure. He looked at my face. And then I left. He said: 'Come back tomorrow.' And after that it was always tomorrow; I convinced my mother that I was working."

37 Interview with Marie-Thérèse Walter by Pierre Cabanne for the radio program *Présence des Arts* on France-Inter, April 13, 1974.

38 See the article by Diana Widmaier Picasso in the exhibition catalogue *Picasso et les femmes*, Chemnitz (Germany) 2003, pp. 162–91. "The whole hypothesis advanced in recent years that there was a meeting [with Marie-Thérèse] in 1926, or even 1925, has been definitively invalidated, despite the stylistic changes that appeared [in his work] in 1925. My grandfather had dreamed up the woman he was waiting for."

They began a conversation that continued the next day. My future grandfather prudently came to get Marie-Thérèse at Maisons-Alfort. He quickly had the consent of Marguerite, Marie-Thérèse's mother, who was reassured by the man's courteous behavior.

She posed simply in the studio in rue la Boétie, the no-man's-land that no one was allowed to enter. Even Olga did not go up there. As Marie-Thérèse would repeat: "I avoided looking, but there was such a mess." To begin with, Pablo represented her in classical fashion. He assured her that she had "saved his life," something Marie-Thérèse could not really understand. She had not yet reached majority. Pablo had to conceal their relationship as best he could, as legally he was committing "corruption of a minor." Despite their burgeoning passion, they waited until the day of her eighteenth birthday (the first stage in legal majority) to "consummate" their relationship.

Every evening, Pablo returned to the conjugal home in rue la Boétie. Olga did not ask for explanations, and although her husband's absences became more frequent and he returned later and later, Olga was satisfied with an "I'm going out!" or a simple "Good evening." Since he always came back, honor was preserved.

These happy interludes enabled my future grandfather to bear the confinement of married life. He and Olga—quite futilely—put off serious discussion. Olga sank into bitterness, Pablo into indifference.

The difference in age worked against Olga. Between a girl in late adolescence and a mother, Pablo made an instinctive choice, albeit one which, on the surface of it, was unfair to his wife.

Marie-Thérèse herself would endure the same experience ten years later, when she was gradually displaced by Dora Maar, and then Françoise Gilot, while Pablo continued to declare that she was the only one, despite all the others.

Meanwhile, he drew the gentle, tender Marie-Thérèse feverishly. The drawings, like those that illustrate the *Chef-d'œuvre inconnu*,[39] were sumptuous, but still anonymous. They were the fruit of his love, which Olga must under no circumstances know about. Was this a sign of respect for his wife? Divorce did not exist in Spain and as Pablo was a Spanish national there could be no hope of that. Perhaps it would be possible to come to some sort of arrangement....

Pablo tenderly intertwined his initials with those of Marie-Thérèse, just as he had as an adolescent, with those of the young Angeles, and then with

39 Edition of engravings for Balzac's novel, freely interpreted by Picasso, in accordance with a contract agreed with the dealer Ambroise Vollard. The print-run comprised 405 prints in all.

those of Éva. This combining of letters, which often took the form of a guitar, pleased him greatly. He rediscovered the carefree spontaneity of times gone by. He became a young lover when he was with Marie-Thérèse.

Life with Picasso "was utterly thrilling," my grandmother always recalled. "Covered with love, kisses, jealousy and admiration,"[40] Marie-Thérèse was different from other young girls because she was innocent and, moreover, because she was not in any way part of the art world. She was so young compared with the experienced Pablo. This young woman enjoyed a fabulous destiny. Plucked from her girlish toys and plunged into an incomprehensible world, she experienced both the passionate love of a man and the equally passionate fascination of an artist. How could she resist the artist, how could she fail to be intrigued?

My grandmother had no social ambitions. She did not even think about such things. Slim and sporty, which was unusual at the time, she rowed (skiffs, to be precise), cycled, and played ball (the famous medicine ball that fired my grandfather's imagination). Later on, she regularly went horse riding, and climbing in Chamonix. She was fresh-faced and spontaneous, and very kind as well—and so young! She was reserved, but not shy; well behaved, but not "educated"—trained in social duties—in the way some girls were. And, finally, she had no ulterior motives. She thus embodied a purity that instantly appealed to Pablo, who at last could be himself. He no longer cheated.

Her elder sisters, Jeanne and Geneviève, who were lucky enough to have received a higher education, were ophthalmologists. But Marie-Thérèse did not have time to think about her future. It is hardly surprising that Picasso's entourage was taken aback by her naivety and her lack of artistic culture when they met her.

My grandfather serenely and discreetly built the nest he had dreamed of. "My life with him was always secretive," recalled Marie-Thérèse. "Quiet and peaceful. We didn't say anything to anybody. We were happy the way things were. We had all we needed."[41] The artist was able to devote himself to his art. He had no material worries and a model all to himself. The lovers were cut off from the world in an ivory tower where Pablo, it has to be said, controlled everything. He alienated his carefree muse, who would pay the price. Pablo had re-created his famous paradise lost. Unfortunately, he could not cut himself off completely from the real world while Marie-Thérèse remained a prisoner, spending her entire life in a gilded cage. To the extent

40 Interview with Marie-Thérèse Walter by Pierre Cabanne, April 13, 1974.
41 Ibid.

that, when her jailer died in 1973 and the door was wide open, she was incapable of living alone and free on the outside. She died grief-stricken four years later.

Experts all agree that the "Marie-Thérèse period" gave rise to exceptional drawings and engravings, both in terms of the subjects and the emotion that inspired them. Pablo was making a new start, the impetus for which—although he may not have been fully aware of it—was provided by Marie-Thérèse. Dora would follow, taking him in a new direction, before Françoise provided a counterbalance, offering an unsuspected resistance to him.

It was not Marie-Thérèse's character that he committed to paper or canvas. Rather, my grandmother suggested a sense of calm and restfulness. "Don't laugh; close your eyes," Pablo told her. "He didn't want me to be cheerful," she recalled. "At the large exhibition at the Galerie Georges Petit in 1932, people said to him: 'Hey, the woman you are showing us is always sleeping!' There were women that he loved in a different way; this was the way he loved me. When he arrived from Paris where he was fighting all the time with Olga and with dealers, he said to me: 'Stay there. Don't move for half an hour.' So for half an hour he got his wits back."[42]

Marie-Thérèse offered a face and curves to Pablo. As she simply confessed, the ritual was unchanging between man and woman, model and artist: "First he raped the woman, as Renoir said, and after we worked." An obliging lover, she offered her physique to his work; when required, she could transform herself into a child, a discreet young woman, or a convulsed woman abandoned to the ardor of a god that was half human, half beast. Gladdened by the inspiration that she provided, Marie-Thérèse was nonetheless detached. She had never heard of Picasso before they met. That side of things all seemed a bit unreal, and would always remain so. She had never heard the word "Cubism." She readily confessed as much at the end of her life. Marie-Thérèse did not belong to the world of the artists of Montmartre or Montparnasse, the Cubists, the Surrealists—that tiny world of privileged people, intellectuals, and wealthy members of high society. She had complete admiration for Pablo. She did not know Picasso.

While Marie-Thérèse emerged quietly from her secret life, between 1927 and 1931, Olga, the serene wife of the first portraits, turned into Dido screaming her fury. She thus provided another form of inspiration for Pablo, in which he expressed the violence of their clashes in a handful of works. But if these quarrels ultimately had the effect of stimulating him artistically, emotionally they had little impact. In terms of passion, his interests lay elsewhere.

42 Ibid.

In the summer of 1927 in Dinard, Olga and Paulo played near the family beach hut, not far from another cabin rented for Marie-Thérèse, who was staying in a small hotel nearby. All Pablo had to do was to walk casually along the shore and he could pass from one world to another. They would all return for the following two summers.

In 1928, a project for a monument to his friend Apollinaire, who had died ten years before, enabled Pablo to return to sculpture, which he had abandoned in 1914. He took advantage of the advice and the studio offered to him in Montparnasse by the sculptor Julio González, whom he had met at the El Quatre Gats café in Barcelona. These four little projects for a "statue of emptiness, of nothing," as Apollinaire himself had suggested, made him want to work his material. His attempts at monumental painting after his trip to Italy found, in the powerful curves of Marie-Thérèse and the oval of her face, the elements of a new plastic experiment.

In May 1930, my grandfather bought the Château de Boisgeloup at Gisors, near Paris. The stables and the annexes promised to provide large workspaces for him, and he had the idea of eventually making it Marie-Thérèse's residence. Fate would decide otherwise, however.

He could now throw himself into monumental sculpture and into painting, switching from one to the other so that he could explore all the relationships. He produced busts, large women's heads, and a series of portraits (including the famous *Dream*),[43] which are radiant with Marie-Thérèse's blondness and soothing contours. He spent the month of July with his family, with Olga and Paulo, in Cannes, following their usual sad routine. In August, he left Cannes alone, and went to collect Marie-Thérèse, who had been secretly staying in Juan-les-Pins, so that he could take her back to the region where she grew up in his beautiful Hispano-Suiza, which he had bought at the Salon de l'Automobile.[44]

Spain was on the way to becoming a republic, but for the time being he did not care. His political conscience was still dormant. Spanish journalists monitored his actions, but, strangely, failed to note the presence of Marie-Thérèse.

Back in Paris, he finally took the plunge. In the autumn, he rented an apartment at 40, rue la Boétie, where he installed Marie-Thérèse, not far

43 Formerly in the Ganz Collection, *Dream* is today the property of Steve Wynn, king of Las Vegas casinos and owner of many other Picassos, some of which contribute to the originality of the prestigious Picasso restaurant in the Bellagio casino, created by Wynn and the Mirage group but since sold to MGM Grand.

44 Pablo bought the model that was displayed on the manufacturer's stand. Their cars were distributed in France by the Poniatowski family. It was a luxury four-door "coupé de ville." The front part where the driver sat could be uncovered. The car was perfect for someone of Olga's status. Before that, Pablo had owned a Panhard-Levassor (a prestigious make, which merged with Citroën in 1953).

from the conjugal apartment. Marie-Thérèse was a major now, so there was no risk legally.

The moment when they had to clarify the situation was inexorably getting closer. For Pablo, 1931, the year of the great economic depression in Europe, following the stock market crash of 1929, was not marked by a particular event, but rather by the slow and sad disintegration of his marriage, and the ever-growing hold Marie-Thérèse had over his inspiration, in various fields of artistic endeavor. As Pierre Daix wrote, "Never had Picasso celebrated a woman in this way."[45] And, curiously, nobody seemed to be aware of the artist's concentration on a single muse. This was no doubt due to the famous commercial practices of the dealers Rosenberg and Wildenstein, who delayed putting works on the market.

The summer saw yet another season in Juan-les-Pins.

In the autumn, he began frenetically preparing a large exhibition for the following year, which he saw as a well-deserved mark of recognition and, more probably, a chance to get even with his friend Matisse, who had reached the heights of fame, especially in the United States. The year 1932 did indeed see the biggest retrospective ever devoted to Picasso's work. It was organized by, among others, the Bernheim brothers,[46] but it took place at the Galerie Georges Petit, between February and August. It included 225 canvases from all "eras," from the Blue Period and earlier up to the most recent portraits of Marie-Thérèse that he had yet to show. He also included in it seven sculptures and six illustrated books. Major collectors willingly lent their works. They were now part of the avant-garde of modern art, faithful disciples for whom Rosenberg and Wildenstein were the prophets and Picasso the divinity.

This was the major event of the cultural season in Paris and an unprecedented society occasion. Pablo did not appear at the inaugural soirée—he would always be where he was not expected.

It was at this time that he got to know Brassaï. The Hungarian photographer came to take pictures of the studio in the rue la Boétie and, above all, of the incredible production—totally unexpected—of sculptures, which he had made at Boisgeloup.[47] With the illustrious exception of a selection presented during the Paris retrospective in 1966 at the Petit Palais, most of these sculptures would not be seen again until the inventory of the Succession was made in 1974.

45 Daix 1995, p.904.
46 The gallery of the Bernheim brothers (known as Bernheim-Jeune), founded in 1877, was a mecca for Parisian dealers specializing in Impressionist works.
47 The photographs were printed the following year in the Surrealist periodical *Le Minotaure*.

The early part of the summer of 1932 was spent at Boisgeloup, which was crudely arranged to cater to Olga and Paulo in order to avoid the great traditional migration south to the Côte d'Azur, with luggage and all the painting material. Pablo wanted to be free from constraints and did not want to leave his studio. For a few weeks, by some artistic "miracle," Olga rediscovered an impromptu intimacy, but unfortunately it would lead to nothing. Far from her customary Parisian pursuits and the pleasures of the Côte d'Azur, she swore that never again would she repeat the experience: in August, she left, accompanied only by Paulo, for Juan-les-Pins. Meanwhile, Pablo shuttled back and forth between Paris and Boisgeloup. His double life was well organized.

But it would not last.

In the summer of 1933, Olga, Paulo, and Pablo went to Cannes and, in August, to Barcelona. This family voyage resembled an official visit: Picasso was a celebrity, honored by the whole city. At any rate, their appearances and the pomp of it all pleased Olga, who was celebrated alongside her now illustrious husband.

This was to be the last family vacation. Pablo had secretly brought along Marie-Thérèse, invisible but essential, putting her up in a nearby hotel. Miraculously, the press still failed to noticed Pablo's comings and goings in the streets of Barcelona. The storm clouds were gathering.

In the autumn of 1933, Pablo looked for the first time into the possibility of getting a divorce, consulting a major Parisian lawyer, Maître Henri Robert. Divorce was now authorized by the newly established Spanish republic, something he could take advantage of in France. All he had to do was make sure he understood the principle, the procedure, and the consequences.

Olga had disappeared completely from Pablo's works. Marie-Thérèse was everywhere—in his drawings, engravings, paintings, and sculptures, which included *La Femme au vase*, also known as *Femme au flambeau*, exhibited at the 1937 Exposition Universelle in Paris, and which today watches over Pablo's tomb at Vauvenargues.

In the summer of 1934, Pablo embarked on another long trip to Spain with Olga and Paulo. Marie-Thérèse followed. She still agreed to the stratagems. After all, the divorce was getting closer. But it was important to be careful all the same.

The correspondence between my future grandparents reveals that they were closer than ever during this period, from 1933 to 1934—precisely because the frenetic rate at which letters were exchanged was slowing.[48]

48 Pablo had Marie-Thérèse send her letters to a false address far from the conjugal home.

Pablo even presented his young mistress to his sister Lola, and showed her works from his youth.

In the autumn, in the chaos of his crumbling household, filled with Olga's fury at his absences and, worse still, his silences, Pablo worked on illustrations and engravings where, curiously, the image of the little girl took on a growing importance, in the guise of Marie-Thérèse guiding an injured Minotaur. These images can surely be seen as reflecting the anguish of Pablo cornered in a blind alley. Olga's suffering had become unbearable.

"And then one day I was pregnant," Marie-Thérèse recounted later. "He went down on his knees, he cried, and he said that it was the happiest thing in his life." It was December 24, 1934. What should he do? "Tomorrow I will get divorced," he promised. He wanted to marry Marie-Thérèse, and now he could.

He immediately began proceedings, to the despair of Olga, who, despite the collapse of their marriage, did not want to get divorced. They had married without a contract and were thus subject to the terms of joint ownership of possessions (including works of art) and property acquired jointly. They thus had to share their possessions.

Marie-Thérèse and Pablo spent afternoons together in the Parc Montsouris, while waiting for news from Maître Robert, who was officially in charge of the divorce. They were nervous, and worried too; the pregnancy was progressing.

A ruling of *non-conciliation*, the first step in the procedure, was made on June 29, 1935. It authorized Pablo to pursue his request for a divorce and entrusted Olga with the care of Paulo. A bailiff immediately came to the conjugal home to make the inventory of the possessions as ordered by the judge.[49] Olga fainted.

She moved with Paulo into the neighboring Hôtel California on the rue de Berri near the Champs-Élysees. The apartment at number 23 was now silent. Pablo was alone. Marie-Thérèse was due to give birth in less than three months. "You know, I have my freedom!" he announced. She asked for nothing.

On July 3, Pablo made an official request for a divorce. He hoped that there was a quick procedure. In fact, things dragged on, with Olga contesting all the facts supplied by Pablo to justify his request.

49 Evidence of the inventory can be seen on the back of numerous paintings, which today still bear a number stamped by the bailiff.

50 Before the reform of January 3, 1972, promulgated in August 1972, a married man or woman could not recognize a child born outside marriage, no matter what their personal situation. The child of a woman who was already married was legally considered to be the child of her husband and of no one else. In the case of adultery, no subsequent establishment of filiation was authorized by the law on

Marie-Thérèse gave birth to Maya on September 5, 1935. Pablo was forbidden by law from recognizing her.[50] He was still married. The divorce proceedings got bogged down. Pablo stopped painting. He stayed with Marie-Thérèse and their daughter: "All day, he was at my home," my grandmother recounted. "It was he who did the washing, the meals. He looked after Maya. He did everything, except the beds perhaps."[51] He even washed the baby's diapers.

Pablo was accorded an official inquiry in April 1937 to assess the validity of his grievances against Olga from a legal point of view. The political events in Spain added to the gloomy atmosphere. On December 20, Pablo installed his new little family at the home of Ambroise Vollard in Tremblay-sur-Mauldre: "Parisian life drove me crazy," recalled Marie-Thérèse. "I couldn't bear it. I had no garden, I didn't have anything anymore. I saw that Picasso was going out a bit. I understood why. So I thought that it would perhaps be best for me to be in the countryside."[52]

The inquiry accorded to Picasso in April 1937 was followed in May 1938 by the second inquiry requested by Olga. Meanwhile, the legal divorce in Spain (and thus applicable in France by assimilation) was annulled in March 1938 by a decree from Caudillo Franco, who was now in power, a decision confirmed by another decree in September 1939.

Incredible as it may seem, it would appear that Olga still did not know about Marie-Thérèse and Maya.

Pablo immediately changed his request for a divorce, which had become impossible, into a request for a judicial separation. On February 15, 1940, this judicial separation was granted by the court, which gave Pablo custody of their son, Paulo, and appointed a notary to carry out the sharing out of possessions, ordering Olga to pay all the costs.

At the same time, in the middle of the war, although he benefited from neutral status thanks to his Spanish nationality, Pablo asked the French authorities for his naturalization. By becoming French, he could get a divorce. His request was denied because of a file at police headquarters which indicated that Pablo had been close to anarchist circles in 1905. He would remain Spanish.

The drama was reaching its climax. Olga appealed against the judicial separation; the Paris Court of Appeal deemed her action to be purely dilatory, and confirmed the couple's separation, again in Pablo's favor, taking cognizance of the fact that Olga "frequently made violent scenes when with

the part of anybody, be it father, mother, or child. The reform of 1972 in particular, together with the laws of 1993 and 2001, did away with any differentiation between legitimate, natural, and adopted children.

51 Interview with Marie-Thérèse Walter by Pierre Cabanne, April 13, 1974.

52 Ibid.

her husband and made his life impossible to the extent of preventing him from working and seeing his friends." The abandoned wife again appealed to the Court of Cassation, but the Supreme Court confirmed the ruling on January 5, 1943.

Given Olga's volcanic personality, it is better not to contemplate what might have happened if she had known about Pablo's parallel life. What is certain is that up until their final separation in 1935 Pablo never imposed another woman on Olga, a sign of respect that is worth underlining. Even his affair with Dora Maar was known only to a small group of close friends, all of whom belonged to an artistic milieu that Olga did not frequent. It was only after 1945, ten years after their separation, that she was informed by their son Paulo, of the existence of Marie-Thérèse, of her long relationship with Pablo, and of their daughter, my mother Maya.

She was no doubt grateful to Pablo for this discretion, which permitted her, in the milieu in which she lived, to keep her dignity: she never said a bad word about either Marie-Thérèse or Maya. Olga was an honorable woman. More strangely, she never at any point demanded the implementation of the judicial separation, nor did she proceed with the dividing up of their possessions to which she was entitled—something which, moreover, Pablo never officially opposed. She rejected a fortune, but she retained the status of married woman, and a facade of respectability. Later on, my grandfather would say that this had been the worst period of his life.

DORA MAAR (1907–1997)

At the end of 1935, Picasso was introduced to a young photographer named Dora Maar. Of Yugoslav origin on her father's side, French by her mother, she had lived for much of her life in Argentina, and spoke Spanish. She had learned about filmmaking and photography, and she had taken part in Surrealist events. Stormy by nature, she was an intellectual, a modern, independent woman who fascinated him long before she attracted him. She was very different from Olga and Marie-Thérèse.

For the time being, Pablo devoted himself to Marie-Thérèse and Maya. It was with them that he went, still in secret, for a three-month vacation at Juan-le-Pins in the spring of 1936, staying first in a hotel and then at the villa Sainte-Geneviève. Maître Robert, mindful of the divorce proceedings that were going on, immediately sent a telegram: "Above all, do not live together!"

The following summer, Pablo sent Marie-Thérèse and Maya to Franceville, near Cabourg. It was the fashion to take small children somewhere where the could enjoy some fresh air. Meanwhile, he joined his

friends Paul and Nusch Éluard at Mougins. They suggested a jaunt to Saint-Tropez, which at the time was a simple fishing village. There, at Villa des Salins, the home of common acquaintances, he met Dora again.

Pablo told her all about Olga, Marie-Thérèse, and Maya. He put his cards on the table. Dora, for her part, was playing with fire: they both liked danger and its rewards. Dora was the ideal complement to Marie-Thérèse. The latter was gentle and submissive, a girl who needed protecting. Dora provided contradiction, a permanent calling into question. One echoed Pablo's emotional gentleness, the other his violence. Pablo, a Scorpio with a Scorpio ascendant, always sought to satisfy the two extremes of his sign.

He organized his love life around Marie-Thérèse, the secret, uncomplicated companion who, furthermore, was fully occupied with their baby, and Dora, the experienced mistress, who felt she was gloriously fulfilling her vocation as an emancipated woman. She did not think she would have any rivals as a militant member of the avant-garde. But little did she know that she was thus creating for herself a form of alienation.

Pablo had been detached from politics for many years, but Dora contributed to his re-engagement with it. Their love affair took place against a backdrop of international turmoil. Civil war was raging in Spain, the Front Populaire in France was encountering fierce opposition, Mussolini was in control of Italy and was taking war into Africa, and Hitler as well was showing his true colors.

The duality of man: Pablo continued to hide my grandmother, preserving Olga's respectability, while appearing in public in Saint-Germain-des-Prés with Dora. In his work, however, Marie-Thérèse and Dora cohabited without any problem. Now the blond hair that had monopolized his work for many years was joined by more elaborate hairstyles in black. The gentle, compliant curves of numerous versions of *Marie-Thérèse in an Armchair* were answered by the tensions of *Woman Crying*. The duplicity fed off the complementary: did he not paint them both in quick succession in the same reclining position, on two canvases with the same date, January 21, 1939? On the one hand there was Dora Maar, intellectually close to him, convinced of the need for a politically committed art; on the other, there was Marie-Thérèse, the embodiment of timeless insouciance.

For a while, Dora thought of moving in with Pablo, but she quickly understood that it would be impossible to live in Olga's deserted mausoleum. Besides, Pablo had asked his old friend Jaime Sabartès to join him in Paris, and the latter moved into rue la Boétie with his wife. Secretary and confidant, he knew everything, the crisis and legal complications with Olga and the existence of Marie-Thérèse and Maya, something he was the only person to know about. Having come to know and like Marie-Thérèse, he

could not hide his disapproval of Dora. No doubt he hoped that it was just a fleeting affair.

Dora was still living with her parents on the rue de Savoie in the sixth *arrondissement*. But she needed a place of her own. She found a studio to rent near where she lived, on the rue des Grands-Augustins—the very place where Balzac situated the *Chef-d'œuvre inconnu*, which Pablo had as it happens illustrated freely. What an "objective" piece of chance the Surrealists would have said. A monumental staircase led to a large room with a ceiling decorated with beams, linked by a smaller staircase to a small adjacent apartment. She arranged for Pablo to visit it, and he took it immediately. She now had a place where they could frolic and, above all, a setting for much loftier artistic endeavors.

On July 17, 1936, civil war broke out in Spain. The army commanded by General Franco in Morocco rose up against the authority of the Republican government in Madrid. The military putsch set the whole of Spain alight the following day, and forced the government to organize a resistance. Franco received support from Mussolini's Italy and Nazi Germany. France and England declared themselves to be valiantly neutral. The civil war, which lasted until March 1939, would kill more than one and a half million people, most of them civilians.

Aided by Dora, Pablo immediately offered his support to the Republican government, who in return appointed him director of the Prado in Madrid, Spain's leading national museum. The title was an entirely honorary one, however, for the defeated Republican government moved the museum's collections. "I am the director of an empty museum!" joked Pablo.

In August, he took Dora to Mougins, to stay with the Éluards. For Marie-Thérèse, he was officially going to work in the provinces. My grandmother never asked any questions, and was happy with the fact they got on well. But my grandfather added an unknown into this perhaps simplistic equation. It was imperative that Marie-Thérèse should not leave the nest and Dora should not enter it. Meanwhile, he roamed freely.

Olga moved briefy into Boisgeloup, which the courts had granted her as her residence. Marie-Thérèse and Maya now lived in Vollard's pretty house at Tremblay-sur-Mauldre, near Versailles. Pablo photographed his little Maya there endlessly, capturing her first steps in the landscape garden with its thousands of flowers.

But since 1937 he had been living at 7, rue des Grands-Augustins, while keeping on his retreat on rue de la Boétie, which was now occupied by Sabartès. With Olga forgotten at Boisgeloup and Marie-Thérèse isolated just outside Paris, Dora Maar became the prime witness to the dark prewar years

and the birth of what would become *Guernica*, a commission from the young and short-lived Spanish Republic. Luckily for posterity, Dora Maar captured the different states of creation with her camera. She thus succeeded in finding her place, alongside Pablo, opposite her true companion—the canvas.

The work marked the beginning of a "political" period that would last until the end of his life. Pablo now accorded absolute primacy to political, militant action over family life.

Dora Maar's real name was Theodora Markovitch. Her father, of Croatian origin and a former subject of the emperor of Austria, was an architect who is said to have designed the Austro-Hungarian embassy in Buenos Aires, as a result of which he was decorated in the name of Emperor Franz-Josef. Dora's mother, was very mystical; of Orthodox origin, she later converted to Catholicism. Dora inherited a strong personality. Unlike Olga, who had been forced to emigrate, Dora the foreigner was a wanderer who had an insatiable appetite for new experiences.

She had been the Surrealists' "traveling companion" since 1933, but a fringe companion: she was together with Georges Bataille up until she met Picasso. With Bataille, she took part in the Contre-Attaque group.[53] She got to know Breton and Éluard. Given her association with them, it was not surprising that she should meet Picasso at the Deux Magots café at Saint-Germain-des-Prés.

Françoise Gilot[54] later described this first encounter between Pablo and Dora in the autumn of 1935: "She was wearing black gloves with little pink flowers appliquéed on them. She took off the gloves and picked up a long, pointed knife, which she began to drive into the table between her outstretched fingers to see how close she could come to each finger without actually cutting herself. From time to time she missed by a tiny fraction of an inch and before she stopped playing with the knife, her hand was covered with blood. Pablo told me that was what made up his mind to take an interest in her. He was fascinated. He asked her to give him the gloves and he used to keep them in a vitrine at the rue des Grands-Augustins, along with other mementoes."[55] He saw her again briefly at the Château de Boisgeloup in March 1936, during a group visit led by Éluard, who wanted to introduce her to Roland Penrose, an English painter and writer who was interested in buying some works. During the notorious meeting in Saint-Tropez in the summer of 1936 Penrose was once again present.

53 Far-left political group which the Surrealists belonged to.
54 Françoise Gilot published a book on her life with Picasso, called *Life with Picasso*, in the United States in 1964. It was translated into French the following year.
55 Gilot and Lake 1964, p.79.

Dora was twenty-nine and Pablo fifty-five, but they got on wonderfully well. She was madly in love with him. He was, let us say, "interested." She joined the Minotaur and offered Pablo that tough side that was required to provide the artistic balance he needed.

The portrayals of Dora Maar all echoed political events: she appeared with marked features, red nails, intense black eyes, brown hair—a reflection of her rebellious personality, *pasionaria* of the tragedies all around them.

The power of the portraits of Dora opened the way to a new kind of art. Brigitte Léal has neatly summarized Dora's place: "[Today, more than ever] the fascination that the image of this admirable, but suffering and alienated, face exerts on us incontestably ensues from its coinciding with our modern consciousness of the body in its threefold dimension of precariousness, ambiguity, and monstrosity. There is no doubt that by signing these portraits, Picasso tolled the final bell for the reign of ideal beauty and opened the way for the aesthetic tyranny of a sort of a terrible and tragic beauty, the fruit of our contemporary history."[56]

On April 26, 1937, at the height of the Civil War, Guernica, a small village in the Basque country, was razed by the combined aerial forces of Spain, Italy, and Germany in a continuous three-hour bombardment during which new bombs developed by the Nazis were tested. Pablo discovered this carnage through press photos that Dora had shown him. Shattered, he changed the subject of the fresco commissioned by the Republicans, which was already largely sketched out. He turned it into a symbol of terror and massacred innocence.

Between the following May 1 and June 4, he produced forty-five preliminary drawings, followed by detailed studies. Dora was a privileged and precious witness to the gestation of this monumental work (approximately 11 feet 6 in. x 25 feet 8 in.), taking pictures in lighting she had set up specially.

Dora Maar's existence was not kept secret from Marie-Thérèse for very long but, thanks to her photographic activities, Pablo was still able to account for her presence in a plausible way. Moreover, Dora would come to the studio in the morning, or very late at night, whereas Marie-Thérèse used to drop by in the afternoon, often with Maya.

Dora was in the process of photographing the completion of *Guernica*, when Marie-Thérèse arrived with Maya. I read with interest the original

56 Brigitte Léal, "'For Charming Dora': Portraits of Dora Maar," in Rubin 1996, p. 385.

novel by Nicole Avril, who studied the numerous archives concerning Dora.[57] Avril imagined this meeting as follows: "'What a surprise!' he [Picasso] exclaimed without leaving his armchair, while Dora Maar attempted to continue her calibration of the light as if nothing was up. It seemed certain that Picasso had not anticipated the arrival of Marie-Thérèse. Usually he coped better with such traffic problems. Marie-Thérèse was keen to show [Dora Maar] that this was not the first time she had come to the rue des Grands-Augustins and that she really could not care less about respecting the rules governing the sharing of territory. She repeated: 'Well, things have changed here again. I almost feel like a stranger here.' Picasso got up and feebly tried to avert a disaster: "Come, come, my dear, this is your home here. And everything is yours. *Guernica* is yours. If you do not come to *Guernica*, *Guernica* will come to you!'"[58]

Nevertheless, the two women did speak to each other, each one trying to justify her presence with the master, Marie-Thérèse citing their daughter Maya and their relationship, Dora Maar mentioning her photography.

In the course of her only radio interview, in April 1974, my grandmother Marie-Thérèse herself described how she met Dora Maar in the presence of Picasso: "The monster made us wear the same dresses from [Jacques] Heim.... As there had been a mistake in the delivery of slips in pale pink silk and blouses from Nina Ricci, I had called Pablo and it was Inès, the chambermaid, who replied that sir was not there.... The address on the package I had was 6, rue de Savoie where Dora lived. I went there." Dora opened. A bitter-sweet conversation started up. Dora immediately reproached her "for having had a child on purpose"! Marie-Thérèse reminded her of the situation and her advantageous position as a young mother. Pablo, who was doubtless in an adjacent room, did not dare show his face: Marie-Thérèse preferred not to break the door down, and to let him sort it out with Dora. The episode descended into farce. In the afternoon, Marie-Thérèse went to the studio on rue des Grands-Augustins to clear things up. Pablo thanked her for having removed her claws from the "dreadful woman" (his words). The doorbell rang: it was Dora! Pablo, feeling very uneasy, let her in. She said to him: "Do you love me? Do you love me?" Pablo took Marie-Thérèse by the neck and then by the hand and replied, in a tender voice: "Dora Maar, you know that the only person I love is Marie-Thérèse Walter and that's all there is to it. She is the one. We understand each other."

Marie-Thérèse grabbed Dora vigorously by the shoulders and pushed her out, well aware that this small triumph would change nothing at all. Pablo was a real devil.

57 Avril 2002.
58 Avril 2002, pp. 54–55.

The seducing of Dora Maar was more intellectual than physical in character. Despite her femininity, her appearance was above all clean, erect, and far from suggestive. She was unable to have children, and was consumed by her love for Picasso, to the extent of regarding his smallest deeds and gestures as sacred. Proud without being jealous, she accepted everything, or nearly everything, that he put her through. She put up with his fluctuating moods. Pablo knew exactly who he was inflicting this brutal treatment on. After all, hadn't she herself given him the opportunity of behaving like this?

Marie-Thérèse and Maya encountered only the affable and open-minded side of the companion and father—on Thursdays and at weekends, when Maya was out of school. According to Françoise Gilot, in the years that followed "She [Dora] only came to the rue des Grands-Augustins on special occasions. Pablo would telephone her when he wanted to see her. She never knew whether she would be having lunch or dinner with him—not from one meal to the next—but she had to hold herself in a state of permanent availability so that if he phoned or dropped by, he would find her there."[59]

Devoted to her lover, at the mercy of his whims, Dora complied with the rituals that he imposed on her. The more she submitted to them, the more the experience approached the limits of what was bearable. But Dora evidently got satisfaction from continuing the game of submission and domination, in which she was the consenting slave. For Pablo, Dora's hysteria was a source of inspiration: "For me she's the weeping woman. For years I've painted her in tortured forms, not through sadism, and not with pleasure, either; it's just a vision that forced itself on me. It was the deep reality, not the superficial one."[60]

When war was declared in France at the beginning of September 1939, Marie-Thérèse, her mother Marguerite and Maya were on vacation at Royan. Pablo joined them there on the second floor of the Villa Gerbier-de-Jonc.[61] In the winter of 1940, he rented a room in the Hôtel Les Voiliers that he would use as a studio, while arranging regular visits to Dora at the Hôtel du Tigre. When he was in Royan, Pablo always slept in the "family" villa. Dora had him for the rest of the day. It was now her turn to live a totally clandestine existence: Pablo never appeared in public with her in the little seaside resort.

59 Gilot and Lake 1964, p.79.
60 Ibid., p.116.
61 The Villa Gerbier-de-Jonc belonged to Madame Hélène Raphanaud. After the destruction of the town of Royan at the end of the war, she went to live with Marie-Thérèse in Paris, working as her maid for five years.

The well-oiled merry-go-round lasted, without Marie-Thérèse suspecting anything, until spring 1941. At this point, the armistice was already a year old and the unbearable Occupation had become "established." Dora had been back in Paris for a long time. With rationing and the black market, people got on with their lives as best they could. My grandmother left Royan and with Maya moved to a large apartment on the boulevard Henri-IV, at the end of the Île Saint-Louis, one room of which Pablo turned into a studio.

My grandfather continued to love these two women, who complemented each other perfectly in terms of providing artistic inspiration: Dora was the muse; Marie-Thérèse, the model. As my grandmother commented when discussing *Guernica*: "I was a bit like an angel for him ... the other woman, Dora Maar, was war, the poor thing."[62] For William Rubin, "That Picasso was now spending more of his time with Dora than with Marie-Thérèse had, I believe, less to do with passion for Dora than the fact that, as an artist and an intellectually absorbing woman, she fit easily into the painter's circle of friends, and, moreover, challenged the artist in psychological and practical ways. Meanwhile, Marie-Thérèse (and Maya, to whom Picasso was deeply attached) remained the center of the secret private world she had always embodied for him."[63]

But France was feeling the effects of the war. With rationing and lines, the threat of attacks, Gestapo raids or interrogations by German soldiers or the Vichy police, gas shortages, curfew, and slanderous denunciations everyone was continually exposed to danger. Aside from the "collaborators," who seemed to enjoy a privileged status, the population endured real deprivation.

Pablo was never suspected of the slightest concession and, putting at risk his position as a committed Spanish painter on "the wrong path" (as far as the fascists were concerned), he did his best to support the Resistance. His situation as an emigrant did not make things easy. Now under surveillance, he was constantly at risk of being deported to Spain, where General Franco was impatiently waiting for him. Only his immense notoriety and the friendship of a few admiring government officials enabled him to hold his head high and to make a few outspoken comments. Thus, he distributed postcards of *Guernica* to all the Germans who came to watch him, saying to them: "Souvenir, souvenir." To one of the officers who asked him if it really was he who had done "that" (*Guernica*) he is said to have replied "No, it was you!"

If the situation with Marie-Thérèse and Dora continued unchanged, this was partly because his geographical universe was very restricted. Saint-Ger-

62 Interview with Marie-Thérèse Walter by Pierre Cabanne, April 13, 1974.
63 William Rubin, "Reflections on Picasso and Portraiture," in Rubin 1996, p.88.

main had become the center of Paris again. Even the rue la Boétie lay outside the center, almost on the outskirts—too far away, given that people moved around on foot. There was hardly any hope of hailing a taxi, or even using a vehicle, in this time of gas rationing. Despite his substantial financial means, Pablo shared the everyday preoccupations of the French, namely eating and keeping warm. The black market provided him with what he needed to cook on his iron stove, but not enough for the heating that he had had installed.

None of this provided a very exciting source of inspiration. In the past, I was surprised by something my grandmother Marie-Thérèse said about Pablo at this time: "He was so cold, the poor thing!" Today, I can see that this struggle was essential for him.

The obsession with getting food to survive inspired him to write, in January 1941, a little tragicomic play in six acts. The characters were burlesque (Tart, Big-foot, Onion, Silence, Fear, Skinny), and the title was evocative: *Le Désir attrapé par la queue* (Desire caught by the tail).[64] The reading, on March 19, 1944, delighted his friends, who had become actors for a day: Michel and Louise Leiris, Simone de Beauvoir and Jean-Paul Sartre, Raymond Queneau, and Dora Maar. Albert Camus directed and Braque and Lacan were spectators. Brassaï captured the great moment on film. What a cast!

Picasso had been writing for several years, particularly poetry. Gertrude Stein had advised him not to spread himself too thinly, but to no avail. My mother Maya possesses a number of poems that her father had dedicated to her: aside from the sincerity of the phrases, the magical "illuminations" are particularly touching. Here at least there was color. Outside, everything was unremittingly gray.

In 1939, the Museum of Modern Art in New York (founded in 1929) organized the first retrospective of Pablo's works on the instigation of its legendary director Alfred H. Barr, Jr. The exhibition toured six American cities and was a triumph. As a result, numerous masterpieces escaped a grim fate at the hands of the Nazis. America, which loves crowns, crowned Pablo the most important artist of the century. But in Paris he was merely a Spanish emigré who enjoyed the unusual status of neutrality. To be sure, he was well known in his milieu, but he was obliged to cease existing officially as far as art was concerned.

64 According to Pierre Daix (*Dictionnaire Picasso*), "Like Picasso's poems, the writing in this play verges on automatic writing and is probably one of the finest examples of Surrealist dream theater." The burlesque story is closer to Surrealism than *théâtre de boulevard*. Scene 2 of Act 5, for example, "takes place in the sewer bedroom kitchen and bathroom of the Villa des Angoisses."

His experience the Occupation is reflected in his work, with its still lifes, dark colors, and human and animal skulls. In January 1943, he went to Dora's and gave her a copy of Buffon's *Histoire naturelle*, which he had illustrated for Vollard.[65] He dedicated it to her: *Per Dora Maar tan rebufon*—a pun in Catalan: "For Dora Maar so *bufona* (cute) and so *rebufant* (breathing anger)."

Throughout their relationship, he offered her, as he did Marie-Thérèse, hundreds of little signs of his affection—paintings, drawings, and above all small objects of all kinds, insignificant in appearance, but which Dora kept until her death.

A few months later, in May 1943, while he was dining with Dora and friends at the Catalan, the small black market restaurant opposite the studio on the rue des Grands-Augustins, Pablo met a pretty young woman who captivated him. She was sitting with a common acquaintance, the actor Alain Cuny, who was enjoying acclaim at the time for his role in the film *Les Visiteurs du soir*. Pablo went up to them and asked Cuny to introduce him: her name was Françoise Gilot.

In February 1944, Dora Maar accompanied Pablo to the memorial service in honor of their old friend Max Jacob, who had died while incarcerated at Drancy, and then attended the famous reading of *Désir attrapé par la queue*. But she and Picasso were gradually, inexorably, growing apart.

In August 1944, at the height of the events celebrating the liberation of Paris, my grandfather joined Marie-Thérèse and Maya on the boulevard Henri-IV. He had just crossed Paris on foot, risking death. He had even been grazed by a sniper's bullet. He made his choice, abandoning Dora Maar and her unfathomable torment on the Left Bank. As for Olga and their son Paulo, he had entrusted them to the supervision of his friend Bernhard Geiser in Switzerland.[66]

Dora was very depressed. Highly strung and filled with mysticism, she became delirious in public. She asked Pablo to repent. She was even taken by the police to the Hôpital Sainte-Anne to undergo heavy psychiatric treatment involving electroshock therapy.

65 Picasso had made a ten-year (1927–37) agreement with the dealer Ambroise Vollard at the end of which he was to supply one hundred illustrations (engravings and etchings). This group of "classical" works, strongly inspired by mythology, constituted the famous Vollard Suite.

66 Bernhard Geiser (1881–1967), a Swiss art historian, embarked on the compilation of a catalogue raisonné of Picasso's engravings and lithographs, which he continued until 1964. He produced two volumes covering Picasso's engravings from 1899 to 1934. Brigitte Baer, who took part in the inventory for the Succession Picasso, has taken over this painstaking task.

My grandfather has been held responsible for this descent into madness, but what was the real cause? By taking steps to bring her internment at Sainte-Anne to an immediate end, and by entrusting her to his friend the psychoanalyst Jacques Lacan, he ensured a gentle separation.

It seems likely that a number of people were indirectly responsible for the gradual decline in Dora's mental state. She had a mind already predisposed to crazy acts of the boldest kind, a taste for adventure pandered to by the Surrealists, who supported her quest for the irrational, which was for them a source of truth; she had complex and painful relations with Pablo, with the two of them endlessly exploiting their highly cerebral sexuality in new experiences. Her love affair with Picasso was perhaps only the catalyst for a general mental instability.

In August 1945, however, Pablo went to Antibes with her for a few days, and then bought a house for her at Ménerbes, which she would keep for the rest of her life. This was no doubt more a convalescence than the continuation of a relationship, which had almost certainly come to an end. Dora indirectly benefited from the fact that Françoise Gilot remained on her guard, and that Pablo was growing apart from Marie-Thérèse: here, passion had been replaced by affection.

Dora attempted to maintain contact between them. Nicole Avril even suggests that Pablo continued to play the game. In 1953, for example, he is said to have sent to her a "wretched" chair. She responded by sending him a "horrible" and totally useless shovel, and he arranged for them to meet (the fact is attested) at the Château de Castille near the Pont du Gard, home of a mutual friend, Douglas Cooper. According to Avril, Pablo is supposed to have humiliated her there by seducing her again in the presence of the American, but the latter could recall almost nothing about the incident.

FRANÇOISE GILOT (b. 1921)

Françoise was a keen and energetic young painter who was well informed about the art world. Against her father's wishes, she abandoned her law studies to devote herself to painting. When she met Picasso in 1943, she knew that he was a living god of modern art, and she dreamed of showing him her works.

To begin with, relations between Françoise and Pablo were tentative. Françoise knew how to make herself attractive and she was keen to retain her independence. She insisted on them addressing each other with the formal "vous," which was doubtless more than just the respect of the student

for the master. It persisted right to the end of their relationship. Distance can be a help in some relationships.

Françoise's intelligence and curiosity left nobody indifferent. Furthermore, she had a strikingly modern beauty. So even before their relationship really got underway, she soon began appearing in Pablo's paintings, although the artist nonetheless continued to depict Marie-Thérèse. He always proceeded in this way: he would introduce a few characteristics of his new companion while continuing to draw his previous one. Was it a fear of solitude or his insatiable need to seduce that led him to have these polygamous arrangements? At least art benefited from it.

Françoise understood the situation perfectly from the outset. "With Picasso," she said later on, "you had to be on your guard."[67] The sixty-three-year-old Pablo's attachment to the blonde Marie-Thérèse evolved gently into habit, into an immutable and grateful routine. Maya alone escaped from this cooling in his affections: between 1942 and 1945 he filled a sketchbook — the famous "carnet bleu" — with innumerable drawings of her.

Marie-Thérèse understood instinctively that their relationship was coming to an end. On July 13, 1944, amid the flood of letters between them, Picasso wrote: "You have always been the best of women. I love you and embrace you with all my heart." In so doing, he was expressing his gratitude and also the end of an era.

The following autumn, the "Marie-Thérèse" period came to an end in a final public celebration at the Salon d'Automne. The world discovered a sublimated woman, a woman who had already vanished.

As for Dora, she determined her own fate.

From one of their earliest meetings at the studio in the rue des Grands-Augustins, where Pablo had invited her on the pretext of teaching her about engraving, Françoise brought things out into the open. Picasso had been surprised by his guest's elegance under the circumstances, which she later explained: "But since I was sure he hadn't the slightest intention of teaching me engraving, I had put on the costume that seemed most appropriate to the real circumstances. In other words, I was simply trying to look beautiful."[68] There followed long intimate conversations during which Pablo blew hot and cold. Françoise prudently gave herself time to think.

Pablo, who would have liked events to proceed more quickly, even proposed to shut her away in the little apartment above the studio in the rue des

67 Statement made by Françoise Gilot in 1990, included in the DVD *Treize journées dans la vie de Pablo Picasso*, produced by Arte Vidéo and the Réunion des Musées Nationaux, 2000.
68 Gilot and Lake 1964, p. 40.

Grands-Augustins. Françoise was evasive without being disrespectful. She was brave but not reckless. Did Pablo think he could repeat the Marie-Thérèse experience with her? Françoise was less innocent, and times had changed. She knew who Picasso was, as did everyone else, aware that many other charming qualities added to his natural charisma.

Faced with this resistance, Pablo got frustrated and fell for a schoolgirl who had come to interview him. Sabartès received her and the zealous secretary, impressed by her forthrightness, arranged a meeting with the master for her. The girl, barely seventeen years old (like Marie-Thérèse had been), was named Geneviève Laporte. She said she was a poet and a communist, and, despite her youth, she claimed to be in contact with the Resistance. She had certain qualities that immediately attracted Pablo, whose heart was between two ports. Geneviève blushed at Pablo's statements about art. A natural teacher, he summoned this person who was almost a child to come on Wednesday afternoon to talk, and their friendship gradually grew.[69]

At the same time, Françoise regally accorded Pablo a few slots of her time, then ignored him completely for several days, weeks, or even months. "From time to time, he said to me, 'You mustn't think that I would ever get permanently attached to you.' That bothered me a little because at the start I had not expected that he would. I thought we ought to go along as we were, without asking where it was taking us. I felt that since I was asking for nothing, he had no reason to defend himself against me. I wasn't the one who wanted him to burden himself with me; he was the one, I realized, who wanted that ... after a while when he said such things as 'Don't think you mean anything to me. I like my independence,' I learned to say, 'I do, too,' and then stay away for a week or two. He would be all smiles when I returned."[70]

Pablo resorted to his favorite weapon: Françoise became the sole subject of his work. That was sufficient for the young woman, who took the plunge.

The start of their life together coincided with the completion of *La Femme Fleur* (dated May 5, 1946), a work of renewal made up of painting and collage. She watched him create it, and she questioned him about his inspiration. Their relationship was thus always based on respect and shared intellectual interests. Marie-Thérèse didn't dare question him, but Françoise rejected all barriers.

The lover metamorphosed into a patriarchal Pygmalion. Françoise developed a passionate interest in the various techniques that he used. Whereas

69 They had a very intermittent love affair, seeing each other in 1950 in Paris, while Françoise was away, then in Saint-Tropez at the home of Paul Éluard, who found the situation awkward.
70 Gilot and Lake 1964, p. 76.

Dora had merely been the inspiration, Françoise was also the privileged observer of his technical explorations in the fields of ceramics, painting, and engraving. Muse, mistress, companion, she was also the ideal interlocutor for gleaning snatches from the past from the mouth of Pablo—at the risk of being hurt by memories that were still fresh. She attempted to reconcile several eras and several women in a modern world where Picasso was no longer an unknown artist and where, unlike his other companions, she would inevitably be in the full glare of the public eye.

For Picasso, this cultivated young woman was someone who could understand his soul and his needs. He almost forgot the needs of their own relationship. He took her to visit the places that had featured in his previous relationships with Fernande, Éva, Olga, and Dora, and told her all about his passion for Marie-Thérèse, whose passionate letters he read out loud to her. Such behavior would have driven many women to flee. And true to her character—and her pride—she decided at one point to leave the great Picasso. Defeated, he caught up with her just in time and suggested she have a child with him because, in his opinion, it was what she needed!

In this postwar period, Françoise shared in Pablo's return to youth. He rediscovered the joys of engraving and lithography with the eminent Fernand Mourlot in Paris, and abandoned the capital for the Côte d'Azur. In this joyous world of bright colors, he and Françoise toured Provence and the Riviera. But gone were the days of following the high society summer rituals like he used to with Olga. He was going to work there full-time. He was going to live there.

In 1946, he set up his studio in the magnificent Château Grimaldi in Antibes, while Françoise, who was pregnant, lived in a house in nearby Golfe-Juan. He painted his new life there, symbolized by the famous painting *La Joie de vivre* (painted in October and November 1946).

Claude was born in Paris on May 15, 1947. Pablo was a happy father once again—a young father. Now more than sixty-five years old, he led an active life, dividing his time between art and politics. A member of the Communist Party since October 1944, he had acquired, thanks to his fame, the status of an international militant.

His love life was now public. Olga, informed by Paulo of the existence of Maya and her mother, learned about Françoise from the press. Furious, she decided to stay close to them (mostly in Cannes, at the Hôtel Miramar, or at Juan-les-Pins, at the Belles Rives, whose bills Pablo paid without batting an eyelid), harassing them every day at Golfe-Juan.

Françoise struggled to avoid depression. Pablo pretended not to notice, until the day when he had to ask a police superintendent to make Olga see

sense. The ruling of 1935 had forbidden her to "disturb" her husband, or she would run the risk of incurring the intervention of the forces of law and order.

Pablo had briefly discovered the little village of Vallauris in 1937. He returned there in 1946 with Françoise and went back the following year to learn about ceramics from Georges and Suzanne Ramié at the Galerie Madoura.

This marked the beginning of a long love affair between him and the little village in the countryside above Cannes, overlooking the little seaside village of Golfe-Juan. In the spring of 1948 he settled there with Françoise and Claude, moving into a small villa called La Galloise. The house officially belonged to Françoise, for it was bought for her by her grandmother, Anne, who refused to have her granddaughter living in someone else's home. Her action is evidence of the family atavism that gave rise to Françoise's independent spirit. Pablo's pride was hurt, though, and in 1949 he bought in Françoise's name an old perfume warehouse, Le Fournas, where he set up his own studio. During their separation, Françoise would sell it back to Pablo for the same price, which meant Pablo paid for it twice!

It was in these large rooms, renovated later by my mother Maya (who had asked to receive Le Fournas in her share of the heritage), that I myself spent many family summers. The simplicity of the place, its immersion in the heart of the village gave me, I feel, a fairly accurate picture of what postwar life must have been like. I was also able to gauge the enormous impact my grandfather's presence must have had in this little village, which had become, thanks to the presence of a single man, a tourist center invaded by coaches from all over Europe. With the statue of the *Man with a Sheep* on the market square, the frescoes of *War and Peace*, and the hundreds of potters and ceramicists who worked in Picasso's shadow, not to mention the celebrations organized in his honor, Vallauris could have been renamed "Picassotown."

The relationship between Françoise and Pablo was based on a strange balance of power. The wide age gap gave their love an intensely spiritual dimension. Pablo, however, who had the experience of a mature man, invariably displayed a fatality that verged on the discourteous: whatever will happen will happen. Françoise had the temperament of a visionary, both in her art and in the way she organized her own life. She wanted answers, and Pablo was often evasive. He allowed himself slots of free time, often devoted to politics, in which Françoise was not involved.

She may have had a feeling of a certain distance, symbolized by the obligatory *vouvoiement*. And yet physically she mirrored Pablo's youthful spirit.

In response to the young woman's worries, Pablo suggested she have another child. A family provided a source of calm at times when artistic creation was a torment.

Paloma was born on April 19, 1949. Pablo was now the father of four children: Paulo, Maya, Claude, and Paloma. He presented them to the whole world. He drew with Claude and Paloma, feeding off their spontaneity. This recomposed family (although the term was not in use at the time) was his. He was happy to pose for photographers on the beach. In a way, what he had presented to Françoise as a solution seemed to be a remedy for him!

The couple and their two young children lived in turbulent circumstances. They were surrounded by journalists, people asking for things, unwelcome visitors, sycophants on many occasions, and friends as well. In the correspondence of this period, much of which is preserved today in the archives of the Musée Picasso in Paris, numerous letters from strangers were left unopened because there wasn't time to deal with them.

Time—this was exactly what Pablo was beginning to run out of. A particular phenomenon linked to his fame emerged: women would offer themselves to him, attempt to seduce him, so they could touch a living myth and perhaps carry off a souvenir.

Pablo could still turn on the chain and this had an effect on his relationship with Françoise. Geneviève Laporte reappeared. She published her memoirs in 1973,[71] and recently she talked to the French biographer Henry Gidel,[72] who attributed much greater importance to her in my grandfather's life than previous biographers. A mystery of the boudoir.

There was a confusing atmosphere of deception and uncertainty. Françoise could not take any more and left with the children.

At the end of September 1953, their break up became definitive. For the first time, a woman had stood up to Picasso, had survived him. "I realized, as I thought it over, that Pablo had never been able to stand the company of a woman for any sustained period. I had known from the start that what principally appealed to him in me was the intellectual side and my forthright, almost tomboy, way of acting—my very lack, in a sense, of what is called 'femininity.' And yet he had insisted that I have the children because I wasn't enough of a woman. Now that I had them, and presumably was more of a woman and a wife and a mother, it began to be clear that he didn't care a bit for it."[73]

71 Geneviève Laporte, *Si tard dans le soir, le soleil brille*, Paris, Plon, 1973. Revised and expanded edition: Laporte 1989.
72 Gidel 2002.
73 Gilot and Lake 1964, p. 313.

She had no doubt realized that Pablo would have preferred to have shut her away and kept her, exactly as he had with Marie-Thérèse, who had understood the strategy: "He would have liked to have a big château, with each of his women in a different room. Like the Arabs. With children, of course. I tell you, he was a devil. He was a devil..."[74]

Pablo went through a troubled period. Claude and Paloma, who had been enrolled in the École Alsacienne in Paris, came back for the summer vacation. Maya left for Madrid in the summer of 1954. Pablo saw Françoise again during a big parade for the bullfight at Vallauris, at which she entered the arena on horseback. He was fascinated—much to the displeasure of another woman who had just entered the circle, Jacqueline Roque. But Françoise left that same evening. Courtesy replaced amorous tension.

In the years that followed, Françoise ensured that the situation of the children was consolidated as well as possible within the terms of the law. Pablo consented willingly: still officially married to Olga, he had not been able to recognize them legally, so in 1955 he spontaneously became their legal guardian, then made an official application in 1959 so that they could bear his name, which was authorized by the Minister of Justice in 1961.

In 1963, Françoise herself told Pablo that she was writing (with Carlton Lake) a book about their story. The news worried him. The publication of *Life with Picasso* in 1964 incurred the wrath of Pablo, who was more than eighty years old at the time and very sensitive to the smallest upset. He took it as an affront, and this attitude was strongly encouraged by Jacqueline, his new wife (whom he had married in March 1961), and his lawyer Maître Bacqué de Sariac.

Roland Dumas, a young lawyer, advised him to let the storm blow over, but Pablo did not listen to him and sued. A petition in his favor, signed by artists, intellectuals, and communist militants, was published in *Les Lettres françaises*.[75] Even Fernande Olivier participated in the manifesto, although

74 Interview with Marie-Thérèse Walter by Pierre Cabanne, April 13, 1974.

75 Clandestine newspaper of the Resistance founded by French writers during the war. The first issue was supposed to come out in February 1942 on the instigation of Jacques Decour. But the latter was arrested in February 1942 and shot on May 30. The first issue was eventually published on September 20, 1942, edited by Claude Morgan, assisted by Jean Paulhan, Jacques Debu-Bridel, Charles Vildrac, Jean Guéhenno, Jean Blanzat, and the Reverend Father Maydieu. The newspaper ceased being clandestine when Paris was liberated. The first issue to appear openly was distributed in the streets of Paris in August 1944. Aragon became the director from March 1952 until the newspaper folded in 1972. Pierre Daix was the editor on an occasional basis. Although they both belonged to the Communist Party, Aragon (who worked on the newspaper) and Picasso rarely had the same ideas about art and politics, giving rise to frequent debates between the two. When the Communist Party stopped financing the newspaper, Aragon naturally turned to Picasso for help. In an ironic gesture, Picasso simply dedicated a photo of himself with the cellist Mstislav Rostropovich, which appeared in the last issue of *Les Lettres françaises*, in 1972.

she herself had published a book of memoirs in 1933 that Picasso had opposed.[76]

The revelations about Françoise and Pablo's private life were joint memories, ruled the judges. Monsieur Picasso did not have sole ownership of them. Pablo lost, and the book received considerable publicity.

The painter shut himself away in ever greater isolation. His friends Georges Braque and Jean Cocteau both died in 1963. Claude and Paloma, who always came to see their father during school vacations, saw him on Christmas of that year for the last time: inexorably, Pablo was distancing himself from his children and becoming one with his work. Furthermore, he feared the influence of their mother, Françoise, and criticized them for not trying to persuade her to abandon her book project. But what could they do? Would he have put down his brushes if they had asked him?

There was a further, tense meeting a few years later, in a street in Cannes. Claude and his father spoke only for a few minutes, watched absently by Jacqueline. Claude and Paloma were spotted again in the arena at Fréjus, at bullfights, a few rows away from Jacqueline and Pablo, but the children ignored them so conspicuously that journalists viewed it as provocation: defying their father. Perhaps it was just a way of calling out to him.

In 1968, Claude and Paloma made a first, unsuccessful attempt to get a "recognition of filiation." It was not an attack against their father; they simply wanted to establish a fact. But this "fact" was still unrecognized in law. And Pablo's entourage interpreted it as an attack. On top of that there was Jacqueline....

It is difficult to put oneself in the position of a woman who has to cope with the influence of her predecessor. Françoise's book provided Jacqueline with the best of justifications. She was careful to protect their world totally—and Pablo wanted to be left alone.

No family member had access to the master aside from Paulo. And even he complained of having to "climb over the wall" in the final years. The go-betweens—housekeeper, chauffeur, secretary, not to mention Jacqueline—declared without batting an eyelid that "Monsieur" was working and could not be disturbed.

JACQUELINE ROQUE (1926–1986)

December 1953. Soon after the official departure of Françoise, Pablo met a young woman called Jacqueline Roque. She was nearly twenty-eight years

76 Olivier 1964.

old. She was a friend of Suzanne Ramié, owner with her husband Georges of the Galerie Madoura at Vallauris. Jacqueline helped her with sales and regularly came into contact with Pablo.

They did not remain indifferent to each other for very long. Their conversations became more frequent. By nature reserved, Jacqueline became more self-confident. They shared the same experience of separation, since she had just parted company with her first husband, André Hutin, with whom she had had a little girl named Catherine. They were both loners.

Pablo noticed her sphinx-like profile: she inspired him straight away. For the first time, however, he did not mix together the faces and hair colors of all the women in his life. The canvas was blank, as if, in the autumn of his life, he was beginning his career as an artist. And a new life as a man.

At Paulo's instigation, Marie-Thérèse came to Vallauris to spend a moment with Pablo. It was at La Galloise, at the end of this year, 1954, that my grandmother met Jacqueline. Pablo introduced "Mme Walter" to her, which irritated Marie-Thérèse a little. Jacqueline mumbled her own name, still intimidated by the Picasso hurricane that was lashing her.

Jacqueline gently took her place, the whole place. La Galloise, which belonged to Françoise, was emptied,[77] and Pablo temporarily went to live with her. He bought a large house in Cannes, La Californie, and retrieved all the possessions of his that were stored in his apartments and furniture storage warehouses in Paris. With the aid of Jacqueline, he re-created a gigantic studio, a veritable cavern where he stored his entire output, which represented a large part of his past life.

In 1955, there was a coming together of generations: Paulo, Maya, Claude, and Paloma were reunited for a summer by Pablo, watched by Jacqueline, who had to confront forty years of a prodigious past that was foreign to her.

Olga died in February; Marie-Thérèse had just rejected the marriage that had been promised to her in the past, but was now impossible; Françoise had chosen to survive elsewhere.

The old man's body may have been tired, but he had rediscovered the enthusiasm to celebrate his new conquest. She was in every work.

He drew inspiration from the masters of the past—he now had the time. Jacqueline brought her modernity to them: around fifteen versions of Delacroix's *Femmes d'Alger* (he had made his first study of this work as early

77 Even works by Françoise herself were removed. She would not get them back until an inventory was made for the Succession Picasso, which was begun in 1974.

as 1940) between December 1954 and February 1955, around fifty versions of Velázquez's *Las Meninas* in the second half of 1957, nearly thirty versions of Manet's *Déjeuner sur l'herbe* between the summer of 1959 and Christmas 1961, and *The Abduction of the Sabine Women* after David in 1962.

These works were part of an ongoing dialogue with his predecessors, as demonstrated by other works of his inspired by El Greco, Cranach, Courbet, Cézanne, Rembrandt for the final period of the *Musketeers*, and Nicolas Poussin, one of his most important touchstones and whose portrait he later painted.[78]

It was in this historical context that the Château de Vauvenargues was acquired in the autumn of 1958, which the historian, collector, and friend, Douglas Cooper, a château-owner himself, had drawn his attention to. "Look, Jacqueline and I fell in love with it when we went back with Jean [Cocteau]: it was morning, the market was still set up on the village square, the locals were speaking Catalan [probably Provençal]! And the displays of fruit and vegetables were like those at our markets!" he said to his friend the journalist Georges Tabaraud.[79]

It gave him a new lease on life. Pablo, as he famously put it, had "bought the Sainte-Victoire mountain" and brought back many memories of his life. He and Jacqueline took possession of the place, gradually transforming the château's immense rooms into studios, decorating some of them with his own works and with pictures from his collection by Matisse, Cézanne, Courbet, Braque, Modigliani, and Corot. He felt that they were better off here in this place impregnated with history than in Cannes or Mougins. Pablo painted the bare walls of the bathroom on the second floor: now a fauna and luxuriant flora would accompany his morning ablutions.

His enthusiasm lasted nearly three years. Then Vauvenargues, ultimately too austere for him, became nothing more than a stopping point on the way to bullfights in Nîmes or Arles.

On March 2, 1961, at the age of nearly eighty, Pablo secretly married Jacqueline. There were forty-five years difference between them. Certain people liked to say that Jacqueline's perseverance had carried the day: a wife has

78 *The Young Nicolas Poussin*, Pablo Picasso, oil on canvas, 73 × 60 cm, dated July 13, 1971. He discovered Poussin at the Prado in 1897, then at the Louvre in 1900. The self-portrait *Yo Picasso* (1902) borrows the pose used in Poussin's self-portrait, which he had seen at the Louvre. The portrait of *The Young Nicolas Poussin* brought this exploration to a conclusion in 1971. This painting was the emblem of the exhibition held at the Palais des Papes in Avignon in 1973; it was the last time Pablo Picasso provided assistance in the selection of works from the last period of his life. He died on April 8; the exhibition opened on May 23. *The Young Nicolas Poussin* appeared on the official poster and catalogue for the exhibition. René Char wrote the preface.

79 Tabaraud 2002.

better guarantees for the future than a simple companion. But the perseverance of which her friend Hélène Parmelin speaks[80] probably had more to do with her need to see her companion commit himself to her rather than financial interest. Moreover, let us not forget that my grandfather had a horror of everything to do with death. His marriage was an act of life. And love. The very fact that this union had been celebrated without any contract being signed proves that, for Picasso, spontaneity prevailed—and fatalism.

Some time before, at the baptism of Miguel, the son of the bullfighter Dominguin, and his wife Lucia Bosé, Pablo had been exasperated by the throng of journalists. With this secret marriage, he was thumbing his nose at those who thought they were entitled to know everything about him and, more particularly, at the press. Once again, it was he who called the tune.

There was no question of organizing a future of any kind. Whatever would happen would happen, whatever the consequences. And anyway, what was the point of knowing who his heirs would be, since he had, as Pierre Daix had put it, "worked enough for everybody"?

As for Jacqueline, who was from a bourgeois, Christian background, and who had entered the art world through the Galerie Madoura, she had had to adapt to new, very liberal practices, and to deal with the clash of her own values with Pablo's non-conformism. She thought that marriage had an official significance, that it was a commitment in full view of everyone. In January 1961, she had publicly and tearfully expressed her annoyance at Pablo's unfulfilled promise to marry her. She had to deal with a procession of visitors—married men and their mistresses, homosexuals and their boyfriends, libertine wives and pretenders of all kinds. She wanted to show she was different.

A few weeks later, it was done.

Jacqueline and Pablo moved into a new home, Notre-Dame-de-Vie at Mougins, to get away from Cannes and La Californie, whose view of the bay had been blotted out by the construction of a large building. Jacqueline organized their life as a "young" married couple. More than La Californie, which was a thoroughfare for everyone, or the Château de Vauvenargues, too heavily scarred by history, the house at Mougins was "her" house, "their" house. She reinvented a lost youth, and filtered visits.

I remember this period as being like the reddish light of late afternoon, under the gentle heat of the sun shining through foliage, as in the pictures of David Duncan (who had already captured Jacqueline and Pablo at La Californie and Vauvenargues), or Roberto Otero, which bear witness to a serene plenitude. The days passed peacefully.

80 Parmelin 1994.

After the celebration of Pablo's eightieth birthday at Vallauris, the painter devoted himself primarily to his studio. The years at La Californie had been illustrated by interior scenes and the Côte d'Azur. The last period marked the return of the painter to his model. Notre-Dame-de-Vie, situated on a hillside, was made up of a very wide main building facing the slope. The architecture was unremarkable, but the very large luminous rooms were perfect settings for his works. On the third floor there was a terrace, which became Pablo's last studio, especially after an elevator had been installed. It was there that a privileged few were taken by Pablo, and by him alone, to discover his most recent works.

I was given an account of one such visit by Mstislav Rostropovich, who was a visitor, witness, and accomplice during an absolutely remarkable evening. It was in the summer of 1972 that he visited Pablo. The Russian cellist had become *persona non grata* in the USSR following his interview with the dissident writer Solzhenitsyn. Exiled (before being stripped of his soviet nationality a few years later), Rostropovich was a protégé of the West at the time of the Cold War. Pablo, who had had a card as a militant of the Communist Party since 1944 (he paid the stamp duty like every other member), still retained a critical distance with regard to the party and the USSR.

He had wished to meet the musician, and received him enthusiastically at Notre-Dame-de-Vie. He immediately offered him a copy of the book containing all the engravings devoted to *La Celestina*,[81] with the following dedication in pencil: "To Slava, my friend. Pablo," below which he drew a lion.

Mstislav (nicknamed Slava) came with his cello and a box of Russian vodka. He was taken by Pablo's gaze: "These eyes were like an X-ray. I had the feeling that something was wrong and, mechanically, I checked that my pants were on correctly...." They spoke for a long time, then Mstislav played some Bach. Pablo was deeply impressed. Jacqueline, who enjoyed classical music, took photographs of this magical moment.[82]

Pablo then took his friend to his studio upstairs, for according to him political discussions should be done one-to-one. He also wanted to show him engravings that he had done in 1968 with the famous printers Aldo and

81 According to the *Dictionnaire Picasso* by Pierre Daix, "This famous canvas by Picasso marks the beginning of his emergence from the Blue Period, something that can be seen even more clearly now that it has been cleaned. It was because of her corneal opacity that Picasso thought of doing La Celestina in this way, with a caricature of Sebastià Junyer and a lady of easy virtue.... Among the 347 engravings, sixty-six were devoted to La Celestina. They were printed on a single sheet and also printed separately in 400 copies for a book (published by the Atelier Crommelynck)."

82 She often saw the cellist and his wife after Pablo's death, notably during the famous Festival de Menton.

Piero Crommelynck. Now his neighbors in Mougins, the Crommelyncks joined Pablo and his guest.

Rostropovich told me that Pablo insisted on showing him how much he worked and showing him the theme of his experimentation in a succession of portraits of the same face, captured in different states of mind: "For two hours, on two easels, he presented one after the other his latest works, helped by one of the Crommelynck brothers." Pablo explained that a happy work was followed by a tragic work, and that he did not show that to anyone except Jacqueline and his assistants.

It was an exceptional day in more than one respect. Pablo opened his heart and soul to a man who had rejected Brezhnev, just as he had opposed Franco forty years earlier. They were both in the same camp: that of the oppressed.

They decided to celebrate this meeting. Around the table in the form of a banjo that Pablo was so fond of, the little vodka glasses were endlessly refilled. And when Pablo proposed, as a supreme honor, to engrave something on the black wood of Mstislav's bow, the latter took it from him! He refused to allow Pablo to touch it, worried at the prospect of the master, visibly tipsy, inscribing some indecipherable mark and an illegible name. So he decided to engrave it himself: "For Pablo, Slava," although it was certainly not his intention to offer his finest bow to anyone.

This meeting at which an elderly grandfather, ordinarily a strict water drinker, and a cello prodigy emptied glasses of vodka together was both magnificent and hilarious. But the story doesn't end there.

Too tired to leave, Slava stayed the night. As she was going to bed, Jacqueline wished him goodnight and removed from Pablo's neck a medallion that she put around the cellist's neck.[83] "I remember the two last sentences that Jacqueline and Pablo exchanged that evening," the maestro told me: "'How can you give him the first present that I gave you when we were fiancés!' said Pablo with an irrepressible tender jealousy. Jacqueline affected an expression of arrogance, 'Well, I love him!'" In the morning Mstislav searched feverishly for his precious bow—in vain, despite the efforts of everyone in the house—and under the malicious gaze of a Pablo who was terribly sorry. Many years after Pablo's death, Rostropovich returned to the house after a concert and found the bow displayed in a glass case on a cupboard with two vodka glasses! Pablo had wanted to preserve the memory of this alcoholic evening and, despite his friend, the indispensable bow that he had dedicated to him.

83 It was an irregular pentagon made of gold, on the front of which there was a face in gold wire by Picasso.

Over the years, Jacqueline and Pablo established an unusual relationship, that went beyond physical relations. Many people I have met were amused by a certain timidity that Pablo displayed toward Jacqueline, and the fact that there were rarely any gestures of affection on his part. Taking his wife's hand and stroking it was not a normal, spontaneous action for him. Was this a slightly "macho" by-product of Pablo's position as a Sun King who was rarely obliged to make any effort? Was it the legacy of a more conventional era when people behaved with restraint in public, despite his fierce desire to break rules? Nobody has ever described Pablo as a demonstrative lover in public—certainly not Olga, Marie-Thérèse, Dora, or Françoise. For these last three there was also the worrying, unavoidable issue of adultery. Jacqueline was also subject to his passivity, but she knew how to take the initiative and probably anticipated his desire.

Pablo's vitality expressed itself in his work. At the end of 1965 and for an entire year he devoted himself to drawing and engraving, turning his back completely on painting. He was exhausted by the incredible number of portraits of Jacqueline that he had produced over the previous few years, exhausted also by a growing body of erotic work, which Louise Leiris[84] had difficulty presenting in her gallery without incurring the wrath of censorship. One day, indeed, she received a visit from the police superintendent of the *arrondissement*.

As far as his health was concerned, Pablo had had a gall bladder operation in complete secrecy—out of vanity and because he wanted to avoid speculation by journalists about his state. He and Jacqueline had traveled discreetly by train to Paris, where they went to the American Hospital in Neuilly. There he was registered under the name of Ruiz. Rumor has it that he also had an operation on his prostate gland. Sadly, like all men of his age, he was no longer the tireless, indestructible person of old—even though he tried to make people believe the contrary. He admitted only to losing his hearing a little.

84 Louise Leiris, often called Zette, was the daughter from the first marriage of Lucie, Daniel-Henry Kahnweiler's wife. In fact, they pretended to be sisters to avoid a scandal at the time, particularly in the eyes of Daniel-Henry Kahnweiler's parents. During the shady period of World War II, Kahnweiler had Louise buy his own gallery so that it would not be despoiled and "Arianized." According to Pierre Daix (*Dictionnaire Picasso*), Louise Leiris "went to the commission for Jewish questions to make an application and, despite an anonymous letter revealing that she was Kahnweiler's 'step-sister,' she obtained the right to buy." After the Liberation, Kahnweiler (a widower following the death of Lucie) joined her in the gallery that she had just opened with Michel Leiris, her husband. This prestigious gallery is still in business.

In the spring of 1967, he was evicted from the rue des Grands-Augustins. He had not returned there for twelve years, but it had remained for him a living trace of his life in Paris, and the dark years. Despite the friendliness of André Malraux, who was Minister of Culture at the time, and despite the national tribute of the previous year, organized by the curator Jean Leymarie,[85] he could not escape the policy aimed at freeing up empty apartments in the capital.

In fact, he was paying the price for his old communist activities. In response, he turned down the *Légion d'Honneur*, which was awarded without his consent, rather tactlessly, some time after. In the end, it was all water under the bridge. He wanted to be a man of the future, again and for always.

And to demonstrate that he was still a living contemporary artist, he continued painting the *Musketeer* canvases, followed by works featuring circus people, including clowns vibrant with color and joy. Between the beginning of 1969 and the beginning of 1970, he produced around sixty-five large paintings. To demonstrate his ardor for his work and the enduring nature of his audacity, on the instigation of Yvonne Zervos,[86] an exhibition of this output was inaugurated in May 1970 in Avignon in the majestic and ancient Palais des Papes. It caused a sensation. From indispensable detractors to loyal aficionados, everyone was talking about Pablo, who was center stage again. He said to my mother, Maya, "It doesn't matter whether they praise you or criticize you, the important thing is to be talked about!"

In October 1971, an event was organized to celebrate his ninety years as an artist. It surpassed the national homage of 1966, which had occupied the Grand Palais, the Petit Palais, the Bibliothèque Nationale, and many other galleries in a gigantic retrospective.[87] French president Georges Pompidou had eight of Picasso's pictures hung opposite classic masterpieces of French painting in the Grande Galerie of the Louvre. It was a historic event, as it was the first time that works of a living artist had been hung in the Louvre.

85 Jean Leymarie, French curator and writer on art, born in 1919. He entered Picasso's life as curator of the Musée de Grenoble and professor of art history in Geneva in the 1950s. According to Pierre Daix: "After Georges Salles and Jean Cassou, he was the curator who fought the hardest against the indifference of French museums towards Picasso, while introducing his art into the École du Louvre when he was its director."

86 Yvonne and her husband, Christian Zervos, opened a gallery in Paris in 1929. In 1937, they brought together a group of works by the leading figures of contemporary art at the Musée du Jeu de Paume. This exhibition, a pioneering event of its kind, contained Fauvist, Cubist, Dadaist, and Surrealist works. Their gallery adjoined Les Cahiers d'Art, the publishing company founded by Christian in 1926, and during the war they were able secretly to preserve numerous works deemed "subversive" by the political authorities.

87 There were over 850,000 visitors.

Harlequin, *Seated Woman*, and *Seated Nude* rubbed shoulders with Watteau and the masters of the past.

Pablo and Jacqueline did not attend. Aware that his condition made it impossible, that his health was fragile, Pablo naturally abandoned the idea of making an appearance, but he was very interested in this retrospective. Jacqueline was just as proud, but discreetly concealed her excitement. So Pablo questioned at length those who had been. His friend Jean Leymarie had participated in the organization of this homage, having continually alerted the authorities about France's failure to honor Picasso. Having failed to offer him a museum, his grateful homeland finally did justice to him during his lifetime. Later—much later—the happy and providential *Dation* that President Pompidou had had in mind for several years proved a way of making up for lost time.

For the time being, Pablo questioned Roland Dumas, who was one of those invited to the inauguration, to be sure of the general harmony between his works and those of the Old Masters, whom he had finally joined. "Your Harlequin, as you say," Dumas said, "holds its own very well." "But Picasso wanted to know more. I described to him the positioning of the works, the lighting, the effects of a particular painting in relation to another. The canvases[88] were not placed side by side, but they were sufficiently close for each visitor to succumb to the temptation to compare them."[89]

Pablo asked his friends who were present the same questions: Michel and Zette Leiris, Daniel-Henry Kahnweiler (who had always been convinced that Picasso's work would enter the Louvre), Hélène Parmelin and her husband Édouard Pignon—his inner circle.

The upturn was short-lived. President Pompidou had said of Picasso that he was a "volcano that would never be extinct." But that autumn of 1972, Pablo grew weak. A bad bout of flu, aggravated by bronchitis, confined him to bed for several weeks: he lived with an artificial respirator nearby just in case. He stopped working. At Christmas, he was still bedridden. He regularly had meals in bed, in the company of Jacqueline and a few visitors. For the New Year at Notre-Dame-de-Vie, Jacqueline invited Hélène Parmelin and Édouard Pignon, the faithful lawyer friend from Cannes, Armand Antébi and his wife, and the Spanish publisher Gustavo Gili and his wife. Everyone knew

88 Pablo Picasso, *Paulo en Arlequin*, 1923, and Jean-Antoine Watteau, *Gilles*, ca. 1718–19. Gilles was a character found in fairground theater, a naïve, cowardly type of boy who was immortalized by Watteau in his traditional white costume. Today this work is known as *Pierrot* and is still in the Musée du Louvre, hanging in the room devoted to French eighteenth-century painting.
89 Dumas 1996.

that Pablo was in bed on the floor above, so the party seemed destined to be a gloomy affair. "Then something moved in the house. There were steps, voices. Pignon said: 'It's Picasso!' The door opened with the usual noise of the bells hanging above it, which tinkled when you touched them. Picasso and Jacqueline made their entrance. Arm in arm. Dazzling. Superb: they had made themselves beautiful. They entered, surprising us, delighted as if they had played an old trick. They embraced us, both talking at the same time. He was more and more cheerful. He even drank a little champagne, and he rarely drank anything at all. He laughed until the tears ran. There were flowers everywhere. Presents. It was a real party. Midnight was a glorious moment, with all its kisses, wishes and follies."[90] Hélène Parmelin couldn't get over it. The following day, January 1, 1973, Jacqueline sighed: "Thank you God, we have got through the year." That month, Pablo seemed to get a bit stronger. But the few friends who had not seen him for a few months noted a considerable change: his voice had " become really old," said Georges Tabaraud.[91] Yet his considerable output testified to his boundless energy. Jacqueline suggested another exhibition in Avignon to follow on from the enormous success of that of 1970 and to display the huge amount of work of the past year.

The closer he got to the ineluctable, the more he rejected it. As did Jacqueline. "Leave me in peace," he repeated endlessly. "He now only followed one imperative: painting."[92] Jacqueline took care of everything else.

Accounts from this period are rare, because there were few visitors. Jacqueline and Pablo formed a single, self-sufficient whole: "She called him my lord, my master, and did not address him *tu* in public. Lover, model, assistant, nurse, permanent interlocutor—she was all of those things! She knew how to protect him from the tide of visitors that was endlessly washing against his door. That was the essential thing. She was the uncompromising guardian of the space he needed to be free, to create, the space that was indispensable to Picasso's work.... But at the same time, she was fiercely jealous of anything or anyone that she might suspect of undermining her sovereignty over this space and her monopoly of the man-god, for whom she posed as a vestal virgin."[93]

In the long corridor running between the large rooms and leading to the elevator, a bench, known as "the station platform," served as a place where people could wait—wait while Pablo was chatting with someone in the salon—or rest—even for Pablo himself, who was too weak to walk long dis-

90 Parmelin 1994, p. 175.
91 Tabaraud 2002, p. 9.
92 Parmelin 1994, p. 177.
93 Tabaraud 2002, p. 9.

tances. Waiting on "the station platform" was a privilege in itself when some people were waiting in vain at the gates to the property.

Paulo, the eldest son, who was Pablo's secretary in Paris, had a final conversation with Pablo at the end of February, before returning to the capital. Little by little, everyone sought to have a talk with Pablo, without knowing, or wanting to admit to themselves, that it would be the last.

Pablo's artistic frenzy no longer left him time to take an interest in anything except his work, or anything outside Jacqueline. And besides, nobody thought of distracting him. He had probably already left the world of the living to join the magical world of his art, the world of immortality. The previous year, he had painted several self-portraits—an emaciated face, still colored with life, but invaded by two large black eye-sockets, which fix the viewer with power and anguish. Between life and death … Pablo said at the time that he had felt something. All these self-portraits were exhibited in December 1972 at the Galerie Leiris in Paris, but Pablo did not keep any of them.

Jacqueline watched over him. Until April 7.

On this day, at around the time he usually started a day of "work,"[94] as he always rightly enjoyed saying, he felt unwell. His physician, Doctor Rance, came straight away. A lung specialist in Paris, Doctor Bernal, was called immediately and arrived that evening.

After dinner, Pablo felt as if he were suffocating. In the corridor, Catherine, Jacqueline's daughter, realized that the end was near. "He can't do that to me!" protested her mother. "He can't leave me!" In the morning, Pablo woke up feeling very weak. Maître Antébi was called in case Pablo wanted to entrust him with something official. The sick man was clear-headed, but his body was gradually abandoning him. He asked the specialist from Paris if he was married. The latter replied that he was not. Pablo looked at Jacqueline, he took her hand—which was such an unusual gesture for him—and added "You should get married. It's useful!" Then, in a serious voice, he added: "Jacqueline, you must tell Antébi …" And he died, on that gray morning.

A life that had lasted nearly ninety-two years and was exceptional in every respect had just come to an end.

Although I didn't know it yet, for me a grandfather had just been born.

94 My mother Maya owns one of the drawings he produced during his last day of work, and she also succeeded in finding and buying Pablo's first painting. Painted in 1889 on the wooden lid of a little box, it is a copy of the picture that used to hang in the family dining room, showing a view of the port of Málaga with its lighthouse.

Politics

Others talk, I work![1]

PABLO PICASSO

Pablo Picasso's oeuvre unfolds within a single dynamic: the rejection of all rules. From his early academicism to the recuperation of his genius, my grandfather rejected everything en masse. He imposed his own standards and created his own language, which, once it had been taken up by others, he would call into question. He loathed to be pigeonholed but despised the tyranny of a new order just as much. More than anything else, he hated and feared the word "end." No other artist's career falls into such clearly defined "periods" and yet no other made such a habit of systematically abandoning them. Other men might stick to a single line: my grandfather knew how to "rebound" at any moment—at the very moment it looked as though he was finished. A traditional artist; yet one who remained an eternal revolutionary: isn't that, perhaps, exactly what genius is?

Revolutionary: unavoidably, the word conjures up politics. Picasso joined the French Communist Party in 1944, at a time when other artists and intellectuals were already standing in its ranks. But, before becoming a famous and worthy militant for the Party, Pablo had already taken up other, just as committed, causes—though without the label. The lion's share of criticism labors over the fact that in the public eye he must have been a bad Communist because, he was a billionaire—but this

1 Quoted in Souchère Dor 1960.

is to skim over everything that happened before and after joining the Party.

My grandfather's political trajectory was as much an expression of his art as indicative of personal commitment. It is reductive to limit the inspiration of a work to its "subject," yet, at the same time it would be absurd to deny that the "idea" is always the primary cause. He could be inspired by human beings as well as events. His oeuvre did not evolve out of models, still less those of a political nature, and, in spite of many emotional attachments, it was always his conscience that prevailed.

It seems important to me today to present Picasso's quest for meaning, with which specialists are well acquainted, to a larger audience.

It goes without saying that the analysis of Picasso's oeuvre is no easy task. On the one hand, the thousands of explanations that occur to the viewer at a cursory glance at the canvas have to be ignored, yet you have to delve beyond that superficial facility that some are in such a hurry to condemn.

For Picasso's painting is as far from meaningless scribble as it is possible to get. The faintest line is an answer to a question, an intellectual problem, or forms part of some basic research on a material or process, or some formal exercise or perspective. None of the people I have met ever heard Picasso speak of his painting as a pretext, as a means and not as an end. This would have been entirely foreign to him, a breach of trust; there is no way to disentangle the intention from the artwork.

His detractors' attempts to portray Picasso as an entertainer, with clumsy quips about his "alchemical" talent for transforming paint into gold, their mania for seeing what is a miraculous transformation as a vast swindle— these are no more than flights of fancy, or fantasies. Pablo generally took criticism lightly, though he never quite managed to remain indifferent to such risible or sarcastic remarks. They hit home, but he waded on regardless: such is the destiny of great men. Though he never dreamed of having been invested with a divine mission exactly, he was perfectly cognizant of his exceptional talent and felt duty-bound to use it.

His painting is at the same time a record of reality and a revelation of what an untrained eye fails to perceive. His friend and confidante of his final years, Hélène Parmelin, wrote pertinently: "His burning passion acquired such intensity, the truth of his painting persona manifested itself with such power, that you wanted to grab people by the scruff of the neck and to say to them: and you call this, 'the man who puts two fingers up to the world,' a 'phony,' a man all smoke and mirrors, a money grubber. A buffoon, even, a clown. He really suffered from all this, more than is commonly thought.

Because it appeared to him, as to any creative mind, that access to his work should be as natural as the work itself."[2]

Pablo embraced criticism when it served as an extension of his work or furthered public understanding. If not, he concluded philosophically, only time would tell. After all, on many occasions he had heard professors in the academy pour scorn on the Impressionists or Fauves. Yet he could never abide criticism when it limited itself to the surface or when it reproached him for veering off the beaten track.

He had lived through the xenophobic political atmosphere of World War I that had turned Cubists into "emigrants," dubbing their work an *art boche*, in the pay of the enemy. He had endured Nazi propaganda that lambasted "degenerate art"— indeed he had been its supreme incarnation. If criticism was like water off a duck's back, at least it spurred him on; in fact, at root, if all the critics had nodded in agreement, he would have probably been alarmed. "They have no idea what they're talking about!" his conclusion might have been. Yet he never let himself be browbeaten: through his work, he lived a single, unbroken passion, on an aesthetic as well as political level.

My grandfather's political vision was a precondition: a carefully considered act in response to a real situation. Whether this act was revolutionary or not, his commitment to it definitely possessed meaning: it entailed making decisions and acting purposefully. Paraphrasing the American dance director Bob Wilson, for whom everything is dance since every movement is a response to a choreography, for Picasso, everything is political, or nothing. Hence the crucial relevance of understanding the origins of his ideas, of his reactions and revolts, and of the paths he followed.

After early years spent "migrating" from Málaga to La Coruña, and from there to Barcelona, Pablo had already chosen his course while adolescent: in his father's footsteps, he was to be a painter. More especially, and thus unlike his father, he wanted to be an artist. Breezing through his entrance exams, he studied at the prestigious School of Fine Arts in Barcelona. Disconcerted and fascinated in equal measure by his son's staggering talent, his father rented him a studio on the Calle de la Plata close to the family apartment.

While still very young, Pablo already displayed his anticonformist character, his painting deriving more from his surroundings than from whatever he had learned at the academy. He gained little satisfaction from what was drummed into him at the academy: technique he had in abundance. At barely sixteen, he decided to leave for Madrid, alone.

2 Parmelin 1994.

His father had him registered at the Academy of San Fernando, but Pablo preferred to study, in situ, the masterpieces in the Prado, spending his leisure time in the less salubrious districts of the capital.

I have already had cause to mention Picasso's retreat to Horta de Ebro in the company of a friend from the academy, Manuel Pallarès. Thanks to this early initiation to humanity and solidarity, Pablo gained an awareness of the harshness of everyday life. He also now believed that one part of society enchains the other and that true happiness resides in a single word: freedom. He would frequent the one place ideas were freely expressed: the cafés. There the tendency was for anarchism—its daily provocations remained extremely dangerous in monarchist Spain, tight-laced and mightily averse to modernist deviance. It was there Pablo cut his teeth, acquiring dauntless courage in the process.

By the turn of the twentieth century, Barcelona was being industrialized and the young painter witnessed the birth of a substantial urban proletariat. He could also gauge for himself—in the victims hanging out in the dives of the Catalan capital—the chronic stagnation affecting Spain's agricultural sector.

The situation triggered frequent strikes and powerful social movements that were already revolutionary: anarchism fell on fertile ground—and was bloodily rooted out. Uttered in hushed tones, the republic was but a dream. Pablo had to put up with a king—or else, like so many others, go into exile. Meanwhile, joining in the discussions at the El Quatre Gats café, his political conscience was burgeoning.

At this time, he was following the left-wing trend advocated by his comrades radically opposed to the artistic circle of Sant Lluc that Patrick O'Brian has perceptively characterized as "the respectable haven of academic painters, good Catholics, patronized by the Church, state, and big business... Whereas at the Quatre Gats although plenty of mysticism was to be found, it was mostly of the cloudy, imported kind, pantheistic, wooly, scarcely of the native growth at all; and since there was also a strong anarchist element, downright atheism was sometimes added to the left-wing anti-clericalism—a striking contrast to a young man fresh from the age-old rural piety of Horta de Ebro."

Ideas jostled for position in his head, rendering the reactions he was pouring onto canvas still more tumultuous.

If Pablo accepted the tenets of anarchism, he was no less conscious of a reality that was sometimes a million miles away from the pipe dreams he heard aired in the bars. Detached from political action in the ordinary sense of the word, he realized that art too can be a powerful weapon. For O'Brian, he

"was increasingly conscious of the misery caused by the system and its injustice—the evidence lay all around him in Barcelona—and his awareness was increased by Nonell."[3]

The "system": that was the key to the problem. The system, together with its rules, spawned others—it was like an infection. And the antidote that would kill off the disease—art.

Isidre Nonell was a Catalan painter specializing in marginal characters (gypsies, beggars) who exerted considerable political sway over the young Pablo. Together, in 1900, they wrote for the journal *Pel y Ploma* set up by Miquel Utrillo, whose objective was to keep abreast of developments in painting and literature at the turn of the century. Taking as its starting point Paris's *La Plume*, this avant-garde review fought academicism at every turn, while informing its readers of trends in modern art. Picasso retained something of an academic technique, but he had jettisoned its emasculating attitudes and its absence of goal. The Academy was for him a perversion of the system. It *was* the system.

The discussions at El Quatre Gats colored Pablo's political standpoint. If he didn't read the writings of the philosophers himself, then he listened to others who had, and was soon impregnated with their ideas. This anarchism by osmosis, if I may call it that, was furthered by a dislike of any authority that imposed its ideas in the teeth of political reason, and by a wholesale rejection of all rules from the outside—as his work would progressively testify.

Another burning issue was Catalan independence. His friends preached contempt for bourgeois art for sure, but all this remained up in the air: words were soon to turn to action. Barcelona was not just a city in the throes of industrial expansion where social friction was endemic; it was also a focal point for new ideas in literature, philosophy, music, painting, architecture, and politics—the stage, perhaps, for a dress rehearsal before the great event.

The "Modernist" intellectuals of El Quatre Gats adopted the young protégé, so that, as Raymond Bachollet stressed: "For ten years, the city [was to] serve as a seedbed but also as a protective cocoon, as a kind of base camp from which he might sally forth on expeditions to Madrid and Paris and back, to which he might retreat in the event of any difficulty...."[4] It is in Paris, Picasso thought then, that everything happens, where the game is being played out. The French Revolution might be more than a hundred years ago—but at least this was a century ahead of Spain. In El Quatre Gats, those who visited Paris could speak with authority: for they had looked over the other side of the fence.

3 O'Brian 1976, p.70 (both quotations).
4 Raymond Bachollet, "Picasso à ses débuts," in Gosselin and Jouffroy 2000.

So Pablo left for the French capital on October 1900 in the company of two friends. According to Bachollet: "He was to discover Paris before the end of the Exposition Universelle in which one of his pictures hung from the rail of the Spanish pavilion." As one of Spain's "academy" contributions, he met up with the local Catalan community in Paris, including Casas, Utrillo, Fontbona, Isern, Pidelaserra, Junyent. He also brushed up against the "modern" art market and its new champions, such as the Catalan Manyac,[5] a useful middleman and translator, as well as Berthe Weill,[6] the latter's principal client.

Following this brief trip to Paris, Picasso returned to Barcelona to celebrate Christmas among his family. He then went off to settle in Madrid, nursing a plan to found a new review whose general appearance was inspired by *Pel y Ploma*: he called it *Arte Joven* ("Young Art").

Picasso had obviously grasped the effectiveness of the print media for rapidly circulating ideas and conveying his own vision of modernity. Bachollet informs us that "Francisco Soler was the literary director, and Picasso the art director of the new Madrid journal. The two friends intended to lay the foundations of an artistic revolution and to import 'Catalan modernism' into the somewhat backward-looking capital, but it proved an uphill struggle; initial enthusiasm soon flagged and the review ceased publication after its fifth number."[7]

The self-proclaimed goals of the review were "the renunciation of traditional models, abhorrence of the bourgeoisie, of its hypocrisy and of its love for things superficial; it advocated derision, 'popular' subjects, the portrayal of the wretched, the sordid, and the grotesque." Wide-reaching aims calculated to alienate the sympathy of precisely those middle-classes who were its only potential purchasers. Collaborators on *Arte Joven* included the writer Miguel de Unamuno, the poet Cornuti, the poet-cum-sculptor Alberto Lozano, the essayist Azorín (who invented the expression the "Generation of '98"),[8] and other forward-looking souls. According to Pierre Daix: "The review formed part of the desire for change of the aforementioned Generation of '98 follow-

5 Son of an industrial family from Barcelona, Manyac settled in Paris, serving as a contact for visiting Spaniards, including Picasso when he arrived. He was both intermediary and art dealer. It was he who first talked to the famous dealer Ambroise Vollard about Picasso and introduced him to Berthe Weill. He was also the first to sign an exclusive contract with Pablo, who once the agreement had been severed would be wary of ever again becoming embroiled in such a leonine arrangement.

6 Famous French art dealer of the first half of the twentieth century. At her very first meeting with Picasso, she bought *Le Moulin de la Galette*, through Manyac, that she was later to sell on for a respectable 250 francs (i.e. around $ 950 today). Later she was to find it harder to get rid of the Blue Period works "taken on" by Manyac.

7 Raymond Bachollet, "Picasso à ses débuts," in Gosselin and Jouffroy 2000.

8 Generation of Spanish intellectuals marked by the defeat of their country in the war against the United States.

ing the political and social shock of the defeat of Spain in its war against the United States, adding a dose of fascination with anarchism. It was an attempt to throw a bridge between this generation and Catalan modernism." [9]

So Pablo's ambition was to liberate Catalonia—little did he know that he was to liberate the world.

In these formative years, he was building the dialectic of a man of the Left, which was to determine his political course forever. Filled with an idealism typical for a young man who wanted to change the world, he edged towards realism so as to reconstruct this world through art.

Some have mistakenly simplified his political evolution by asserting that he was "won over" by Communist ideas at the end of World War II. His prior intellectual progress proves, however, that, if Communist tenets were closest to his political ideals, they were not their precondition.

Once back in Paris in April 1904, Pablo experienced the worst material difficulties of his entire life. Logically enough, this suffering is reflected in the Blue Period pictures, which beyond their subject matter, are a faithful depiction of daily life. He did not only see the poverty of the people; he lived it. Subsequently, the brighter "Rose Period" also kept faith with the simplicity of ordinary folk.

In the evening, everything is beautiful in a glittering Paris; but Pablo awakes to find everything drab. His friend poet Max Jacob describes this harum-scarum life: "On his arrival in Paris, he lived the turbulent existence of an apprentice. He went to the Moulin-Rouge, the Casino de Paris, and other fashionable variety venues. He also knew the dames à la mode: Liane Pougy, Otero, Jeanne Bloc, and painted true-to-life portraits of them. There was also the Médrano circus in Montmartre and the Commedia dell'Arte, the inspiration behind a number of paintings on the theme of tumblers and harlequins..."[10]

At this juncture too, a far cry from the norms of "good behavior" that Pablo was always to consider ironically and to defy, erotic art raised its head, inspired as much by fantasy as experience.

Together with one of his first serious companions, Fernande Olivier, Pablo became a figure on the Parisian art scene, where he soon met collectors and flirted with the avant-garde. He took himself off to Le Lapin Agile and bars in Montmartre, forging friendships with Guillaume Apollinaire, André Salmon, Juan Gris, Marie Laurencin, and Léo Stein.

9 Daix 1995.
10 Jacob 1927.

This hotbed of talent, where you felt part of a happy band, and yet still had the latitude to assert your individuality, offered a "human" response to Picasso's concerns. Amidst this welter of influences, whose only common denominator was freedom, he could create a consciousness of his own.

Léo's sister Gertrude Stein introduced him to Matisse, an encounter that proved crucial to both artists. Their relationship was to be a mix of cat and mouse games, competitiveness, and the urge to stress their differences. Pablo would chat openly to anyone but he had to remain master of the field. It is patently obvious that through this heady brew of intimate exchange and indifference—an indifference that was sometimes baffling—he imposed himself on his entourage: he would shift from one friend to the other casually but not spitefully.

Political combat was certainly not a priority at this time. There were enough worries in everyday life, eating, sleeping, painting—surviving, physically and morally.

Montmartre was packed with "Cubists-to-be," all waiting for someone to light the blue touch-paper: Derain, Braque, Gleizes, Herbin, Le Fauconnier, Léger, Metzinger, Picabia, Gris, Delaunay.

Was there ever such a melting-pot of intellect and talent? And has there ever been a more far-reaching revolution in thought since then? Artistic ideas were impacting on society, freeing it from the "bourgeois" straitjacket. I can see no one else as capable of sparking awareness, of relaxing inhibitions as Picasso—except for Freud, who came later.

Pablo was beginning to earn a living. One cannot really even dare to call it "better living," so hard it is today to picture the difficulties of daily life at that time. The odd photographs of the Bateau-Lavoir look quaint enough, but such a picturesque lifestyle entails cold and hunger. Cobbled together from whatever came to hand, the Bateau-Lavoir is simply a reflection of the precariousness of life at the time. However, together, the artists could believe in it, each in his own way. And hope is the first form of courage.

At the height of his success, my grandfather remained a simple man, a man of the community. Even when extremely rich, he was a man of the people and for the people, living in a spirit of togetherness. What he saw in Communism was its ostensible commitment to making the people happy, and Pablo, like so many others, believed in it.

His "gentrification," such as it was, was only ever skin deep. By the onset of the 1910s, he could already buy the bare necessities and a little more besides. But he lent a deaf ear to the sirens of the bourgeoisie. From a very early stage, Picasso imposed his own working methods on his dealers. He could hardly bear to be separated from a canvas, yet if he had to knuckle down to earn his keep, he would do so on his own terms: very soon, he was

selling not what he could but what he wanted to and, in a total reversal of the accepted rules, fixing the lowest price himself.

Pablo did not, however, abandon his anarchist ideals. Just as he had backed the people of Cuba in their struggle to free themselves from Spanish oppression,[11] he took part in a demonstration in 1909 in favor of Francisco Ferrer, "Spanish revolutionary and ardent defender of secular values shot following a show trial."[12] For Pablo, to protest against Ferrer's execution was symbolic of his struggle against "black Spain."

In 1912, he began to frequent the Café de l'Ermitage, on boulevard Rochechouart very close to a new studio, where he met his future partner Éva Gouel and soon found himself swept up in the Futurist movement. This group of Italian writers and painters who had been advocating revolution in art since 1909 seemed an attractive prospect. Yet the claims of futurism were entirely artistic, not political; for Pablo, Futurism was a stylistic device and he did not share in its convictions.

Being Spanish, my grandfather took no part in the War of 1914 in which Spain was neutral. He looked on as his French friends set off full of heroism and hope.

Some were never to return and others (like Apollinaire who had to be trepanned) were seriously wounded. Wandering through a deserted Paris far from the futile bloodletting at the Front, Pablo would have felt totally at sea.

The exceptional TV documentary *Treize journées dans la vie de Pablo Picasso* features an interview dating from the 1960s with Daniel-Henry Kahnweiler, who since 1907 had been Pablo's "historic" dealer.[13] Recalling World War I, he states that the Cubists had asked ground-breaking questions "by not doing anything"—something he sees as an act of resistance. Continuing to create was a way of spurning the enemy. Between 1914 and 1918, painters no longer exhibited at official Salons and dealers could no longer sell. As he was an immigrant of German extraction, Kahnweiler's own gallery was sequestered, and the lion's share of the collection disposed at rock-bottom prices, so sabotaging the reputation of these modern painters who were surely, be it only "by default," hand in glove with the Germans.

Lost in a Paris that was witnessing the arrival of the first wounded men from the front, Pablo watched on helplessly as Éva died. At this time, Cocteau proposed that he join him working on Diaghilev's ballets. He was

11 He signed a declaration from the Spanish colony in Paris in 1901 in support of anarchists imprisoned for opposing the 1889 war against the Cubans.
12 Gérard Gosselin, "Picasso: La Politique et la presse," in Gosselin and Jouffroy 2002.
13 See Bibliography.

also to meet Olga Khokhlova, a "White Russian" émigré with no political ax to grind, simply a desire to make it in "high society," if not in Moscow or St. Petersburg, then in Paris.

In a sense, for Pablo, the idea of short-changing a world inaccessible to her, of gnawing away at "polite society" from the inside, was revolutionary too. Still, one has to know how to pull the strings—this is where Olga's background came in; and then one has to last the course—and Pablo could provide the means to do so.

He thus placed his talents in the service of his future wife's cause. Somewhat cannily, with help from his new dealers, Rosenberg and Wildenstein, who knew all the right people, he began peddling a relatively loose Neoclassicism. Form and content fused. But the political animal in Picasso only ever slept fitfully: under the veneer of a dutiful, middle-class existence, the artistic rebel, the matador of pacifist ideals in a topsy-turvy world, was about to stir. Though for a time Olga might have made him less in touch with his social conscience, he was soon ready to return to the fray.

As 1925 dawned, he wavered between the intellectual awakening of the militant and the artistic audacity of an adulterous lover. He did not take long to opt for both paths.

His new friends included the Surrealists with André Breton at their head. The poet of *Clair de terre* was a stimulating conversationalist and a spiritual guide, while Surrealism, as Patrick O'Brian rightly describes it, was an "anarchist, turbulent, youthful, sanguine, iconoclast state of mind that matched Picasso's."[14]

Throughout his political life, in Barcelona, in Madrid, in Paris, where he rubbed shoulders with the Cubists, the Futurists, and eventually the Surrealists, Pablo always wanted to believe in an ideal. Though he hardly ever acknowledged it, this desire to belong to a group, to join an artistic-cum-political community, undoubtedly reflected a need to (re-)create family life. The eternal outsider liked to feel others around him, ready to detach himself from them as soon as he needed to move on.

As Gérard Gosselin brought out, "international events in the 1930s, in Spain, then throughout Europe, left a deep scar on Picasso."[15] Pablo the pacifist, the man of the Left, could not bear to see Spain fall into fascist hands. In 1932, he signed the "protest against Aragon's conviction for incitement to murder for reasons of anarchist propaganda" following the publication of *Front Rouge*. In "April 1935, as attested in a letter to the editors of the

14 O'Brian 1976, p. 268.
15 "Picasso: La Politique et la presse," in Gosselin and Jouffroy 2002.

newspaper *Le Monde* by Henri Barbusse, he sent a telegram to Hitler asking him to spare the lives of Albert Kayser and Rudolf Klauss, two German anti-Fascists condemned to death." And yet, Gosselin continues, Picasso lived for his art and "the circles he moved in were primarily intellectual and artistic, concerned with literature, painting, sculpture, music, and dance: he was above all bound up in his own pictorial research...."

Day to day, Pablo and his contemporaries lived through events that with hindsight we can see more clearly. At the time it was hard for them to distinguish propaganda from reality as unbiased information was hard to come by. Pablo's political idealism confronted chillingly ruthless forces, whose weapons were to include unparalleled acts of violence.

Sparked by General Franco in summer 1936, the Spanish Civil War led Pablo to adopt a clearer position than ever before. His nomination as Director of the Prado on September 19, 1936, was proof positive of the Spanish Republicans' interest in his work and its impact. Picasso served as an intermediary. Of course, this too was a maneuver, the full import of which escaped Pablo—just as he had little inkling of his own importance generally: intellectuals and artists were also weapons, pawns in the political debate.

Picasso, though, reacted instinctively to events in Spain. Gosselin presents a vivid description of his action as tension mounted: "Honorary President of the Franco-Spanish Committee, he came to the assistance of the Spanish Republicans, by signing petitions, launching appeals, paying subscriptions, and selling works for their benefit. Photographs of the conflict, in particular those Robert Capa published in *L'Humanité*, *Ce soir*, *Vu*, or *Regards*, the accounts of bombardments of civilians and the atrocities meted out by Franco's partisans, all influenced his creation."[16] Aided and abetted by Dora Maar, Pablo put his weight behind the opposition.

Without realizing the material danger this placed him in, he published *Sueno y mentira de Franco*, a kind of comic strip recounting the tragic events in favor of a Spanish Republic.

"Franco's Dream and Lies" is a Surrealist poem illustrated with etchings depicting the horrors of the war—slaughtered women, houses in flames, and a monstrous form that surely represents Franco. As O'Brian describes: "The sequence is not clear, but sequence is not necessary: the whole set of prints and their integrated poem express the hideous chaos, unreason, and meaningless cruelty of war, and Picasso's utter rejection and loathing not only of war but of right-wing values."[17] This was his most explicit denunciation of the horrific events in Spain and, as he was to declare to Georges

16 Ibid.
17 O'Brian 1976, p. 318.

Sadoul, he had been "more than willing"[18] to execute this album for the Spanish people. And yet when Kahnweiler refers to Picasso's political opinions in his *Entretiens* he recalls the painter proclaiming loud and clear: "I am a royalist. In Spain, there is a king, I am a royalist."[19] For his dealer, Picasso was the most apolitical man he had ever encountered. "He had never thought about politics in any way, but Franco's uprising was to lift the scales from his eyes and turn him into a defender of peace and freedom."

My grandfather, a "royalist"? I asked Pierre Daix, who assured me that Pablo always answered idiotic questions in this manner. In the same fashion, when someone asked him about ethnic art, he would retort cursorily: "No idea!" For Daix, "it was all rather dramatic, but it was his way of cutting things short. However, people noted such remarks; but they didn't understand that was just to bring the discussion to a close." Pablo adopted this strategy essentially to avoid wasting time. For my grandfather was no daydreamer—he acted.

In spite of the caution that in theory his position as an immigrant in Paris should have imposed upon him, Pablo took the side of the oppressed in Spain. In the course of my research, I have uncovered evidence of many payments to the National Committee of Assistance to Spain, particularly at the end of 1938, with a gift of 100,000 francs (i.e. about $53,000 in today's money) in November and 300,000 francs (approximately $156,000) at the beginning of 1939. To this one must add the setting up of two children's aid centers in Barcelona and Madrid initiated by Pablo with more than 200,000 francs (around $105,000).

To me, it seems important to stress these figures: to accumulate such sums, my grandfather, who found it so painful to part with his creations, went out of his way to sell works. This was real commitment for which he had to work and sacrifice. Just for the record, Patrick O'Brian adds: "Then as the refugees poured into France many of them turned to him, and I have not heard of a single case where they wrote or called in vain."[20]

Later, much later, he donated pictures to some of those who had come to the assistance of the Republicans: in 1940, to the Ducuing hospital in Toulouse, which had housed many refugees; in 1971, a splendid work from the "Blue Period" (*La Jeune Morte à l'hôpital [Head of a Dead Woman]*, 1902) was given to the foundation in memory of a friend of his when he was younger, the doctor Jacint Reventós, an eminent tuberculosis specialist, who had done much during the Civil War in Barcelona.

18 *Magazine Regards,* no. 187, July 29, 1937, interview with Georges Sadoul.
19 Kahnweiler 1971.
20 O'Brian 1976, p. 338.

Pablo was apolitical in the sense that at that time he belonged to no party and had no desire to get involved in infighting. From then on, he became a humanist, a militant for Republican Spain. Moreover, the choices he made from 1936 to 1938 were motivated as much by psychological factors as by political events: it should be recalled that his mother, sister, brother-in-law, niece, and nephews were still living on the Peninsula. Pablo found himself trapped between rebellion and personal concern: he had to proceed carefully.

Once again, it was a woman who galvanized him: Dora Maar.

Their affair was also a "militant" liaison. Politics were hard to avoid, and ideas flew back and forth between them. Engagement was the watchword: Right, Left, xenophobia on both sides, while Communism in the East stared at Fascism in the West.

When news came of the brutal bombing of the small Basque town of Guernica, on April 26, 1937, Dora was at Pablo's side. Shocked by the tragedy, together they held firm.

With "editorial" support from Dora, he countered those spreading the rumor that he was a reactionary artist, committed to the Right: "The war in Spain is a battle of reactionary forces against the people, against freedom. All my life as an artist has been a continual struggle against reaction and the death of art. In the painting that I am working on, which I will call *Guernica*, I proclaim my horror of the military caste that has dragged Spain into an abyss of pain and death."

This was the act that lay the foundations for a political attitude that was to affirm itself more and more. *Guernica* was presented in the Spanish pavilion at the Exposition Universelle in Paris on July 12, 1937 (next to a large-size and extremely distorted sculpture, *Head of Marie-Thérèse*). The exhibition had opened on May 24, with the German and Soviet pavilions squaring up to each other and curiously similar in their "monumentality" and military severity. *Guernica* provided a marked contrast, though paradoxically its impact was tempered: incredibly, the Spanish Republicans criticized its lack of "populist realism"!

The picture was later to be shown in Sweden (1938), London, Manchester (1939), and at the Valentine Gallery, New York, in May 1939, before joining the great retrospective at the Museum of Modern Art, where, at Pablo's own request, it was subsequently deposited.[21]

Simultaneously, international events were coming to a head. In March 1938, Austria was annexed by Germany. France sat on her hands. Málaga

21 A number of pieces remained in the museum until 1954, while *Guernica* stayed there until 1982.

was besieged and Barcelona, bombarded by Germans and Italians, finally fell into pro-Franco hands in January 1939. That was followed in March by Madrid. At the same time Hitler marched into Prague.

Pablo was torn between his French reason—he had been living in France for some forty years—and his Spanish heart. But, in the hurricane that was sweeping through Europe, what did geography matter? The important thing was for voices to be raised. His included. Patrick O'Brian noted that Picasso was reproached in *Guernica* for turning painting into agitprop, since propaganda can never be art, art can have nothing to do with politics or with morality.[22] In company with the biographer, my opinion is that this is propagandist criticism responding to (alleged) artistic propaganda. Art frightens people.

All communication may be propaganda. The talent of Nazi Germany in this area is unquestionable. In Picasso's case, even if the initial reflex had been proselytism, the humanist gained the upper hand over the political animal: still more than a republican militant, he was a militant for peace. As O'Brian avers: "In view of Picasso's own words it is impossible to deny that propaganda was intended: in his first fury he may well have meant as direct an attack on the fascists as he had already made on Franco, but in the course of his painting he sublimated all particularity and all reference to immediate events."

Antonina Vallentin recalls my grandfather remarking to the effect that "artists who live and work with spiritual values cannot, should not, remain indifferent before a conflict in which the stakes are the supreme values of humanity and civilization."[23] The bombing of Guernica was like an electric shock, a "Massacre of the Innocents" for our time. In what was an appropriate answer under the circumstances, the proclamation of his pacifist convictions took the shape of a manifesto in paint against the Franquists and their allies.

Dora was at the same time a witness of and an actor in *Guernica*. Witness, because she took many photographs of various stages in its development, between May 1 and the end of June, after Pablo had carried out more than forty preparatory drawings. She also assisted actively in its creation. A powerful intellect, she gave succor to Pablo's political statement, just as he, in his desire to accomplish his mission, had become almost hysterically reclusive.

Her reportage, now conserved with the work itself and its preliminary studies in the Centro Cultural de la Reina Sofia, Madrid, is an invaluable source of information on the work's genesis and creative process. It is at one and the same time a turning-point in the history of art, and a vivid record of a new and original way of thinking.

22 O'Brian 1976, p. 328.
23 Marina Picasso and Vallentin 2001.

My mother Maya recalls Pablo and Marie-Thérèse's conversations during that period. At the time of the visits she made to rue des Grands-Augustins, Maya, recognizing the profile of her mother in the portraits she saw every day in the studio in the house at Tremblay-sur-Mauldre where they lived, exclaimed, "Maman, Maman...." One day she even put her tiny hands on *Guernica*'s wet paint—a trace of childish innocence on a brutal epic.

The conflict in Spain served as a dress rehearsal for World War II. They were times that called for defiance or submission. Pierre Daix one day confided that Pablo was to forgive those, who like Jean Cocteau, had "hung about" with the Germans; but never those of his friends who had actively collaborated with the Franquists, André Salmon and Max Jacob, for instance. Daix recounted that the latter, who had penned some very ambivalent poems, "was given the dressing-down of a lifetime by [my] grandfather, and he never forgave Salmon or Dalí either. To people who'd sided with Franco, no quarter was given!"

In March 1939, Pablo signed a petition together with Jean Cassou, Louis Aragon, José Bergamín, and Georges Bloch to save some Spanish intellectuals being held in a French camp at Saint-Cyprien. After the fall of Barcelona, Picasso's nephews, who had fought on the Republican side, fled Spain to shelter under their uncle's wing. He took them in, together with a great number of Spanish refugees.

In September 1939, Pablo left for Royan to meet up with Marie-Thérèse and their young daughter: it was there too that he installed Dora. In a manner of speaking, he was organizing a war cabinet. With Marie-Thérèse and Maya, he experienced the anxieties of the conflict; with Dora, he was to experience the Resistance.

Doña María had passed away in Barcelona the previous January aged eighty-three. In spite of unwavering attachment to his mother, Pablo had not gone to her funeral since, at around the same time, the city fell into the hands of the pro-Franco faction. He had irrevocably decided that he would never again set foot in Spain as long as Franco remained in power. Faithful to his word, he was never to return to his native land since he died two years before the Caudillo.

My grandfather was obsessed by what he called "black Spain," the Spain of priests, backward Spain. He said one day to Daix: "Cézanne would have been burnt at the stake in Spain." If Franco had died before him, perhaps he would have gone back, because, in spite of everything, he felt Spanish to the tips of his fingers. As my uncle Claude, his second son, affirmed: "With his passion for the corridas at Arles, Nîmes, and Vallauris,

and with all the Spanish influence in his post-war work, he had recovered his *hispanidad* this side of the Pyrenees!"[24] According to Daix: "For him there were always two Spains: the Spain he loved, his Spain, that of his friends, of Alberti[25] and all the others; then there was 'black Spain,' the Spain of the landowners, of the Church." Pablo loved his homeland deeply and testified throughout his life to a profound solidarity with its people. This, I defy anyone to contest.

The huge retrospective at the Museum of Modern Art, New York, which was later to tour many major American cities, brought my grandfather international acclaim. America found in Picasso an energy and a freedom that echoed its quintessential values. His political commitment was to become as well-known as the aesthetic revolution he had spearheaded. In a sense, the one explains the other, a fact his admirers could readily decode. Invitations to Picasso from the other side of the Atlantic, from Mexico and Argentina, as well as the United States, now poured in.

In spite of the many inducements to flee abroad, Pablo lingered on in drab Occupied Paris, in the small apartment next to the studio on rue des Grands-Augustins. In the overwhelming climate of insecurity and shortages, he went back to work, turning in particular to sculpture, though there was a frustrating dearth of raw materials: clay, plaster, a *fortiori* bronze. A few months earlier, he had run into Matisse who was thinking of setting off for Brazil, finding time for a witticism on those responsible for the defeat of 1940: "Our Generals, they're the School of Fine Arts!"

The two painters chatted about the general situation. In fact, Matisse, determined or inspired, stayed on in France, at Vence in the department of the Alpes-Maritimes.

A prudent Spain kept out of the European conflict, its neutrality logically making it the ally of the Nazis. Pablo thus emerged as the most visible and most awkward of all Franco's opponents. Worse, the owner of the Grands-Augustins apartment was a Jew, by the name of Lipchitz. This constituted a splendid pretext for the Gestapo regularly to come and interrogate Picasso on his lessor, living supposedly in the United States.

24 Claude Picasso interviewed in the television documentary (reiussed on DVD) *Treize journées dans la vie de Pablo Picasso*.

25 Rafael Alberti, Spanish poet and painter. According to Pierre Daix (*Dictionnaire Picasso*, op. cit.), "his relations with Picasso began in 1936.... Together with Federico García Lorca and José Bergamín, [he] embodied new Spanish poetry's homage to Picasso. Joining the Republican side in the Civil War, after its defeat he went into exile, settling in Paris in 1939, where his ties with Picasso became still closer. After a sojourn in Argentina, after the War he returned to live in Rome. He once again entered Picasso's orbit, becoming a close friend and dedicating numerous books to him. He wrote prefaces to the albums shown at the exhibitions in Avignon in 1970 and 1973."

Pablo's papers, though, were always in order. Legally speaking, he had nothing to fear—except that the collaborationist Vichy administration might suddenly, "at its discretion," decide to repatriate him to Spain. Indeed he was haunted by the idea of being frog-marched to the border. And as I have mentioned, since the Barcelona episode, where he had rubbed shoulders with anarchists, he had a police record alleging that he had been an anarchist himself from 1901 to 1905.

The file was confiscated by the Germans during the war (it was later purloined from the Germans by the Russians). When, in April 1940, Pablo made moves to have himself naturalized as a French citizen, it provided sufficient reason for the authorities to reject the application.

The only possibility was then to become French, for which Pablo would have to divorce Olga, and tie the knot with Marie-Thérèse. The naturalization procedure was also symptomatic of political commitment. As a Spaniard, he would remain on the margins of the conflict though a national of a State basically friendly to Nazi Germany; by becoming French, a "decadent" and subversive French painter at that, he ran greater risk of being handed over to the Germans. In my opinion, this attitude stemmed as much from despair at being Spanish under Franco as from a desire to stand up and be counted. But France, after welcoming him, never issued him naturalization papers, making it easier to keep tabs on him.

During the final days at Royan, a painter asked him: "What are we going to do with the Germans at our backs?" "Exhibitions!" my grandfather retorted.

In fact, compromised as he was in German eyes, he was expressly forbidden to exhibit in Paris. He hid most of his pictures in two vaults at the BNCI (National Bank for Trade and Industry, later the BNP, Banque Nationale de Paris) in the boulevard des Italiens in Paris, where Matisse had a strong room next to his. Thanks to some subtle sleight of hand, Pablo managed to hoodwink the German officers posted at the vault: he would move his works into Matisse's store and vice versa, so, whenever checks occurred, each appeared to contain mere trifles—bits and pieces, "degenerate" pictures to which the Germans attached scant importance.

Frozen to the bone, true to himself, and deprived of materials, Pablo nonetheless kept his head held high: "This was no moment for an artist to falter, to retreat, to cease working," he was to say later. The only thing left was to set about things in earnest, to struggle for food and fuel, meet up quietly with friends—and await freedom. My grandfather embarked on a program of organized artistic resistance that was necessarily contradictory for a Spanish citizen, but which redounds to his honor. He had already left one homeland and did not want to desert France in her hour of need.

Matisse summarized their common attitude: "What would become of France if she lost her most valuable assets...?"

Pablo was both free and captive. Under surveillance by the French police, he was an émigré muzzled by his duty to keep clear of trouble. He had no dealings with Germans or Petainists, but he had to watch his step as the authorities were always on the lookout for the slightest pretext to expel him back over the Pyrenees: forced to sit it out, he remained *engagé*. All too well aware of the blackmailing techniques employed by the Gestapo and the French militia, he had to protect both "families" counting on him—Olga and Paulo, as well as Marie-Thérèse and Maya. He could not possibly expose them to danger—or even to risk.

He thus devoted himself body and soul to the only means left of fighting the oppressor—work, so as to leave a record in the shape of emaciated women, still lifes of wretched meals, carved skulls. *Still Life with Steer Skull* and the daring *Aubade* (an elegiac work by Titian transposed into the Nazi prison system) in 1942, *Tête de Mort, The Jug*, and the celebrated *Man with a Lamb* (also known as *Man with a Sheep*) the following year. Art is a weapon of resistance. His works during the Occupation reflect everyday life, harsh and morbid; they bear witness to a reality from which he could not break free.

Renewing his identity papers as an alien in November 1942, the Vichy Government made him sign a declaration to the effect that he was not Jewish. The very next month, Hitler ordered the arrest and deportation of all Jews and other "enemies"—Communists, Freemasons, and Romany: the "Aryanizing" of the Reich was now well and truly underway. Max Jacob was deported to Drancy, where he was to die in 1944; Kahnweiler, hunted by the Gestapo, hid in the Zone Libre. In *Picasso and the War Years, 1937–1945*,[26] mention is made of a letter sent to my grandfather in autumn 1943 by the authorities (the German Employment Exchange). It contains an order to present himself for a medical with a view to being sent to Essen for labor in the "Compulsory Work Service." The German administration had found a loophole to get rid of Picasso, now sixty-two-years-old, yet considered "fit". History does not record the miracle that enabled him to slip through the net —probably the intervention of the German sculptor Breker, whom the Nazis idolized.

The occupying authorities, however, never missed an opportunity to "drop in." As Pierre Daix recounts: "In January 1943, alerted by Dora Maar that the Gestapo were in his house, [Picasso] went to rue des Grands-

26 Nash and Rosenblum 1999.

Augustins just as the Germans were leaving. 'They insulted me,' Picasso recounted, 'they called me a degenerate, a Communist, a Jew. They kicked my canvases.'"[27] Pablo was perhaps sheltered from financial worries during the War, but he was still walking on thin ice.

More than once, the former assistant chief commissioner of the police force, the Sûreté Nationale, André-Louis Dubois, had to extricate him from one of the administrative entanglements that beset foreigners. He was thus able to renew his *carte d'étranger* giving him leave to stay in France without having to apply personally at the Spanish embassy. In his memoirs, Dubois tells how Picasso remained neither indifferent nor inactive faced with the menace: "'They [the fascists] have given us a dose of the pox,'" Pablo spat. "'And there are a lot who've caught it without even knowing. They'll soon get wind of it! And the poor, all these poor people! They're to be served up as victims, perhaps? Well, they won't take it lying down. They'll fight back. There'll be strikes and with all this going on you want me to stand on the balcony like it's show time? No, that's impossible. I'll be with them in the streets....'"[28]

And indeed he was, for the Liberation of Paris, when, on August 25, 1944, General Leclerc's troops paraded into the capital. Pablo was with my grandmother Marie-Thérèse on boulevard Henri-IV. As soon as clashes broke out in the city, he left Saint-Germain-des-Prés and went to the Île Saint-Louis in spite of a constant threat from snipers. Maya, then just nine, remembers those turbulent days well, and told me the story with emotion. "During the Liberation of Paris, we had the dubious pleasure of 'rooftop gunmen.' Delightful—the barricades at street-level stopping the Germans going left or right also prevented us all from getting across the road quickly. The sharpshooters on the housetops could be FFI (French Forces of the Interior), or more generally, German snipers, who, caught like rats in a trap, were fighting their last stand and would fire on anything that moved. We were therefore forbidden from leaving the house even to go and get bread [and] were all cooped up in the house—or rather flat on our stomachs in the corridor. I was a little girl and there was a park in front of the house where I normally spent the school break time immediately behind our building. I would have really liked to go and play ball, but papa didn't want me to venture out. Papa 'imprisoned' me in his workshop, saying: 'You're going to work, just like me, you're going to do still lifes!'"

My mother recalls them "doing art" together: "As watercolor takes a bit of time to dry, all round the living-room papa had put up a system with nails

27 Daix 1995.
28 André Louis Dubois, *Sous le signe de l'amitié*, Paris: Plon, 1972.

and string, and we hung up our works next to one another with clothes pegs."

They also cut out paper chains that, once the shootings had ceased, they hung over the balcony of the apartment to greet the liberating soldiers. Pablo and Marie-Thérèse took snapshots of the historic day: "Pablo and Maya can be seen in cahoots and blissfully happy—just as all Paris was that day."

It was astonishing how many American soldiers were absolutely determined to meet Picasso. For, on the other side of the Atlantic, he had become a symbol. Some found out his address on boulevard Henri-IV. "When the Americans arrived," my mother told me, whose memories of the great event remained fresh, "they started by photographing Picasso's most recent work. A big picture depicting me in my little red and white apron was placed on a Spanish chair next to an American helmet [it was the picture that had pride of place in my childhood dining-room in Marseille]. The Americans found the set-up superb: the American helmet on the chair and, behind it, Picasso's painting. As they wanted to take more photographs, they photographed more or less every work hanging side by side in the living-room on the length of twine.... The worst of it was that papa and I had mixed our works up when we put them up to dry: papa, Maya, papa, papa, Maya.... They photographed away without asking, and sent the shots to the States where the newspapers published them as new works by Picasso.... Back home we almost died of laughter because they had taken photographs of my stuff, ascribing it to Picasso!"

O'Brian adds: "The Liberation filled the whole of France with joy, and Picasso was as happy as any of his friends; yet for him it was the beginning of imprisonment within his own myth and of banishment from ordinary society, a sentence that he was to serve for the rest of his life."[29]

Fame was getting out of control: "Picasso" was bigger than "Pablo". Meeting him in 1943, Françoise Gilot experienced Picasso's new-found glory at first hand, since this new partner was soon in the public eye. For her, "at a stroke, Picasso became 'the man of the moment.' The weeks following the Liberation, one could hardly walk across the studio floor without stumbling over the prone body of some young GI. They all went to see Picasso but were so tired they hardly managed to make it to the studio before collapsing with exhaustion. One day I counted about twenty of them dozing about the atelier. In the beginning, it had mostly been young writers, artists, and intellectuals: later, they were tourists. Top of their list, like the Eiffel Tower, they had to see Picasso's studio."[30]

29 O'Brian 1976, p.371.
30 Gilot and Lahe 1964.

My grandfather soon received a request from the Communists to join the Party. After all, the end of the War had been hastened by the Soviets and their rout of the Nazis in Eastern Europe, and Communism was doing well in the early days of the Liberation thanks to an energetic policy of pacifist propaganda. The collectivist experiment, it was rumored, was bringing joy to the people. A good number of Pablo's friends, former Resisters for the most part, soon joined up, and a whiff of nostalgia for the Popular Front of 1936 was in the air.

Picasso too turned to the Communists, since they embodied ideals he had always defended: freedom, equality, solidarity. "I came to the Communist Party as one goes to a well," he remarked. He officially joined the French Communist Party (PCF) on October 4, 1944.[31] Marcel Cachin, editor-in-chief of the Communist newspaper *L'Humanité*, and Jacques Duclos, Secretary of the Communist Party, notably were delighted with their new recruit. At this time Aragon, Éluard, Fougeron, and Camus were all members of the PCF.

In a way, Pablo was joining a new intellectual family. *Picasso et la presse: Un peintre dans l'histoire*, states that "*L'Humanité* devoted half of the front page to Picasso joining the Communist Party with several photographs and texts."[32] On October 6, the newspaper *Ce Soir* reproduced a declaration by Picasso: "We have just interviewed Pablo Picasso on his reasons for joining the party of those who had been shot down. This is his answer: 'During the days of the Liberation, I was on my balcony as the bullets flew. There were men firing from the rooftops, there were others firing from the street. And, as I didn't want to be in the middle, I made up my mind.'"

L'Humanité of October 21, 1944, also published a long interview with Pablo on his decision to enter the lists. He was by then a recognized artist, present in the great museums of the world (though not in France), particularly feted and appreciated in the United States—this last point on its own being a massive propaganda coup for Soviet Communism.

Pablo remained a lifelong member of the PCF, receiving his membership card every year, militating in many different ways; joining demonstrations and congresses, giving donations, making posters and scarves or drawings for the Communist press, appealing for the release of political prisoners. He was very much one of the Party's "fellow travelers."

31 It was at the congress at Tours (December 25–31, 1920) that, following its succession from the Socialist Party, the French Section of the Communist International (SFIC) was founded. Two years later it became the PCF.
32 Gosselin and Jouffroy 2002.

A Picasso retrospective, comprising 79 works produced during the War years,[33] was held at the Salon d'Automne, also called the Salon de la Libération as it was devoted to "degenerate" work banned by the Nazis. This exhibition occasioned violent protests, aimed at once at Picasso's work and his professed political opinions, with young Nationalists spraying paint on his pictures.

It was also the first public appearance in France of the numerous "destructured" works inspired by Marie-Thérèse. "Many people," O'Brian reports, "were astonished at his joining them [the Communists]—the gesture was entirely against his best interests as they were seen by the dealers, since it was obvious that some American collectors at least would stop buying works by a Communist—and very soon he was asked why he had become a member. He replied in an interview conducted by Pol Gaillard for *New Masses* of New York that was also published in *L'Humanité*...: I should much rather answer with a picture for I am not a writer; but since sending you my colors by wire is far from easy, I shall try to tell you in words. My joining the Communist Party is the logical outcome of my whole life and of the whole body of my work. For I am proud to say that I have never looked upon painting as an art intended for mere pleasure or amusement: since line and color are my weapons, I have used them in my attempt at gaining a continually greater understanding of the world and of mankind, so that this understanding might give us all a continually greater freedom. In my own way I have tried to recount what seems to me the truest, the most exact, the best, and, naturally, as the greatest artists know very well, this is invariably the most beautiful too. Yes, I do feel that by my painting I always fought as a true revolutionary. But now I have come to see that even that is not enough; these years of terrible oppression have shown me that I have to fight not only with my art but with my whole being. So I joined the Communists without the slightest hesitation, because fundamentally I had been in the Party from the very start... I am among my brothers once again."[34]

Following the War, many intellectuals saw the Communists as defenders of freedom (the majority had been active in the Resistance during the Occupation) and as the incarnation of the leftist ideals Picasso had always staunchly supported. By joining its ranks, my grandfather undoubtedly had the feeling—illusory and transitory—of escaping from his position as a perpetual outsider, of belonging to a larger body, a group, just as years ago when

33 The exhibition included 74 paintings, including numerous unknown portraits of Marie-Thérèse and Dora Maar, as well as five sculptures.
34 O'Brian 1976, pp. 374–75.

debating with his friends at El Quatre Gats. He was well aware that his personality, his oeuvre, his fame conspired to isolate him physically and psychologically. And there was the then widespread utopian dream of a new world order, which would see people freed from state borders. Communism was a form of Esperanto.

Be that as it may, at the Liberation, he was to receive support from the National Committee of Writers, and from a considerable number of intellectuals who understood his essential humanism. At the end of 1944, he was named President of the Committee of the Friends of Spain, an umbrella group of Spanish refugees and anti-Franco activists.

He often returned to the enthusiastic declaration he made on joining the Party, retouching it slightly for fear of seeing it exploited. According to O'Brian, Picasso himself proposed a simple and convincing explanation: "'You see I am not French but Spanish,' he said. 'I am against Franco. The only way I could make it known was by joining the Communist Party, thus proving I belonged to the other side.'"[35]

On the artistic front, as Gérard Gosselin emphasized: "He would show his creative work to people who for the most part were ignorant of painting, and for whom this was their first contact with the art of their time. Faithful to his principles, he would do this without beating the drum. A new period of drawing for the press was to begin; the kinds of newspapers to benefit were often those that kept afloat solely through subscriptions and sales by militants. A Picasso drawing on the front page of *Le Patriot* [a communist newspaper on the Riviera], in *L'Humanité Dimanche* or *Les Lettres françaises* at once increased circulation. Lithographs taken from these drawings and signed by him were sold on behalf of this press and made a significant financial contribution."[36]

In June 1945, Pablo took part in the 20th Congress of the PCF. He underlined his commitment with several portraits of the Party chief, Maurice Thorez. At the same time, his work was peppered with symbols of his political convictions.

Truth to tell, however, these pictures were scarcely at one with the aesthetics of a Party, which officially preferred the Realism preached by Moscow. Pablo, however, always exercised his freedom, saying and doing exactly as he saw fit. He executed three major political works: *Le Charnier*, spring 1945, *Monument aux Espagnols morts pour la France,* December 1945 (exhibited, with *L'Aubade,* at the Salon Art et Résistance in 1946), and in

35 O'Brian 1976, p. 374.
36 Gérard Gosselin, "Picasso: La Politique et la presse," in Gosselin and Jouffroy 2002.

1951 *Massacre en Corée.*[37] Lastly, between 1952 and 1958, he was to paint *War and Peace,*[38] denouncing the ravages of war.

According to Gosselin again, "through public acts, Picasso became associated with many of the great moments of history. From 1948, and during the entire Cold War period, he expended much effort assisting the partisans of peace…. With drawings and participation in various activities, Picasso fought to release unjustly incarcerated militants such as Beloyannis, the Rosenbergs, Djamila Boupacha, Manolis Glezos, and others languishing in Spanish jails…. He also celebrated the great moments of hope: the ends of wars, international youth conferences, the victories of science with Gagarin, the conquest of space, and took part in festivals, carnivals, Christmas, New Year…."[39]

Since settling on the Riviera in 1946 with his new partner, Françoise Gilot, and their children, Claude and Paloma, Pablo regularly provided drawings for *Le Patriote,*[40] a local Communist daily edited by Georges Tabaraud. The first drawing came out on the occasion of the 1951 Nice Carnival and a new one followed every year thereafter. By then part of the local community, Picasso received a certificate from the Communist mayor of Vallauris, Paul Derigon, in February 1950 recognizing his status as "honorary citizen."[41] It should be recalled that the Côte d'Azur at that time voted heavily for the Communist Party, like much of France. The Yalta agreements had given official sanction to the Soviet regime and the Resistance had whitewashed its blunders and atrocities. To vote Communist was by no means exceptional.

Pablo was also a highly visible figure on the international scene. In September 1948, he accompanied Paul Éluard to Wrocław, in Poland, for the

37 The painting was in fact not well received at that year's Salon de Mai since the soldiers were not Americans as the comrades would have preferred but stateless robots.

38 These panels were set up at Vallauris in a "temple" and inaugurated after an absurd delay thanks to political changes in France.

39 Gérard Gosselin, "Picasso: La Politique et la presse," in: Gosselin and Jouffroy 2002.

40 "Since the Liberation, the artist had repeatedly contributed to what was euphemistically termed the Communist and democratic press. *L'Avant-Garde, L'Humanité* and *L'Humanité, Dimanche,* with *The Dove of Peace. Europe, La Nouvelle Critique,* and *Femmes du monde* had all benefited from drawings by his hand. In November 1948, *Les Lettres françaises* published a portrait of Picasso's fondly remembered friend, Guillaume Apollinaire. These drawings celebrated either some social event— Franco-Italian youth meetings, the creation of the movement for peace, International Women's Day—or an anniversary. The page from the *Roi Carnaval* was something quite different. It evinced the playful character of a celebration, popular of course, but without any connection whatsoever with the Party and its struggles. Still with the people, but without political connotation, in pure joy." Georges Tabarand, "Picasso et *Le Patriote,*" in: Gosselin and Jouffroy 2002.

41 *Picasso: Documents iconographiques,* preface and notes by Jaime Sabartès, Pierre Cailler, Geneva, 1954. No author is mentioned but it was Sabartès who collected the illustrative documents and added his own notes.

"Congress of Intellectuals for Peace," intervening to demand freedom for Pablo Neruda, persecuted in his native Chile: "Always," went his speech, "Neruda has taken the side of the wretched in their pleas for justice. Today, he is a hunted man. Let us demand the right for Pablo Neruda to express himself freely wherever he likes."[42] He then paid a visit to the Warsaw and Cracow Ghettos, before traveling to Auschwitz and Birkenau, where he went, as he put it "to understand...."[43]

He did not come back empty-handed from this journey: he took up the ancient symbol of the dove, nurse to Jupiter, Venus' favorite bird, the same that announced the end of the Flood, and transformed it into a universal secular symbol of peace, friendship, and freedom. On his return from the poignant excursion to the death camps, he carried out countless *Doves for Peace*—one of which Aragon chose as the poster for the Peace Congress in Paris, at the Salle Pleyel, in April 1949. And, when Françoise Gilot gave birth to Pablo's second daughter, he gave her the forename Paloma (Spanish for dove).

Convinced, like so many others, of the perfection of the Soviet overlord, he drew the famous *À ta santé, Staline*, at a time when Éluard and Aragon were also singing the praises of the USSR's leader. One year later, in October, Pablo went to a second Peace Conference in England. The poster once again used the image of a dove, this time in flight. In November 1950, he received the Lenin Peace Prize.

His position vis-à-vis the Communist Party did not alter radically before Stalin's death, yet the bone of contention came from the Party itself.... On March 5, 1953, *Les Lettres françaises* commissioned a portrait from Picasso, as an homage to the beloved leader now departed, for the front page of its next issue. In a recent text devoted to Picasso and the press, Gérard Gosselin goes over this "affair of the portrait."[44] He recalls that my grandfather had never met Stalin and hardly knew him from photographs. He continues: "Françoise Gilot, Picasso's partner, recounts that she 'ferreted through the studio and dug up a photograph in an old newspaper showing Stalin aged about forty. I [Françoise] gave it to Picasso.' 'Very well,' he said, 'since it's Aragon who needs it, I'll give it a go.'"

Pablo began with no preconceived ideas, and produced, as Gosselin puts it, "a psychologically revealing likeness in which each feature, hair, eyes, moustache, neck, comes from a different period in Stalin's life, and are then

42 Speech by Pablo Picasso pronounced at the "Congress of Intellectuals for Peace," the founding congress of the Movement for Peace, at Wrocław, Poland, August 27, 1948, published in *L'Humanité*, August 28, 1948. Pierre Hervé was the special correspondent sent to report on the events.
43 "Picasso at Auschwitz," *Art News*, September 1993.
44 "Picasso: La Politique et la presse," in: Gosselin and Jouffroy 2002.

sculpturally reorganized. Picasso drew in charcoal, partially erasing it and working over the lines more firmly, laying in uniform or graduated shadows; he underlined the basic forms with a strong, black line, conveying all the complexity of the personage."

The result was rather faithful, even flattering, since it made Stalin look younger. Reactions were many and varied. "I had the revelation," Pierre Daix told me, "of a portrait of a young Stalin, very close to a photograph of 1903 or 1904.... It was naive yet surprisingly decisively drawn." "I saw a young Stalin," Aragon remarked, "of markedly Georgian character." "It did not deform Stalin's face," Elsa Triolet added, "it even respected it. But he had dared to touch it, he had dared...."

This was the crux of the problem: Pablo had dared. Taking no notice of the Party luminaries, he had dared to interpret the face of a god. He had uncovered an unexpected aspect in Stalin, friendlier surely, less official, yet still impressive. But not precisely "Realist." The communist readers of Les Lettres françaises were up in arms. "Where, in this drawing, do we see expressed the kindness, the love for his fellow man, that expression we discover in every photo of Comrade Stalin?" "Such a portrait does not measure up to the immortal genius of him we love the most." Of course, with the benefit of hindsight such an outpouring of devotion raises a smile—all the more since Picasso's offering was totally exempt from malice. The fact remains that, on the front page of L'Humanité dated March 18, the secretariat of the Communist Party "categorically disapproves of the publication in Les Lettres françaises of March 12 of the portrait of the great Stalin by comrade Picasso." The upper echelons of the Party were quick to take Aragon to task though "elsewhere he had courageously battled for the development of realist art."

"The affair of the portrait turned into a political issue that called into question Socialist Realism as defined in France at the 1947 and 1950 Congresses Officialized during the Cold War, French Socialist Realism was the result of a world split into two opposing, enemy blocs. This partially explains why the Realist trend advocated at the time of the Popular Front was to become the official aesthetics of the PCF.... Authentic, i.e. Socialist, Realist art was characterized by clarity of content and transparency of form, thereby guaranteeing its comprehension by the masses."[45]

This heavy-handed promotion of State Realism by the cadres of the PCF could only be to the detriment of Picasso. The "affair" concluded with the publication of a photograph of Maurice Thorez in the company of Aragon and the artist on the front page of L'Humanité for January 27, 1954.

This may have calmed the waters, but Pablo was not going to forget.

45 Georges Tabaraud, "Picasso et Le Patriote," in: Gosselin and Jouffroy 2002.

The portrait scandal created a precedent and was an eye-opener for Picasso. Photographer André Villers once confided to me, that one day Aragon had upbraided Picasso because his painting did not clearly symbolize his agreement with Party diktat. My grandfather turned on him roundly: "You put on your short pants, take a hoop, and go play in the Luxembourg [gardens], but don't say a thing about painting, painting is my business, not yours!" A riposte that proves that his commitment was not to be limited by Communist phraseology. Even if he liked to feel a member of a group, he also had a dread of being saddled with someone else's words or decisions.

Henceforth, he was to distance himself from the Party—more notably as the international situation worsened. Signed in May 1955, the Warsaw Pact proved to be more the legalization of a Soviet military presence in the people's democracies of the East than a response to the setting up of NATO. This "treaty of friendship, cooperation, and mutual assistance" showed its true face with the intervention in Hungary.

Then, on the occasion of the 20th Congress of the Party in the USSR, Khrushchev denounced the excesses of the Great Leader. The French Communist Party preferred to keep to the Stalinist line; Picasso then signed a letter (together with other French intellectuals, including his friends Hélène Parmelin and Édouard Pignon) addressed to the central committee of the PCF that exposed the silence of the Party and of *L'Humanité* concerning the repression of Hungary and called for an extraordinary congress.

The committee opted not to react and Pablo realized that he was now being stonewalled by the system.

Over the following years, he continued to offer support to the Communist cause, but solely at the local level, via *Le Patriote*, whose editor, Georges Tabaraud, was to become a close friend. Political conversations with Paul Éluard, Pierre Daix, and Yvonne and Christian Zervos became less frequent. The art dealer and collector Heinz Berggruen confirmed how much Pablo had been troubled by the events in Budapest in 1956. For him only the ideal of the cause lived on. The very structure of a party, the obligation to tow the line, was a straitjacket, a far cry from the freedom he had dreamed of. Too bad if Aragon still kowtowed to the preeminence of the Party.

Signing up, Picasso had expressed a longing for a homeland: "I have always been an exile; now I am one no longer." But he had never forgotten his true, his Spanish family. Loyalty dictated he keep his card and he never severed links with his political family, through thick and thin…. Nonetheless, slowly but surely, he was leaving the fold.

By the beginning of the 1960s, it was enough for Pablo to meet up with Party friends and keep abreast of events. He nevertheless participated actively in

various causes, donating works to the local section, to the bullfights in Vallauris, or to *Le Patriote*. He was no longer the dyed-in-the-wool Communist that some made him out to be in their effort to discredit the one they called the "Red billionaire"—implying he couldn't be a true defender of humanity. Once an asset to the PCF, he was now, through no fault of his own, a tool for undermining it.

It mattered not a jot. Pablo devoted his time solely to art. After disappointments he was loathe to admit, he viewed his political commitment from a distance, in storybook fashion. He was once again free, indeed freer than ever.

And freedom had always been the real leaven of his art. Whenever Kahnweiler whispered to him: "Your last still lifes, they did well, you know!" Picasso would fly off the handle and retort that he would paint whatever he wanted to. But this would not prevent him from going back to still life some time after. And if politics often fed into his creativity, it never could limit or constrain it.

In May 1962, he received the Lenin Prize's gold medal bestowed by a committee chaired by … Aragon. Following the award for the "dove," this was thus the second time Pablo received a prize of this kind. The homage was also a ploy by the Communists to reel Picasso in, and, for poor Aragon, it constituted an olive branch.

But it was already too late. Pablo no longer paid much attention to "noises off"; and still less to the jangle of medals.

1961 saw a number of ceremonies to celebrate Picasso's eightieth birthday. In Vallauris, these would be the last he would agree to take part in. The Communist village did its best to honor its most famous one-time citizen, inviting more than six thousand people on October 28 and 29, but the full-blown tribute was to take place five years later in Paris. On November 19, 1966, Picasso was feted with an exhibition in the Grand Palais (paintings), another in the Petit Palais (drawings, and, especially sculpture, the real revelation), and a third (prints) at the Bibliothèque Nationale. André Malraux, then Minister for Cultural Affairs, whose relationship to Pablo was less than straightforward, appointed Jean Leymarie (then conservator at the Musée de Grenoble and a close friend of Pablo's) to oversee proceedings.

Pablo's brand of "Communism" was a thorn in the flesh of the Right then in power, and particularly to de Gaulle, who had little time for modern art. My grandfather thus lent some five hundred unexhibited works to the Petit Palais as it was administered by the City of Paris and not by the cultural arm of the State. He did not want to be seen making concessions to a government

that had never even thought of showing his works in a national museum. It was a fine line, of course, but it meant something.

Apart from a few privileged individuals—including Georges Salles, director of the France Museums after the War, who was to try to heal the "split between the genius and the State," according to his own expression, and writer and Resistance hero, Jean Cassou, director of the Musée d'Art Moderne—Picasso did not enjoy particularly good relations with the French cultural establishment. Jean Leymarie remembers that, "for the most part, civil servants had little comprehension of contemporary art." One act was symptomatic: they forgot to send him an invitation! Furious, he telegraphed Malraux: "Do you think I'm dead?" And the future author of *La Tête d'obsidienne* filed back in return: "Do you think I'm a minister?"

The huge Parisian retrospective lasted until February 1967, attracting nearly a million visitors.

Despite all these honors, Pablo was forced to leave the apartment and the historic studio on rue des Grands-Augustins: the faithful Inès Sassier and her son Gérard now had to move, via Mougins, after nearly forty years of Paris life. Pablo was at once incandescent with rage and inconsolably sad. The government, unthinkingly applying a general directive concerning unoccupied residences, had acted clumsily, something for which Pablo never forgave Malraux. The latter, who had had the grand total of two conversations with Picasso, and brief ones at that, was to publish in 1974 some "dialogues"[46] in 1974 with the artist that on occasion betray a greater talent for lyricism than accurate recall.

Another example of clumsiness: in 1967, they awarded him the Légion d'Honneur without asking his permission. He never asked for it and politely refused. In 1971, Jacques Duhamel, the new Minister for Cultural Affairs, traveled especially to Mougins in a second attempt to pin it on him. And my grandfather had to turn it down once again: he had clearly not forgotten the eviction.

Art historian Werner Spies has told me that he sounded out Pablo on the subject but he had abruptly eluded the question: "There was a story in [the newspaper] *Nice-Matin* for Pentecost headed: 111 deaths on the roads. Pablo was dismayed: 'Did you see that? One hundred and eleven dead!'" True-life events concerned him far more than a more or less inconsequential honor.

An occurrence in Basel in 1967 took a similar course. Two masterpieces, *Seated Harlequin* and *The Two Brothers*, were in the city museum's holdings at the time. In autumn 1967, their owner decided to sell them. The museum's curator, Franz Meyer, managed to exercise a right of first refusal on behalf of the city council on the basis of a price fixed at 8,400,000 Swiss francs

46 André Malraux, *La Tête d'obsidienne*, Gallimard, Paris 1974.

(today, about $ 16,500,000). Six million Swiss francs would be drummed up by the city, with the rest to be found by the museum itself.

Collections took place and a city-wide festival was organized in search of funds. Eventually the money was gathered together. Meanwhile, a petition had been drawn up against the city council's exceptional vote of six million francs and calling for a unique referendum.

On December 22, the "ayes" had 55 percent of the votes. Swiftly informed of this manifestation of popular support, Pablo was overjoyed and invited Meyer to Mougins. There he offered him a further four significant paintings to thank the population of his city. Basel thus obtained six pictures.

This outburst of Swiss enthusiasm made little stir in the French press, however, neither on the Right—nor, more curiously, on the Left.

France was to make up for lost time as regards contemporary art only when Georges Pompidou became president. The lack of Picassos on the market and the absence of the necessary funds made wholesale purchases unthinkable. But, as early as 1969, Pompidou had in mind the acquisitions resulting from the Succession Picasso. The Malraux law of 1968 had instituted the principle of offsetting death duties (*Dation*) by conferring artworks or collections on the State, and Picasso was to provide its most glorious illustration. Before then, however, it was still incumbent upon the political class to pay due homage to Picasso in keeping with the (dis)proportion of the personage: thus, for Picasso's ninetieth birthday celebrations, Pompidou suggested the Louvre.

This event, the story of which I have related in the preceding chapter, reconciled Pablo with the French Republic. For its part, the Musée d'Art Moderne exhibited twenty-five major paintings lent specially for the occasion by the Hermitage and the Pushkin Museum in Moscow. The Paris administration then offered Picasso the "Freedom of the City." Outwardly, Pablo abstained from comment, but he was very pleased all the same.

One day Werner Spies was with my grandfather at Mougins when the telephone rang: a minister was on the line. "I don't need to speak to a minister," he responded.

It was all too late. His break with the world of politics was now total and sincere. There is politics and there are politicians: to exist, he needed neither governments nor parliamentarians. No more than he needed the Communists: he asked Roland Dumas to pass on his thanks to the comrades for the solemn homage the Party had paid him with the reading of a poem imbued with duly authorized regret by a venerable Aragon.[47]

47 "Discours pour les grands jours d'un jeune homme appelé Pablo Picasso," published in *Les Lettres françaises*, no. 1407, October 27, 1971.

As Jean-Pierre Jouffroy underlined, he was now one of the prime movers in a very different contemporary landscape: "He would never allow himself to place objects in our hands in the same state he found them. Passing through his hands, they emerged transformed. This is a moral lesson for us all: never leave anything in its prior state—always try to see what can be done."[48]

To transform the world, to make it more accessible to others, to decode it, to offer a personal image of it to one's fellows, and, ultimately, to magnify its beauty or horror to grab our attention—isn't that, at bottom, what being a "committed" artist is all about?

In November 1969, Pablo called Roland Dumas.[49] He had just received two letters forwarded by his dealer Kahnweiler that rattled him: one came from a Dr. Luis Gonzáles Robles, director of the museum of contemporary art in Madrid, the other from a Spaniard in Paris serving as an intermediary. Both were dated October 25, 1969 (by unlucky chance his birthday). The museum director, making the most of Picasso's alleged remark to the effect that "*Guernica* belongs to the youth of Spain," requested that the picture be transferred to Madrid to find a home there "as the Master would wish."[50]

Picasso, however, would never permit *Guernica* to go to Spain for as long as Franco lived. Anxiously, he asked his lawyer to prevent at all costs what seemed to him to be a "political operation under cover of a cultural initiative," with the old dictator pulling the strings.

In effect, an earlier letter dated December 6, 1968, and addressed by the vice-president of the government to Florentino Pérez Embid at the Spanish embassy in Paris, was entirely unambiguous: "Following our conversation of the other day, I have agreed with the Caudillo as to the manner of recovering the picture *Guernica* by Pablo Picasso, and he has concurred with me to put this operation into motion."

Details followed on exactly how to proceed. This was too much for Pablo. He did not leave *Guernica* to the "youth of Spain," but to the Spanish Republic. It was out of the question for the picture to be sent back to Spain.

Roland Dumas, however, was worried about the picture's future—someone will have to be appointed to make a decision after Pablo. "After me, it'll be you!" the artist retorted, and on December 15, 1969, informed his lawyer as to precisely what he had in mind. "I confirm that it is necessary to draw

48 Jean-Pierre Jouffroy, "Un Fondateur de la deuxième renaissance," in: Gosselin and Jouffroy 2002. Jean-Pierre Jouffroy, painter and art historian, has written several books on artists. With Édouard Ruiz, he published, *Picasso, de l'image à la lettre*, Messidor, Paris 1981.

49 Dumas 1996.

50 The picture had been on loan since 1939 to the Museum of Modern Art, New York.

up documents with the Museum of Modern Art relating to *Guernica* and the works (drawings and studies) that accompanied it at the time of the deposit realized with the museum …. The picture is to be returned to Spain, but only when a Republican government has been reinstated in my homeland. Until that comes to pass, the picture and studies connected with it are to stay on deposit and under the protection of the Museum of Modern Art."

To forestall any diplomatic hitch, the museum was contacted in New York. Roland Dumas prepared an instrument equivalent to a clause in a will —without stating as much of course—which appointed himself executor to act in accordance with his estimation of the state of any future Spanish political regime.

On November 14, 1970, Pablo transmitted the following communication to the Museum: "… Many years ago, I donated this picture, with its studies and drawings, to your museum. Correspondingly, you agreed to return the picture, studies, and drawings to accredited representatives of the Spanish government when public freedoms are restored in Spain …. It is up to the museum to see fit to release *Guernica* …. The single condition I stipulate for [its] return concerns the findings of a lawyer. The museum, prior to any initiative in this direction, is to request the opinion of Maître Roland Dumas, lawyer at court, 2, avenue Hoche, Paris, and the museum is to act as he recommends."

After Pablo's death on April 8, 1973, and the opening of the Succession, "a text was signed by all the heirs-at-law in acknowledgement of the fact that the picture did not form part of the estate …. This attitude was not without dignity," as M. Dumas duly noted.

William Rubin, then curator of the Museum of Modern Art, traveled to Madrid to see the lie of the land. Franco, however, was still in power. The Caudillo died on November 20, 1975, and Adolfo Suárez became head of the government. Pressure increased and at the most senior level. Every week Republicans who had taken refuge in France wrote to Roland Dumas stating that it was his moral duty not to confuse Republic and constitutional monarchy. The Cortes, the Spanish Parliament, voted a law in autumn 1977 demanding the return of the picture, citing the democratization of a State, which had reverted to a monarchy. On April 15, 1978, the American Senate adopted a resolution, "noting the return of democracy in Spain, and requesting that, in the very near future, the picture be returned to the people and the government of democratic Spain." Meanwhile, mayors of many large Spanish cities were laying claim to *Guernica*. Roland Dumas obtained an audience with Adolfo Suárez on February 19, 1979, in the presence of the Foreign Minister and Ambassador Quintanilla. Official ties were stabilizing.

It was more especially King Juan Carlos himself who managed to inspire confidence on Dumas's part, speaking to him freely of the ongoing restoration of democratic freedoms. It was initially proposed that the picture be returned to the Basque Country, since the victims of the bombardment of Guernica had been Basque. Roland Dumas, however, suggested a more federal solution to the king: "In the context of an event of historical magnitude, I do not believe that one has to try to satisfy one fraction of opinion over any other. Of course, the Basques have rights, but the work itself goes beyond the massacre of 1937."

Then, in March 1980, Jacqueline Picasso recalled that her late husband had been appointed director of the Prado Museum in September 1936 and corroborated the fact that the painter had indeed intended Madrid as *Guernica*'s final resting place. On paper, then, the problem was resolved.

The attempted putsch sparked by Colonel Tejero (who burst into the Cortes waving a gun on February 23, 1981) slowed proceedings down for a time. Roland Dumas, the whole Picasso family, of course, together with the Museum of Modern Art and the US government, were all concerned—just as Pablo had been in earlier times. But the putsch was swiftly quashed: the incident demonstrated the king's unwavering support for the democratic process and his determination to preserve national unity and guarantee the rights of his people. In a way, this sideshow had made it possible to judge the solidity of the fledgling Spanish State. On September 10, 1981, after an exile lasting forty years, *Guernica* returned to Spain, to the place my grandfather had always wished it to be. Next to the canvas stands the sculpture *Woman with a Vase* (or *Woman holding a Torch*), inspired by my grandmother Marie-Thérèse. As I have said, the other copy, in bronze, watches over her tomb in Vauvenargues.

In a sense, on the day of this preeminently official entrance, Pablo at last returned to the Spain he so cherished. In 1970, Werner Spies came back from the inauguration of the second building of the Picasso Museum in Barcelona; Picasso pointed to a Blue Period work, *The Roofs of Barcelona*, and asked him: "Did you see them?" He was still dreaming.

If the end of *Guernica*'s adventures was posthumous, I think that Pablo's final political act was inspired by the famous evening with Mstislav Rostropovich in 1972 at Notre-Dame-de-Vie. Pablo had been absolutely determined to see published a photograph of himself in the company of the "cellist harried by the USSR—and devil take the consequences."

The photo appeared in *Les Lettres françaises* on October 10, 1972, when Pablo was almost ninety-one. This testified, once again, to his commitment to freedom, expressed explicitly in a weekly magazine recently deprived of

financial assistance from the Party for offering support to intellectuals harassed by the same Soviet authorities.

A little later, the publication stopped coming out. The PCF had cut its funding. When Pierre Daix informed Pablo of the fact my grandfather did not even bother to tear up his now irrelevant Party card. The ideal lived on.

Family

Ultimately, there is only love.[1]

PABLO PICASSO

PABLO'S CHILDHOOD

From the moment he was born, on October 25, 1881, in Málaga in southern Andalusia, Pablo was the family's little treasure. His then forty-one-year-old father, Don José Ruiz Blasco, an art teacher but also the curator of a small local museum, his twenty-six-year-old mother Doña María Picasso y López, and his maternal grandmother Doña Inés Picasso all went into raptures over him. His two aunts, Eladia and Heliodora, did likewise. Following the devastation of their vineyards by the phylloxera pest, the two women had come to live with Don José, and were then making braid for railway workers' uniforms.

In 1884, the family expanded with the birth of a first sister, María de los Dolores, known as Lola, then in 1887 with a second, María de la Concepción, known as Conchita, who, to Pablo's enormous grief, died of diphtheria in 1895.

It was in this "clan" that my grandfather acquired the sense of group solidarity that he would seek to recapture all his life, and which he would demonstrate capably to the people close to him. The "families" he created around himself would hardly be traditional, but deep in his heart he would retain a nostalgia for this "Spanish family" that would always provide a refuge and, in some way, absolution from his audacious behavior. Pablo was

1 Efstratios Tériade, "En causant avec Picasso," *L'Intransigeant*, June 15, 1932.

very superstitious, as we will see later. The Spain of his childhood was a land of superstitions and, for him, the only effective barricade against "the evil eye" was the respect for family traditions. This attitude also allowed him to forgive himself his own "wicked" actions.

Leaving behind Andalusia's hot climate in 1891 the whole Ruiz Picasso family moved north to La Coruña, where Don José was appointed as an art teacher in a secondary school. He had lost his post as curator in Málaga (admittedly of an empty museum) and his reasonably comfortable salary.

Little by little, the family's material conditions improved. But the very humid, windy, Atlantic climate did not suit any of them and in 1896 the family moved once again, to Barcelona, Don José taking the unexpected opportunity of swapping positions with a colleague who, it so happened, wanted to settle in La Coruña.

Patrick O'Brian described Pablo's happy childhood perfectly: "These early years were cheerful enough for a child who knew little or nothing about the struggle for existence and to whom the overcrowded, somewhat squalid flat was as natural as the brilliant and almost perpetual sunshine in the square."[2] Apart from his father, Pablo was the only male in the family circle. Pampered by his aunts and female cousins, he was an infant-king. "… The relationship between them [Pablo and his mother] was uncomplicated love on either side, with some mixture of adoration on hers; and it is perhaps worthwhile recalling Freud's words on Goethe, with whom Picasso has often been compared: 'Sons who succeed in life have been the favorite children of good mothers.'"[3]

His relationship with his father was more complicated. "This man about whom the whole household revolved, the only source of power, money, and prestige, the women's *raison d'être*, had as his symbol a paintbrush. Although he did not work at home, it was Don José's custom to bring his brushes back to be cleaned; and from his earliest age, Pablo regarded them with respect and full of awe, soon to be mingled with ambition. At no time did he ever have the least doubt of the paramount importance of painting."[4] As he grew up, Pablo understood that his father had great difficulty making enough money from his painting for the whole household to live off. What is more, Don José, at nearly fifty years old, had lost faith in his talent. "In his son's portraits we see a weary man, tired through and through, deeply disappointed, often very near despair."[5]

2 O'Brian 1976, p. 20.
3 Ibid., p. 20.
4 Ibid., p. 21.
5 Ibid., p. 19.

"The relationship between the father and son is obviously of the first importance for an understanding of Picasso's character; but like everything else to do with him it is immensely complex and full of apparent contradictions."[6] From 1901, Pablo signed indiscriminately as "P. Ruiz Picasso," "P. R. Picasso," or simply "R. Picasso." From 1902 onwards, he would use nothing other than "Picasso." He had abandoned his father's name, a very rare step in Spain.

He would, however, always talk about him with affection and respect. In his "conversations" with Brassaï, Pablo made his father into an archetype: "Every time I draw a man, automatically I think of my father.... As far as I am concerned *the man* is Don José, and that will be so as long as I live.... He had a beard ... I see all the men I draw with his features, more or less."[7]

Pablo, who was very fond of his parents, owed some important elements of his personality to them. As Jaime Sabartès, his childhood friend who later became his secretary, has emphasized, "we must recognize that in terms of his good qualities at least, he resembles his mother more than his father, since it is from her, without a doubt, that he gets this good humor, this natural grace that's characteristic of him; but that, if we consider him in terms of his involuntary gestures when he is annoyed, impatient, tired or contrary, when someone is bothering him, when something interrupts him in his work, we recognize Don José in him ...; except for the fact, however, that what irritated him—conversely to his son—was to have got him into painting!"[8]

At the age of fifteen, Pablo entered the School of Fine Arts in Barcelona, known by its pupils as La Lonja or La Llotja (in Catalan). His father rented him a small studio close to the family's flat. On his first day at the school, he met Manuel Pallarès, his elder by six years, who would guide him on a premature passage to adulthood.

Like every other impatient adolescent, Pablo detached himself from his family very quickly. He eagerly explored other universes: cafés, where he met artists and intellectuals, brothels, where he very soon lost his innocence, and museums, where he could contemplate his Old Masters at last. Each occasion was an exhilarating opportunity to re-create a new family for himself, based around the sharing of a wealth of new ideas.

6 Ibid., p.19.
7 Ibid., pp.19–20. Cited from Brassaï 1991.
8 *Picasso: Documents iconographiques* 1954.

The exhibition "Picasso érotique"[9] at the Jeu de Paume museum in Paris laid bare all his potent recollections of physical pleasures and of the young women that bestowed them. Pablo's propensity to content himself with paying for sex continued later in Madrid. It was only after his second journey to Paris, and him settling there in 1904, at the age of nearly twenty-three, that he would embark on a genuine love life.

Life was difficult for him in Paris. The family cocoon he had always known had disappeared. He had lost his illusions. His love affairs came to nothing. From the very first of his Parisian conquests he started thinking seriously about fatherhood: that is with Madeleine, a rather flighty type, in the course of 1904. This first "serious" liaison—serious in spite of its very licentious aspect—continued discreetly over several months, resulted in a pregnancy that ended in miscarriage. Out of this ultimately very commonplace episode, the splendid *Maternités* of the Rose Period took form, around a child that was never born. "It was his way of creating things," Pierre Daix has confided to me. For want of being a natural father, he would be a "father" to pictures: one who would never be able to let go of a number of his "children."

In August that same year, he met Fernande Olivier. They were the same age. Their on-off affair lasted for nearly a year, with Fernande never getting wind of Madeleine's existence.

With this passionate liaison turning gradually into a sort of conjugal life, from September 1905, Pablo was again contemplating having a child. Unfortunately Fernande had undergone an abortion that had left her sterile, as often happened at that time, the interruption of pregnancy taking place in deplorable conditions, with disastrous consequences.

Difficult times notwithstanding, their desire for a child turned into a tentative wish to adopt. According to Pierre Daix, Pablo had been very struck by all the infants he had seen in France, by the way they were wrapped up or taken out for walks, being so different to Spanish habits.

When in 1966 Daix started reconstructing the first exhibition at Ambroise Vollard's gallery, he would be astounded by the number of canvases featuring babies and small children.[10] "It's true that he would have wanted to have children. For a start, he had a thing about fatherhood, the way other people have about other things.... Fernande was there, she was steady, and he would have wanted to have a child with her."

9 *Picasso érotique*, exhib. cat., Jeu de Paume, Paris (February 19–May 20, 2001); Montreal Museum of Fine Arts, Canada (June 14–September 16, 2001); Picasso Museum, Barcelona (October 15– January 27, 2002); Munich, London, New York: Prestel, 2001.
10 For his catalogue of Picasso's early work, from the periods 1900–06 and 1907–17.

It was Fernande who had the idea of adopting a little girl, in April 1907. She went along to the orphanage in the rue Caulaincourt and came back with Raymonde, actually a girl of twelve or thirteen years, whose presence would quickly become a nuisance. Conscious of having made an error in judgment, Fernande took the adolescent back to the orphanage in July.

Pablo was profoundly shocked by this casual attitude, precipitating their first separation, from June to September 1907. Fernande's indifference to his work, at a time when he was working on the *Demoiselles d'Avignon,* reinforced his decision.

André Salmon and Max Jacob, poets and friends of Pablo's, have given very uncertain accounts of the adoption—not only regarding the name or the age of the young girl but also Pablo's reaction. The only certainty is that this episode would have deeply affected him. During this difficult period, my grandfather was living and working in a world of mixed emotions, where sentiment, compassion, and suffering combined as fuel for his inspiration. Americans assign a much stronger meaning to *inspiration* than the French, bringing together within one concept the impression that can be made and the motivation that can be inspired by one person or thing. Pablo always knew how to detach himself, sometimes quite harshly, from those who did not inspire him and who made him waste precious time.

When I visit an exhibition or reread an art book on Picasso, I cannot imagine that such an oeuvre could have been conceived without love and without genuine affection for others, for which Pablo had an enormous need. No doubt he often had difficulty expressing his own feelings but he always had a ready response, one way or another. In the Málaga of his childhood, surrounded by his mother, his sister, and his aunts, he was the "conductor." In Paris, he had to compose a new tune for himself, express his emotions, communicate feelings, and serve his apprenticeship to joys and failures. He had, also, to nourish his work. Certain things had been given to him; now was the time to acquire others.

The separation did not last. Pablo got back together with Fernande—a second attempt that, lasting a long time in the end, from 1907 to 1912, was rather melancholy. During this period Pablo devoted himself above all else to a dialogue with Cubism, to real artistic jousts with his friend Georges Braque. Fernande took care of routine. Pablo looked elsewhere.

A year before they separated for good, Pablo met Éva Gouel, at that time the girlfriend of the painter Marcoussis. If it was not a thunderbolt, it was not far from it. Their affair, beginning in a great riot of sensuality, would always remain paradise lost for Pablo. Éva's illness arrived and interrupted all their plans. This woman, who was possibly his greatest love, perhaps

because so ephemeral, would not be the one to give him the joy of becoming a father. She died of cancer in December 1915.

PAULO

The violent unhappiness that followed this loss, the despairing feverishness with which Pablo multiplied his short-lived affairs, plunged him back into an exploration of the mechanics of women: the opposite extreme of any family plans.

It was the era of the Russian ballet, of *Parade*, Erik Satie, and Cocteau. We know that Pablo met up with Serge de Diaghilev's troupe in Rome in January 1917, and that he met Olga Khokhlova there. It was through her that he became a father, in 1921. The lateness of this event, at the age of almost forty, can be put down to earlier failures rather than any resolve to be single or ego-centric self-importance, as some people would have it. According to historians, Pablo did not care whether he was married or not before having a child. The incident of young Raymonde's adoption had cooled his relationship with Fernande. When she got divorced at last he did not propose to her. In any case, she was sterile. The marriage would have been too. The magic of their relationship already belonged to the past. With Éva, the war and her illness were dramatic obstacles to his desire to have a family. With the emotional drift that followed, Pablo's spleen would only be resolved positively in an "establishment," in the literal as well as the figurative sense. Olga was a sign for Pablo, an antidote to misfortune: she was the idealized representation of a world that was itself at once pure and yet, conversely, so enticing.

With due respect for preambles and form, Pablo married Olga in July 1918. Following the meticulous setting-up of a home for the couple, the time came for the patter of tiny feet. Olga became pregnant in the summer of 1920, and little Paul, known as Paulo, was born on February 4, 1921.

All Pablo's paternal tenderness, so long suppressed, could finally be articulated, through the most charming drawings and watercolors, breaking with his previous experiments. Not only did this see Pablo return to a formal serenity, but this Neoclassical style also perfectly suited his new art dealers, Paul Rosenberg and Georges Wildenstein, who finally made Pablo a lot of money. They also encouraged him to exploit his talents as a portrait artist, out of which came the many evocative "Paulo" works: *Paulo in a White Bonnet* (1922), *Paulo on a Donkey* (1923), *Paulo Drawing* (1923), *Paulo as Harlequin* (1924), *Paulo as Pierrot* (1925), *Paulo on his Rocking-Horse* (1926). Paulo became the medium for the expression of an entire traditional imagery. Through Paulo, his own flesh and blood, Pablo transposed inspirations from his youth, such as academicism, traveling acrobats, and naïve themes.

It was during their stay in Fontainebleau—a large forested area to the south of Paris—in the summer of 1921, that Pablo got to share in a calming intimacy with Olga and the baby. Here in the large house, the figurative gradually evolved into extraordinary monumental, almost statuary, forms. Olga's small frame and her refined clothes disappeared, making way for impressive figures with thickset bodies and heavy features in simple clothes, set in an almost monochrome universe, beyond time.

But very quickly the deterioration of his relationship with Olga turned Pablo inexorably away from Paulo who, cared for by a nanny, was distanced from his parents. Olga, for her part, drew Pablo into a social calendar that was scarcely compatible with family life.

Observation and analysis followed, but were cut short. Pablo would never witness the adolescence of this baby, turned toddler, then little boy. In growing up, and especially on becoming an adult, Paulo was no longer a source of inspiration. Pablo's other children would take that place.

Paulo faded gradually from the canvas and gained the independence of a little boy. Jostled between his father, with his passion for work, and his mother, who really didn't have the time, he "got by." Some people looked on him simply as some kind of pretext for painting, without a character of his own! Even worse, they would have liked him to be an artistic rival to Pablo, imposing on him a superhuman ambition, and an inevitably disastrous destiny. From this point on Paulo had only one solution: to escape. But how?

Now, Pablo was proud of his first son; he had fun with him, and fed off his youthful spontaneity. Paulo, as a child, as the artist's first-born, could only be an exemplary, inspirational subject. Pablo's paternity revealed itself through acts of love, and acts of painting, which, for him, were one and the same thing.

In reality, if Paulo effectively ceased to be a model for the artist, it was partly due to an actual geographical distance between them from 1935 onwards (the date of Olga and Pablo's official separation), and partly to the themes the artist took up subsequently—minotaurs, painters, soldiers, and musketeers—which differed radically from the reality of Paulo's life. To offer a different argument: reproducing the adult Paulo against novel backgrounds would have effectively reduced him to a pictorial "pretext." Moreover, Pablo's mind was taken up with another model from 1927 onwards: Marie-Thérèse. Pablo was a father, but first and foremost he was a man. And he was a very inspired lover.

Olga had planned out a day-to-day life that accorded with her aspirations and sense of respectability. This was reflected in her son's education. "Olga," writes Pierre Daix, "pushed Picasso to employ a great entourage, with a nurse,

chambermaid, cook, and driver, and to accept all social invitations...."[11] Pablo seemed to bend to his wife's whims, but his independent streak tormented him. And society at that time neither allowed Olga to soften the rules of a protocol to which she aspired, nor Pablo to impose his own very personal adjustments. His elegant made-to-measure suit, chosen with Olga, made him ill at ease, even if he did find in it a complement to his natural charm and a return to his youth. Olga, with her display of ostentatious and voluptuous luxury, was a necessary experience, but necessarily brief—like the monumental Neoclassicism of his painting, which rapidly reached its explorative limitations.

Meanwhile, little Paulo was receiving a distinguished education. Olga had decided on a private tutor for him. Dressed like a little prince, he had to stay away from his father's studio and its paint stains. In Man Ray's photographs, we discern a young Paulo, his gaze straight, his hair well greased, a little stiff in his double-breasted suit, impeccable, and implacable. Despite the photographer's great talent and his friendship with Pablo, these shots simply attest to the hold the grand bourgeoisie had over the fashionable avant-garde.

However much he was Picasso's son, Paulo's childhood was comparable in every way with that of a banker's or great industrialist's son. His misfortune was that neither a factory nor a presidential office awaited him. Being an artist's son isolated him from the outset from the social class his mother had aspired to for him. What is more, being taught by a private tutor deprived him of any external environment and contributed to marginalizing him.

It was not until he was about ten years old that Olga consented to send him to school, to the Hattemer School in Paris. Lagging behind the overall level of his classmates, he would never adapt. On being introduced to his half-sister Maya, after World War II, he declared to her sadly: "How lucky you are to go to school!"

I am certain that, even if it was not his fault, my grandfather felt partly responsible for his contribution to his son's childhood. He took responsibility, for whatever reason, and never stopped providing for his needs. They established a special dialogue with each other, consisting of discretion and unspoken words.

Olga's authority over the running of the house, their social life, and Paulo's education often clashed with Pablo's counter-example. The latter, very much taken up with artistic creation in his studio on the floor above, would

11 Daix 1995.

essentially see his son during meals—an opportunity for the father to transgress the rules of decorum fixed by Olga, and to initiate his son into disobedient ways. This would irritate Olga but delight the little boy. The father would get close to his son: it was their time to be silly, to bend the rules.

Pablo even set up a little electric train in his studio for Paulo—an unspeakable mess and a true "egging-on," it went entirely against Olga's precepts. It was probably here, in these breaches of the rules, that their relationship was formed and where, despite the rigor and precision in his life, Paulo acquired that casualness that would later make up part of his charm.

But this conflict of personalities hardly allowed him to become independent: on the one hand there was an unreal isolation with no future, and on the other a castrating dependence, which prevented him from finding his own way. The son of a Rothschild is a Rothschild. The son of Picasso would not, however, become a Picasso. Right from the start, he was an heir with no inheritance.

In 1923, portraits of Olga, including the mother and child paintings, already began to feature a new face, revealing Picasso's habit, repeated so many times thereafter, of including his female inspiration of the moment. That inspiration, unquestionably a seductive one, went by the name of Sara Murphy, that famous American girl living in Paris, the daughter of a millionaire industrialist and wife of a fashionable painter.

Pablo produced a great many works in which Sara's face, or that of her son, are ever more clearly identifiable but with his dealers' help he refrained from making any reference to them in the titles he gave his works. Already plagued by Olga's jealousy, he persisted in giving his pictures his wife's name, despite all the evidence to the contrary.

The year 1923 marked the peak of Sara's inspiration and the end of that of Olga. Yet it is likely that the liaison between Pablo and the rich American was only ever a platonic one—despite the very demonstrative interest that Pablo showed her.

I have recounted how Pablo would meet my (future) grandmother, Marie-Thérèse Walter, in January 1927. The time had come for him to rediscover the freedom necessary for creativity. Olga's ideal of bourgeois perfection, though certainly sincere, and which he had once perceived as a real discovery, had suffocated his independent instincts. My grandfather had to re-create a balance. He set out on a double life.

In 1935, Pablo asked for a divorce. Marie-Thérèse had just become pregnant.

The main argument behind Pablo's request for a separation is that Olga "through her difficult character, and in frequently causing violent scenes, makes life impossible for him, to the point of preventing him from working and from seeing his friends." He cited numerous witnesses. Via almost daily lawyers' letters and bailiffs' missives, Olga denied all the claims in Pablo's petition and slowed the process down by every means possible. Pablo was absolutely livid, especially when, on Olga's initiative, locks were put on his studio, officially to avoid any of his works escaping some hypothetical inventory. In fact, it had more to do with emotional pressure: by preventing him from working, Olga still believed she could force him to return home to her.

An official inquiry into the couple's situation was ordered by a second judgment issued by the Seine Court of Appeals on April 15, 1937, resulting from Olga contesting Pablo's allegations. The inquiry and counter-inquiry did not take place until the spring of 1938.

Among the witness statements collected on this occasion, that of Georges Braque in support of Pablo revealed great tensions: "Having come to see his friend Picasso shortly after his [own] marriage, he was received by his wife in such a manner that he decided never to return again." As for Jaime Sabartès, he remembers Olga "frequently harassing her husband to come home, in person, or by telephone, in order to insult him in the rudest terms." However, the non-conciliation order of 1935 that officially forbade him, and Olga, from acting in such a way—that is from issuing threats in public— could only make her situation worse and, although she didn't know it, strengthen Marie-Thérèse's position as Pablo's peaceful refuge.

Perhaps if Olga had accepted this inevitable divorce more quickly she would have had a better time of it over the following years. Pablo detested problems and now Olga was creating growing problems for him. Her ferocious opposition to divorce and, at the same time, the continuous scenes she inflicted on his entourage led everyone to believe that she was attached not to a love that appeared improbable but to her status as "Madame Picasso." This status alone prevailed over all the material advantages that she would get from a separation in due form. Olga knew that they would have to separate the estate, and so too the paintings—or at least their commercial value, but neither of them made any mention of this issue in the proceedings. Olga wanted to stay married; Pablo wanted freedom.

The irony is that they each got what they want.

So today I aim to quash the view that Pablo wanted to avoid divorce because of the sordid question of money or to avoid sharing his artworks. There is not a single document from the proceedings that could back up this rumor. Duly noted.

On October 25, 1941, in spite of all Olga's go-slow maneuvers, and in conclusion to a dramatic serial drama that I won't return to, the Court of Appeals in Paris confirmed a legal separation. It was Pablo's birthday: he was given the gift of freedom. Olga, meanwhile, in the middle of a World War, shut herself up in a cage and threw away the key. In pointlessly delaying a divorce, now rendered legally impossible, she no longer had the possibility of divorcing even if she were to be won over by another man. She had literally buried herself alive.

Olga's obstinacy was not without its consequences. Pablo, still legally married, could not marry Marie-Thérèse, nor could he legally recognize their daughter Maya. Later, he would neither be able to marry Françoise Gilot (whom he would meet in 1943), nor recognize their children, Claude and Paloma.

As for the adolescent Paulo, he learned about life out in the streets, escaping this household in which anger passed relentlessly between his parents up until their separation in 1935. Jacques Prévert, the poet and a friend of his father's, often welcomed him in after his strolls around Pigalle and outings in Saint-Germain-des-Prés, thus saving him from an umpteenth reprimand from his mother. Paulo, deceptively tall for his age, went around with people older than he was. Even Braque was taken with affection for him and they would remain friends, sharing the same passion for cars.

Paulo was the one who found himself the most exposed in this maelstrom of antagonistic desires. He was torn between his parents, especially when, after the war, Olga got it into her head to pursue Pablo wherever he went and to insult him publicly in front of their son. "In the summer of 1947," Françoise Gilot recalls, "whenever we went to the beach—and Paulo, her son, was often with us—she would come sit down close by." And, "… Olga was never far behind, shouting her threats and accusing me of stealing her husband away from her."[12] (Which was absolutely not the case!) In addition, Pablo received almost daily letters full of reproaches and insults, monotonous litanies with the insistent refrain, "You aren't any longer what you used to be. Your son doesn't amount to much, either, and he's going from bad to worse. Like you."[13]

Olga's public scandals could only serve to distance Paulo from his mother. He too had to put up with Olga's scenes. Françoise Gilot, again, remembers, "First she would start talking to Pablo. He would ignore her or even turn his back. Then she would start in on Paulo, 'Well, Paulo, you see

12 Gilot and Lake 1964, pp. 208–9.
13 Ibid., p. 209.

that I'm here and I want to talk to your father. I must talk to him. I have something of the highest importance to tell him.' ... Paulo would ignore her. Then, she would move closer to Pablo and say, 'I must speak to you about your son.' Getting no reply, she would turn again to Paulo and say, 'I have to talk to you about your father.'"[14]

By then Pablo and Olga had been officially separated for twelve years.

This was how, thanks exclusively to his mother, Paulo saw the drama of his childhood trauma prolonged for the long-term. In 1949, he gave her a grandson, Pablito, with his companion Émilienne, whom he married a year later. Thus Olga gained a new status: at once both grandmother and mother-in-law. A second child, Marina, was born in late 1950. Olga died in February 1955 when her grandchildren were still very young.

Divorce proceedings between Paulo and Émilienne, initiated in the spring of 1951, were difficult, and destroyed any chance of a rapprochement between Olga and Pablo who still, however, had the same first grandchildren and the same (ex-)daughter-in-law in common. Once again, other people would suffer from a needlessly long and pointless battle.

Curiously, the division of Pablo and Olga's assets never took place after the ruling of the final Court of Appeals in 1943. This is something no one can explain. Certainly the war did not help, added to the fact that Olga lived in Switzerland until the end of the conflict, but she did not undertake any action to coerce Pablo into it. To go ahead with dividing up their assets would have been to validate their separation. Wasn't she pretending, in 1948, to be living together with her husband still?

In reality, at this time, Pablo, his companion Françoise, and their son Claude (born in May 1947) were living in a little rented apartment in Golfe-Juan. Olga would come regularly to the front of the little house to insult Pablo. Sometimes, in his absence, Françoise was faced with unimaginable scenes, "... [Olga] would wait outside Monsieur Fort's house until I returned. While I was finding my keys and unlocking the door, all the while holding Claude in my arms, Olga would come up behind me, and start to pinch, scratch, and pull, and finally squeeze into the house before me, saying, 'This is *my* house. *My* husband lives here,' and pushing at me so that I couldn't go in." She continues, ".... one day when she [Madame Fort, the owner's wife] heard that scene going on at the door, she came to the window and called out to Olga, 'I remember you. You're Picasso's wife, aren't you? We met years ago, when my husband was Vollard's printer.' Olga, delighted by this windfall, said, 'Of course. And I'm coming in to have tea with you.' From that day on, Olga came every day to call on Madame Fort. She would sit at the window

14 Ibid., p.208.

and whenever anyone came looking for Pablo, call out, 'No, my husband isn't here. He's gone out for the afternoon. And I'm back living with him, as you see.'"[15] This piteous fantasy was enough for Olga, who preferred it to reality.

There is a sort of irony here: if Olga had claimed her half of the couple's assets (essentially half of Pablo's artworks in actual fact), it is Paulo who would have inherited it "directly" on his mother's death in 1955. The relationship between Pablo, his son Paulo, and the latter's children—Pablito (who was to commit suicide in 1973) and Marina—would have been turned upside down by this. Failing this, Paulo, as his mother's heir in 1955, would have had to make a legal claim for his mother's share of the (separated but not divorced) couple's assets. He took no such action. It is clear that Paulo was particularly fond of his father, and did not envisage stripping him of half of his work. In any case, my grandfather knew nothing of the decisions made by Olga and her son.

While Olga remained Madame Picasso forever, she had lost Pablo for good. Only appearances were saved. Pablo kept all his artworks even though, in deciding on divorce, he had tacitly accepted in advance the idea of being separated from them. He paid Olga's maintenance like clockwork— and many other occasional expenses besides. Olga had the use of the château de Boisgeloup, but did not move into it, moving at whim from hotel to hotel, and always at Pablo's expense. Towards the end of her life she settled in Cannes, in the Beau-Soleil nursing home (at 76, boulevard Carnot). From here she wrote to Pablo regularly, often via telegrams, as if they had just been parted the previous night, and beseeching him to take scrupulous care of the payment of the medical bills. He never responded but he did pay the bills.

My grandfather retained a very traditional vision of the family: proof, if ever there were any, that his independent spirit had not completely swept away his rigid Iberian upbringing. Marriage was a foundation and a sacrament.

MAYA

My mother Maya was born on September 5, 1935, in the Belvédère clinic in Boulogne-Billancourt. In official registers she is María de la Concepción, in memory of her father's little sister who had died. The usual diminutive form of the name is Conchita, but María quickly became Maya—on the initiative of the little girl herself, who was incapable of pronouncing her first name.

15 Ibid., p.209.

Olga having custody of his son, Pablo consoled himself with a passionate devotion to his daughter. If Maya had not existed, it is certain that Pablo would have been hit hard by Paulo's absence. Luckily—yet unluckily, Maya replaced him. With her, each moment was marvelous. For my grandfather, aged fifty-four in 1935, life with Marie-Thérèse and Maya was truly rejuvenating; it was a return to an unconstrained simple day-to-day routine, with neither balls nor society life.

Since the middle of the 1920s, his participation in the Surrealist movement had been experienced against the unhappy backdrop of a conjugal life that stood in contradiction to his artistic milieu. The "Marie-Thérèse period," from 1931 onwards, marked Pablo's return to the connected worlds of emotion and creation.

Just as he had portrayed his little boy in paintings fourteen years earlier, his tenderness towards little Maya was reflected not only in his canvases but also in his poems and letters. During the few months of 1935 that he was denied access to his studio, writing replaced painting. My mother owns these countless intimate pieces of writing, which are enough to contradict the reputation of heartlessness that some people have preferred to assign to him. Brigitte Léal describes Maya, comparing her with Pablo, as a "blooming child, brimming with vitality, who has her mother's blonde hair and blue eyes but who resembles him to a striking degree, (and) who will remain his most faithful accomplice. And, just as he had incarnated the beginnings of his clandestine relationship with Marie-Thérèse through still lifes, scoring their intertwined initials with scissors, so he signaled his daughter's presence at their side by little signs evocative of their shared tenderness.... Throughout Maya's early childhood, he would continue to keep a sort of journal, by way of notebooks full of drawings, describing day by day, sometimes hour by hour, and at close range, the changes in the little girl. The pages unfurl a succession of astonishing rough sketches, sorts of flashes in which Picasso tries to capture the moments of a life that is growing and slipping away and being transformed second by second. We see her asleep, sucking her thumb, dreaming, or bursting into laughter, in all her physical and emotional intimacy; a little blonde tornado issuing from her parents...."[16]

Pablo created an impressive quantity of drawings of Marie-Thérèse and their daughter, then of Maya alone, as a nursing baby or a cheerful little girl. There were the sumptuous *Motherhood* (1935–36), then the chronicle of a happy childhood: *Maya and the First Snow* (1936), *Maya with Red Apron* (1937), *Maya with her Puppet* (1938), *Maya with a Boat* (1938).

16 Léal 1996.

And yet, through the way in which he depicted my mother's face on the canvas, I have always discerned his anxiety and his own fears—the divorce that was dragging on, the seclusion forced on him by a companion and child he could not acknowledge, and about whom he worried, the fascist turn in Europe, in short, this world that would be knocked off balance and to which he felt himself an involuntary hostage.

When war was declared suddenly, in September 1939, Marie-Thérèse and Maya were on holiday in Royan, and would remain there until the spring of 1941. Pablo told Marie-Thérèse nothing of Dora (his mistress since the summer of 1936), and generally kept the latter in a state of total compliance (including when it came to Olga). Pablo needed both women.

On the beach, Maya played with Aube, the little daughter of Jacqueline Lamba and André Breton—the founder of Surrealism—to whom Pablo had recommended Royan. After the armistice in June 1940, out of a situation of total collapse, the general situation started to stabilize. My grandfather organized the return of my grandmother and their daughter to Paris, to the new flat at 1, boulevard Henri-IV, at the tip of the Île Saint-Louis. My grandparents' relationship had lasted fourteen years by this time. Marie-Thérèse had her instincts nonetheless. Pablo could not lie to her about his new situation. She finally learned the details of Pablo's love affairs: she realized that she would have to share him from now on, but that she was his priority. She had her territory. In addition, she could visit Pablo when she wanted to at his studio in the rue des Grands-Augustins. Dora, for her part, knew that, in spite of all the love she thought she got from Pablo, his true passion was for another.

Maya was brought up on the "fiction that it was her father's work that made him unavailable,"[17] as Françoise Gilot would later recall. I have noted the extent to which the existence of Marie-Thérèse and Maya was a secret at that time. My grandfather created his own world for himself and Marie-Thérèse; he erased any difficulties from it, and my grandmother wrapped herself up in it, fearing it might vanish. Pablo was the driving force in her life, just as she was the mainspring of his art. This natural innocence turned gradually into a sort of irresponsibility, an aberration in those times of war. Marie-Thérèse did not look any further: "We were happy, there you have it!" she would declare to Pierre Cabanne.[18]

Paulo got to meet his half-sister Maya when he was twenty-four years old. He was indescribably happy about it. Had he really been taken in all that

17 Gilot and Lake 1964, p. 241.
18 Interview with Marie-Thérèse Walter by Pierre Cabanne, April 13, 1974.

time? My mother Maya recounted this troubling anecdote to me: "What's astonishing is that on the day I was born, on September 5, 1935, Paulo gave our father a bouquet of flowers even though, apparently, he was unaware of his liaison with Mum, even less of the fact that she was expecting a baby! Not really knowing what to do with the bouquet of flowers, my father offered it to my mother saying to her, 'Here, this is funny. Paulo knows nothing. Maya's just been born and he's given me these flowers!' They never understood." Paulo, perhaps, had.

Having been sent to Switzerland by Pablo during the war, Paulo worked at the "Bureau de coordination des œuvres en faveur de la France" (an office for humanitarian causes) at the French embassy in Geneva. He lived in the rue de la Cité and spent time with a certain Erica (the third Christian name that he would give his daughter Marina), staying there until the dissolution of national service in October 1946. During this period, he made several round trips to Paris on his motorbike following the liberation of the capital. It was on one such occasion that he would be introduced to Maya. He was then transferred to an administrative post on the Quai d'Orsay, where he worked until the beginning of the 1950s.

"Officially," my mother continued, "Paulo and I met one another right at the end of the war in 1945. I was almost ten years old. And I was very proud of having a very big brother! All of a sudden, he was told that he had a little sister. He was very happy and didn't stop congratulating me on being the first to go to school...." According to her, if Pablo had decided that his two children should meet one another, it was because it was the end of the war and people were happy. "There was to be a clean slate and the kids were to get to know one another. Paulo took it very well. He was very happy to have something of his own at last. He took me all over the place on his motorbike," she remembers still.

From this point on, Paulo would write her postcards from wherever his outings in Paris took him, always signing them "Your brother Paulo." He had discovered this word "brother" at the age of twenty-four and was making up for lost time.

Maya took her first communion as part of what resembled a perfect family: her father Pablo, her mother Marie-Thérèse, and her grandmother Mémé, her brother Paulo, her maternal aunt Geneviève, and the Spanish first cousins Javier and Josefín Vilato. It was a delightful day, and Pablo appeared to be relaxing, at last.

Contrary to one of the scenes in *Surviving Picasso*, in which Olga slaps Marie-Thérèse, there was never any such scene between them, since they never met. So there was no suffering there for either Paulo or Maya, which explains their very great spontaneous and reciprocal affection. No news-

paper at that time published photos of Picasso's double life. When Olga learned about it from her own son, there was no public humiliation. Moreover, she remained indifferent: wasn't she still "Madame Picasso"? My grandfather never wanted to hurt Olga, nor Paulo, nor Maya.

While the existence of Marie-Thérèse and Maya was always shrouded in silence, this would not be the case of the new liaison between Pablo and Françoise Gilot, which came to light after the war.

The media age had arrived. Magazines all around the world showed photos of Pablo Picasso on the arm of a very beautiful young pregnant woman, then introducing himself to journalists as the happy father of a son, Claude, and finally of a daughter, Paloma. Before the war, no one knew whether Pablo had a son or a daughter, and then here he was with two small children at his side. All the press had to do was to help themselves to the inexhaustible well offered to them by Pablo the personality: genius painter, world celebrity, multimillionaire communist and a father at sixty-eight. Love, talent, glory, money, and this virile ardor alongside a young, intelligent, and cultivated beauty. It was a dream for the paparazzi.

CLAUDE AND PALOMA

The relationship between Pablo and Françoise Gilot, begun back in May 1943, was expressed in a rediscovered *joie de vivre* after the war, shared by the artist and the entire world. The natural conclusion to this euphoric climate was the birth of Claude, on May 15, 1947, followed by that of Paloma, on April 19, 1949.

Since 1946, as we know, Pablo had been making frequent return trips with Françoise to the Côte d'Azur: to Juan-les-Pins, Ménerbes, Vallauris, Golfe-Juan, and Antibes. At the Château Grimaldi in Antibes, he painted *Joie de vivre*, a symbol of the new peacetime world, which is there to this day. Finally in 1947 he moved to Vallauris, into the villa La Galloise, which belonged officially to Françoise, and into the studio Le Fournas, before setting himself up in 1955 in Cannes, where he bought La Californie.

Family plenitude. He has introduced Paulo to Maya, and Françoise introduced the two older children to their younger siblings, Claude and Paloma. In her book, published in English in 1964, she related how it seemed normal to her to have this odd kind of family live together: "When Marie-Thérèse and Maya came to the Midi, Pablo continued to visit them twice a week. In the summer of 1949 I asked him, since they were at Juan-les-Pins, why he didn't have them come to the house. I wasn't being naïve in suggesting this.

I saw no reason why Maya shouldn't be brought together with her half-brothers, Paulo and Claude, and half-sister Paloma ... all she had to do was pick up a copy of *Match* or one of the papers to see her father rolling around on the sand at Golfe-Juan with his present family. But when Marie-Thérèse saw that I was glad to have her come with Maya from time to time my relations with her became more relaxed."[19]

Maya has described her first visit to me, one that was traumatic for her. Claude and Paloma were the living proof that the miraculous cocoon that she had believed in, made up of only her mother and her father, had ceased to exist. Even though still young, she quickly realized that the children were vulnerable, being confronted with inexplicable tensions between Pablo, Olga, Françoise, and a whole court that changed sides according to the latest dispute. So she decided to protect them in her way, to take care of them, like a nanny, and if possible to temper the general atmosphere: Françoise would thank her later for her kindness.

There are many photos of these family years. Pablo did not tire of displaying himself as the patriarch surrounded by his four children. Paulo, now an adult, had rediscovered his father after all these years. He was suddenly the eldest of a large family of whose existence he had had no inkling. Maya had become their father's privileged confidante.

Claude and Paloma, in turn, were an undeniable source of inspiration. Pablo, now almost in his seventies, rediscovered in them an image of innocence. He loved, then, to spend time with the children. Inès Sassier, his housekeeper, resident administrator even, and the irreplaceable witness to almost forty years of my grandfather's life, told me this.[20] He discovered in them spontaneity, the immediate grasp of things, and the natural intuition that are at the heart of his own work. "I do not seek, I find." This famous declaration of his, truly characteristic of his personality, illustrates the present account perfectly. Inès's son Gérard, born in 1946, belonged to the group of children. "Picasso," he remembers today, "would sometimes stop painting, and we would talk around the table or we would paint, all together.... He would make us cut-out figures. With the children, he was like a child himself too. He would put himself on the same level as us." The truly beautiful portraits of Claude and Paloma testify to this happy atmosphere: *Claude*

19 Gilot and Lake 1964, p. 241.
20 Picasso met Inès Sassier on the road to Mougins when she was nineteen. She became a life model, then his housekeeper in Paris in the rue des Grands-Augustins, in 1937. She was resident administrator there, and joined Pablo regularly during the school holidays in Cannes and in Mougins to continue her service. With her son Gérard she took care of the entire process of moving from the studio and flat in the rue des Grands-Augustins when they were turned out in 1967. She went back to live in Mougins with the family and remained in Pablo's service until the beginning of the 1970s, before retiring. She died in April 2002.

with a Ball (1948), *Claude and Paloma Playing* (1950), *Claude Writing* (1951), and *Claude Drawing with Françoise and Paloma* (1954).

My grandfather would observe the children's games and their artless gestures in minute detail; he was like a camera lens getting up as close to them as possible in order to capture the moment. Didn't he once say that it took him sixty years to paint like them! In addition, he would construct little objects for them, figurines made out of wood, cardboard or material, crafted in minute detail and with great affection. Pablo would always spend time with Claude, Paloma, their friend Gérard, who would join them in 1955, and Cathy (the daughter of Jacqueline Roque, Pablo's future companion). But wasn't this also in exchange for the children's toys he would pinch from them: little cars, a van, a horse on wheels ... so many beautiful objects that would be used for wonderful sculptures and other unexpected constructions?

Brigitte Léal notes how even Cocteau could not get over it: "What happens when he touches one of his son's toys? It's no longer a toy. I have seen him manipulate a yellow cotton-wool chick like the ones you buy at the fair, talking all the while. When he puts it down on the table, this chick is a Hokusai chick...,[21] his genius in putting things together and dabbling in everything would find a new youthfulness in this daily artistic companionship. With one cut of the scissors, he would invent delicate mobile sculptures out of paper[22] (*Woman with Outstretched Arms*, 1961) and works in linoleum (*Dancing Harlequin*, 1950). And then, some really funny beast would take shape under his fingers, made out of forks and matches (*The Crane*, 1951), or indeed there were his son Claude's little cars that provided the material for the head of *La Guenon and her Son* (1951), one of the most formidable mother-and-child depictions ever created."[23]

These incredible reconstructions followed the no less remarkable *Young Girl Skipping* (1950) and *Pregnant Woman* (1949–50, the original cast of which was acquired, moreover, at the end of 2003 by the Museum of Modern Art, New York).

The departure of Françoise Gilot, with Claude and Paloma, at the end of the summer of 1953, was a terrible blow for my grandfather. "They're taking my children from me," he complained. They did, however, come back regularly: at Christmas, Easter, and during the long summer holidays. Pablo loved the children and loved to play with them. Sometimes, nonetheless, Pablo would

21 Katsushika Hokusai: Japanese painter, designer and engraver (1760–1849). He made studies of animals, and inspired Degas, Gauguin, Van Gogh, and Toulouse-Lautrec.
22 Picasso would make these sculptures out of paper and his friend, the collector Lionel Praejer, would reproduce them in metal, which Pablo could choose whether to paint or not.
23 Léal 1996.

simply say hello to them before going back to his studio on the second floor. He would shut himself away for the day, called on by other deities.

Jacqueline Roque appeared on the scene from 1954.[24] Her daughter, Catherine Hutin, known as Cathy, and born in 1948 during her mother's first marriage, became part of the gang. Gérard Sassier, whose godfather was Paulo, recalls the way they would sometimes call the children, "they would say 1946, 1947, 1948, 1949.... When we were at La Californie, there were no differences; we all sat together around the table, at midday, in the evenings...." 1946 was Gérard, 1947 was Claude, 1948 Catherine and 1949 Paloma.

In addition, there were Paulo's children, Pablito and Marina, who lived a few miles away. They were the innocent victims of their parents' turbulent divorce, finalized in June 1953.

Still, it was through Pablito that Pablo became a grandfather for the first time. In the autumn of 1949, Paulo took a series of photos, all on the same day, in the same place, at the foot of the steps up to La Galloise in Vallauris, capturing a curious bunch of kids: Pablo holding his own daughter Paloma, born the preceding April, her cheeks chubby (making her portraits an artist's dream); Paulo himself, holding his own son Pablito in one arm and his own half-brother Claude in the other—a nephew and his uncle almost the same age. Pablo was jubilant. His great pride was to still belong to the category of reproductive males.

Paulo and Émilienne's second child was their daughter Marina, born a year later, on November 14, 1950, six months after they were married. Curiously, Paulo did not bring her to show his father. The relationship between the couple at that time was very difficult and, a few weeks after Marina's birth, they were in the process of separating. It was only several months after her arrival in the world that Pablo was to meet his granddaughter. My grandmother, Marie-Thérèse, who divided her time between Paris and Juan-les-Pins, had become friends with Émilienne, who lived in Golfe-Juan, below Vallauris. Once, at Easter, while walking on the promenade by the side of the beach with Émilienne and her daughter, Marie-Thérèse caught sight of Pablo in the distance. Quite naturally, she called to him, and was keen to introduce Marina, "Here, let me introduce you to your granddaughter!" Paulo had not yet told Pablo.

And besides, in that spring of 1951, Paulo and Émilienne were already no longer living together.

Later, during the summer of 1955, Maya would ask Pablito and Marina, Paulo's children, to come to La Californie to meet Claude and Paloma. Maya

24 She would become Pablo's official companion in 1955, and then his wife in 1961.

considered it normal that children of the same age and of the same family should get to know each other and spend time together. Following his separation from Émilienne, Paulo had completely cut the ties between his children and his father's universe. He probably wanted to avoid anything that might get in the way of divorce. Émilienne had a tendency to hold forth in public on her imaginary relationship with her (ex-)father-in-law—a tendency that her daughter Marina would describe in great detail later.[25]

Paulo preferred, then, not to feed the gossip. The fact that Pablito and Marina were experiencing the customary fate of children of divorced parents, that is as victims of their parents, saddened him. But that was the way it was. And then, was it not the case that Émilienne had demanded that her (ex-)husband undergo a psychiatric examination to "determine whether the interested party should or should not be considered of sound mind"?

At the end of the summer, having observed and often appeased this emotional circus, Maya decided to leave what had become Picasso's universe. Unexpectedly, since she was now an adult but also a woman, Maya was her father's confidante, almost like a lady's companion that he took everywhere. But Maya understood that her freedom was at stake. She had to find her own feet. Since she was used to not depending financially on her father, her decision was feasible: "It's over now. I won't look after your children any more! I'm going to have children of my own." Pablo, half credulous, replied then "It's not possible! How can you leave me!" Maya nevertheless left for Spain to join her cousins in Barcelona. Gradually, the geographical separation distanced her from her father, but they still stayed in contact. The deed was done. Pablo would get used to living without his daughter. From now on he had Jacqueline. My mother's worry about losing her freedom would transform into a veritable phobia of complicated relationships and dependence. She would get married and gradually build her own world, far removed from her father's emotional life. Marie-Thérèse and Paulo would keep Pablo up-to-date with what was happening to Maya, Pablo proudly gathering up any news. He would learn about my birth, that of my brother and that of my sister. He would appreciate the photos. Nothing more. The habit of distance would settle. And it would last. Jacqueline would organize a new daily routine. Maya too. Each of them would be happy. My grandfather too… in his studio. No one would suffer.

Jacqueline and Catherine

Pablo Picasso had met Jacqueline Roque in 1953. From the following year, his visits to Jacqueline were more frequent, but remained discreet. After

25 Marina Picasso and Vallentin 2001, pp. 20–1.

Olga's death in February 1955, and after Marie-Thérèse had turned down, rather logically, his unexpected marriage proposal, he was a free man.

From then on Pablo lived with Jacqueline and her daughter Catherine. Jean Leymarie, whose two daughters were very friendly with Catherine, has told me how they would often go to Picasso's house to play: so the children's ballet continued to resound around Pablo. "He adored children," Leymarie clarifies again, "there was a sort of complicity there and he himself had a childlike character when he played with them, in the best sense of the word of course, as in great spontaneity and a constant desire to play." Catherine would always remember having received the love of a second father who was around and attentive, worrying if she did not come home in the evening at the agreed time. She found in him quite the opposite of the possessive and authoritarian Andalusian father...."

If Françoise Gilot's departure had been a trial, so was the fact that the children were growing up and drifting away; but the devil take *pater familias*! At almost eighty years old he was rediscovering the reflexes of a young lover with Jacqueline—his muse, his companion, and already an attentive mother—a relationship which, on many levels, seemed to turn back time. Currently alone—and faced with Pablo's overloaded past.

After the children had gone off to school, Pablo found inspiration in the works of artists he had formerly copied in Madrid: Murillo's *Los Bobos* and Velázquez's *Las Meninas*. Jacqueline would tell André Malraux later: "Pablo had a score to settle with them." They would not have any more children.

Pablo, now living with a new and pretty woman, had to work around Paulo, Claude, and Paloma, as well as a crowd of people—anonymous admirers, friends, journalists, and experts. And he no longer had the time. In addition, he would avoid debates, often responding absurdly to the questions he was asked, to put an end to all the useless chattering.

He married Jacqueline in March 1961, a few months after my mother married my father in 1960. I was the firstborn from this union—followed by my brother Richard and, much later, our sister Diana.

We discovered that Picasso was our grandfather quite naturally, via the walls of the house. We were too young then to ask questions or to interrogate our grandmother, this Marie-Thérèse in the portraits, whom we called "Baba" and who never came to see us with her "husband."

I remember a happy and studious childhood, which unwittingly prepared us for the tidal wave that followed my grandfather's death. Our parents brought us up to respect values such as school, work, and the recognition that comes with mutual affection. This reassuring, uneventful, daily life

kept us safe from the torments of grown-ups, in complete ignorance of the legal complication that was, at that time, the Picasso family.

Rebuilding the Family

Pablo Picasso had four children: that is a fact. How many postwar articles related the movements of Paulo or Maya, here or there, in France or in Spain? How many others, too, celebrated the births of Claude and Paloma?

However, things are neither as simple, nor as pretty and colorful, as on the picture rails in the museums. The difference for us was that everything, or almost everything, was made public. With "almosts," with little errors, and sometimes enormous ones, a legend was created around Picasso the man, further adding to a genial incomprehension of the artist. For many journalists, the more complicated it was the better.

Legally married to Olga, Pablo Picasso restructured his life as he saw best. He had wanted to get divorced and had not been able to. He wanted to marry Marie-Thérèse, which was not possible. This, *ipso facto,* prevented him from legally recognizing Maya.

Until the reform of the Filiation Act of January 3, 1972, effective from the following August, it was impossible for a married man legally to recognize a child born out of wedlock. This was the case of Pablo: married in 1918, officially separated in 1935, but still "legally married" to Olga in spite of the separation judgment of 1940. So in 1935, when Maya was born to another woman, he was a married man, and he was still married, to the same woman, in 1947 when Claude was born and in 1949 when Paloma was born. Picasso's illegitimate children were all born in a legal context of adultery and qualified, therefore, as "children born of adultery." The word "adulterous" appears incongruous here when it is realized that any relationship between Olga and Pablo had as good as ceased prior to the births of Maya, Claude, and Paloma, but that was the law. Pablo could not escape it. Neither could they.

Moreover, legally married at the time of their respective births, he could not even, according to the law prior to 1972, legally recognize them on Olga's death in 1955, which nonetheless freed him from the bonds of this marriage. Quite simply the process did not exist. He would have had to remarry. He proposed, then, to my grandmother, but she politely refused him.

The Napoleonic code was particularly inhuman on this point. It barred a child born of adultery (though innocent of course) from seeking out paternity, and barred a married father from potentially voluntarily recognizing that child. For good measure, the latter was forbidden any generosity to the

"child of sin," either through a settlement or a will, and this even extended to the available discretionary portion of the estate![26] The father could include his dog or the Army in his will, but not his biological child. A child born of adultery was considered guilty even though it never asked to be brought into the world. It alone had to suffer the consequences of its parents' actions.

This situation did not affect only three little Picassos. More than two million children, in 1972, were suffering as a result of the same peculiarity.

The civil code did, however, grant a child born out of wedlock the possibility of receiving maintenance from its adulterous parent, but for all that this maintenance did not establish any kind of parental bond. Moreover, the legislator had foreseen everything. He disallowed the child from any attempt to have his or her parentage legally recognized during a maintenance claim.[27]

The law aimed deliberately to avoid "scandal." The child was outlawed from society, and the married father remained sheltered from any turmoil ... (this was the same in the case of a married mother, a much rarer occurrence, but whose child, if conceived with someone other than her husband, was automatically considered her husband's child). Hence the vogue for ancillary love affairs. Hence the infamous cases of the child born to the housemaid.... Men had nothing to fear, no scandal, and no patrimonial risk.

Few people today understand how abominable the law was for these children, who were victims even if they had been conceived through love. We can also imagine the psychological problems that afflicted certain children following the discovery that their father had conceived other children "elsewhere," having only the superiority of being labeled "legitimate" with which to console themselves. We need only reread Maupassant's *Pierre et Jean*.

The law of December 21, 2001, which granted equality to all children from then on, whether legitimate, illegitimate (the term "born of adultery" disappeared from the civil code in 1972; it was then legally called "natural"), or adopted, reinstated relationships founded on love and no longer only on the right to a future share of the estate.

The law prevented Pablo, then, from legally recognizing Maya, Claude, and Paloma. Even after the 1972 reform, Pablo could not acknowledge them spontaneously. It was necessary to go through the judicial process of "seek-

26 This refers to part of the inheritance that does not pass obligatorily to the children: that is half in the case of one child, a third in the case of two, and a quarter in the case of three or more.

27 Former Law of July 15, 1955, art. 342, 3rd paragraph.

ing paternity." What did it matter? He had wanted them, just as he had wanted his son Paulo, his only reputedly legitimate child, and, if the law would not bring them together then love would be their bond.

Pablo Picasso did not want only Paulo, the sole child conceived within the framework of his marriage, and he did not "pick up" three kids by mistake. We need only consider the artistic inspiration that each birth motivated. Picasso's four children all have the same "artistic legitimacy." All the art lovers in the world know that.

It is also evident that Pablo was in scrupulous and determined control of everything, including his lineage—just like his artworks.

"For him it wasn't an unusual situation," Pierre Daix has confided to me. "The fact is he had children, just like that. He had his wife, Olga, whom he could not divorce, who lived until 1955. I don't know whether under other circumstances he would have married Marie-Thérèse, but he couldn't. Likewise, he couldn't marry Françoise Gilot. Olga died after it was over with Françoise. And I think it didn't come into the equation, for him, especially with the environment that your grandfather had lived in all his life. It was of no importance whether the children were legitimate or illegitimate … they were children! There was no difference between Paulo and the others."

And this historian, my grandfather's friend, adds, "it never occurred to him, except for administrative documents, that Paulo was his only legitimate son. I believe that, day to day, it just never occurred to him. Maya was his daughter, Paulo was his son...."

Monsieur Armand Antébi, a solicitor in Cannes and Pablo's lawyer, has confirmed to me that my grandfather simply left the matter up to the law. The law told him that his children Maya, Claude, and Paloma were considered as children born of adultery because he was already married when they were born. Very well. He would say, then, that he was the adulterous father of his three children. His respect for the framework of law in general allowed him to ridicule anything hypocritical. Besides which it created no distinction for him day to day. Paulo was his legitimate son; he would not love him any more or less than the others.

It could never be said that Paulo took the least advantage of his "legitimate" status: he never reveled in it. What would have been ridiculous at the family level would have been so on a moral plane too: in fact Paulo had real moral sense, and he would never reproach Maya, Claude, or Paloma over a situation for which they were not responsible. Moreover, when Pablito was born at the beginning of May 1949, Paulo was not yet married to Émilienne

and Émilienne was still married, and had been since October 1944, to a man called René Mossé, who owned a pottery studio in Vallauris.[28]

Émilienne met René when he had just left his wife, shortly after the birth of their fifth child Daniel in 1935. At scarcely twenty years old, Émilienne had therefore found herself "mum" to five children, none of whom was her own. She took on this task with great courage, bringing them up unhesitatingly as her own and so protecting them, as well as her husband, during the war. Living in Marseille, she officially took over management of René's small masonry business: he, as a Jew, then being at the mercy of the Gestapo.

Having made it through the war, Émilienne decided to live her life to the fullest rather than just endure it but, with René's agreement, she kept the little last-born Daniel, whom she had "received" when he was only fourteen months old. The young boy called her his real mum then, and always would.

This young, very self-assured woman met Paulo, five years her junior, shortly after his return from Switzerland. She became pregnant in the summer of 1948. As she was still married to René, Émilienne was in an adulterous relationship with Paulo in the eyes of the law. Worse, her unborn child was legally considered her husband René Mossé's child and not Paulo's. So Pablo junior, soon known as Pablito to avoid confusion, was born a child of adultery. Émilienne secured a divorce a few weeks later, at the end of June 1949.

For a year Pablito remained their illegitimate son, until their marriage on May 10, 1950, when she was already expecting another child, Marina. It really could be said that our family has experienced every possible situation known to law. This new and very rare one illustrates that even Paulo, the legitimate child par excellence, made free with social conventions.

As for little Daniel Mossé, aged around fifteen when Pablito and Marina (in his heart his brother and sister) were born, he was a privileged onlooker to the romance between Paulo and Émilienne, and then to a new family but also to terrible arguments, including those between Paulo and Paulo's own mother Olga. He would stay close to the little ones, even after Paulo and Émilienne's separation in the spring of 1951. Several years later, having left home to start his working life, he would still come back regularly to visit his "mum" and the children. While we are on the subject, we have no choice but to observe how Marina totally "eliminated" the young Daniel from her personal accounts in each of her two books,[29] even though

28 Marina Picasso and Vallentin 2001, p. 21.
29 Marina Picasso 1995, and ibid., pp. 20–21.

Daniel's presence, far from being episodic, was part of her daily life for a long time, and even though, thanks to his age at the time all these things were happening, he possesses a lot of very precise details on the events and personalities she narrates. He knows a great deal, then, that could usefully corroborate or dispel so many things. Marina used to call him "my brother" when she talked about him. How curious, then, to have wiped him out of the story like that.

Paulo would reiterate the principle of free love with Christine, his second companion, and the birth of his second son Bernard in 1959, only marrying the child's mother three years later. Given that he was not concerned about having illegitimate children, ostracizing his brother and sisters would have been an infamy he would never have have dreamed of.

During proceedings to acknowledge the parentage of Maya, Claude, and Paloma, which quite naturally followed the 1972 reform, Paulo would prove his great integrity. He never contested the parentage of his brothers and sisters—he could have been tempted to do so, considering his part of the inheritance, greatly compromised by the arrival of three supplementary heirs. Once again, love triumphed over questions of legitimacy.

The issue of Pablo's children took on a new dimension when my grandfather died in April 1973. It must come as a surprise, when you are the child of one of the most famous men in the world, for the law to suddenly care about finding you a father. And for it to even have to look!

But the farcical aspect of the legislation did not stop there. It was funny in one sense. Yet in danger of becoming repellent.

The whole world had seen the proof of Pablo's paternity via a string of news reports. But Maya, Claude, and Paloma could only be acknowledged in law by their own mothers, since their father was married to another woman. They were considered as born of adultery if, and only if, the father could be identified—which, however, the law forbade!

I must insist on this point: the child could have possessed all possible evidence, but the procedure did not exist and none could be initiated. The parent could be publicly identified, as was the case with Pablo, a most illustrious father, but he could not become the official father to his children under the law, even if there were a general consensus (which might have included the concurrence of the apparently "cheated" wife or might follow her death). The case was "illicit."

Furthermore, as I pointed out earlier, the law prevented the parent from naming any children born of adultery in his will, even with respect to the

available discretionary portion of the estate, and even in the absence of legitimate heirs![30] Otherwise, the will was declared null and void.

The only real hangover from all of this now was Marina, repeating incessantly that she is "Picasso's only legitimate granddaughter," and reproaching Maya, Claude, and Paloma for being illegitimate children and for having been legally recognized only after a judicial process. This process was obligatory and unavoidable yet she has often labeled it, curiously, a "long battle." That was never the case: no one opposed the principal of their paternity— neither Paulo, her own father, nor Jacqueline, Picasso's widow.

To reproach children for being illegitimate, to make them out as guilty when in fact they are victims, is unbelievable. In line with her previous interviews, Marina declared again in an interview in the autumn of 2001: "I have nothing against the fact that those of Picasso's children that were born of adultery take his name, but at least they should know to keep their place!"[31] What an incredible declaration! Didn't the term "born of adultery" disappear from the civil code some thirty years back, doing away with any notion of blame on the child's part (which in any case was an aberration)? We cannot reproach children for the circumstances of their birth. What should Gaël and Flore, Marina's son and daughter, think? Their father, Dr. René Abguillerm, was actually still married to another woman when they were born (in 1976 and 1978 respectively), as he himself has disclosed.[32] Is this a problem, is it really a problem? Should they be reproached for it? Fortunately the new law of 1972 meant that they were not deprived of a father. The new law allowed Dr. Abguillerm to recognize them legally. They had an identity at least, a mother and a father. It is up to them, subsequently, whether to live with or without them.

It was the law that deprived Maya, Claude, and Paloma of a legal father. And it was the law that gave them this back. This was a time when unmarried mothers were vilified. Fortunately, they are known as single mothers now. In any case, the European Court of Human Rights today sanctions any such linguistic deviations.

And what reasons does Marina have for choosing to proclaim her legitimacy for so long, when everybody is in perfect agreement about it? She is Paulo's legitimate daughter, who is in turn Pablo Picasso's legitimate son— in effect the judicial concept of a legitimate granddaughter does not exist. Should only "Picasso's legitimate granddaughter" have the right to talk about a grandfather that she knew so little and so poorly?

30 Former article 762 of the civil code.
31 *Madame Figaro*, no.17778, October 6, 2001.
32 *France-Dimanche*, December 21–27, 1991.

Picasso was perfectly aware, then, of the legal situation that his perennial marriage caused. Nonetheless, he would not renounce living and loving elsewhere.

He had even imagined, quite absurdly, that he could marry Maya, since he was not legally her father and since, according to him, "that would really annoy everyone." Revolutionary, and pure "Picasso"!

Because of the constraints of the law, in 1955 Pablo Picasso became Claude and Paloma's surrogate guardian, as designated by a supervision board, even though he was their biological father, and not one single person contested it. There can be no ambiguity about his resolve to exhaust all legal possibilities in a bid to declare himself however he could. The same step did not mean much for Maya, since she was already twenty years old.

As Claude and Paloma still had their mother, Françoise, Pablo could not be their guardian but, failing this, their surrogate guardian, legally appointed to substitute for their mother in case something should happen to her. For the record, Pablo and Françoise, having separated in 1953, maintained a dispassionate and responsible relationship. Didn't Pablo say to her, in 1954: "The reward for love is friendship"?[33]

Then, following an amicable agreement between Pablo and Françoise, and with Paulo's formal agreement, which is very important, an application was made to the French Minister of Justice, and published in the *Journal officiel* on May 12, 1959, to change Claude and Paloma's names. Pablo requested that they be allowed to take his name. Under the terms of this process this same *Journal officiel* proclaimed, on January 10, 1961, that Claude and Paloma would thereafter take the name Ruiz Picasso—the name of their surrogate guardian who was, by public notoriety, their biological father but not their legal father.

Only Marina persisted obstinately in believing and declaring—wrongly—everywhere, notably in her last book,[34] that they had had to "battle" to have the right to take the name, which they only won in 1974. "Battle"? Why? Marina forgets that her own father, Paulo, officially consented to it in 1959 as well ... thus sweeping away any ambiguity himself.

What is more, Pablo had asked Maya to be part of this name change application, so an identical petition was published simultaneously in the *Journal officiel*. My grandfather's lawyer, Monsieur Bernard Bacqué de Sariac, was

33 Gilot and Lake 1964, p. 360.
34 Marina Picasso and Vallentin 2001.

in charge of all three cases. It is one of history's puzzles that he did not pursue Maya's case with the Ministry of Justice and gave the file back to my mother—ten years later—without any explanation. Perhaps the simultaneity of the cases would have jeopardized one. With Maya, Claude and Paloma not sharing the same mother, the French Ministry of Justice might have been worried about too great an audacity (a married father, remarried in 1961, three children, two different mothers....). Avant-garde behavior and scandal were tolerated from an artistic point of view, but were less practiced in the stifled atmosphere of juridical dealings, especially since the very conservative society of the 1960s was a long way from engaging the least reform regarding filiation. The lawyer did not make any comment and did not reveal his strategy to anyone at all. But it gets better. He regularly telephoned Maya, on the pretext that the matter was following its course through the judicial process, from appeal through to final appeal! He carried his secret to the grave.

Only Claude (in August 1968) and Paloma (in February 1971), on reaching the age of adulthood, and in spite of the civil code holding them back, tried to push on against the law. They brought an action in support of "the judicial declaration of paternity outside of marriage." At that time, the process did not exist, nor did any such wording. It had to be invented.

Monsieur Antébi had me read my grandfather's written attestation, dated December 18, 1968, concerning Claude. I noticed the great regularity and energy of his writing—he was then more than eighty-seven years old. In it he denounces the rumor that he "would object to the step" taken by Claude and Paloma, willingly recognizing his adulterous paternity as defined by law. However, on April 4, 1970, in Claude's case, and on November 30, 1971, in Paloma's case, the High Court in Grasse declared, logically, their cases inadmissible since "the principal action seeks to establish an adulterous parentage"—which the law, as we have seen, prohibited. Pablo was declaring his paternity but the judges could not hear him. In response to an appeal against this judgment, the Court at Aix-en-Provence confirmed this rejection, on May 3, 1971, in Claude's case and on November 20, 1972, in Paloma's. Claude's final appeal at the Supreme Court would be rejected on June 27, 1972.

The most infuriating thing is that the Court of Appeals and High Court gave their verdicts in June and November 1972 with respect to the law prior to January 1972—even though the legal situation had been modified from that time on through the filiation reforms, but still it conformed to the law in place at the moment of the initial petition, now obsolete. An idiotic story!

The new law came into effect on August 1, 1972. Picasso was about to turn ninety-one.

In accordance with the unavoidable procedures set out by this great reform, Maya was the first to initiate a case at the High Court in Grasse, on December 13, 1972, to be legally recognized as Pablo Picasso's natural daughter—the term "born of adultery," as we have seen, having disappeared definitively from use. The 1972 law authorized the declaration of paternity on the birth of a child born out of wedlock, even if the father was already married to another woman (or vice versa for an already married woman). It allowed the retrospective regularization of natural paternity, but only through means of a legal action. The possibility of a free and spontaneous act of recognition by the biological father would only be authorized by a law of January 8, 1993! Therefore it was necessary for children to initiate proceedings to establish paternity in order to authenticate their parentage and, that being achieved, enforce their inheritance rights.

Of course, for many people it was the immediate issue of inheritance that stood out in the Pablo Picasso paternity case. He was old, he was rich, and he would soon die. However, establishing lineage is the constitutional basis of the legal protection of people and property under French law and abroad. So unless inheritance is abolished....

On February 8, 1973, two months after Pablo's death, Claude and Paloma each initiated new legal proceedings, with the objective of being declared his natural children.

The reform foresaw a limit to initiating proceedings: a person could be no more than twenty-three years old, the deadline for bringing action being limited to a period of two years after reaching adulthood, which was at that time set at twenty-one (article 340–44, § 3). Maya, Claude, and Paloma were all older than twenty-three. As a result they would remain the children of the artist Pablo Picasso in the museums forever, but not the children of the man Pablo Picasso!

The lawyers immediately criticized this incoherence, and the legislator attached a number of attenuations to it.

At the beginning of 1973, Pablo was living his last weeks as a recluse in the house at Mougins, devoting himself—more than ever—entirely to his work. He had had a bad winter, exhausted by bronchitis. His friend Georges Tabaraud paid him a visit at the end of January, "The sight of him upset me. In three months, the great magician who seemed to be made out of stone, for all eternity, had completely changed. He had become thinner,

the features on his face were emaciated, and age had caught up with his voice."[35]

Pablo, who had a real aversion to public displays, had to sit by unhappily and watch the legal action that his "illegitimate" children had instigated. Monsieur Roland Dumas had explained to him that this was the only way, since the reform did not authorize him to acknowledge them spontaneously and by private agreement.

The circumstance of legal action meant, for him, the public exhibition of family matters. What rumors and gossip would follow. Neither Pablo nor Jacqueline disputed the facts of his paternity but they did take issue with the legal process. Pablo's only reaction was to suggest bringing an action without delay, that is to say more or less turn it over to justice.

He passed away on the morning of April 8.

The Court in Grasse gave its judgment on Maya's petition on June 29, 1973, and rejected it because of her age. What did the real basis of the affair matter!

On March 12, 1974, the same court retrospectively acknowledged Claude and Paloma's paternity. During their failed cases of 1970, 1971, and 1972, Pablo had in any case expressly declared in writing that he was their father. According to this new law (article 12, section 2), a judgment pronounced under the former law would from now on be considered with respect to the effects of the new law. In the decisions of 1970, 1971, and 1972, it had been accepted that Pablo Picasso was Claude and Paloma's adulterous father, but decided that the "action to legally recognize paternity outside of marriage" was in reality a "search for adulterous paternity," a procedure that was forbidden by law—for which reason the pleas were rejected.

However, since the preceding two actions incorporated Pablo's written declaration of paternity then, according to the new law, such a declaration did not have to be "reiterated" but led logically to natural paternity.

Arianna Stassinopoulos-Huffington's biography[36] loses its way in the complexity of the law when it asserts that Claude and Paloma escaped the condition of the deadline of any action by two years because their mother had "registered" them in law before they were twenty-two. Some people, including Marina, as I have said, have propagated the sordid rumor that Maya, Claude, and Paloma had to "battle a long time" to be legally recognized. To

35 Tabaraud 2002.
36 Stassinopoulos-Huffington 1988.

be fair, it must be clarified that they were up against an absolute legal impossibility prior to August 1972 (as was Pablo himself). They were battling the law, not their father!

It took a little over thirteen months for Claude and Paloma to have their parentage legally recognized (and eighteen months in Maya's case). A long battle indeed!

Let us come back to Maya's case.

After the decision of June 29, 1973, rejecting her claim of being "outside the deadline," I remember that my mother took time to reflect before appealing. She had been very upset by the judges' decision and she probably thought her case was hopeless. Her father had just died, and the situation in the media concerning the inheritance was becoming tense. Would she have the courage to take up proceedings again under such circumstances? Her life had been buffeted by the law, yet she had never asked for anything. Just to be her father's daughter, since this was now possible. Just like anybody else.

My mother never showed any great interest in material things—she was, and remains, "the unbuyable Maya," as Pablo used to call her. But following Picasso's death the media practically made out that financial interests were the sole objective in the requests for recognition of lineage. Why, they asked, would one want to be the son or daughter of somebody if not for his money?

Because it is a right, a natural requirement even, to be the son or daughter of somebody. When one experiences the distress of children born under an X (as unknown parents), one understands the need for this recognition.

Monsieur Roland Dumas, on the request of his client Jacqueline, who was disgusted by the court's judgment, refusing to Maya what it had granted to Claude and Paloma, asked Maya to contact Monsieur Paul Lombard, to appeal against this decision. I still remember my mother's hesitation. She was exhausted by putting together the case, providing justifications, and so on, and so on.

A few days before the deadline for appeal, and given Paul Lombard's determination to put up a fight, Maya decided to pursue her case. If she were to be successful, the judgment would be a milestone, indeed would set a legal precedent, and would rectify the perverse effects of the law on hundreds of thousands of anonymous others.

Of course she was also thinking about us, her children, and about this untenable contradiction of always being on the edges of the Picasso family

even while knowing we were his grandchildren. She lodged an appeal at the very beginning of October 1973. Proceedings started up again.

Monsieur Paul Hini, her lawyer, recalls a meeting of the heirs, in the spring of 1974, organized by Monsieur Darmon, the first inheritance lawyer from Cannes. Jacqueline, Paulo, Claude, and Paloma—"freshly" reunited—took part in it and ... Maya, non-suited, but in the process of an appeal.

The meeting testified to the solidity of the family once again. The family "would wait for" Maya, nothing could start without her. In an aside, Paulo even said to my mother that, whatever the results of the action in the courts, "we will find a solution." This one small phrase alone demonstrates what a just man Paulo was, in spite of his reputation for his troubled youth. He loved his sister and, like their father, would make love triumph over "legitimacy."

At the end of this general meeting, without having asked for anything, Maya was given a substantial check, as a down payment on the sharing out of the inheritance, amounting to 100,000 francs, that is more than $73,500 today, even though there was no legal requirement to do this! Everyone already believed in a happy outcome to Maya's appeal.

Paul Lombard managed the whole appeal proceedings, and there was unanimous praise for the case he prepared and his presentations to the court on April 8, 1974, exactly one year after Pablo's death. Monsieur Lombard pleaded, to take the legal term, "possession of status" for Maya. All her life, Maya had held the status of being Pablo Picasso's daughter. All the witnesses and all the proof brought there demonstrated that. However, the legal notion of possession of status was mentioned in the civil code (article 321) only with regard to legitimate children. On the contrary, nothing was prescribed for illegitimate children. So, nothing stood in the way of making things comparable.

This possession of status, he pleaded, was unanimously recognized by all the family members. According to the law, the procedure for establishing paternity identifies the presumed father (indicated by the plaintiff) who is "summoned" to respond to the claim. Because he was dead, it was Jacqueline and Paulo, his heirs, who stood in for him, with Claude and Paloma now at their side, to answer to Maya's claim.

Monsieur Roland Dumas, Jacqueline's lawyer, came to plead in Maya's favor. Pablo was her father: everyone knew that. Monsieur Bacqué de Sariac represented Paulo and did the same, as did Monsieur Bredin on behalf of Claude and Paloma.

The restriction to the procedure linked to age, declaring Maya "beyond the deadline" for taking action had no effect. The law envisaged circum-

venting the age limit, by offering up (article 340–4, paragraph 2)[37] an extension to the deadline of two years in all those cases where the father contributed to the child's needs. (This made allowance for instances where a mother might seek to establish paternity for a child who was still a minor but, fearing the interruption of her maintenance through blackmail, could fail to take action). This short "extended" deadline counted from "the cessation of acts of participation in the maintenance and education of the child." Maya had benefited from such upkeep from her father via her mother Marie-Thérèse's pension. Pablo having died on April 8, 1973, the material support had ended on that date. Maya was within the deadline of two years. So her case was admissible!

Monsieur Lombard's plea made the history books. The "Picasso case," as remarkable as it was, was an exemplary symbol for the new law. The possession of status filled a legal void by making the search for paternity no longer applicable.

The certainty of Maya's parentage offered the court the impossible moral situation of ignoring this case, in which the facts were uncontested, and forced it to recognize the potential power of the possession of status, even though the law made no reference to it.

But the judgment that was returned could not be sustained on legal grounds, and there was a reluctance to set a legal precedent. The judges therefore declared that:

– the possession of status was recognized in Maya's case. It did not constitute a legal state (as a natural child), but was a means of evidence. Her action was not therefore "declaratory" according to the terms of law, but remained an action that sought (!) to establish paternity;

– this action, the attempt to establish paternity, was admissible, by legal exception, because it was exercised within the deadline of two years following the interruption of acts of participation in the upkeep of the child (less than two years after Pablo's death);

– acquiescence to the establishment of paternity was possible at any moment in proceedings.

37 Article 340–4, paragraph 2 of the law refers to the fourth and fifth cases of article 340 ("paternity outside of marriage can be declared in law"—establishment of paternity). So the fourth case indicated: "in cases where the presumed father and the mother have lived in a state of cohabitation during the legal period of conception, implying, if not communal life, stable and continuous relations" (which was moreover the case between Marie-Thérèse and Pablo in 1934–35, the period of Maya's conception). The fifth case indicated: "in cases where the presumed father has foreseen or participated in the upkeep, education or establishment of the child in the capacity of a father" (which was the case via the pension given to Marie-Thérèse up until Pablo's death in April 1973).

Paul, then Claude and Paloma, had assented to this procedure. Jacqueline, Picasso's widow, recognized that Maya had the same rights as Claude and Paloma. Consequently she assented. Everyone had supported Maya in the step she took. So there was no "adverse party." The court thus recorded "the reconciliation" of everybody.

Reconciliation. This word is important.

So on June 6, 1974, the Court of Appeals judges in Aix-en-Provence yielded to the evidence: María Walter, known as Maya, married name Widmaier, should carry the name of her father, Ruiz Picasso.

Specialists in legal principles went ahead with their commentaries. The irony is that I myself would study this famous case, a few years later, on the seats of the law faculty in Aix-en-Provence!

This "long legal battle" was, in fact, just a simple proceedings, lasting less than eighteen months ... the usual time for any ordinary proceedings.

My mother was born a second time that day. And she shared her happiness with all those natural children who, thanks to her case, would be able to gain a new identity. She remained immensely proud of this.

Paul Lombard was jubilant. To re-create his tone then: "The Court proved me right. I want so much to say that I'm as proud as Punch " he confided to me. "I paid a visit to the state prosecutor and said to him: 'This is an absolutely historic decision!' Justice had triumphed; rights had triumphed, but not the law.... In this regard, I went to see a certain number of parliamentary friends to say to them, 'Listen, the law must catch up with rights.' This is how, several years later (in June 1982), Parliament voted on a law to amend the status of natural parentage. This law is the natural daughter of the Court of Appeals in Aix-en-Provence!"

On June 6, 1974, Paulo, up until then the sole Picasso, or at least only in the eyes of the law, thus officially became the oldest brother—beside his father's other children, Maya, Claude, and Paloma.

Unfortunately, this new head of the family only had less than a year to live.

In that summer of 1974, Pablo Picasso's legitimate heirs were finally reunited: his widow Jacqueline and his four children, Paulo, Maya, Claude, and Paloma.

Here was a properly rebuilt family.

My grandfather died, as I have said, during the morning of April 8, the news of his death being broadcast by the media at around one o'clock in the after-

noon. Ever since they had found out he was ill, a number of journalists would telephone the house in Mougins, trying to find out more. A German press agency had once called, and Pablo himself had picked up the phone, "They've just told us that Pablo Picasso is dead. Is he?" To which Pablo replied calmly, "No! Are you?"

Monsieur Antébi had been asked by his friend, the state prosecutor in Grasse, to let him know as soon as Picasso died. The unexpected visit the previous summer of Pablito, Paulo's son, who had got in over the railings—having been turned away at the main entrance—and the media coverage of the court case to establish paternity, were a worry for the authorities, who wanted to avoid any public scandal.

On the morning of April 8, while Jacqueline was still weeping, completely at a loss, Monsieur Antébi informed the chief of police and the Ministry of Cultural Affairs of Picasso's death, then prepared himself to contact the family and close friends. But the media had already taken this upon themselves. Meanwhile, the police had organized a roadblock close to the gates of Notre-Dame-de-Vie.

Paulo, whom Jacqueline had not telephoned, and to whom my mother Maya had not dared announce the news she had overheard on the television, heard the news through a phone call made by someone at Notre-Dame-de-Vie. He went to Paris, and then jumped on the first flight to Nice. He arrived in Mougins towards the end of the afternoon.

He was absolutely calm, next to Jacqueline, who had gone to pieces. She did not want to see anyone, howling as soon as they announced a visitor at the main gate, come to pay their last respects to Pablo. Amongst these "ill-timed" visitors were Manuel Pallarès, Pablo's one-time fellow reveler, who had arrived from Barcelona, and who was turned away, and Georges Tabaraud, the owner of the communist daily newspaper *Le Patriote*, and a faithful political friend. Paulo called Maya back and advised her not to come. Jacqueline was beside herself, and could not be reasoned with.

When they informed Paulo that his own son Pablito was at the gates of the villa, he made the decision, alone, that it was not a good idea to let him in. According to Monsieur Antébi, his bad relations with Pablito made Paulo suspect that he might behave in a way that would be inappropriate given the circumstances, and in front of the media, who were lying in wait. The gates remain closed.

Contrary to what Arianna Stassinopoulos-Huffington[38] has written, taking up Gerald McKnight's assertions[39] to give credence to her vision of a

38 Stassinopoulos-Huffington 1988.
39 McKnight 1987.

universe that she always wanted to be more "sulfurous," Paulo was absolutely not "drunk again." Monsieur Antébi remembers his austerity, befitting the circumstances.

My uncle Paulo perhaps did not fully grasp the distress and psychological instability of his eldest son. Having been turned away, Pablito roamed the streets of Golfe-Juan with a placard around his neck bearing the following slogan: "I am Picasso's grandson and they won't let me into my grandfather's house!"

The much-dreaded scandal was breaking.

Three days later, filled with despair, Pablito swallowed a carton of bleach.

His mother Émilienne Lotte and his sister Marina discovered him lying in a pool of blood.

During the three months he lay dying in hospital, Marina and Émilienne took turns at his bedside, along with my grandmother Marie-Thérèse, who lavished him with every possible comfort, and covered the costs of his hospitalization. Émilienne has paid homage to her generosity, declaring in the daily paper *Nice-Matin* that she survived thanks only to her kindness: "She was admirable. Up until the last moment she did everything to ease my son's suffering. Today, it is she who pays for Marina's studies in England, and who attends to my upkeep. In order to meet all these expenses, she didn't hesitate in selling one of the paintings given to her by Picasso."[40] What Paulo did not give them, my grandmother generously offered. So she sold a little still life of Pablo's for 50,000 francs (that is $42,000 today), and halved the money between Émilienne and Marina, on Maya's recommendation. Her spontaneous generosity was mentioned in *L'Express*: "Moved by their distress, Marie-Thérèse, who is nothing to them, has sold a Picasso painting for their benefit. Finally, a fine act. And a breath of fresh air."[41] Marie-Thérèse's sincere affection is astonishing if we consider that these children are Paulo's, Paulo is Olga's son, and Olga had been the obstacle to Marie-Thérèse and Pablo's union. It demonstrates in any case that Marie-Thérèse harbored no ill feelings towards Paulo, Émilienne, Pablito, or Marina, since they were in no way responsible for the quarrels of the past. Perhaps she had rediscovered in Pablito, or Marina the receptive grandchildren that we never were? Did Marina not call her "grandmother"? She herself used to call Marina her "dear granddaughter."

This emotional imbroglio would probably not have displeased Pablo, reinforcing his idea that a united family has no need of the law. This token

40 *Nice-Matin*, January 19, 1974.
41 *L'Express*, January 14, 1974.

of tenderness led me to believe that we were finally close, since we were "sharing" the same grandmother.

I discovered later that Marina would have preferred that we didn't share the same grandfather!

THE CHILDREN'S CHILDREN

The family's day-to-day life never stops changing.

A few months after the birth of their daughter Marina in November 1950, Paulo wanted to divorce Émilienne. The separation became effective from the spring of 1951. The non-conciliation order was given in September 1952. Paulo wanted to pursue his divorce petition. Émilienne's love life, involving those men whom her daughter Marina will later call her "thugs,"[42] will facilitate proceedings.

The divorce was finalized on June 2, 1953, by the Court of Appeals in Grasse, on the grounds of mutual consent, Émilienne also having filed a claim of adultery against Paulo who, since his separation from his wife, had been living with Kitty, a sweetheart from his teenage years.[43] Moreover, he rediscovered his bachelor habits so quickly that for a long time many people knew nothing of his first two children.

Relations between Paulo and Émilienne would nevertheless worsen even further during this period and would never improve, even though Paulo seemed to be in control of the situation. Pablito and Marina, of whom Émilienne had custody, were the first victims of this. Pierre Daix confirmed that my grandfather detested problems and that, from that time on, he spent all his time working: "If Paulo's having family troubles, let him sort it out. If it's about money, then here it is! But leave me in peace with my work schedule," he said. But according to Daix, "there were his limits; beyond that, the question wasn't raised. If Paulo had brought over his children, I'm convinced Pablo would have gladly seen them." Also, Émilienne's behavior could not fail to worry Pablo, as a grandfather. Perceiving how distressing the situation was, he offered to take the children. He put in an official request, but a judgment (on March 12, 1957) refused him custody and, failing this, ordered social reports, which were followed moreover by a police inquiry carried out at the state prosecutor's request! Émilienne was worried, suggesting that this Picasso wanted to snatch her children from her to send them to Spain

42 Marina Picasso and Vallentin 2001, p. 22.
43 Shortly after his separation in 1951, Paulo had met Kitty, a trapeze artist from the east of France, whom he had known since the age of seventeen, when he escaped from his mother Olga's sight to enjoy himself in Montmartre.

or the USSR. Long before the Berlin Wall, an insurmountable wall was erected between them.

In 1955, events unfolded rapidly. Paulo met a pretty young woman, Christiane Pauplin, known as Christine. He fell in love with and married her. That same year Olga died: Paulo became his mother's legal heir. From that date onwards, he seemed very worried, obsessed with the idea of his father's death.

Pablo gave him the use of the Château de Boisgeloup, which he had assigned to Olga in 1935 (though she had never moved in there), and a few bits and pieces. His life continued between Paris, where he lived and where his wife Christine worked, and the Côte d'Azur, where he went any time his father needed him. After leaving his administrative post at the Foreign Affairs Office on the Quai d'Orsay, Paulo effectively took over temporarily from Marcel Boudin, the driver his father had dismissed in 1953. "I don't know how it happened," Pierre Daix told me, "but once Paulo became his driver, it was exactly as though Paulo had no family." We should be clear, moreover, that contrary to what has been stated before, he was only his father's driver for a year. After that Jeannot, a taxi driver from Vallauris (who owned a Citroën 11cv), was taken on. After him Jacques Baron took over—up until 1970—and then Maurice Bresnu, the famous "teddy." Both men drove a beautiful white Mercedes, even if Pablo preferred to go out for drives in the pretty Alfa Romeo coupé that Jacqueline drove.

Paulo then became his father's secretary. Living in Paris, he could take care of his affairs there, meaning Pablo need never set foot in the capital. It is in this capacity as secretary that Paulo appears in all the official documents. On the other hand, Mariano Miguel, known simply as Miguel, was Jacqueline and Pablo's permanent secretary on the Côte d'Azur from 1968, and also—since they had known him since World War II—their confidant.

Out of Paulo and Christine's peaceful and loving relationship came a child, Bernard, born on September 3, 1959. Christine and Paulo married in March 1962, that is to say a year after Jacqueline and Pablo—which did not fail to amuse my grandfather again, pleased at thumbing his nose at the new generation. A father and his son, both "newlyweds!"

All accounts concur when it comes to Paulo: he was a very kind and spontaneous man, with a simple passion for mechanics, cars, motorbikes, and speed.

The famous art dealer Heinz Berggruen told me that one day his Jaguar broke down in the rue des Saints-Pères in Paris. He was in despair. "Horns were blaring behind me, it had to be pushed towards a corner, and I was useless with mechanics. Then suddenly who do I see turning into the road, by

chance? Paulo! 'Can you help me, I've broken down?' He was great, he took off his jacket, slid under the hood, and set to work tinkering! He was really good at mechanics. I wanted to say to people 'See this boy, he's Picasso's son!' He managed to get the car going again, he was so kind, so kind...." Pierre Daix confided to me that he "could have been a Formula 1 driver in another era." He had been a courier for the daily paper *Ce soir* because he had a motorbike, was very pleasant, and always ready to do service.

The photographer Luc Fournol often went out in Paris with him in the evenings and also considered him to be "very nice." Who knew then that a gigantic inheritance awaited him? He himself did not think about it. He was a happy roisterer, with nothing of the daddy's boy about him—even if materially he depended on his father.

According to Pierre Daix: "He changed the moment he got the inheritance from his mother, in that he became more responsible and anxious." From then on he knew that death really did exist: "Before his mother Olga's death, Paulo was an independent boy, a *bon viveur*, not a worrier at all and ... an excellent driver." He then became a more austere man, his father's death only accentuating this tendency. The great responsibilities that burdened him, which no one imagined to be so monstrous, constituted a test for which he was not prepared. He would be capable, however, of displaying a certain authority and unexpected calm.

His premature death in June 1975 deprived our family of a unifying element.

Pierre Daix once told me a troubling anecdote about him: "Paulo had said to my wife Françoise that he only had one son, Bernard, thus wiping out the entire period of his first marriage to Émilienne and the existence of his first two children, Pablito and Marina. This 'memory lapse' must have had aftereffects on his two children's psychological development." Even if they were not aware of his attitude, Pablito and Marina experienced the real consequences of it.

Daix adds: "When one day the magazine *Noir & Blanc* (which focused on society life and crowned heads) ran a headline in 1975 with 'Bernard Picasso, the youngest multimillionaire in France' or something like that, making out that Bernard was Paulo's only child, Marina's suffering was understandable: she was now alone, without Pablito, who had also died. In the past, certainly, their school friends used to say to them: 'You're called Picasso, but it's not true....' because in fact there was an enormous discrepancy between this famous name and their day-to-day life."

Roland Penrose described La Californie humorously, noting: "The pretentious architecture ... built ostentatiously as a status symbol in the early years

of this century...."[44] Pablo found other charms in it: space and light, its numerous rooms, and its excellent condition. There was neither any work to be done there, nor any particular modification to be made when he bought it on April 6, 1955, for scarcely twelve million old francs (that is about $252,000 today) but the Côte d'Azur had not yet experienced the huge appreciation in property prices of the last twenty years. It had a large main gate and high surrounding railings, the whole lot doubled up with painted metal sheets, so that it was impossible to see anything at all through it. Pablo could enjoy a certain privacy at last, which he had not had at La Galloise in Vallauris.

Lucette and Antoine Pellegrino were its caretakers. Lucette was the official caretaker, assisted by her husband, a horticulturalist who worked elsewhere but devoted his free time to the great house's garden. They had been taken on by the previous owner, Monsieur Bonnet, who had always maintained the great white building. Antoine was born in March 1915, and Lucette in July 1921.

In June 1955 Jacqueline, Maya, and Pablo left Paris and settled in Antibes, in the Ziquet villa[45] (which Jacqueline had bought for life and where her "assignee" and some thirty dogs stayed on). They awaited the arrival of the furniture from Paris before moving into La Californie. Lucette told me, with all the vitality she has maintained to this day, about the life of the household in 1955 during that first summer. There was Pablo, with Jacqueline, his companion since the year before when they had met, Paulo, Maya, and the little ones, Claude and Paloma, as well as Cathy, Jacqueline's daughter, who had come to join them for the school holidays. And of course there was Lucette, ever discreet, permanently in control of the comings and goings at the main gate, helped by her husband in the evenings and at weekends. They absolutely never left the house, where they lived with their son Gabriel.

PICASSO AND HIS CLAN

The youngest ones played together in the garden. Emerging from his studio, Pablo drew with them in the house, at a large round mahogany table. Often Pablo joined Claude and Paloma in their bedroom on the first floor, creating little objects with them. They advised one another and each drew inspiration from the other ... even Pablo.

At the bottom of the garden there are a small, classical, ceramic woman's head, some stone columns, pompously known as "the open-air theater,"

44 Penrose 1965, p.15.
45 Pablo's first portraits of Jacqueline bear the mysterious title *Madame Z*, the first letter of the villa's name.

and a little house, on the right—a "hunting lodge" as the last owner used to call it. While they were moving in, the bronze sculptures[46] were left outside but not those made of plaster, such as can often be seen in photos, like *Pregnant Woman* (1949–50), nor others made of clay. These are far too fragile, and were stored inside, where the bronzes would also be taken for good in the autumn.[47] A bronze *Head of Marie-Thérèse* sat enthroned in a little pond on the right-hand side of the garden. At the bottom, on the left, *Man with a Sheep* (1943) is concealed, at the base of which Claude, Paloma, and their cousin Gérard secretly buried their treasure trove. Hidden beneath foliage, *Man with a Sheep* thus eludes the many photos that have appeared of the garden at La Californie, and would remain the children's secret companion.

Pablo had also brought his ceramics over from Vallauris. While there was never a pottery kiln at La Californie, Pablo installed a large press in the basement to make prints from engravings, with the help of the Crommelynck brothers, who came to visit him on the coast. At Françoise's recommendation, a cook, Marie, and her nineteen-year-old daughter Monique came to help out at the end of July 1955. Up until the end of August Maya, Jacqueline, and Pablo visited the Studios de la Victorine in Nice, where Henri-Georges Clouzot[48] was filming *Le Mystère Picasso*.

At the beginning of this same month, August, one Sunday when there was no filming, Maya suggested that her father should have Paulo's children Pablito and Marina over. Paulo had been obliged to live a long way from them for almost four years. The divorce ruling had given Émilienne total custody of the children without the court making any arrangements for the father's access! So it was she who made the decisions.

Paulo went to fetch them in Golfe-Juan, dropped them off and left again straightaway. Pablito enjoyed himself with the other children who were about his age. Marina was only four and a half years old and did not stop crying, frightened by all these people she did not know.

They would come back to La Californie with their father. But Lucette, the housekeeper, also recalls with sadness unexpected visits from the two chil-

46 The bronze sculptures included *The Goat* (1951), a *Head of Marie-Thérèse* (1932), and a large *Woman* (1943–44). *Pregnant Woman* (1950) quickly joined them to free up room inside.

47 Before being transferred, like *Woman with Vase* or *Man with a Sheep*, to Mougins in 1961.

48 Henri-Georges Clouzot (1907–77) wanted to make people understand Pablo's process of creating artworks. Through an ingenious system of transparent paper stretched on a frame and using felt pen and then paint, Picasso created a whirlwind of artworks in front of the spectator's eyes, exposing his doubts and his certainties. This film, more than an hour and a half long, received the jury's special prize at the Cannes film festival in 1956 and the gold medal for best documentary at the Venice festival in 1959.

dren, brought over by their mother Émilienne: "Paulo never came with them. Their mom would come as far as the Bel Respiro, the house next door to La Californie, and she would send the children up to the gate all on their own ... but they were never let in. Madame Jacqueline had given orders that no one should be let in: 'Not even the good Lord. Monsieur is working!' Sometimes they would hand over little notes, little messages that I would always deliver to Madame Jacqueline. I never saw those children in the house again. Never!"

Pablo was in his studio.

In her book,[49] Marina talks about numerous visits to the villa with her father Paulo. She does not give any precise, nor even approximate, dates for the scenes that she evokes and which seem, curiously, to bring back to life famous photos of Pablo's studio, in which she does not however appear. So Pablo would probably have done the same thing twice. But it is her personal version. Also, she was very young.

Marina uses one visit as a particular example, the only one that can be dated in her book, to a Thursday in November 1956. She mentions, with great realism—at least apparently—the supposed housekeeper: "an elderly Italian [man] worn by servitude,"[50] "He ... the wrinkled Italian ..."[51]— whereas Antoine was only forty-one years old and the housekeeper in post was his wife. Furthermore, all the protagonists evoked by Marina are dead (Pablo, Jacqueline, Paulo, Pablito, and the supposed "housekeeper"), with the exception of the female housekeeper who, curiously, is not mentioned. Also, she passes over the visit in August 1955 to which, on the other hand, there were a lot of witnesses who are still alive. What a shame.

Moreover, Marina saw fit to recount frequent "afternoons drawing with the other children" alongside our grandfather, again undated. With the exception of a single visit in August 1955 and another in 1957, Claude, Paloma, and little Gérard Sassier never saw Pablito and Marina again at La Californie between 1955 and 1962. Nor did Gabriel, the housekeepers' son. And his mother Lucette is definite: she never saw either Pablito or Marina in the house again. Who should we believe? And from 1961, no one lived at La Californie any longer—except the housekeepers. Who then were all these children that Marina used to meet there? The debate continues.

With reference to those testimonies that tally and to the famous photographs of the drawing and creative sessions with Pablo (such as in Edward Quinn's photos with Claude and Paloma), I am won over by the conclusion that Marina, today, really thinks she is drawing on her supposed meetings with our grandfather as a child. According to her, Pablo would

49 Marina Picasso and Vallentin 2001.
50 Ibid., p. 3.
51 Ibid., p. 4.

"... make us understand subconsciously that he was all-powerful and we were nothing!"[52] Why?

In that same month, August 1955, my grandmother Marie-Thérèse also visited Pablo, who asked Jacqueline to leave them on their own. She complied, sure now of her position next to her companion. Marie-Thérèse came back again on a few occasions, always by bicycle—a great sporting effort, reaching the villa perched high up in Cannes. These visits bear witness to the good relationship she still maintained with Pablo and, equally, to Jacqueline's supreme patience.

Inès, the faithful housemaid turned resident administrator, who had been staying at the rue des Grands-Augustins in Paris, moved into La Californie during the school holidays with her son Gérard. A cleaning lady named France Aime worked there daily. Lastly, a little goat came to join the whole team: she had been given to Pablo by Jacqueline for Christmas 1956, and would delight all the children. She was called Esmeralda—even though Pablo always called her "Biquette" [kid], recalling the French nursery rhyme ("Ah! Come out, Biquette, Biquette ..."). Esmeralda indiscriminately haunted the ground floor rooms and the garden, where she would nibble all the grass. Antoine, the housekeeper, had warned Pablo that this was not good for her and that it would be preferable to give her hay. My grandfather, who adored the little goat and granted her all sorts of liberties, decided that it was not necessary to transform the house into a little farm, even if there were already three dogs (the boxer Yan and basset Lump, joined by Perro, a dalmatian). Every evening Biquette slept on the second floor in a box placed in the corridor, just next to Claude and Paloma's usual room, and Gérard's room.

One Sunday, Gabriel, the housekeepers' son, given the task of taking the goat up to the second floor for the night, found her asleep in the garden— dead, in fact, her stomach swollen from the grass that she did not stop eating. Pablo was away. The housekeepers, in tears, thought their last hour had come: "We'd let the goat die!" Pablo came back. Lucette took him aside, and explained to him the drama and its cause. Pablo declared solemnly, "She did well to die. She was not an intelligent goat!" Biquette was never replaced.

Life at La Californie rippled along like this until 1958. Those visitors who were still allowed in were rare: Kahnweiler and the Leiris, the ceramicists Georges and Suzanne Ramié from Vallauris, the painter Édouard Pignon and his wife, the writer Hélène Parmelin, the tailor Sapone, the hairdresser

52 Ibid., p.7.

Arias, the lawyer from Cannes, Monsieur Antébi, the journalist Georges Tabaraud. And, sometimes, more unexpected visitors: the president of the United States, Harry Truman, Gary Cooper, or Brigitte Bardot—and Maurice Thorez, the secretary general of the French Communist Party, whom Lucette refused obstinately to allow in the first time he visited (and who had to go off and telephone Pablo who was, however, in the house)!

And, as always, the children: Claude and Paloma, Cathy and Gérard, often joined by Gabriel, would gather there during the school holidays. I have rediscovered numerous photos of this whole joyous brood that brightened up the atmosphere at La Californie. As for Paulo, he would stop over there sometimes during his travels in the south, accompanied by Christine. He rarely went back there after 1959, and then that was with their son Bernard.

Pablo bought the Château de Vauvenargues, near Aix-en-Provence, Cézanne country, in September 1958. He did not move in there with Jacqueline until January 1959—the time needed to have central heating installed. In Vauvenargues, with its hilly landscape, he would find all the inspiration of a "Spanish" painter. He also produced still lifes, turning to *ideogrammes*, according to Pierre Daix's analysis.

During the holidays, he would have Claude and Paloma go with him, Inès and Gérard then joining them. Gérard and Claude would go horse riding to forget the stifling heat of the summer and the melancholy of this provincial scrubland that was far too isolated. It was also an opportunity to visit the arenas at Arles and to confront, every time, the impressive shock of the bulls ... and of the photographers.

I have already recounted how the construction of a building that permanently blocked the view at La Californie disgusted Pablo. Finally, in November 1960, he would buy Notre-Dame-de-Vie, the large house in Mougins. No one went to La Californie any more except Jacqueline, to check on the closed studios and the artworks Pablo had left there.

The sculptures in the garden were transferred to Mougins.

Relations between Paulo and his father were a mix of reciprocal affection and a savored rebellious spirit. Pablo knew that Paulo was, by nature, isolated from everyone. He was older than Maya, Claude, and Paloma. He was the same age as Françoise Gilot. But he was "the" son—neither the confidant, nor the friend, nor the fixer at work.

He had not pursued studies. During the war, he had been in Switzerland, where he worked at the French embassy before returning to Paris, where he

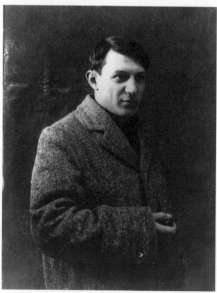

Self-Portrait *(Yo Picasso)*
Paris, spring 1901
Oil on canvas
73.5 x 60.5 cm
Museum of Modern Art,
New York
(Zervos XXI, 192)

Self-Portrait
at the Bateau-Lavoir,
Paris, 1908

Olga, pensive
1923
Pastel and black chalk,
104 x 71 cm
Musée Picasso, Paris
(Zervos V, 38)

Olga Khokhlova,
Pablo Picasso, and
Jean Cocteau in
Rome, 1917

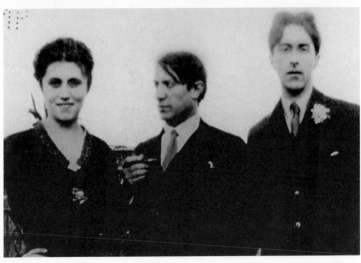

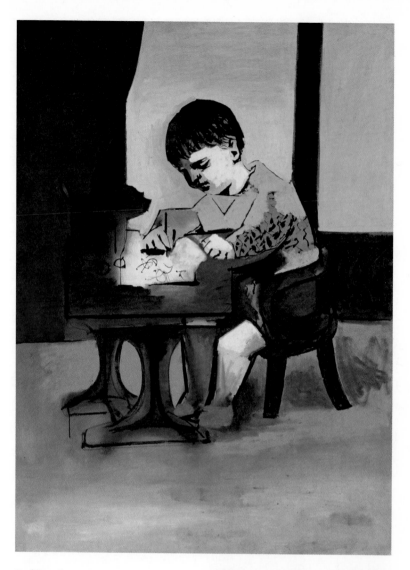

Paul Drawing, 1923
Oil on canvas,
130 x 197 cm
Musée Picasso, Paris
(Zervos V, 177)

Paul, called Paulo, in the arms of
his father Pablo, 1922
(Photograph: Man Ray)

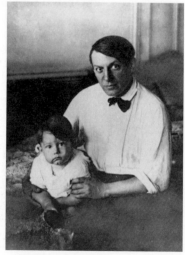

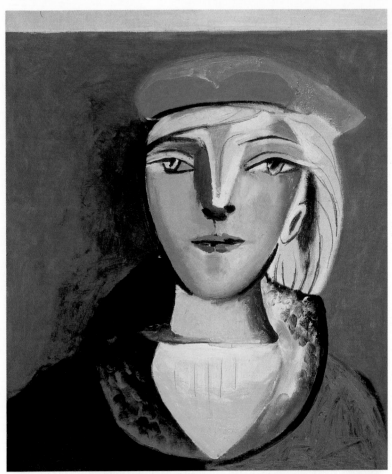

Portrait of Marie-Thérèse in a Red Beret, January 15, 1937
Oil and charcoal on canvas, 55 x 46 cm
Private collection
(Duncan 288)

Marie-Thérèse on the beach promenade at Dinard, August 1928

Pablo, Marie-Thérèse, and their daughter Maya on the balcony of their apartment on Boulevard Henry IV, Île Saint-Louis, Paris, summer 1942

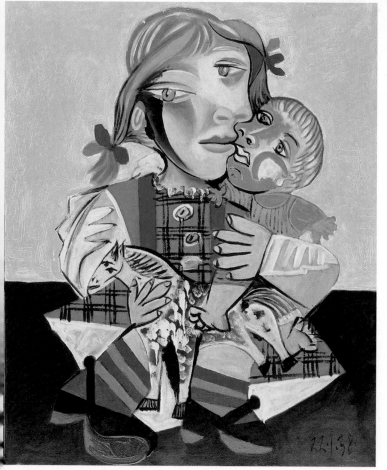

Pablo and his daughter Maya
on the day of her birth in the
Clinique du Belvédère,
Boulogne-Billancourt,
September 5, 1935

Maya on her father's
knees in the Villa Sainte-
Geneviève, Juan-les-Pins,
April 1936

*Maya with a Doll and Wooden
Horse,* January 22, 1938
Oil on canvas, 73 x 60 cm
Private collection
(Duncan 405)

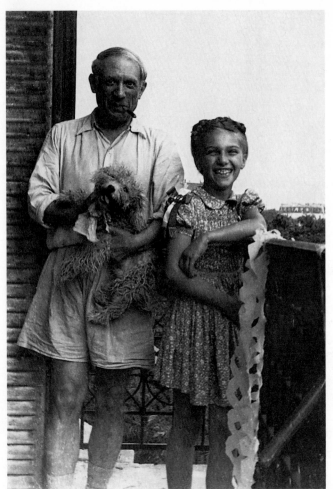

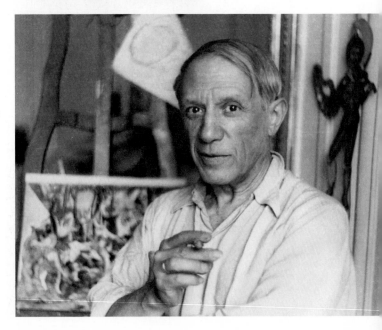

Pablo, his daughter Maya
and their dog Ricky on the
balcony of their apartment
on Boulevard Henry IV,
August 25, 1944, the day of
the liberation of Paris

During the liberation of
Paris a GI helmet and rifle
are placed under the por-
trait of *Maya with a Red
Apron*, painted in 1938
(private collection), in the
living room of his apart-
ment on Boulevard
Henry IV

Picasso posing in front of a
watercolour after Poussin,
August 1944

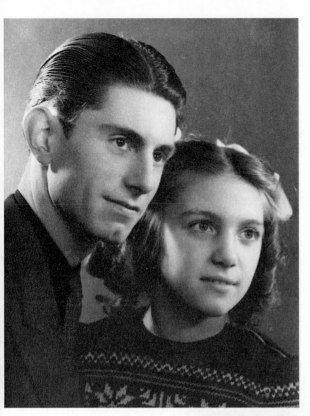

Paulo and Maya 1945—their father had just introduced them to each other; Paulo insisted on immortalising this unexpected encounter

Marie-Thérèse and Maya on the same day

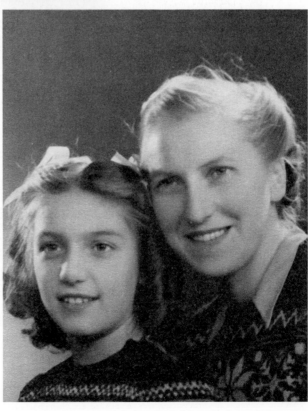

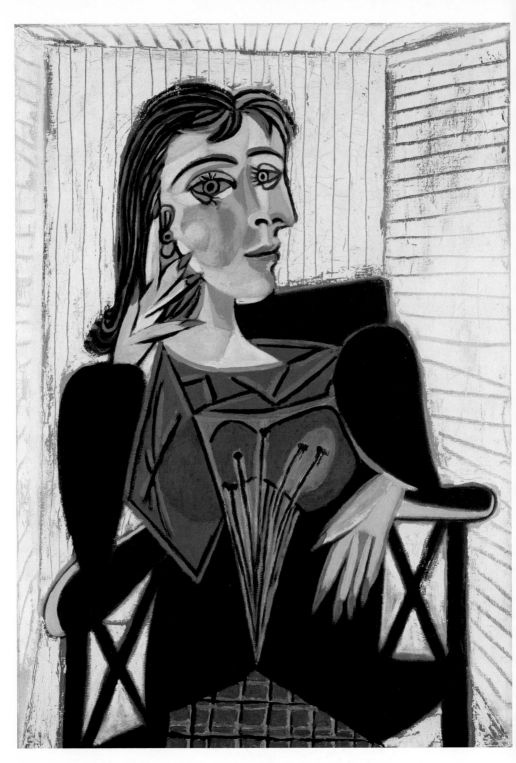

Portrait of Dora Maar, 1937
Oil on canvas, 92 x 65 cm
Musée Picasso, Paris (Zervos VIII, 331)

Woman Flower (portrait of
Françoise Gilot), 1946
Oil on canvas, 146 x 89 cm
Private collection (Zervos XIV, 167)

Françoise Gilot, Pablo, and both of
their children Claude and Paloma
in the Villa La Galloise, Vallauris,
1952 (Photograph: Edward Quinn)

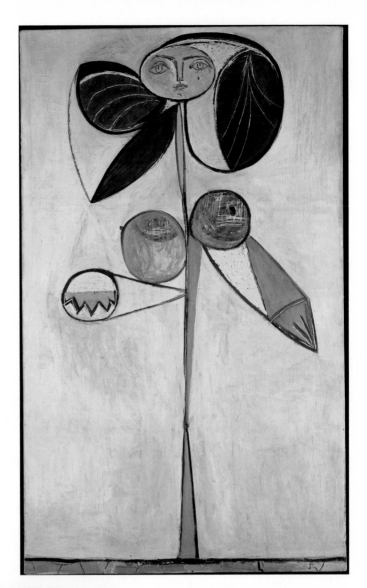

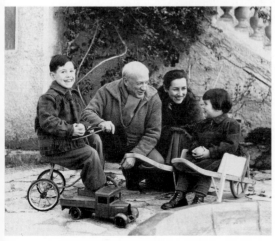

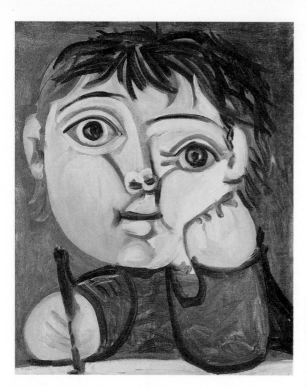

Claude Drawing, 1951
Oil on canvas, 46 x 38 cm
Private collection

Pablo preparing a paper cutout for his children Claude and Paloma, 1952
(Photograph: Edward Quinn)

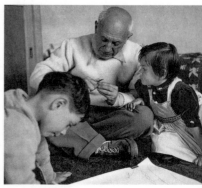

Pablo with his four children
Paloma, Maya, Claude, and
Paulo in the Villa La Galloise
Christmas 1953
(Photograph: Edward Quinn)

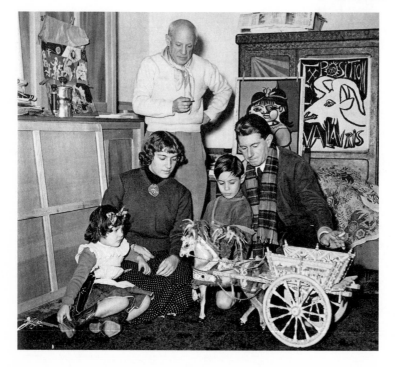

Paloma in Blue, 1952
Oil on canvas, 81 x 65 cm
Private collection
(Zervos XV, 202)

Picasso and his daughter
Paloma, Villa La Galloise,
Vallauris, fall 1949

On the same day: Picasso
and Pablito, Paulo's
eldest son

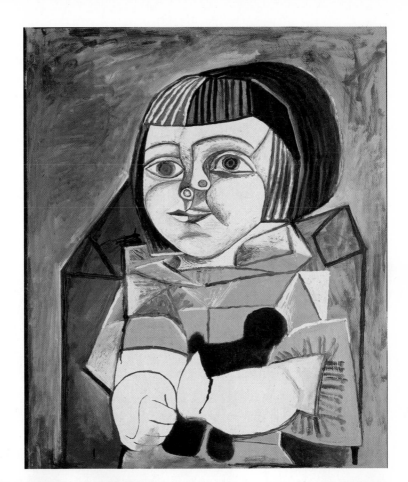

Paulo and Maya on a motorcycle,
Chamonix, August 1946

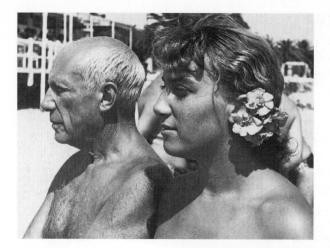

Pablo and Maya on the beach
of Golfe-Juan, August 1952

Paloma, Maya, Claude, and their
father Pablo with Jean Cocteau at
the *corrida* in Vallauris,
August 15, 1955 (Photograph:
Edward Quinn)

Pablo during a drawing lesson
with his children Paloma and
Claude, Cathy (Jacqueline
Roque's daughter), and Gérard
Sassier (son of the caretaker Inés)
in the Villa La Californie, Cannes,
1957

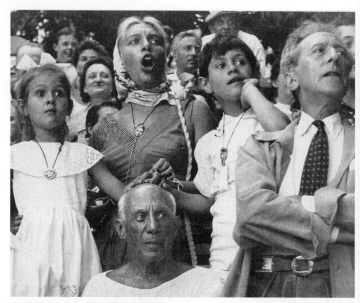

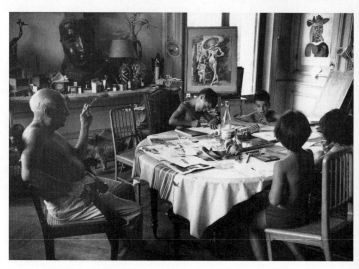

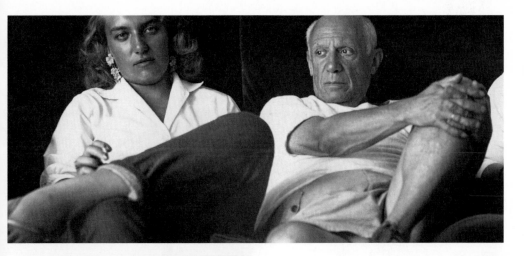

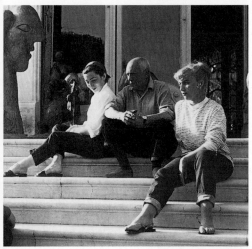

Maya and her father Pablo in the Villa La
Californie, summer 1955 (Photograph:
Man Ray)

Jacqueline, Pablo, and Maya on the stairs of
La Californie, summer 1955 (on the left a
bust of Marie-Thérèse, 1932)

Pablo and Maya photographed at Eden
Roc, a hotel in Cap d'Antibes,
July 1955

Pablo and Maya during the shooting of
Henri-Georges Clouzot's film *Le Mystère
Picasso* in the La Victorine Studios in Nice,
August 1955

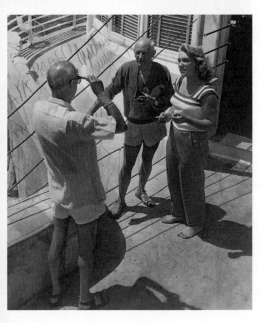

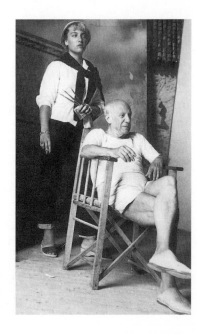

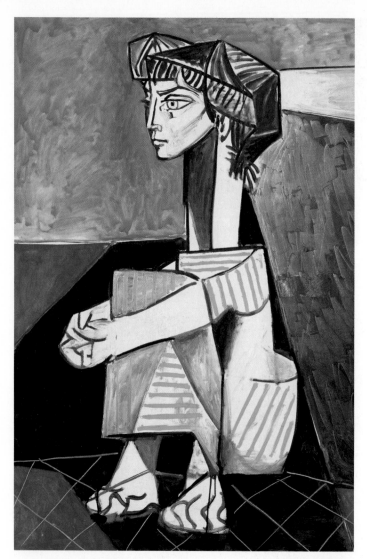

Jacqueline with Crossed Hands,
1954
Oil on canvas, 116×88.5 cm
Musée Picasso, Paris
(Zervos XVI, 324)

Jacqueline, Pablo, and both of his
children Paloma and Claude, with
Cathy and Gérard, in front of a
sketch for *Bathers* in the atelier at
La Californie, 1957

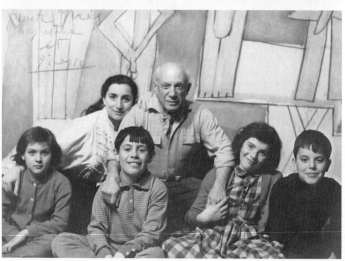

 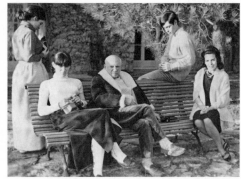

Cathy, Paloma, Claude, and Gérard on the steps in front of the Château de Vauvenargues, 1958

Cathy, Paloma, Pablo, Claude, and Inès Sassier on a bench at the Villa Notre-Dame-de-Vie, Mougins, 1963

Christine (Paulo's second wife), Marina and Pablito (Paulo's children with Émilienne his first wife), Maya, Paulo, Richard and Olivier (Maya's children), Château de Boisgeloup, August 1968

Paloma, Émilienne, and her daughter Marina at Pablito's funeral, July 16, 1973

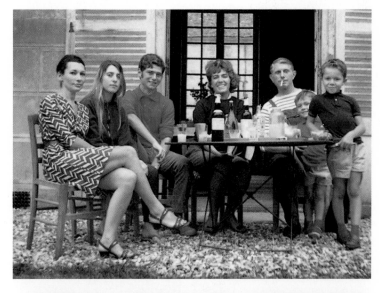

Ratification of the agreements on
the inheritance of Pablo and Paul
Picasso by the heirs and their
advisors at Maître Zécri's in Paris,
September 1979
(for a list of people see p. 343)

Family reunion to mark the opening
of the exhibition *Picasso et le Por-
trait* at the Grand Palais, Paris,
October 16, 1996
(for a list of people see p. 343)

Maya and her three "Picassos":
Olivier, Diana, and Richard,
July 2002

secured a post on the Quai d'Orsay, but he had never learned a specific profession. On the other hand, as I have related, he had a gift for mechanics and especially for motorbikes. He drove very well, and one of his best friends was the champion Georges Monneret, alongside whom he perfected his technique. In a professional race run between Monaco and Nice, Paulo came second. Pablo was very proud of his son but, frightened by the thought that he might have an accident and die, he discouraged him from pursuing this path. Paulo was then nearly thirty years old ... but did not dare defy his father.

In her book, Françoise also talks about Paulo: "I think Paulo would have done lots of things if his mother hadn't held him back. He lacked neither intelligence nor a sense of humor." [53] Duly acknowledged.

One day in the summer of 1950 in Vallauris, Pablo received Philippe de Rothschild, owner of the Mouton-Rothschild winery, who wanted a sculpture for the entrance to his vineyard in the spirit of the famous *Homme au mouton* in Vallauris. He confused Françoise with Olga, and exclaimed: "But they told me you were paralyzed!" Olga was then in a nursing home in Cannes, half-incapacitated according to the rumor. "It's incredible that you could have a son this big...." He (Paulo) burst out laughing: "You know, I was a slightly premature baby, very premature even. In fact, I was born before she was." Then, rolling his trouser legs up to his knees, he set to running about, crouched close to the ground, right around the room, waving his arms and shouting "Mummy ... Mummy!" Claude, who was three years old, was delighted and followed him around, imitating him.

Silly Rothschild!

Paulo had built up friendships in the world of bullfighting. He frequently accompanied Pablo and his entire household to the arenas in Arles, Nîmes, or Vallauris. He liked to stay in the *burladero*, the area around the arena, from where he would harangue the bulls and often bravely approach the furious animals.

These were moments of intense excitement for Pablo, who rediscovered the ambience of his lost Spain there. He himself was the main attraction for the public in the arenas, who celebrated the toreadors and the picadors, but also the illustrious master to whom the show was always dedicated.

Paco Muñoz was one of Paulo's best friends. He lived in Nîmes, and was of Spanish origin. He was an *apoderado*, a bullfighters' agent. Because of restricting legislation, deaths in bullfighting were extremely rare events then. This state of affairs allowed Muñoz to offer his best bullfighters to different arenas. Paulo frequently accompanied him, especially in his travels

53 Gilot and Lake 1964, p. 250.

between Nîmes and Vichy. Pablo looked on this association favorably, and hoped that Paulo would integrate into the area of bullfighting, to which he seemed well disposed. But Paulo did not pursue this fleeting interest.

I met Paulo a few times. He was tall, with a great air of authority, and pepper-and-salt hair. I remember how close he and my mother seemed. No doubt his discussions with Maya reminded him of the good times with their father? Despite the age difference, they were from the same prewar generation.

In 1968, Paulo asked Maya to come to Boisgeloup, while his children Pablito and Marina were staying for a full month. Paulo was not really at ease faced with this "reunion," since it was apparently the first time in a number of years that he had seen them again for such a long period.

Maya accepted and took me there with my brother Richard.

Although it was in average condition, I was very impressed by the property. It appeared immense to me and—a supreme "luxury" to my eyes—it had its own chapel! Christine, Paulo's wife, was there, and I remember finding her very pretty and very gentle towards us. Pablito was lively, his face lit up by a radiant smile. He shone. He was almost nineteen years old, he was big; I was a little shy and I didn't know what to say to him. His sister and he were going back to school, to start in the sixth grade, in September.

Of course, at the time, I did not know anything about the situation. I was not old enough to understand. It was probably an exceptional day for Pablito. He was with his family, the "Picasso side": his father, his brother, an aunt, cousins! On the other hand, his sister Marina seemed rather melancholy, and I remember that she did not talk. Their (half-)brother Bernard was jumping for joy in every sense and, being about the same age, I remember that my brother and I were delighted to run about with him.

We took some photos. Paulo seemed very happy. Everyone was smiling.

Except Marina.

Scarcely two months after Pablo's death, on June 7, 1973, in the middle of the legal proceedings to recognize paternity, Paulo, provisionally the unique descendant heir, came to ask my mother for advice.

They talked for a long time. Of the past, and of the present. They were disorientated by all that had happened. Jacqueline was taking all the initiative from that time on, and he was struggling to find his role. Maya advised him, first of all, to take on a personal lawyer. Not that Roland Dumas, historically Pablo and Jacqueline's lawyer, could have been a bad adviser, but the respective situations of Jacqueline and Paulo were very different. Whereas Jacqueline's was hardly clear in terms of inheritance, Paulo's depended on the outcome of the ongoing proceedings of the other

children. Certain decisions fell to him. His responsibility was really much greater.

Maya recommended Monsieur Bacqué de Sariac, not because she especially rated him—after the unbelievable incident with the name-changing, which, in the end, had mattered little to her, since she was a married woman and so had already changed her name—but at least he knew all about Picasso's universe. Paulo then asked my mother to go together with him to Vauvenargues, where their father was buried. He regretted all the turns that their father's funeral had taken, the siege at Mougins, the departure of Pablo's body for Vauvenargues in the middle of the night, the precipitous burial in the garden with neither family nor close friends, and without any official tribute. I will come back to that again. He regretted having conceded to Jacqueline's despair, and of having rejected Maya, Claude, Paloma, Marie-Thérèse, Pablito, and all Pablo's old friends. Everything had been turned upside down within a few hours. He had not been ready.

Jacqueline was at Vauvenargues. She willingly accepted Maya and the three of us, her children (our sister Diana was born in 1971), joining Paulo there. For the latter, meeting Jacqueline in Maya's presence was a psychological trump. He would feel supported.

We arrived as the sun was setting. Vauvenargues is only some fifty kilometers from Marseille, where we were living at the time. The place was sinister, with night falling. In the middle of the hills that had inspired Cézanne and seduced my grandfather, the Château de Vauvenargues was shrouded in silence. Even the little village below seemed deserted. The place lent itself well to eternal rest.

Paulo's car went through the big gate and climbed the little slope. We followed it.

For me it was like a journey to another life, to that of Picasso, which had been recounted to me but which had nothing tangible about it, beyond the artworks in the house. The most curious thing was that this initiation brought together all those elements indispensable to a rite of passage: my mother, her brother, Jacqueline, the château, a symbol of wealth, and finally my grandfather, so close but invisible. And also, curiously, a large bronze sculpture of Marie-Thérèse holding a sort of vase, placed on his burial place. I concluded from this that my grandmother had been of considerable importance, to have been chosen as the watchful guardian of the tomb. All this was really not very clear.

The car stopped in front of the monumental steps to the great fortified building. Jacqueline was on the steps. While I had seen her in photos, I had never met her. She was dressed in black, and I seem to remember that she wore a scarf on her head. She smiled gently at my mother, kissed her, and

greeted each of us, one after the other. Finally she pointed out Pablo's tomb, which was opposite the steps, about fifteen meters away, on the other side of the car.

I had never been to a cemetery. And although there was just a single tomb there, it made a great impression on me. So this grandfather, born to me a few weeks beforehand, was there then, dead. Dead already. The ground was still fresh and humid, forming a perfect circle at the center of which was (and still is) the great statue. I felt I could touch death. It all seemed unreal. I did not know what to do.

So I led away my brother and my little sister and left my mother to her contemplations. We then went into the château, slowly. The rooms were immense. I remember having looked curiously at the great hall's stone floor —and worrying about crossing this deserted mausoleum. Had Paulo not spoken to me about *oubliettes*?

While my mother and Paulo were talking together, I went back out into the garden. After a few minutes, encouraged by the cold, I was preparing to go back up the steps when Jacqueline appeared above. I started back, near the balustrade. Very strangely, half a dozen workers whom I had not seen when we arrived were gathered at the bottom of the staircase. The facade was actually covered with a tarpaulin for restoration. It was at least eight o'clock in the evening. Jacqueline spoke, like a priestess, and reminded them all what Picasso meant to her, to us, to everyone. The workers held their heads lowered, and I had the impression they were used to hearing this liturgy.

This ritual mass lasted only a few minutes, but it paralyzed me, and I hoped that Jacqueline had not seen me, in the half-light. I understood on that day that Pablo had been the star of her life, and that the sun had gone down. She had stood next to her god, and from then on she was confusing her destiny with this person, now deceased, whose memory she was perpetuating. When I discovered, later, the keys to Jacqueline's romantic language, it being made up of formal addresses and symbols ("my lord," "my sunshine" ...), I was hardly surprised by it. The tragedy of her suicide, in 1986, fitted inevitably into this emotive theatrical aspect.

Jacqueline organized dinner in the large dining room. Jacqueline and Maya talked about Pablo calmly, as if they had only been parted the night before. Two people from the village came to join us and appeared to me to be like two apostles during the discussion, celebrating Jacqueline's great courage in these circumstances of mourning.

We set out on the road back to Marseille a little after midnight. Maya stopped in Aix-en-Provence, and Paulo came to join us in our car. While we were sleeping, my mother and Paulo talked together for almost two hours. I knew nothing of the complexity of the situation, but I knew that an

unbreakable bond existed between them. For Paulo his exceptional life, as the sole recognized descendant, was a drama. Even though he knew of course that all this was provisional.

Life resumed its rhythm. That month, June, was lugubrious in spite of the spring and the heat that already seemed summery. My mother acted normally, our day-to-day life as schoolchildren gave rhythm to our existence, but we could feel the tensions around us—those articles on Picasso's life, his women, his oeuvre, his supposed fortune. The legal actions took on an entirely different appearance with the journalists presenting them as if they had been started on the day after his death. Even because of his death. What idiocies! My cousin Pablito's suicide was the horrific paroxysm in this whole dramatic tale.

In her first book,[54] his sister Marina explained his suicide as an appeal for help launched at our family. Pablito had not understood that the only person he could turn to in trust in a family in the midst of rebuilding itself was his father Paulo, or, failing him, his mother. But according to Marina's account, it was too late, and had been for a long time.

Can one conclude that our grandfather could figure among the ranks of those responsible, or more-or-less "guilty"? Pablo was extremely old, and lived as a recluse with his art. The photographer Edward Quinn summed it up well in 1965: "For ultimately Picasso's life is ruled by one passion—his work. Even when he is not painting, he is absorbed by his art, to the exclusion of all else."[55]

Then he would forget his children, his grandchildren, his friends, or the rest of the world. He would rejoin the world that he had been re-creating throughout his entire life—a world where there was plenty going on but to which there was no access.

I did not know Pablito. Perhaps he suffered from carrying the name Picasso without getting any of the advantages from it that he dreamed about. Perhaps the gate his father closed on him catalyzed his sufferings as the child of divorced parents. This banal gesture took on gigantic proportions. His material difficulties, a difficult schooling, all this must, in his eyes, have culminated in our grandfather's death. But, all the same, his father was not dead. Pablito, above all, should have sought recognition of his existence, as Picasso's first grandchild. In one sense, he was born too early. His own father, so absent, suddenly became too present. He was the final obstacle, even more impassable than the garden gate.

54 *Marina Picasso*, 1995.
55 Author's note in Penrose 1965, p. 5.

Once again, I learned about his death, occurring on July 11, 1973, via the media, in this case on the radio, and had to announce it myself to my parents. My mother was upset, especially as she knew about the affection her own mother, Marie-Thérèse, had for Pablito and Marina, and about her efforts to have him cared for, at the Hôpital de la Fontonne in Antibes, where he had been admitted to the emergency ward. My mother still remembers the visit she made there and their long conversation. Pablito confided in her that he would never have done what he did if he could have imagined the pain that he would endure; he thought he would die instantly! That day, she gave him a little lead soldier that had belonged to Pablo and which he had given her when she was a little girl. She suspected sadly that he would not survive the irredeemable damage resulting from what he had done.

His death was a shock for the whole family. My mother could not go to the funeral as my little sister Diana was ill, my father was at work, and we had no baby-sitter. She sent a spray of flowers in all our names. My grandmother Marie-Thérèse went, and placed a wreath of flowers tied up affectionately with a ribbon "To my grandson," and paid for the tombstone. Paloma also went, and stayed beside Émilienne and Marina the whole time. Claude was in the United States at that point. It was assumed that Paulo was also present, at a certain distance, but his face did not appear on any negatives in spite of the pack of photographers. But Marina does not remember having seen him, nor does anyone else.

Maya remembers advising Paulo then to take care of Marina, and to help her, financially at least, since he was then their father's principal heir and, in this capacity, could access the advances on the inheritance which the lawyers had already released. But for Marina nothing would ever replace the presence of a brother or the affection of a united family. She did not want to see her father again, and never did see him again before his death in June 1975.

Monsieur Bacqué de Sariac, her lawyer, then gave her an envelope containing 100,000 francs (that is $66,000 today). Paulo had apparently followed Maya's advice, but without daring to face up to Marina's refusal to meet him. During those two years, my own grandmother, Marie-Thérèse, had herself lent to Marina and to her mother a total of 200,000 francs (that is $165,000 today).

I was not old enough to understand at the time. With hindsight, I think that my grandfather's situation was so atypical that it is unthinkable to compare it to anything else. Werner Spies,[56] too, told me that "Picasso escapes human

56 Werner Spies, professor of art history, specialist in Picasso's sculpture, former director of collections at MNAM/Centre Georges Pompidou.

qualifications." It is futile to place him in a context of normality. If he had been an ordinary man, he would not have accomplished such an oeuvre.

The inheritance could not be settled without the resolution of the proceedings that had been initiated. At Claude and Paloma's request, and even before they were officially recognized, the High Court in Paris returned an interim ruling, on June 6, 1973, presuming "hereditary rights" to the future heirs who were Maya, Claude, and Paloma, and ordered the appointment of a legal administrator.

Monsieur Darmon, originally Jacqueline's attorney, had very logically opened the succession process. He had not imagined the titanic amount of work he would have to put in to bring it to an end. Any inheritance must be officially "declared," in its totality, within a deadline of six months. Evidently this would not be possible here, by reason of the enormous number of artworks to inventory and value. What is more, the heirs were in very different situations.

At the beginning, Paulo and Jacqueline had together officially opposed the appointment of a legal administrator. Even if I think that as a general rule the presence of an outside administrator in a family makes people behave tensely and perpetuates animosity, this was, in the case of the Succession, the wisest of decisions. A conductor was henceforth in charge of regulating the expected cacophony.

It would have been unreasonable not to wait for the judgments on paternity: Jacqueline and Paulo were particularly careful on this point. With good reason. One year later, all the legitimate heirs having been identified, a ruling dated July 12, 1974, confirmed Monsieur Pierre Zécri as the designated legal administrator. Later, everyone was very pleased with his zealous and efficient action—except Marina, when she became her father's heir. She questioned the general division agreement that she had, however, signed herself, "without assessing all the consequences," she would say, and she claimed without any proof that Jacqueline had placed some artworks and funds abroad.

It was Marina, in fact, who in September 1996 was sent by the chamber of the Cour de Cassation (Supreme Civil Court) before a correctional tribunal for illegally exporting works of art abroad, at the beginning of the 1980s. Life has such ironies. My cousin will probably tell us about these events sometime, pointing out how she is, to this day, the only one in our family to have been thus strongly suspected of customs infractions. I will, however, abide by the assumption of innocence until proven guilty that is the French law's point of honor.

The settlement of the inheritance began at last with the five heirs and their advisers. A provisional calendar was put in place from the summer of

1974. Monsieur Pierre Zécri officially designated Monsieur Maurice Rheims as expert valuer. They drafted a methodological memorandum. They both sensed that they would be administering an enormous surprise.

Regular meetings began in September 1974. I remember my mother leaving for Paris each month on the famous *Phocéen*, the night train between Marseille and the capital. She did not want to leave us alone for more than one day, Diana, Richard, and me. So her return trips were very quick.

She answered my questions willingly. I was fascinated by this world of adults that she mixed in, this world of legal men that was so serious.

The meetings, she explained to me, took place at Monsieur Zécri's. All the heirs and their counselors would gather in his meeting room. There were a few meetings on the Côte d'Azur, in Cannes, at the time when the inventories of my grandfather's houses at Mougins, Vallauris, and Vauvenargues had been begun. I accompanied my mother, more precisely to the Hôtel du Mas d'Artigny, near Saint-Paul-de-Vence, where everybody had gathered, this being more discreet than at the Carlton Hotel in Cannes, where the teams charged with the inventories lived for more than six months.

Coming out of this meeting, I caught sight of Jacqueline with her measured, almost theatrical, walk. I remembered Vauvenargues; she also remembered me. I cannot say that she was overflowing with affection in embracing me, but I had taken my place in "her" family. Even if she was no one's mother, she considered herself to be the original matriarch. With this very official kiss, I was accepted into the fold.

These meetings hardly impassioned her. All of it must have appeared derisory to her.

She had an extraordinary, seductive, and terrifying presence and I had the impression that nothing and nobody could scare her. She was already living in another world.

Paulo had come in a superb car, which was really exciting for me. Each of the heirs, having received some significant financial credit, could buy what he or she wanted from now on. The Citroën DS that he owned before Pablo's death had been succeeded by a Jaguar, a Daimler, a Bentley, some Rolls-Royces (including, unexpectedly, a gigantic Phantom VI, like that of Queen Elizabeth, which he drove himself), a Range Rover and some Mercedes! Each of my mother's journeys was punctuated by the discovery of a new car.

Being younger,[57] my other uncle Claude stood in contrast to Paulo, the imposing "monsieur," who was going gray in his fifties. Claude was sporty and "hip." His mechanical side was more Porsche. He talked about every-

57 Born in 1947.

thing, he knew everything. When we worked together on the CD-ROM *Picasso*, a few years back, I think he knew more about the technological side of it than many of the computing experts in our team.

Paloma seemed to me to be in perpetual motion. She ran incessantly from one airplane to the next—she truly symbolized the jet-set, in the original sense of the term. She fascinated me with her total "glamour," which became her trademark and would be expressed successfully, several years later, in her collections of jewelry and cosmetics.

At no time did my mother tell me she had been present at a fight during these meetings, whose objective was to reach a rapid settlement. Even the journalists, deprived of official information, told of the advancing of the inventory and of the "amiable" agreement between the heirs of an inheritance valued "summarily" by them at five thousand million francs at that time. The daily paper *Nice-Matin*, in April 1976, talked of the "fabulous work of inventory and of estimation ... carried out well within a relatively rapid timeframe." The famous "court actions," in reality simple proceedings, were ancient history.

As I said in the preamble, it was only during the 1980s that some people imagined a long and sordid affair, broken up by battles between the heirs. Thus false legends are born. Questioned by me on relations between the heirs, Monsieur Maurice Rheims (who died in 2003) confirmed to me that they were good on the whole.... "There was a general willingness given the importance of the oeuvre, given the importance of the personality!" He did not remember any incident during the meetings. Good sense prevailed over everything.

The only tensions were all, I am sorry to have to say, on Marina's initiative, she having become her father Paulo's heir in June 1975. I will come back to that.

PAULO'S DEATH

There was an unexpected drama on June 5, 1975. That morning, my mother woke me to go to school as usual. Her eyes were red and she was having trouble drying her moist cheeks. She said to me, "My brother Paulo is dead." I was stupefied. "But how?" I asked her. "Cancer of the liver; he has been very ill for some time. It was getting better and he was in Spain with his wife Christine. He had telephoned me to say that he was feeling fine. He had even been driving his car. And then, it suddenly got worse in Barcelona. He was taken to Montpellier by ambulance and to Paris by plane. He died suddenly in the hospital yesterday. It was Christine who called me this morning."

Paulo officially left a widow and their son, Bernard, and a daughter, Marina, born during his first marriage to Émilienne. Marina and her mother were still living in Golfe-Juan.

Marina came to Paris very quickly. My uncle Claude had sent her a one-way plane ticket, prepaid from Nice to Paris. He did not know when she would go back again: she would choose herself. He knew on the other hand that she would have the means to get herself organized from then on. In fact, Maya, Claude, and Paloma asked Pierre Zécri, the legal administrator, to pay a significant advance to Marina, since they had benefited from this themselves.

Paulo's funeral took place in Paris, at the Montparnasse cemetery. The whole family, in mourning once again, gathered on a sunny day. Old friends had been joined by the inheritance lawyers. In the big hearse, in front of Paulo's coffin, were his widow Christine, and their son Bernard, as well as Maya and Marina.

The atmosphere was strained. Everyone was trying to forget the past. Pablo had died two years before, Pablito had committed suicide the same year, and now Paulo was dead. Three generations scratched out. It was certainly hardest for Marina who had lost "her" family: an absent grandfather, an inaccessible image, a father "despite himself," and a despairing brother, so near and yet so far ... in the hearse, with a vague look in her eye, she declared: "No more court actions, no more of that!" Too distanced from everything and everyone, she too must have thought that there had been rifts between the members of her family. There were so many things she did not know.

It was a vain wish.

I will come back to that, too.

From then on there were two succession cases to settle: on the one hand that of Pablo and his four heirs, Jacqueline, Maya, Claude, and Paloma and, ongoing, that of Paulo and his three heirs, his widow Christine and his children Marina and Bernard. Marina was then twenty-four years old; her (half-) brother Bernard was barely fifteen.

In spite of mourning, inventories and meetings had to be followed through. Paulo had died on June 6. The next meeting took place as planned on June 16, and the presence of Christine, Marina, and Bernard substituted for that of Paulo. Jacqueline excused herself. It is true that she only attended a very few of the meetings, in fact, and on the whole relied on her two advisers, Monsieur Dumas and Monsieur Weil-Curiel. Maya was accompanied there by Monsieur Lombard, and Claude and Paloma by Monsieur Bredin and Monsieur Verdeil. Monsieur Bacqué de Sariac assisted Christine and

Bernard from that point on, whom he knew well. Marina had chosen Monsieur Albert Naud, a Parisian lawyer of great renown who had been recommended to her by Monsieur Ferrebœuf.

Monsieur Guy Ferrebœuf, a young lawyer from Antibes, had met Marina and her mother Émilienne Lotte at the time of Pablo's death. Monsieur Ferrebœuf had first approached Monsieur Albert Naud in 1973, to try to "participate" in Pablo's inheritance, arguing that Paulo did not have the right to "renounce" the inheritance of his mother Olga in 1955, and that Émilienne should consequently have benefited from it during the divorce (occurring, however, on June 2, 1953, two years, with legal effect, before the date of the first claim) since they had been married on a community-property basis.

The two lawyers had intervened free of charge, hoping to register their clients as having rights to the inheritance, to be settled subsequently. Monsieur Naud had contacted Roland Dumas, but this—fantastic—step had ended in failure. More audacious still was Émilienne's hypothesis, which took up an argument again that had already been rejected in 1958 during the appeal ruling on her divorce: she had not been served notice of this divorce ruling according to legal terms, and therefore, one could deduce that she would still be married to Paulo, whose second marriage to Christine would *ipso facto* be illicit by cause of bigamy, their son Bernard becoming a child of adultery! It was Balzac, *Scènes de la vie de province*....

Of course Émilienne had briefly become the object of attention of local journalists. A return to the limelight. One can imagine how the affair might have affected Paulo, already tormented by the death of his son.

So that month, in June 1975, Monsieur Naud made an official "comeback." Monsieur Ferrebœuf was "forgotten" for the moment. For Marina he was now only the lawyer of her mother, from whom she was starting to distance herself. She paid him some fees for services rendered. Monsieur Naud recommended fixing them at 10,000 francs (that is $6,660 today).

Things did not stop there. The young lawyer from Antibes prepared a sensational return the following year, marked by a series of "mind-blowing" offensives, to use the Parisian lawyer's term, dismissed then in his turn. Real boulevard theater!

During her first interview, prior to the meeting with the legal administrator Monsieur Zécri—who had to inform the other heirs about it—Marina reckoned that she should inherit her brother Pablito's share, who had died in 1973—a pure legal fiction. It was envisaged that her half-brother Bernard—born in 1959, that is to say before the marriage in 1962 of their father Paulo to Christine—be considered a "natural" child, worthy of half of one part. So Marina would thus have, according to calculations, three quarters of

Paulo's inheritance. Monsieur Zécri unfortunately had to remind her of the law: Bernard had been made legitimate by his parents' marriage. They would be equal.

As for the recognition of Maya, Claude, and Paloma, it was an incredible judicial error! But, very well.

After these few legal clarifications, it was just a matter of watching and waiting....

MARIE-THÉRÈSE'S SUICIDE

During all these years, my mother always put on a determined and gentle face for us. She never allowed her worries to show through. She had always been optimistic and honest. Our father, more passionate about sailing than the inheritance, counterbalanced the disproportionately large place that the "Picasso universe" took up in our lives from time to time. Without us realizing it, his resistance must have given us a sense of balance.

Two years passed. As I related in the introduction, I was identified at school as "Picasso's grandson"—and as such was the object of curiosity. Did I have paintings at home? I would answer, without any particular pride but without embarrassment, that there had always been some. Sometimes, I eluded the question, to avoid seeming as though I was getting some kind of glory from it. The fact of being one of Picasso's grandchildren did not necessarily give me any innate artistic qualities, or a sense of what is beautiful.

Fortunately I escaped any jealousy from my school friends, but I had to face an unjustified admiration from the art teacher, exhibiting to the whole class the drawings that I tried to execute (with a ruler!): "This is magnificent, he has gotten that talent from his grandfather!" I did not even blush anymore. I had gotten used to denouncing his praise to my friends as soon as the class ended, applying myself to describing my works as "real rubbishy"—and therefore remarkable, which made everyone laugh. This contributed to getting me elected, year after year, as class head or rep.

At home, the experience of the inheritance was a parallel world that did not affect us. My mother took care of the home, which she had always dreamed of. We were living in Marseille, a long way from the other family members. Maya kept up contact with the others, principally via telephone, and notably with her mother, Marie-Thérèse, with whom she spoke regularly.

That is, up until October 20, 1977. My mother woke me and announced to me that my grandmother had died the previous evening.

At first I thought she meant my father's mother, Marcelle, who was already over eighty. "No, it's Baba, my Mom." She could not hold back her tears. A few moments afterwards, I saw her leave in the car with her friend

and lawyer, Marie-France Pestel-Debord (who worked with Monsieur Lombard at the time), for Juan-les-Pins, where Baba had lived. She also asked Monsieur Hini, her lawyer friend, to join them.

My father, rightly judging that I was capable of understanding, revealed to me then that Marie-Thérèse, my grandmother, had committed suicide. My mother did not know. The police in Antibes had told her on the telephone that Marie-Thérèse had had an "accident"—without any more explanation about her death. Marie-France Pestel-Debord had given my father more precise details.

My father decided to say nothing to my brother, or to my sister. As usual, during the day, the media repeated it, this time on the television: the television anchorman announced the death of "Picasso's famous muse and companion" on the eight o'clock evening news program. My father switched off the sound. I did not hear the rest, and my little sister had not heard.

Meanwhile, my mother, having arrived in Juan-les-Pins at the villa, La Lusitane, had been informed of the drama. The world was collapsing.

Marie-Thérèse left nine letters—of which a page for Maya, which was never given to her by the Criminal Investigation Department. According to a superintendent, Marie-Thérèse had simply asked for her forgiveness. On the other hand, there was another letter of nine pages for Marina: was it ever passed on to her? According to the correspondence that Maya had received from her mother, the very close relationship between my grandmother and Marina had deteriorated quite badly after June 1975.

My mother explained to me later that Marie-Thérèse had lost "her" contact with Pablo, maintained continuously since their meeting in 1927. It had been interrupted on April 8, 1973, by the death of her only love.

Marie-Thérèse and Pablo had spoken on the telephone eight days before he died. She had understood that he was not doing well. She had warned Maya about it, this bad presentiment being confirmed by Pablo's very feeble handwriting in his last letter, received the morning of this telephone call.

Marie-Thérèse had lived in a virtual world, made sublime by Picasso, protected by him from the outside world. On Olga's death, hadn't he immediately proposed marriage to her? She had allowed herself the luxury of refusing. "It's too late," she had responded. Her dream life had since turned into a gilded nightmare. Hadn't she received dozens of artworks and a passionate correspondence from him? He had always paid her a significant pension, of about 6,000 francs per month until that spring 1973 (that is $5,500 today). But, since then, the spiritual bond had been completely broken. The pension was no longer paid. She had to face up to the outside world, alone. Fifty years after their first meeting, she had chosen to rejoin

him. She had hanged herself in the garage of her pretty house near the famous pine forest of Juan-les-Pins.

My mother discovered Marie-Thérèse's world, the reality that she had had to face since Pablo's death, with infinite sadness. Cut off from him, she had continued to do good, buying a coffee for this person, a fur coat for that, a car or a journey for the other, paying for a cosmetic surgery operation for such a person ... without realizing that, unconsciously, she was buying herself friends. When Marie-Thérèse had to start being careful with her money, the "dear" friends disappeared.

Contrary to what may have been said, Marie-Thérèse and Maya had not been estranged since 1971. I myself knew of warm exchanges of correspondence, from 1976 or 1977, and they telephoned one another regularly. Marie-Thérèse lived a carefree existence, which did not correspond to my mother's patterns. Maya reflected a conformist but happy image of a family life that she had never known. Maya had succeeding in building her own home, outside of this "Picasso" environment whose irrational aspect was so destabilizing. Baba was the proof of it and the reminder. She was original, sometimes eccentric, and often incomprehensible. She evolved in an unreal situation, with no tomorrow. With Pablo, she lived an eternal present. On his death, she had been tipped into the future. Pablo belonged to the past.

All this passed us by. Our parents had understood it on our behalf for some time. With no complications, we went to classes, played with our friends, saw girlfriends; we did not count on a pension for life, we did not live with the idle and optimistic expectation of some kind of inheritance.

For Marie-Thérèse, following Pablo's death, easy money became rare; the tax office was asking her for explanations for the origin of her revenue, undeclared all these years. Her friends had fled. Cornered, worried, incapable of managing the least problem in her life, she preferred to rejoin the imaginary world of the Minotaur that she guided by candle in Pablo's engravings.

Her death added another stone to the edifice of fantasies that the Picasso legend had become. Six months later (because of the legal inquiry that had necessitated keeping the body in the morgue), my mother attended Marie-Thérèse's funeral alone, in Antibes, surrounded by a crowd of journalists and photographers whose noise and fury she had, significantly, erased from her memory.

Life carried on. But we knew from that time on that we had to protect ourselves from Picasso's great spiritual hold. This worrying hold was not of his making, but came from our relationship with him and his work. To be one-

self before being Picasso. The possession of his artworks for his heirs should have been a simple anecdote of life, of their life. Was this possible?

My mother had always lived with her father's artworks. Later, she had hardened her heart and thus her life. And then we were there, and she had fought for us. Claude and Paloma had the advantage of being young adults —and having their lives ahead of them. Their mother had also brought them up outside the Picasso universe. She had nevertheless taken steps to protect their rights, with Pablo's agreement.

It was really Bernard, being so spontaneous, so wealthy now and so fragile, who was the source of worry; someone would have to watch over him. So Claude became his second father, his friend, usefully supplementing Christine's natural affection, mother of an heir too young.

Since the age of twenty-two, Marina had been living with her companion, Dr. René Abguillerm, a married man at the time, and about twenty-five years her elder—a sort of second father. He was already father to two girls, Véronique and Florence, nicknamed Flocy. Marina had met him, she revealed,[58] when she was fifteen. She was going through a difficult stage.[59] The director of the Chateaubriand school had asked Dr. Abguillerm, a specialist in psychology, to pay a visit to Émilienne Lotte and her children as he thought there was a big problem there. The romantic liaison between Marina and the doctor began seriously only in 1973 after Pablito's death. When Marina received the first advances from her father Paulo's inheritance, from summer 1975 onwards, their relationship was facilitated on a material level. They lived on the Côte d'Azur, at the appropriately named *Marina Baie des Anges,* between Antibes and Nice, with their son Gaël, born in the autumn of 1976. Marina had rediscovered our grandfather's will for freedom, defying laws and making love triumph. What did it matter that René was still married. She was no longer only René's mistress, she was the mother of their child. Legitimate child, natural child, child born of adultery: these terms already no longer had any importance for her. Marina and René separated, then got back together and a second child followed in 1978, a daughter, named Flore in memory of René's deceased mother, tragically assassinated in Vietnam. For Marina, love triumphed once again over legitimacy. Like for our grandfather. But the new separation between Marina and her companion, shortly after Flore's birth, was terrible, according to the declarations of the latter. Marina lodged complaints of assault and grievous bodily harm, and attempted murder, against him. The press reported it. But the doctor, not knowing about the proceedings, and already having left to

58 Marina Picasso and Vallentin 2001, p. 110.
59 *France-Dimanche*, December 21–27, 1991.

move to Thailand then to Cambodia for a humanitarian organization, was at first condemned in his absence without knowing about it, but managed to be totally cleared by the justice system when he learned of his misfortune on his return several years later. Marina, though so verbose on other subjects in her books, did not plumb this far into her memories, leaving a "blank" in place of this relationship.

She was still close to her mother at the time. She seemed to have a family. We did not know that all this happiness in the past had been ephemeral, and that Marina was going down the long road of psychotherapy that, as she explained later, would last fourteen years. She was looking for answers. Did she have the right questions?

Finally, there was Jacqueline—"Picasso's widow," like the Queen Mother.

She would have liked the world to have stopped on April 8, 1973. The world had continued, her world had been overturned. After that, the inheritance would be settled, the Picasso Museum opened to the public, with these incredible funds of which she had been the keeper for almost twenty years. Her function had ceased.

This woman, who had directed the scene for the ending of her husband's life, withdrew with one final episode. She organized every detail of a large exhibition of her collection in Madrid, under the patronage of the Spanish royal family. The evening of the opening, on October 15, 1986, she shot herself in the temple with a revolver and rejoined Pablo.

She is at rest in Pablo's burial place in Vauvenargues, under the protection of the Sainte-Victoire.

Her daughter, Catherine Hutin-Blaye since her marriage, born during her first union, became her unique heir. One of life's ironies, she thus received a significant part of the Picasso inheritance, since her mother had been the principle beneficiary without having any inheritance rights to settle. So there was a second very important *Dation*,[60] comprising notably some extraordinary portraits of Jacqueline, and eighty notebooks of crucial drawings. They were passed to the Picasso Museum in 1990. As for Catherine's important collection, it was revealed in part, for the first time, on the occasion of the opening of the Pinacothèque museum in Paris in November 2003, during a first exhibition entitled affectionately *Jacqueline's Collection*.[61]

60 This was the legal solution (i.e. the conferment of artworks) proposed by the Picasso heirs to pay off the inheritance tax on Pablo's legacy, then on Paulo's. The Picasso *Dation* alone allowed the setting-up of the Picasso Museum in Paris, enriched by the Jacqueline Picasso *Dation*.
61 This exhibition, conceived with the help of Marc Restellini, Director of the Pinacothèque, traveled to Japan and to the United States in 2004.

Today, divorced from her Brazilian husband, Catherine lives with her two children. Catherine and my mother Maya became very close when Jacqueline died. They shared the same anguish of having lost their mothers in comparable dramas. Just as Marie-Thérèse had not been able to survive the departure of Pablo, the love of her life, so Jacqueline had not known how to live without her sun.

This final episode ends by adding all its excessiveness to the legend of Pablo Picasso. All the ingredients of a tragedy had been brought together to feed the craziest fantasies—and also, unfortunately, the sordid tales and provocative rumors. It is against these rumors that I am fighting here, methodically but confidently, as though going into battle, with truth as a weapon—and also proof. So that the Picassos are forgotten a little and *the* Picasso is remembered. The one and only, the original.

Money

*Living modestly
with a lot of money in
your pockets.*[1]

PABLO PICASSO

Picasso and money: the subject intrigues us, fascinates us, makes us dream. Sometimes, it gets on our nerves. My grandfather was certainly the richest painter in the history of mankind. He left those close to him the most important — and unforeseen — legacy, both in volume and value that a painter's family ever shared. He seemed to have rediscovered an old alchemical secret of being able to transform all he painted into gold. Consider the record prices obtained from the sales of his works.

Approximately 40 percent of his total production reverted to his heirs. These (with the exception of his widow Jacqueline, who died in 1986, and her daughter Catherine Hutin-Blaye) formed a joint ownership, holding and exercising the moral rights on his entire oeuvre, his name, his image — and all derivative rights. According to the law, moral rights are non-transferable, being largely passed on by descent. Today, this joint ownership is probably the best organized in the world for the protection and promotion of such a legacy, considering the particular interests of the heirs forming it.

To associate art with money appears unpleasant, even unacceptable. Some prefer mendicant painters to millionaire artists. However, money has always financed art. Would Michelangelo have painted the Sistine Chapel without

1 Cited by his daughter Maya.

Pope Julius II? Raphael, the Vatican chambers without the Medicis? What would Chambord have been without François I or Versailles without Louis XIV? Is it possible to organize a large exhibition without a sponsor? Money is intimately allied with the development of art. But, as a philosopher once said: "… art does not prove itself, it experiences itself." If emotion is incomparable, the price of a work of art is limitless.[2]

Art, the fatal passion of the misunderstood creator destined to a premature death, in poverty and madness … a romantic phantom! This may, unfortunately, have been the fate of some. My grandfather always thought of "poor Van Gogh" or Modigliani. Artists have always attempted to sell their talents, binding themselves to society and its functions. Without any embarrassment! The United States followed this dialogue, with the success and affluence one knows, even outside its own borders. Sometimes, society, in certain countries (including France), views money with suspicion—not without a certain kind of hypocrisy. In fact, money is the only measure for that irrational object, the object of art. It is a paradox that, in a society that worships merchandise, its value is not the product of a measurable investment, of time spent mixing various price ingredients, but of an abstract consensus, of an emotion.

As I said earlier, my grandfather came from an unpretentious family, from a certain bourgeois background. The Ruiz Blasco y Picasso family, however, had to tighten its belt to get through to the end of the month.

Pablo's childhood, first in Málaga, then in La Coruña and finally in Barcelona, unfolded in this relative fashion. Pablo's father, my great-grandfather Don José, a painter and drawing teacher, earned just enough money for his family to survive.

He soon recognized his son's exceptional artistic gifts, but his own make-up and character of a loyal civil servant placed limits on his ambition: Pablo, he thought, would become a drawing teacher and happily succeed him. Formed by the orthodox academicism of Spain, Don José saw his son as, primarily, an extremely talented portrait painter, who could round off the end of the month with commissions from bourgeois families. These extras would be a welcome complement to the modest salary of a civil servant.

Artistically, Don José had one specialty—pigeons and doves. These were young Pablo's first models.

All this promised a kind of conformity. Don José loved traditions, which brightened up his uneventful everyday life. However, this steady life was,

2 Ref. to the Sotheby's auction sale in New York (May 5, 2004), at which the record price of $104 million was paid for Picasso's *Young Man with a Pipe*.

unfortunately, full of hazards: his position as conservator of the small art museum in Málaga was done away with. This event probably ignited Pablo's wish to see other things and to proceed in a different manner.

Another member of the family was aware of the youngster's talent and "contributed," in the real sense of the word, to his development. Don Salvador, the supposedly wealthy doctor uncle who was, out of necessity, the head of the family, provided the means for the young Pablo, and then for the art student who went to Madrid in 1897 to participate in courses at the Academy of San Fernando. In this way, Don Salvador has a place in the short history of benefactors: it was in keeping with his social standing, and Pablo obtained some academic awards that were his pride and the repayment for his investment.

Pablo, however, became bored and, above all, nourished his spirit with nocturnal rendezvous, life in disreputable areas, and visits to the Prado. Don Salvador learned that Pablo was no longer attending classes and cut off his allowance.

Pablo had never known hunger or cold. Now he was suddenly drifting towards poverty and, then, destitution. This period of his life determined his attitude to people and matters. Being in need brutally defined his attitude to reality—and to money. These material difficulties in no way turned him away from his vocation.

Picasso started from scratch. The legacy that he would establish in the sixty-five years following his experience in Madrid was entirely the result of his work and stubborn determination. And, as a modest form of defense, his career and business sense primarily resulted from not relenting. It was not the product of a life spent in boredom and complaining—nor was it the result of taking risks.

Pablo traveled a great deal. Madrid, Barcelona, Paris. These journeys were long, strenuous, and uncomfortable, on wooden benches in third-class carriages, pulled by noisy steam engines.

In Paris, which he visited in 1900 on the occasion of the Exposition Universelle, he realized that a new breeze was beginning to waft through the world and he wanted to be one of those fanning it. He finally settled in the French capital in 1904.

I have already related how some friends, Catalans like himself, put him in contact with art dealers. Did this mean that he now had to overcome the almost carnal relationship he had to his works—or should I say to his "children"? Pablo never liked selling his works. His talent had originally been developed under the guidance of his father and uncle, without any real

commercial necessity. But, in order to survive, he now had to make some choices.

When his estate was opened in 1973 it became necessary to catalogue all of these "children" going from one house to the next. Throughout his long life, my grandfather had held on to the works he loved, "Picasso's Picassos," which nothing could make him give up. Of course, he had to sell many works at the beginning of his career; his "production" was restricted by his limited financial means, and he only kept a few paintings from his blue, rose, and cubist periods. But rapidly, as soon as money and time were less short, he produced more and was able to, more often, retain his works.

The Picasso Museum in Paris, created from the payment-in-kind which his heirs made for their rights of succession, is an exact reflection of the treasures, preserved by my grandfather, and gathers together works from all periods of his life—mostly those which he would never have consented to part with for money.

When Pablo arrived in Paris, at the most intense time of his Blue Period, his life was particularly precarious. He could feed his hunger—but not every day. He told Maître Antébi, his lawyer, who remained his friend to the end of his life, that he once ate a sausage, stolen and brought back to the atelier in the Bateau-Lavoir by the little dog that lived there!

His only source of income came from selling his canvases; very meager sources, because for each handful of francs he received in payment, he had to buy new canvases and paints, as well as food. Hasn't it been suggested that the reason for the Blue Period was that blue paint was the least expensive?

And the legend has survived.

Anne Baldassari, conservator at the Picasso Museum in the Hôtel Salé, suggested more seriously that the Blue Period was a result of the new techniques developing at the time, which Picasso adored: photography and cinematography both had blue as the dominating color.[3]

At this time, Picasso was still not integrated into the art dealers' circles. His first contact with Parisian dealers was made through the mediation of a certain Manyac, a Catalan émigré who purchased his first canvases. He acted as a middleman—and took his percentage for doing so.

He introduced Picasso to the great Ambroise Vollard. But the promised success of 1901 (a few dozen francs of the period, when 10 francs represented a little more than $38 today—a treasure trove) did not become reality. Pablo replaced the flighty colors and images of Belle Époque Paris with

3 In *Treize Journées dans la vie de Pablo Picasso.*

sinister, sad, emaciated persons, a reflection of his everyday life—but not of his clients'. His friend Casagemas' suicide made him melancholic. Moreover, he became disturbed at having found a style that pleased, but in which he risked becoming entrapped. In addition, the demonstrative, or better ambiguous, affection shown by Manyac, who put him up, was becoming suffocating.

His paintings weren't selling. What could be done?

After a trip to Barcelona, paid for by his father, and a short period of uncertainty, Pablo returned to Paris to fight. He had dealings with both the difficult "second-hand dealer" Clovis Sagot and the enthusiastic "debutante" Berthe Weill. Ambroise Vollard, however, came back to him and purchased, little by little, a significant portion of his production in 1906 and 1907, the preparatory painting for *Les Demoiselles d'Avignon*, among others. At the same time, two wealthy Americans, Leo and, particularly, his sister Gertrude Stein, entered into Picasso's life.

Pablo became talked about in the Parisian microcosm of the time, comprising more or less a dozen people. As I said, a young German-born dealer, Daniel-Henry Kahnweiler, discovered him during an unannounced visit to the Bateau-Lavoir in 1907. Pablo finished *Les Demoiselles d'Avignon,* a historic event that rocked modern art. Kahnweiler, however, did not become his preferred dealer until autumn 1911.

There and then, he was surprised at Picasso's negotiating skills. With the success of his first Cubist paintings, the costs for a Picasso exploded: he received around 150 francs (approximately $588, today) for paintings of the 1906–07 period, this rose to more than 3,000 francs (approximately $9,700) in 1911. Pablo signed an exclusive contract with Kahnweiler at the end of 1912, where he determined the conditions and prices—in keeping with the growing market. This went as far as a falling out when, at the beginning of the war in 1914, the eve of the German attack, Kahnweiler, as a German citizen, took refuge in Italy. The works in his Parisian gallery were seized, and he could not honor a debt of 20,000 francs, which he owed Picasso. He insisted on being paid in full before consenting to re-establishing their dealings in 1923. In 1914, such a sum was the equivalent of about $64,000 today —a small fortune.

In the meantime, Pablo had met the dealer Léonce Rosenberg—at Kahnweiler's no less—who took the latter's place during the war. But, he lacked "vision" and his place was taken by his brother Paul, a friend of Eugenia Errazuriz, a famous figure in Parisian life and modernist confidante of Pablo. She was the one who introduced him now.

Paul Rosenberg and his associate Georges Wildenstein must receive the credit for Picasso's international stardom. The first dealt with Europe and

the second was responsible for the USA. An agreement, reached in 1918, organized Picasso's visibility in the media and his share.

The selection the dealers made of the canvases to be put on sale—those recommended by Picasso—certainly corresponded with those that the public was capable of appreciating. But they falsified the perception of Picasso's oeuvre, exhibiting older works and refusing to sell those new paintings, which they considered, right or wrong, as being less "commercial."

On the other hand, on the financial level, they were in complete accord with the intentions of their client. All the more as a flamboyant period with Olga began; Pablo lived life to the full.

Kahnweiler's relationship with Picasso lasted for the rest of his life; but the artist always—and very cleverly—knew how to keep him in competition with other dealers, by summoning them to his atelier at half-hour intervals, having them pass each other in the entrance, and live out their anguish of being overtaken. He never allowed others to call the tune.

When a woman asked him what one of his Cubist paintings was supposed to represent, Pablo replied ironically "... Madame, it represents 20 million francs." To those who did not understand his work, Picasso provided one primary reason for at least admiring it: the price. This apparent cynicism was merely an expression of his contempt for helots.

Does this mean that, from a very early age, Pablo's financial interests were greater than his artistic ambitions? I do not think so. Simply, in the pyramid of necessities, constructed by Maslow,[4] he is still, at the age of twenty, at the stage of satisfying elementary needs. A Cubist, but also a realist, he understood that, without money, life is impossible.

I do not believe, as Patrick O'Brian does, that he "had to have it and [that], all his life, he preferred to keep money, rather than spend it."[5] And, in a bizarre overstatement: "He hated to be separated from it against his will. His parsimony was such that an enemy would have been able to consider it as sordid avarice; but did that not merely reflect his fear of death?" Who would want to be "separated" from the fruits of his labors against his

4 Abraham Maslow, an American psychologist constructed a theory seeking to identify an order of priority for the satisfaction of human needs. The pyramid of psychological factors in our behavior is composed of five hierarchical levels motivated by the forces of the environment, namely: 1. Physiological needs: breathing, eating, drinking, sleeping, taking shelter from inclemency, clothing. 2. The needs of security: stability, order, liberty, protection. 3. The needs of love and belonging: belonging to one/several group(s), affection (loving and being loved). 4. The needs of self-esteem: respect, accomplishment, strength, confidence, competence. 5. The needs of personal accomplishment: knowledge and comprehension, realization of one's potential, mastering one's environment, creativity. This is, above all, a need for inner growth, the source of intrinsic motivation.

5 O'Brian 1976.

wishes? Who would like to be bled by others? Besides, we have innumerable examples for Picasso's generosity. During the inventory of his estate, between 1973 and the end of 1976, an astounding number of letters from unknown persons was discovered—it has been calculated that in the 1950s and 1960s he received more than one hundred pleas each day, which did not all remain unanswered.

Concerning the connection with death, mentioned by O'Brian, one fact must be recalled—in the society of the late nineteenth and early twentieth centuries poverty and destitution led to death. The network of social protection and solidarity that we know today did not exist. There were no charity evenings, no telethons, no unemployment benefits. Life expectancy, itself, was much shorter.

My grandfather lived in those times and he lived meagerly. He saved his skin and, very quickly, he provided for well-being. Through this experience of extreme poverty, he acquired a "reasonable" attitude towards money: not to squander it wastefully, since it served for the essentials, at least, for himself and those close to him—wife, companions, children, the Spanish family, the wide circle of friends, former lovers, political causes, and employees … without taking the upkeep of the houses, which had become warehouses for his gigantic oeuvre, into account. Nor can the innumerable requests for help be ignored. Pablo ended up with responsibilities he never desired. He would have preferred to have devoted his time to his art.

And then, certainly, this fear of death. Poverty, that was death! As such, he wanted to protect himself from it. This could lead to the conclusion that this foresight was parsimony, or sordid avarice.

At the beginning of the 1970s Pablo's annual costs of living amounted to a little more than 3 million francs for everyday expenditures (more than $2.6 million today). This included the upkeep of his houses and various allowances and salaries. He fulfilled his natural obligations as spouse, companion, father, and employer. For the rest, he kept quiet about his altruism. There can be no doubt that he ignored the fact that, in our exhibitionist society, generosity should be public and publicized. What self-promotion! He valued, "in an old-fashioned way" so to speak, that he had no open accounts with anyone.

My grandfather held out on his dealers. He showed them the things he was inclined to sell them, not those they wanted to buy from him. Even with Rosenberg and Wildenstein he preselected those things that would finally "please" them without ever painting to their orders. The price fixed for each work was a gamble for the dealers. Picasso played with them. One day he even volleyed a "Good news, I have given you a raise" at Kahnweiler. In fact,

he came to increase the prices, set by himself, for his works—and not Kahnweiler's percentage.

If he made more, so did his dealer as his commission increased. Why should he be satisfied with an unchanging quota?

Beginning in 1910, Pablo's standard of living increased in a significant measure. He moved into a beautiful apartment on boulevard de Clichy along with Fernande Olivier, his first official partner, whom he had met at the Bateau-Lavoir. In accordance with the traditions of Montmartre, he organized convivial dinners, evenings without end, faithful to the bohemian spirit.

Later, my grandfather taught Maya that "you should live modestly, with a pocket full of money." Was he thinking of his quite humble early years—his golden age, according to reports—as opposed to the years of becoming bourgeois, of the confinement to follow?

He separated from Fernande at the beginning of 1912. From now on, his lifestyle was comfortable. Since his Cubist canvases, he had become known and recognized. He initiated impulses. In the Café de l'Ermitage, on boulevard Rochechouart, he set his eyes on Éva Gouel. A few months later, he set her up on Montparnasse.

Until Éva's death, in December 1915, he led a happy existence, withdrawn, almost carefree in spite of the war. After the passing of the young woman, Pablo, as I have said, drowned his sorrows in short-lived adventures. He was lucky in being able to keep up several simultaneous liaisons, proof of his romantic wanderings and the absence of family ties.

The year 1913 is notable for the extraordinary purchase of works acquired by a group of discreet investors with the evocative name La Peau de l'Ours (the Bearskin). La Peau de l'Ours was formed in 1903 on the occasion of the Salon d'Automne, which was destined to make the art of the new century known. The objective of La Peau de l'Ours was to purchase paintings by promising, contemporary artists, to the value of 2,750 francs (approximately $10,374 today) each year, for ten years and to resell them at the end of that period. The "initiator" of this consortium was the dealer André Level. Among others, he convinced his three brothers and a cousin to participate in the adventure. It can truly be said that he was the sole specialist and it was more a gamble than an investment. In addition to some post-Impressionist works, Level mainly acquired Fauvist paintings and Picassos. He visited the ateliers of the artists themselves—Matisse sold numerous works to Level—and the most avant-garde galleries. In fact, only a single gallery offered "modern" works: Berthe Weill's.

Madame Weill had adopted a very moderate commission policy, on the order of 20 percent on completed sales—without any price guarantee. Level

bought three Matisses and twelve Picassos, always scrupulously within his annual budget of 2,750 francs. In 1906, he asked his associates to devote the major portion of their budget to works by a single artist: Picasso. In this way, Level, through the services of Clovis Sagot, bought six canvases and drawings.

Ambroise Vollard understood that something was happening. He resumed selling Picasso.

At the end of 1907, Pablo took up contact with Level: abandoned by his first dealers, my grandfather needed money. He offered him *The Family of Acrobats,* which he had painted during the spring and autumn of 1905, and refused to sell to Vollard for a price that he considered too low. Level offered the sum of 1,000 francs (around $3,800 today). This was a major part of his budget for 1908. He immediately gave him 300 francs as an "option" on the painting (Pablo had received other offers from German and Russian collectors). At the end of January 1908, Level collected the picture. Business settled.

In the following year, he purchased his first, daring canvas, the still life *Basket of Fruit,* which bore the mark of what was not yet named "cubism."

The activity of La Peau de l'Ours awakened the Parisian galleries and dealers. Bernheim-Jeune signed Matisse. Sagot, Vollard, Uhde, and Kahnweiler fought each other over Picasso's favors. The two years 1910 and 1911 were a period of consolidation for Level, who bought the incredible *Three Dutch Women* (today in the Musée d'art Moderne du Centre Georges Pompidou in Paris) and *Harlequin on Horseback* (in the Mellon Collection in the United States), purchased from a gloomy dealer who had acquired them from Clovis Sagot.

The developments on the art market during the ten years were such that, in 1912, La Peau de l'Ours, with its unchanging budget, was only able to make an offer for works by secondary artists.

In the following year, Level began with the programmed resale of the 145 works accumulated over the ten years. Following an extensive campaign in the press, he organized an auction sale—the very first in the twentieth century in the world of art—and the preparation of a prestigious, comprehensive catalogue. On March 2, 1914, the auction room was packed with eminent collectors, famous dealers (including Ambroise Vollard and the German Heinrich Thannhauser), intellectuals in the public eye, and *tout-Paris.* It was a real society event. Total sales finally amounted to 116,545 francs (approximately $380,000 today), which was four times as high as the total investment of 27,500 francs. This was a period of stable economy, without monetary speculation, without inflation in the cost of living: the total of the

sale was a fortune. The twelve works by Picasso attained staggering sums and alone made up 27 percent of the total value of sales, namely 31,301 francs (approximately $102,000 today).

The "orthodox" press created a scandal. They accused foreign buyers (to make matters worse, "the Germans," in an era when the revengers for the 1870 war still ran the show) of wanting to scuttle young, traditionalist painters, of forcing them to imitate these "grotesque works," of sinking French art!

Illusory reactions. The market had understood, the market had chosen. Kahnweiler, who had signed a contract with Pablo (in December 1912) sold "his" artist even more expensively. *Acrobat with Ball* had been sold a few months previously for 16,000 francs ($52,000 today), a much higher amount than the record price of 11,500 francs ($37,500 today) paid at the sale for *The family of Acrobats*.

Today the same works are worth a thousand times more.

Even more unbelievable was the spontaneous decision of La Peau de l'Ours to give 20 percent of the increase in price to the original artists. In this way, each artist benefited from the increase in value. This is the very first occurrence of "resale rights" six years before the official birth. This revolutionary action sealed the friendship between Picasso and Level—it was to last until the latter's death in 1946.

I have already recounted how Olga Khokhlova introduced Pablo to the customs of the Parisian establishment, starting in 1917—permitting him finally to lead a life in keeping with her education and hopes. Their ambitions for penetrating high society were very similar. She knew the score, he played the music. After their marriage, they established a bourgeois household, splendidly furnished, which Olga was able to organize with mastery and *savoir faire*. Pablo regularly met the artistic intelligentsia in the Parisian cafés of those crazy years. Olga, who had only a limited affection for bohemian life, made Pablo accustomed to the dinners and balls of the high society, and he was definitely not disappointed that he was "recognized."

Olga's personality was less atypical than it appears in Pablo's round of love affairs. She played a role in his own coming out, which can not be neglected. Olga was the response to Pablo's social aspirations, admitted or not. At that time, Pablo was approaching forty and drawing on the dividends of his art; the only thing missing was a family, and in correlation with this, social status. She had fine manners and distinction; what is more she was a virgin: the spouse of a king! She was also an immigrant, which brought them closer together emotionally. With her, the heart united with reason.

This complementary nature rapidly reached its limits when my grandfather, as was his way, had made his tour of the subject.

The layout of their beautiful duplex apartment in rue la Boétie in Paris, where they lived, had an area similar to a no-man's-land with inviolable rules: Pablo's upstairs studio. It had to remain in the state he left it. His nature prevailed and, probably, his creativity as well.

Some were strangely offended by the state of my grandfather's ateliers and homes, speaking of "a pigsty" or "a shambles." But this studio did not encroach on the household. In any case, it was the atelier that financed the household. This "bourgeois" criticism was intolerable, according to Picasso's semantics.

If Pablo knew how to take care of his money, it was not in refusing sumptuous expenses, and he always met Olga's demands: furniture, furs from Révillon, jewels from Chaumet, clothes from Chanel, Fairyland, and Jean Patou. He was proud of having such an elegant companion. Even in their most bitter quarrels, money was never a subject of discord between them.

Furthermore, Pablo never hesitated to help his family or friends in need. He regularly sent money to his mother, who had been a widow since 1913. She went to live with her daughter, Lola, and her husband, Dr. Juan Vilato, in Barcelona. Lola had children. As was customary a few years later, Pablo would give all the clothes of his son Paulo to his sister. In addition, he got his brother-in-law back on a sound financial footing after some failed transactions—all the more because the couple had six children, five boys and one girl.[6]

According to Maya, her father Pablo had always felt indebted to his niece María de los Dolores (called La Nena, "the little girl"), for taking care day and night of Lola, who was paralyzed for twenty years before her death. There was never a shadow cast on this unshakable affection, in spite of distance.

After the death of his sister Lola in 1958, my grandfather retrieved all the works of his youth, mainly paintings and drawings, which he had entrusted to her and, in 1970, added these (along with 58 *Meninas*) to the donation that his Catalan friend Jaime Sabartès had made to the City of Barcelona in 1963. As compensation, Pablo gave each of his sister's children a portrait of their mother along with five pictures from the final stage of the *Muskateers*.

I remember our cousin Javier Vilato, one of Lola's sons—a talented painter who died in 2001. I have never met anyone who was so happy to have taken part in Picasso's life. In his eyes, I rediscovered the spontaneity of the beaming young man in the background of Robert Capa's photograph that immortalized Pablo, carrying a parasol, and Françoise Gilot on the beach at Golfe-Juan in 1948. It was alongside him that I best understood

6 Juanín, Josefín, Pablín, María, Javier, and Jaime.

what the feeling of having a real family, with "tribal" aspects, founded on the sentiment of a clan and not on financial matters, meant to my grandfather.

For my grandfather, this "Spanish" family was well worth being cared for. They were dignified, courageous, and far removed from the "gossips" who so irritated him.

During his entire life, Pablo paid allowances: 10,000 francs net to his wife Olga ($5,570 today—and this was before the judicial decision on non-conciliation of 1935), to their son Paulo, to his children Claude and Paloma, to my grandmother Marie-Thérèse. Françoise Gilot was the only one to refuse. And, my mother Maya ordered that the allowance intended for her be given to her mother Marie-Thérèse.

In the same vein, Pablo never denied his son Paulo anything. Why has one always reproached Paulo for not having moved out and attempted to live his own life? Some saw a certain weakness of character in this, or an exaggerated affection towards his father. To me it appears to be absolutely understandable proof of the special tenderness one feels towards those parents who provide one with a life independent of financial worries. In my opinion, the fact that Paulo received an allowance from his father is in no way indicative of his supposed psychological dependence.

Furthermore, placing the entire burden of responsibility on my grandfather also appears, to me, to be too simplistic. There was a particular relationship between Pablo and his son Paulo, which only few people could understand. A reciprocal affection existed, a gentle interaction between father and son, made up of reverence and strong rapport. The "material" relationship that some would like to reduce their exchanges to, is dangerously superficial: Pablo, popular, courted, without doubt deceived, was able to reveal, with some people, his spontaneity and openness. Paulo was one of those so privileged.

With the death of Olga in 1955, the act of community property by default, resulting from the marriage of his parents, would have permitted Paulo to receive one half of the assets of the couple, in principle, his mother's share. This meant half of Pablo's fortune in 1935—the year of their official separation (the date of the first assignation to initiate proceedings). There was no arrangement in this sense. An inspection at the tax office in Cannes, where Olga lived until her death, showed that a declaration of succession was never recorded, under this title. There was no inheritance from Olga! In 1955 the essence of Picasso's fortune was made up of works of art. Paulo never dared challenge his father, in spite of his rights. He never said a word. He had already experienced the comfort of money and was satisfied with that; he preferred affective relationships. To take his share would have been

a way of depriving his father. Would he have had to make an inventory? Would he have had to sell some works?

Pablo had a complete understanding of the legal situation, and did not attempt to influence his son in any manner. He did not refuse him the alternative. He did not offer him any more. Pablo only offered Paulo to take back possession of the Château de Boisgeloup, Olga's official residence, even though she had never really lived there. Paulo came to bury his mother, not "kill" his father and risk burying him alive. In any case, the settlement of the community of property was postponed until later and wound up, using extremely complicated calculations, in the inheritance of Pablo himself. Nobody was robbed: later, Paulo reported that he was the only one who should have received anything. For one time in his life, he made a decision.

He did not become a millionaire in the year 1955; but he did manage to preserve the quality of his relationship with his father. Money was not a major point between them.

My mother Maya, the daughter of Pablo and Marie-Thérèse, was born in 1935, and always had the same attitude. After a serious period of studies, and going to and fro between her father and mother after the war, she paid many visits to her Vilato cousins in Spain. She even lived in Barcelona from 1955 until 1959.

Pablo was very proud of her. He found his ideal confidante in Maya. On top of this, she had a strange resemblance to him. And, like him, she was not particularly interested in material goods. Did he not offer, in the mid-1950s, to buy her an apartment on the harbor of Saint-Tropez above the Le Gorille bar? She turned the offer down. Then, there was the large plot of land on Tahiti beach in Pamplona. "I don't need it," she would reply. She had been a witness to the various appeals that her father had received. Stunned by their audacity, she comprehended the danger: to be indebted meant to lose one's liberty.

Taking account of the hold Picasso had on others, she wanted to preserve this liberty at all means, and the quality of their personal relationship. She dared to give him her opinion, which he appreciated. She had become an adult before her time, and managed the allowance Pablo sent her mother, before she was even fifteen years old. My grandmother Marie-Thérèse was quite carefree.

After having shared the intimacy of her father, to the point of overflow, and the little secrets of his love life, having taken care of Claude and Paloma, having assisted in the departure of Françoise and the arrival of Jacqueline, Maya finally decided to leave in the autumn of 1955. She had become an adult; she had no moral or financial obligations towards anybody; she had

a woman's dreams that she wished to fulfill. Pablo could not do without her; she could do without her father. In a sense, she left her father in the way Françoise Gilot left her partner. He was alone in his art, he would also be alone in his life. There can be no doubt that it was this "audacity" that strengthened Pablo's respect for Maya.

Upon her definitive return from Spain, in 1959, my mother met my father, who was a marine officer. The marriage took place in 1960 and Pablo offered my mother 25 million old francs ($385,543 today) as her dowry. Such a rancorous gesture! Who could still accuse him of being stingy?

The situation with Claude and Paloma, after the separation of their mother Françoise and father Pablo in 1953, was such that they received a living allowance up until the artist's death. The publication of Françoise Gilot's book[7] in 1964 enraged Pablo, but it did not put a stop to the material assistance he gave his children. This manna did not prevent Claude from becoming a photographer, at the end of the 1960s, chiefly in New York, where he worked for *Life* magazine. Nor did it hinder Paloma from starting a promising career as a jewelry designer, her passion even as a child, with Lalaounis, a jeweler of Greek origin. Atavistically, both children became part of the artistic world.

Concerning the following generation of Pablo's grandchildren—my generation—we are six. In chronological order: Marina and her half-brother Bernard (Paulo's children), Richard, Diana, and myself (Maya's children), and Jasmin (Claude's daughter).

As I have already mentioned, the oldest, my cousin Marina, described her relationship with our grandfather in a book co-authored with Louis Vallentin, in which she "declared" Pablo responsible for everything and everybody.[8] She dwelt on his total indifference and recounted "memories," the common quality of which, as I have already emphasized, is that precise dates are never mentioned—as if that isn't "zapping" people or vital information, or leaving a fortunate "blank." The invectives that peppered this book bowled me over, and they bothered everybody who knew our grandfather: "a gnome barely five foot five inches tall,"[9] "a mixture of not-kept promises, abuse of power, of mortifications, of contempt, and above all, incommunicability,"[10] "diabolical,"[11] "boor that he was,"[12] "a manipulator, a despot,

7 Gilot and Lake 1964.
8 Marina Picasso and Vallentin 2001.
9 Ibid., p. 27.
10 Ibid., p. 34.
11 Ibid., p. 39.
12 Ibid., p. 64.

destructive, a vampire,"[13] "the great aficionado of human distress."[14] This string of "praise" culminated with the words that everybody could appreciate: Picasso, "the genius of evil!"[15]

Marina, nevertheless, warned her readers: "My purpose is not to say anything bad about Picasso."[16] Who could have doubted that?

Despite the lack of dates, the sordid descriptions of both material and intellectual aspects could only be disturbing; and I was sincerely disturbed. Unfortunately, Marina's essay was not a novel. Was it intended to cloud over the individuals' responsibilities, leaving only a single ideal culprit?

We must remember one important point: Marina and Pablito are not only Pablo Picasso's grandchildren, they are, above all, Paulo and Émilienne's children. Just to clarify the situation once again: at the time of the birth of their first child Pablito in May 1949, Paulo was not yet married to Émilienne —she was still married to another man, René Mossé. Her marriage to Paulo took place in May 1950. A new life began for her: she finally became Madame Picasso. In the following November, she gave birth to a second child, Marina. And Marina has always emphasized her mother's particular nature. Émilienne, especially proud of being Picasso's daughter-in-law, thought, according to Marina, that she could duplicate the presumed lifestyle of her famous and extremely wealthy father-in-law.[17] But she had only married his son. It seemed that she would have to make do with the varying allowance that Pablo handed out. In spring 1951, shortly after the birth of their daughter, the couple separated. The adventure was short-lived. From then on, Émilienne lived with her two children and Daniel, the six-year-old son by her first husband René, whom she wanted to have with her. (I must however also mention once again that Marina totally ignored his existence in her own book.) Marina gave a long list of their material difficulties. It is true that Émilienne refused to work, in view of her "social standing." This was a personal decision, a choice which developed into a material problem, but which was completely foreign to our grandfather. I was astonished that Paulo did not provide regular alimony. Strangely, Marina does not mention that in her writing, only going so far as to indicate that Paulo transferred, randomly and parsimoniously, merely an insufficient portion of his own allowance.

All the same, the court in Grasse had set an allowance for Paulo to pay, determined for his children alone. Marina questioned the fact that her father

13 Ibid., p.134.
14 Ibid., p.109.
15 Ibid., p.63.
16 Ibid., p.33.
17 Ibid., pp.40, 42–43, 56.

was never forced to meet his obligations, but never looked for a satisfactory reply.

Maître Armand Antébi, Pablo's lawyer, handled the settlement of Paulo's divorce from Émilienne, and has vivid memories of a nonconciliatory meeting in September 1952.

The courts granted the divorce on June 2, 1953, stipulating that Paulo pay a modest allowance for his children. The judges did not award a personal allowance to Émilienne.

Émilienne appealed against the ruling and, after discussions, proceedings began. First of all came Émilienne's maneuvring tactics, all of which were brushed aside by the judges: the various "incidents" during the proceedings, such as the inexplicable reservation concerning Paulo's nationality (Was he Spanish? Divorce did not exist in Spain in those days, so if Paulo had been Spanish he could not divorce Émilienne), a reputedly suspended nullity suit—under the pretext that the notification of divorce had been erroneously addressed—but which she had submitted without delay (after one year!). We must add her outrageous demand for a psychiatric report on Paulo, which was rejected, and the demand for educational supervision and help for the children, which was granted in April 1957.

During the five years the appeal proceedings lasted (a record), Émilienne attempted to obtain a larger allowance from her husband, which would seem normal if she had not demanded an amount commensurate with the fortune of her father-in-law Pablo. Because she had been married to Paulo, according to the laws of universal estate, she imagined that after the death of Olga (Paulo's mother) in February 1955, she should receive part of the inheritance that Olga had left to Paulo as, legally speaking, the appeal proceedings dealt only with the period up until 1953. All the better. This was mainly intended to involve Pablo in the case. It was therefore absolutely essential to make the divorce proceedings, initiated in 1951, and the divorce itself, granted in 1953, invalid in order to reconsider many matters, and to extend the said period of marriage beyond February 1955. This had the logical goal of forcing Paulo to demand his inheritance from Pablo. And then she would receive her share of it.

Between 1955 and 1958, Jacqueline and Pablo expressed more and more clearly their desire to have nothing to do with Émilienne. The doors of La Californie remained closed. As Émilienne had official custody of the children, Pablito and Marina became the involuntary victims of these disputes, as so often happens in such divorce cases.

I have already told how Marina and Pablito, unfortunately, saw our grandfather only "by default." All other unexpected attempts by Émilienne to send them as scouts met with the guardian's strict but polite refusal.

The final divorce proceedings in January 1958, dramatically froze the situation of Paulo and Émilienne's children. They were placed in the exclusive custody of their mother, with no procedures established to permit visits by their father. In the meantime, Pablo, knowing of the torment in which the children were living, made, as I have already indicated, a request for custody, which necessarily entailed a social investigation and then an investigation by the police. Despite his good intentions, his own position as a "multiple" father, hardly in accordance with the strict legislation, and the procrastination of Émilienne, made his useful proposition ineffectual.

The allowance that Émilienne had been granted during the proceedings was lowered. A certain Madame Bœuf, a social worker in Nice, was commissioned to check the material and moral conditions that Émilienne provided for her children and ... consider their placement in an appropriate establishment.

Two people were always absent on the photographs taken in Cannes, Vauvenargues, and Mougins, and at the corridas with Pablo: Pablito and Marina. In her book *Grand-Père*, Marina "erroneously" captioned two crucially important photographs: in one she is seen as a baby in Pablo's arms; the baby is really Paloma.[18] In the other, she claims to be in the arms of their father Paulo, along with Pablito. If the negative really shows Pablito, the other child has to be Claude! Marina was not even born when the photograph was taken! In her first book *Les Enfants du bout du monde,* she also captioned a photo of Pablo with Jean Cocteau taken during a cocktail party as: "In La Galloise, Vallauris, 1956."[19] However, nobody lived in the villa La Galloise after spring 1954 (at this time, Pablo had set up home with Jacqueline, his new liaison, in his villa Le Ziquet) and La Galloise was completely empty in 1955. The photo must have been taken someplace else.

WHAT ARE THE FACTS?

Faithful to his principles, moved by the situation his grandchildren were in, but not authorized to take care of them, Pablo decided to pay the costs for the education of Pablito and Marina—the burden to be successful was on them.[20] After the Protestant school at La Colline, courses followed at Chateaubriand. This did not prevent Marina from stating "somebody" had refused support for her endeavors to study medicine and to become a

18 Ibid.
19 Marina Picasso 1995.
20 Pablo preferred to pay directly for the education of the children to ensure that the money required was actually used for that purpose.

pediatrician because it would have taken too long and been too expensive. That "somebody" was Pablo Picasso, represented by Maître Antébi, the interlocutor of Pablito and Marina, who would never have accepted such an outlay.

Maître Antébi told me, in the most lively manner, about his meeting with Marina. In fact, Pablito and she visited his studio in the rue d'Antibes in Cannes in 1968: "... This is how I got to know the children. They came to visit me in my office, to give me their desiderata.... They had demands in keeping with Picasso's supposed fortune."

Pablito wanted to be "a diplomat," but "he did not even have the elementary diploma...." Pablito, eighteen months older, was a sophomore like his sister Marina. The advocate remembers that Marina did not speak. Maître Antébi drew to their attention that his mission was to pay for the costs of schooling, nothing else. According to him, Marina never asked to study medicine. Maître Antébi never saw the two young people again.

This meeting was related in two different ways by Marina. In her first book, published in 1995,[21] she places it at the end of the second year (1968) at the insistence of Pablito. Then, in her second book, published in 2001,[22] she changes her story and places it after the high-school diploma, two years later, on the recommendation of her mother.

Moreover, Marina first of all wrote that Pablito had refused to take his diploma examination (baccalaureate) at the end of the term,[23] and then, in her second book, confirms that they both passed it, exclaiming "phew!"[24] Which of her books should be trusted? The education offices of the Academy of Nice know the answers.

Why did she make accusations about our grandfather with regard to a wish to study medicine, which was never communicated? Why make him appear to be a base skinflint, or attack Jacqueline who "would have" refused in his place? Why did she not speak about this great study project with Pablo himself, during the "visit" to Notre-Dame-de-Vie in Mougins in 1969, which she talks about? Perhaps because he could have answered.[25] In this book, Marina does not even relate that, at that time, Picasso was eighty-seven years old, had had a gall bladder operation—and probably on the

21 Marina Picasso, 1995.
22 Marina Picasso and Vallentin 2001.
23 Marina Picasso, 1995.
24 Marina Picasso and Vallentin 2001.
25 A photograph of Pablito and Marina, alone, was taken on this occasion in front of the statue
 L'Homme au mouton placed in front of the sliding grilles of the gallery on the ground floor of the
 villa in Mougins and not at Vauvenargues, as in the erroneous caption of the photograph in Marina's
 book *Grand-Père. L'Homme au mouton* was never located there.

prostate. Can one sincerely reproach a man of his age for being tired, for being "evasive"?

Finally, if one only stays with Marina's accounts concerning Émilienne's public statements or to her "pretences," one can understand that Jacqueline and Pablo kept their distance from these children, reluctantly, without doubt.

To do what one wants to do

According to Maya, Pablo did not contemplate the future. He would have been incapable of saying, "Later, you will have that." No, if he gave, he gave immediately or he provided the means for it. Thus, as a father philosopher, he gave my mother one of his first shoes (he gave the other to his own mother), because he considered it to be a necessity on earth. This was a symbol. He said that a man or a woman became liberated only when they walked, for the first time, without any assistance from their mother or father.

Pablo was born in an age of legal child labor, where the difficulties of everyday life were harsh, where sickness and death lurked among families. The youngest helped the oldest. It was an eternal renewal. The foundation of society was work, particularly after the Industrial Revolution—which took place in the nineteenth century—and the decline the fortunes of the ancien régime. Businessmen had become the new masters.

Pablo considered that one should always help others to reach fulfillment —and not just through short-lived pity. "The essential," he said, "is to do that which one wants to do." He made this his motto, the key to his freedom, his success.

According to Jean Leymarie, the famous art historian: "Picasso was extremely generous, that is to say, he wanted everyone to be fulfilled in his endeavors. Consequently, if you are an art dealer, you must make money. You must do your work seriously, and you must reap the harvest. To me, an art critic, he gave all the means for understanding him. Later, as he knew that I refused paintings as a museum curator, he made several drawings for me, on books, but he also said to me on several occasions 'If you need money, anything, let me know.'"

In the same manner, the famous photographer André Villers told me that, in 1953 he had a small camera and the desire to become a photographer. He often came across Picasso in the street and greeted him timidly. One day, Pablo remarked that he did not have his camera with him. The young man explained that it was broken. "That is as if somebody had stolen your eyes!" cried Pablo. The following day, Pablo sent him a magnificent Rolleiflex

professional camera. He gave him the possibility of becoming a genuine photographer, and Villers remained eternally grateful to him.

This same Villers also confided to me that when the artist Hans Hartung had to go back to Spain with their friend the sculptor Julio González,[26] in 1942, they received a bulky envelope from Pablo, with money for his Spanish political friends. Hartung confirmed this fact to Pierre Daix—although Pablo had never talked about it to Daix, even though he was one of the few with whom Picasso discussed politics. Villers also recalls that, when Germaine Richier[27] had health problems, Picasso sent her a small note: "I have just sold a gouache. It's for you. If I am in difficulties one day, I know that you will be there."

Françoise Gilot gave a precise description of her visit with Pablo to the Bateau-Lavoir in Montmartre in the 1950s: " I was better able to understand what the Bateau-Lavoir meant to him. It was his age of gold, when everything was still fresh and intact, before he had conquered the world just to discover that the conquest was reciprocal. The irony of this paradox struck him unexpectedly and he was prepared to try anything to rediscover this age of gold. We had climbed the slope to the rue des Sales. There, after knocking on the door of a house, he went in, without waiting. I saw a little old lady, slim, ill, toothless, lying on her bed. After a few moments, he left a little money on the table. She thanked him, with tears in her eyes, and we left. Pablo did not say a word. I asked him why he had taken me to see the woman. 'I want you to get to know life,' he said gently to me. 'That woman is called Germaine Pichot. When she was very young and very beautiful, she made a painter friend of mine, who committed suicide, suffer a great deal. After we arrived in Paris, he and I, the first people we met were the washerwomen where she worked. We had been given their address in Spain, and they often invited us to dinner. She was a real head-turner. Now she is old, poor, and miserable.'"[28]

Françoise Gilot never for a single moment doubted Picasso's generosity. However, she never tried to gain even the smallest financial advantage. And, she took great pleasure in describing humorously the sessions of frenetic counting and recounting of notes carefully locked in a trunk: "When he

26 Julio González (1876–1942): Catalan sculptor whom Pablo Picasso knew from the El Quatre Gats café in Barcelona.
27 Germaine Richier (1904–1959): French sculptor, pupil of Bourdelle. She renounced figurative conventionalism, taking up little-known animal themes and creating allegorical figures of strange creatures, mixing human, animal, vegetal, and mineral elements. Mixing the invented forms with a ferocious realism, she submitted anatomy to strange metamorphoses: mutilations, angular elements, bloated volumes. Her oeuvre evokes a world of anguish, of violence, and aggression, where the grotesque and tragic mix, revealing a powerful Expressionist temperament.
28 Gilot and Lake 1964.

came back, he often asked: 'Where is the money?' I replied: 'In the trunk' because he always took an old red Hermès box with him, filled with five or six million francs in notes in order to have 'enough for a pack of cigarettes.' But when, thinking that he was referring to the children, I replied: 'In the garden!' he would shake his head impatiently: 'But, no I meant the money box. I want to count it.' That really was not such a problem, because the box was padlocked and Pablo always had the only key with him. 'You're going to count it,' he said, 'and I will help you.' He counted a wad and discovered eleven notes. He gave it to me and I counted ten. He started again and, this time, only found nine. This made Pablo very suspicious, and we set out to check each bundle. He greatly admired the method Chaplin used in *Monsieur Verdoux* and tried to count just as rapidly. He made more and more mistakes, and he had to count more and more often. Sometimes, this ritual could last as long as an hour. Finally, Pablo stopped and said that that was enough, the accounts had fallen to zero."[29]

Describing their long relationship from 1943 to the end of 1953, Françoise Gilot never talked about Pablo's supposed avarice. Money seemed to be outside their common life, not that it was without interest, but because it was never a specific problem between them. They lived, by common agreement, quite modestly, mainly in Vallauris, between the small villa La Galloise and the Fournas atelier, an old building in quite a bad state of repair.

Patrick O'Brian wrote that in 1958 "Alice Derain and Marcelle Braque informed him that Fernande, having become deaf, old, and arthritic was not only ill but without resources; [Pablo] took an envelope, stuffed a million francs into it (enough to live for at least a year) and sent it to Fernande, who, however, had offended him cruelly by publishing *Picasso et ses amis* (Picasso and his friends), in 1933."[30]

The testimony made by the art dealer and collector Heinz Berggruen is similar: "All that I saw was generosity personified. He made lithographs for me; he never asked anything of me. He knew very well that I made quite good money with them. I do not remember the details, I merely know that, from time to time, I felt a debt towards him, a material debt. Each litho that I sold for one thousand francs, made me a profit of one thousand. In this way I made a pile of money; I gave it to him when we were alone.

'That's OK, that's OK!' he said.

'You don't want to know how much it is? Wouldn't that be better?'

'No, no. It's fine like this!'

And he put the wad in his pocket."

29 Ibid.
30 O'Brian 1976.

The young dealer, with his mischievous look, a German who had settled in Paris in 1948, had met my grandfather two years later and won him over. Pablo wanted to help him, but in his way, by providing him with the essential material for his business: works to sell.

Berggruen added that my grandfather often invited everybody to *Chez Félix* in Cannes for lavish meals at midday and in the evening. Did he pay —according to stories—by making a drawing on a corner of the table? For him, as for the others, this drawing would have been worth more than a bank note. Finally, everybody got what they wanted. Far from being a form of contempt, it was much more an agreement that satisfied all, nose thumbing the power of money, on which he was conscious of having an influence. It is possible that the story is true, and that the feeling of being more powerful than money made him quite happy! He beat money in his own way.

The rumor still makes the rounds that, when he paid by check, the check was not cashed because his signature had more value than the written amount. This rumor cannot be verified, as is the case with many others.

However, there is one true anecdote. A *corrida* was organized in Vallauris in 1961 to celebrate Pablo's eightieth birthday, and the famous torero Dominguin killed a bull in honor of Picasso. That was illegal in France. Maître Antébi told me that a member of the society for the protection of animals filed a complaint against Dominguin and that he was fined 100,000 francs. I appealed and, altogether, that cost 5,000 francs! Pablo decided to pay his friend's fine himself. I said to Pablo: 'I do not want any payment. It is a pleasure for me to be able to do something for you but I do not want to be out of pocket.' Pablo then sent me *his* check for 5,000 francs, which he had drawn just like a real one, with the payee, date and signature!" Maître Antébi decided "to be out of pocket" and kept the work of art. The framed check is still hanging in the office in his house in Gers. (Maître Antébi died in August 2002.)

One could reproach Pablo for being theatrical to the extreme with money. Heinz Berggruen also told me that "at the beginning of de Gaulle's government, 500 franc notes were produced. This time—it was not Chez Félix, but in another bistro in Cannes—there was a group of people and somebody asked him:

'Have you seen the new 500 franc note?'

'No, show me,' Pablo said.

I had a note, I showed it to him and he said:

'You know, the government is really not very intelligent. I should have been minister of finance.'

'What do you mean?'

'I could double your fortune immediately. Give me your note, now....
You see, there is a small round circle in this note, there.'

Then, taking a pencil (he did not always have one with him and could
become impatient if nobody could find him one) he drew a small *corrida*. He
did not sign, but designed a miniscule *corrida*.

'Now, it's worth 1,000 francs.'

'I took my note back and, that evening, with a few friends, told this story
as I have just recounted now. Then, one of my friends said:

'I'll buy it from you for 1,000 francs.'

'Agreed!'

'And he gave me the 1,000 francs. The others made fun of me: 'You are
really so materialistic, you have no shame! Picasso gave you that and....'

'Oh, but he said that its value would double, I wanted to see if that was
right!'

Still later, that same evening, I told Picasso what had happened because
I knew he would understand. He said to me 'You see, I should have been
minister! The proof! You proved it, that's great!'"

In his memoirs *J'étais mon meilleur client*, Berggruen tells a rather amus-
ing anecdote that shows how much my grandfather recognized the value of
his work and how much he loved to joke about those who valued his paint-
ing more than himself. This was the other side of the coin, and he was com-
pletely aware of it.

This happened on the beach at Golfe-Juan in the 1950s. It was very hot.
Picasso met a Parisian antique dealer from the rue de Seine, Mr. Ascher, who
asked him to make a picture for him. Picasso accepted. "The next day,"
Berggruen continued, "Picasso returned to the beach. It was one of the hottest
days that summer. 'Lie down,' Picasso ordered Ascher, pretending to be
harsh. 'Lie down on your back and don't move!' Picasso took several wax
crayons from his bag and started to draw light lines on Mr. Ascher's ample
paunch. 'Stay completely still,' he said, 'I need to concentrate.' Mr. Ascher did
not budge, sweating profusely. His chest became eyes, his navel a sullen
mouth. This is how Mr. Ascher was transformed into a walking self-portrait,
dripping with sweat. 'Look at my body,' he said sorrowfully. 'It's a genuine
Picasso. But what can I do? I will never be able to wash myself, to take a
shower. At night, I will be afraid of rolling over in my sleep and erasing my
portrait on the sheets. What can be done? I will spend my time looking at
myself in the mirror—a victim of the heat and a victim of Picasso. I will suf-
fer so much.' Mr. Ascher, with his astute business sense, finished by saying
with a sigh: 'Maybe I could offer the portrait on my belly to a major magazine.
That would be a sensation. Title: *The Walking Picasso*, or something of the
sort.' When I told Picasso about Mr. Ascher's problems, he was greatly amused.

At moments like that, he was somewhat diabolical: 'Poor Mr. Ascher,' he said, 'I painted his portrait and now he will just have to live with it.'"[31]

His friend Douglas Cooper, a collector and art historian, had a similar misfortune. He had damaged the side of his car, a black Citroën. A coat of antirust had been applied in the repair shop. What a beautiful surface! Pablo rejoiced and suggested drawing on it with chalk. The drawing was magnificent, in many colours, and the car was then worth a fortune. Pablo suggested going to the beach with the car-masterpiece. Cooper was worried the whole time that the drawing could be effaced with the speed and dust from the road. That happened inevitably, because Pablo had suggested taking the long way round. The drawing had disappeared when they arrived! Douglas Cooper was mortified, Pablo delighted with his prank.

At the beginning of the 1960s, at the time of a *corrida* in Arles, along with Jacqueline, Paulo, and the photographer Luc Fournol, Pablo wanted to photograph the admirers who came up to him with their own cameras. Each time he tried to "create" a comical situation, which the poor victims would only discover when their films were developed. Luc Fournol caught on to this and gave him a complicit wink.

Pablo mistrusted people who asked him for an autograph and often refused to sign a picture or sheet for tourists. Deep down, he controlled his own brand name, and never stopped saying: "I don't do just anything," adding with a malicious smile, "I have a precise plan."

He loved to be surrounded by his friends and to enjoy life with them. At the restaurant *La Colombe d'Or* in Saint-Paul-de-Vence, which he often visited with Simone Signoret and Yves Montand, he also saw Henri-Georges Clouzot, Fernand Léger, and Le Corbusier.[32] He was a regular guest.

Fifteen years ago, I went over my memories in a long session with Montand himself. The actor depicted, with sweeping gestures, a larger-than-life, jovial Picasso. He said that he soaked up the youth of other guests without the slightest reservation and was a model of vitality and audacity for the youngsters.

I can hardly imagine the monster that certain people have described, the soulless being, Jekyll and Hyde—Hyde above all. If he was a monster, then it was a sacred monster! I recently spoke to Francis Roux, who has taken over his parents' restaurant, about this. He also remembers the spontaneity of my grandfather towards his own father. When Pablo learned that the latter was seriously ill, he visited him and asked his son to accompany him to

31 Heinz Berggruen, *J'étais mon meilleur client, Souvenir d'un marchand d'art*, trans. Laurent Muhleisen, Paris 1997.

32 Le Corbusier (Charles-Édouard Jenneret, 1887–1965), architect and designer.

Mougins to select a canvas for his father. "Francis, come to the studio," he said, "I'll get a painting ready, because I know that he would really love to have a work of mine in his house. Come home with me, come and choose one." Francis Roux went and selected the one for his father, which still hangs in the restaurant's dining room.

In other respects, Pablo had a kind of "intelligent" generosity. All testimonies agree: he wanted to give well, hoping that his gesture had a reason. He gave willingly, and generously, when he knew that somebody was in need; but not if he felt that there was no emergency.

Maya told me that when her father found out that somebody had had an automobile accident, or that a picador had been wounded during a *corrida*, he took some of the money at hand and offered it: "Go and give it to his wife. She is going to need it during the few months he is ill...." It was important that this was neither embarrassing for him nor the person he helped. She remembered that her father never refused to lend money to anyone. A way simply had to be found. He gave, in a "special" way, because, as he said, "if the people are broke, it will be hard for them to repay." According to Maya, what he often did was to give a painting and then say "I have given you this picture, but I want it back, I'll buy it from you." And he paid, saying: "I know that sooner or later you will have to sell this painting and not as well as I can. I will buy it from you." An inch of Picasso was worth a lot. "Maya, will work it out ..."—they did not have a calculator. Then he would say: "I'll give you a good price." He would then hand over the money corresponding to the fictive—but still real—sale.

This anecdote proves the ingeniousness of his method, but also the modesty of his gesture. My grandfather never needed the approval of others for his actions. He disliked hurting or humbling people.

All the rest is simply gossip from those who did not know him.

I met Georges Tabaraud, former director of the communist newspaper *Le Patriot,* on the Côte d'Azur on the occasion of the publication of his memoirs *Mes années Picasso.*[33] He had had long conversations with Pablo during the last twenty years of his life, and was, at the same time, his friend and "political" interlocutor. He gave an example that illustrates the refinement of his "technique": "In 1963, I was in Barcelona.... My guide was called Minuni, Picasso himself had recommended him to me. He was an old *banderillero,* but a serious injury had forced him to give up bullfighting. At that time, Picasso, who had been at the ring, took financial responsibility for his care and hospitalization. At the end of his convalescence, Minuni replied

33 Tabaraud 2002.

that, before his accident, he had been saving to buy a little bar in the Calle Nero de San Francisco, not very far from the Picasso Museum. But the accident had dried up his resources. Pablo went away for a moment and returned with a small picture under his arm: 'Take it. You will only have to sell it and you will have enough to buy your little bistro!'

Minuni left with the painting. The next morning, Pablo telephoned him and asked if he still had the picture. He told him to bring it to him immediately. Minuni saw his dream coming to an end. He thought that, without doubt, Picasso had reconsidered. 'Listen,' Picasso said to him. 'You have no idea of how much this picture's worth, nor who you could sell it to. You are really going to be had. Sell it to me, I want to buy it from you.'.... Picasso telephoned Kahnweiler (his dealer) to ask what a fair price would be—he bought back his painting and Minuni bought his bistro."

There are countless similar anecdotes—proof that, with Picasso, the exception was the rule. Maître Antébi witnessed a similar scene at the house Notre-Dame-de-Vie: "There was a weaver who made carpets, and he had reproduced one of Pablo's pictures in fabric: it was magnificent! I was with him the day he brought the carpet, and he had to get two million francs for his work. Pablo said to him: 'Here are the two million, give the carpet to your son!' Pablo was no more tight-fisted than anyone else...."

My mother told me that one of Pablo's friends, a Catalan sculptor called Joan Rebull, was in France in 1942–44 during the war and had had great difficulties making ends meet. His sculptures were not selling well and Pablo did not know how to help without offending him. Now, Rebull had a little daughter, a very small, very thin, puny girl, who was the same age as my mother. They had become good friends. Rebull made a sculpture of his little girl's head and offered it to Maya. Picasso then made a proposition to Rebull: "You gave your girl's head to my daughter, why don't you do Maya's head now?" He then made a sculpture of young Maya's head. Pablo bought the head which Rebull had created at the market price. He wanted to avoid humiliating him.

My mother has always kept these two small statues, which now have pride of place above a large fireplace in her home. They have a particularly strong meaning.

My grandfather was also generous in a discreet manner. That is praiseworthy in principle but not in fact; in their ignorance, certain people have fiercely accused him of egoism and, unfortunately, have found willing listeners.

Pablo took absolutely no notice of these rumors. He was more afraid of spoiling the personal relationship he had to those he helped. The difficulties

of his youth had made him understand the uneasy feelings of someone who receives without knowing when he will be able to repay. He did not forget that he, himself, had suffered, and above all else, he did not want to humiliate anybody.

He told this anecdote about his beginnings in Paris to Georges Tabaraud: "The winter of 1907–08 was hard, extremely cold. Even the Seine froze over. A winter, he recalled, increasingly more difficult for him because, after *Les Demoiselles d'Avignon*, his new ventures had not been really understood and supported by art lovers, as well as by his own friends and the critics who had shown an interest in his work since the Blue Period. Sales had become rare, the studio was not heated, he did not have enough to buy canvas and paint; his meals were as frugal as those of his acrobats. Pablo said, 'Manyac and Vollard, my first dealers, detested my new paintings. They pretended to have too many unsold works on stock to be able to buy any more.' One morning when he was broke, Picasso plucked up his courage, and rang the doorbell of the banker Leo Stein, Gertrude's brother. 'Before *Les Demoiselles*,' Pablo continued, 'he always compared me with Raphael.... Leo had not yet gotten up, he received me in bed. He was smoking a cigarette and reading the newspapers. I attempted to tell him my story; that I had not come to ask for alms but merely for an advance on a painting that he would like and that he, or his sister, would buy one day. Leo interrupted me with this small sentence I have never forgotten: "Why do you keep on painting these horrors which nobody wants?"... He did not want to hear anything, he opened a drawer next to his bed and threw me a 20 franc coin (around $73 today) as charity. I had not come to beg, I asked myself if I should not throw it back in his face along with the armchair and bedside table. But I had no paint, no canvas, no heat, no bread, so I took the twenty francs and left.'"[34]

My grandfather's *political* generosity had an absolutely individual character. Elsewhere, I have stressed Pablo's unshakable support for liberty—as he called it. I discovered the traces of the contributions my grandfather made to the committee for help to Spain. One example? A donation of 100,000 francs ($55,400 today) in November 1938, at the height of the Civil War. Pierre Daix confirmed to me that Pablo regularly gave money to the Resistance during World War II. But, he never made public the financial assistance he offered his friends. Out of principle, he never reported on these matters: he did not pay the slightest attention to what others thought.

34 Ibid.

Probably, the word "generosity," which I have repeated so often, mainly because others have spoken of avarice, should be replaced by "solidarity," seeing that this indicates my grandfather's real engagement.

"I always saw Jacqueline," Daix continued, "signing checks for old friends.... Pablo did not want it to be known. If necessary, he, in fact, wore the mask of Scrooge, because he received ten letters every day requesting money. Whenever it was reported that Picasso had broken a record there were all those cadgers he wanted to defend himself from, as was also the case with visitors. And, Jacqueline was not the one who made the decisions. I can witness that that happened to me towards the end of his life. When an old friend called he sent me to the telephone because he detested answering. When I returned with 'It's M. So-and-so,' he replied 'No, I don't want to see him. If he likes me he will understand.' He was the one who decided. Later, people gave Jacqueline credit for this; but Jacqueline could never say a word. Nobody had anything to say in his presence. It was your grandfather who decided, who decided yes or no."

Jean Leymarie also confirmed my grandfather's modesty regarding money—and other things. Several times, he was present at the regular sessions when Jacqueline brought him a signature book and my grandfather signed all the checks. Not only running expenses but also "gestures" to people he loved or had loved.

Sometimes Pablo even offered royalties. This was the case with the Madoura workshop. Alain Ramié, the son of the founders, recalled that Pablo, "in recognition of the efforts his parents, Suzanne and Georges, made for him in the workshop where all the staff were conscripted when he arrived, granted them all his editorial and royalty rights [for the ceramics he had created]. He reckoned that, at the time, it was an enormous loss for my parents. My mother was not capable of producing these herself. It was in recognition of this that, in 1948, he authorized my parents to make copies. Concerning royalties, he granted them in 1967. My father had him make this little paper for the Madoura workshop...". I have seen the original "little paper," in my grandfather's handwriting, a moving testimony of sincere appreciation, and worth much more than the debt. Pablo was not a lawyer, this slip of paper was contestable. But, in a few lines, in an extremely improvised fashion, he had probably given back one hundred times that which he had been lent. Discreetly. Sincerely.

Picasso very quickly learned the ropes of the business. He did not say "I am going to paint or draw," but always "I am going to work." In his eyes there was a concrete connection between work and money. He received large

amounts from his dealers but the money that he gave he did not count so precisely. It was much better to leave calculations to his spontaneity and give him the initiative than to ask for a precise bill or salary.

Inès Sassier worked for him for more than thirty years—her official title was "chambermaid"—becoming, in practice, his steward. She confirmed to me that Pablo had always been very generous towards her. She did not always have a fixed salary, she never asked for anything, but my grandfather regularly gave her enough to live comfortably—and often more. In fact, every year, Picasso gave her a portrait he had painted of her and some drawings. This still elegant woman told me how, at Christmas, my grandfather drew no distinction between the presents for Claude and Paloma and those for her own son Gérard, who was the same age.

It was the same with his barber and friend Eugenio Arias. He remained with my grandfather, in this function, until his death. He also let himself be "paid" in works of art in exchange for his services. He was more a confidant than a barber, because, in a ritual that took place almost every day, there cannot have been an enormous amount of work in cutting the few white hairs my grandfather had. Pablo, nevertheless, insisted that he come very regularly. The collection of works he received, and which were dedicated to him, formed in 1984 the first donation, followed by the final inheritance, to the "small" Picasso Museum in his home town Buitrago del Lozoya near Madrid.

In general, there is not the least proof that the financial assistance Pablo provided for his family, for Olga and Marie-Thérèse, Claude, or Paloma, occurred with the slightest hint of moral horse-trading. The nature and quality of his relationships, real affection or open conflict, were such that he stood completely to his decisions. In accordance with a definite, ultimately natural, engagement.

If some things misfire, or are forgotten, everything rapidly falls back into place.

And so, the allowance that Marie-Thérèse had received for decades, was interrupted, without explanation, in spring 1970. It could have been out of forgetfulness: Marie-Thérèse waited a little; nothing came. In panic she wrote to Pablo, a letter that was too emotional, almost superstitious, and that made the situation more tense. The entire post was opened by Mariano Miguel and looked over by Jacqueline. Jacqueline's tolerance for the continuation of exchanges between Marie-Thérèse and Pablo was now strained to the limits.

Left without a reply, Marie-Thérèse consulted a lawyer, Maître Georges Langlois, to take up a more diplomatic contact with Pablo. Cornered by her

need, she thought about selling some of the numerous works Pablo had given her. Warned by her mother, Maya contacted an American dealer, Franck Perls,[35] who was known to her friends. He traveled to Paris, met my grandmother, and offered to buy the complete collection of paintings, drawings, and lithographs.

For the first time in her life she was forced to make a heartbreaking decision. The offer was serious, but certainly much lower than the sum she would have received for selling the works individually. And then, she did not want to be separated from all her memories. They had become part of her flesh. What should she decide? Marie-Thérèse felt lost, between yesterday and today, between illusion and reality.

Naturally, the works were not signed. It was Pablo's policy to sign only the works "he" decided to separate himself from. Those that he distributed in his surroundings remained in "the family." But, at that time, it was absolutely essential for the dealers that those works intended for sale be signed by Pablo, as proof of authenticity. Perls and his associate, the dealer Heinz Berggruen, who had an excellent relationship with my grandfather, went to Mougins, to show the works to the master and have him sign them.

They had told him that they would show him about one hundred works. Pablo was very curious to find out who could be in possession of such a large number. Berggruen, however, brought only a few with him, in particular a magnificent engraving of the *Minotauromachie*, which belonged to him and which he wanted to have dedicated at the same time.

My grandfather was surprised that Marie-Thérèse wanted to sell these works. He did not seem to be up-to-date with her imperious demands. He was about to sign when Jacqueline appeared. The meeting turned into a storm. Pablo was nervous and tired, Jacqueline shattered: with the reappearance of these canvases from the past, the reality of the relationship between Pablo and Marie-Thérèse had become clear. Jacqueline threw a tantrum and "forbade" Pablo to sign. According to her, the works were only "stored" with Marie-Thérèse! She blasted out into the room: "She would only have to work! Why doesn't she get a job as a housekeeper?" Then she left.

Berggruen, who himself was visibly upset by his only memory of the scene, confided in me that "Pablo was livid."

35 Franck Perls, son of the art dealer Kate Perls, of German origin, who had made the acquaintance of Pablo before the war. They had always stayed in contact and her son, living in Los Angeles, had become a friend of the family's, notably during the period with Françoise. In Europe, he had connections with Heinz Berggruen, the young German art dealer who specialized in prints, and was appreciated by Pablo. Perls organized several exhibitions in Los Angeles, including a collaboration with the UCLA Arts Council (for which Pablo offered to carry out several series of lithographs in 1961) and the Los Angeles County Museum of Art in 1966.

The two dealers were struck dumb. I have already explained that Pablo hated it when others sold his works and preferred to do it himself. He was also upset that amateurs could be taken for a ride by the dealers. But here, above all, he was dealing with sentimental gifts and the parting was heartbreaking. Money he had and gave. But works, which were genuine declarations of love, were something completely different.

Using Jacqueline's anger as a pretext, Pablo suddenly refused to sign. He dedicated Berggruen's engraving and left the room, worn out by the incident.

Then he had Roland Dumas intervene, who took up contact with Maître Langlois.

A few negotiations later, Marie-Thérèse committed herself to not selling Pablo's works and they remained hers without any dispute. The payment of her allowance recommenced immediately. After all, the support of Marie-Thérèse could appear, after so many years, as a natural and legal obligation. In sadness, the heart can rediscover reason.

Dora Maar was in possession of several sketchbooks that Pablo had given her. Once, when she was in need of money, probably after their breakup at the end of World War II, she sold the sheets from one of the books, separately. My grandfather was beside himself with rage. He always preferred to help financially rather than see his works dispersed. He had also come to her assistance when, after their separation, she had suffered a mystical, hysterical crisis. She was admitted to the Sainte-Anne Hospital; Pablo managed to have her released and asked his friend, the psychoanalyst Jacques Lacan, to intervene. She then began serious psychotherapy. Following this, I well remember Pablo offering her a house at Ménerbes in Vaucluse, as a souvenir of their intellectual complicity and support during the darkest hours of the war in Spain and World War II. She spent the rest of her life in the mausoleum she had secretly constructed around her vanished love, a cavern of treasures discovered after her death and then sold at auctions, after having been exhibited, to an audience moved at discovering the tenderness and violence of their relationship. Alongside the major canvases, the sentimental value of the small pieces greatly increased the official estimation and the sale was an enormous success (almost $36 million). The public was moved by Pablo's intimacy.

Pablo's situation, which was absolutely unique both in terms of fortune and celebrity, had caused him to be more than just a sought-after person. The major solidarity organizations did not yet exist. Today, personalities serve to stimulate the public's generosity, they do not substitute for it. What was expected and demanded of Pablo was money.

It is interesting to note that the quality of solidarity, of which my grandfather was constant proof, has been passed down through the entire family. Just like Pablo, Maya, Claude, and Paloma have always—anonymously and to the best of their abilities—given their time and a great deal of money to medical research, humanitarian and charitable causes. It may well be that they will not be all too happy with my disclosure, but it is exemplary. I often remember questioning my mother about the invitations she received from medical-research institutions. Those in charge, she replied, thought that because of her standing, she could take part in galas organized to thank donors and collect additional funds—although she always wanted to remain anonymous, however great her contribution. She never accepted invitations. Recently, she spent several full days in a hospital with cancer patients to cheer them up. I saw her devastated after returning, but so happy at having shared her smiles with them.

If I permit myself to reveal this information here, it is because I feel exceptionally proud. Faithful to her actions and in keeping with my own means, I myself try—as do millions of other people—to react to major national or international causes.

The Marina Picasso Foundation, created about ten years ago in Thu Duc on the northern outskirts of Ho Chi Minh City to assist Vietnamese orphans, is a further illustration of our family's tradition of solidarity. It is not a public foundation, in the traditional sense, since it does not seek external funding, but is financed solely by Marina. Through this "redistribution," to which each of us contributes—aware that the luck of our birth and the work of our grandfather has left us in a privileged position—Pablo, in some way, has been given a second life.

I have related how, upon his arrival in Paris, Pablo found himself in a delicate financial situation. My grandfather, who did not know what the future had in store, was obliged to live modestly. And, he remained that Spanish émigré who had belonged to a disadvantaged, sometimes abused, class.

If everything that flowed from his hands turned into gold, he had the reflex of regarding his work as sacred. His art was a right not a privilege. Despite his conviviality, he was very serious, even uncompromising on certain points, whether art or money.

One of Heinz Berggruen's sons wanted to make a spontaneous visit to Picasso. "You want to go to Picasso, but I don't know if he'll see you," replied his father in way of a warning. "Yes, of course, a boy from California ..." replied the young lad, thinking that this double label would seduce Pablo. He went to Mougins, rang the bell and was, so it appears, very disappointed that Picasso did not deign to receive him. He introduced himself as Berggruen's

son and somebody told him that Picasso had no time. He could not even speak to him. In these matters, my grandfather never showed any favoritism.

If he was miserly with anything, it definitely was only with his time. The frustrating feeling that time was flying by led him to offend, deceive, even humiliate people without knowing it. Sometimes, his door remained locked for his children and grandchildren. And this race against the clock accelerated by leaps and bounds as he grew older. Even Paulo, his oldest child, had to announce his arrival at the Côte d'Azur. He took it completely in his stride, without being offended, when told on the telephone: "Monsieur would greatly prefer that you come tomorrow!" He knew that his father did not like to be disturbed when he was working. The bond that united them existed outside any physical proximity. It is quite understandable that Paulo, trying to coordinate his visits to his father with visits to his own children Pablito and Marina (of whom he had no custody), very often gave up making them coincide—unfortunately.

As long as he could control his fame, he remained very accessible. But, after the war, he became a global public figure. The time he could devote to his own family was, little by little, whittled away by all those who wanted to meet him. It was necessary to divide up the time available in an extreme manner. Paulo and Maya, his two oldest children at that time, possessed an independence that the youngest Claude and Paloma did not yet have. The separation of their parents, in autumn 1953, accentuated this growing incommunicability. However, Pablo tried to see them on a regular basis, during the school holidays and on certain weekends, as happens with most separated parents. The arrival of Jacqueline in his life was not the sole factor of isolation.

In addition, it must be remembered, that in the 1950s, Pablo, already in his seventies, was a very old father. The children only accentuated, involuntarily, in his eyes the passing of time.

Gérard Sassier, a privileged witness, remembers Picasso's constant preoccupation: not to lose any time, to be entirely devoted to his work. "That was the only thing that interested him. Not what there was to buy or everyday life! He wasn't materialistic at all, except with regard to time!" Above all, he lived with and for his work. Money was simply a means of making it possible to indulge his passion—to dwell in it entirely, *in fine*, on its result. In his *My Galleries and Painters* Daniel-Henry Kahnweiler tells that one of the things that meant the most to my grandfather was being creative. One day "his studio was broken into. The bed linen had been stolen and the paintings left. He was not happy; he would have preferred the paintings to have been stolen."[36] And so he was forced to deal with the mundane matter of

36 Kahnweiler 1971.

buying bed linen—something that definitely didn't interest him. The paintings would not have been a problem; he could paint some more. Nevertheless, he was slightly annoyed that the linen was preferred over his paintings.

I have said how much he loved his work, how proud he was of it—and how he was always saddened when he had to part with one of his canvases. Fernande, cited by Antonina Vallentin, confirmed that she "always saw Picasso depressed when he had to sell a painting."[37] His passion for his work was possibly excessive. Alongside this passion, money represented nothing. My grandfather felt a *physical* need to create. If he had not been famous and rich, he would have died for his art—an impoverished painter, without a dime.

When Patrick O'Brian discusses Picasso's connection with money he cannot stop avowing that "Picasso loved money, that is indisputable; and he loved hanging on to it; but what distinguishes him from the majority of people, is that this enrichment did not show itself in arrogant exultation."[38] Haggling and selling exhausted him; parting with a canvas depressed him; this was one of those rare things that suspended his activity. During the days after a sale, he was unable to pull himself out of his melancholic state.

He loved to paint, he could not conceive of painting without love. When he was still not very well off, Vollard asked him for a copy of *Child with Pigeon*. "Picasso looked at me with surprise," Vollard relates. "But, it wouldn't give me any pleasure to copy my own painting; how do you think I could paint without joy?"

Here, we are at the heart of the matter: work filled him with joy. He no longer needed to care about the material matters of life, since after 1916 he lived sheltered from need. One day he said to Kahnweiler, "I would like to live like a pauper, but with a lot of money." The dealer commented on this, "Essentially, that is the secret. Picasso wanted to live like a pauper, to continue to live like a pauper, but to be sure about tomorrow. That is what he meant: to have no material problems."

That was the case after he became famous. He wanted to rediscover the charm of his golden age, without its problems, as Françoise Gilot once said. "To live modestly, but with a lot of money in your pockets," as he told Maya. And it all made sense.

He was perfectly aware that his prices were rising tremendously. This made him very circumspect, often uneasy, sometimes it even angered him. Some would say that this was coquetry or a form of false modesty. Maître Antébi was witness to his satisfaction parallel to his irritation: "He purred,"

37 Vallentin 1957.
38 O'Brian 1976.

he said amusingly. Pierre Daix told me about one of these moments of astonishment: " I experienced the resurrection of his portrait *Yo Picasso* with him, in 1969 [it had been painted in 1901, been sold, and then disappeared for many years]. I brought him the Ektachrome which he had not seen since…. He was very happy and said to me:

'That's what broke the record?'

'Yes, it made $500,000' (approximately 3 million francs at the time, $3,278,000 today).

He looked at me:

'$500,000—what does a Rolls cost?'

I did not know the price of a Rolls so I replied in a roundabout way:

'Let's say, it would be ten Rolls.'

He looked at me again and said:

'Can you see Van Gogh in a Rolls? They're crazy! I did that when I was nineteen years old! $500,000! $500,000! Can you explain that?'

He was not "offended" by the price, but he thought here was something irrational and, at the same time, he said to himself:

'That poor Van Gogh, who starved to death..!'"

According to O'Brian: "Although he was extremely interested when financial questions suddenly came up, there were long periods where they never affected him; in any case they never had the slightest effect on his painting, not even when money was indispensable for the essential needs for everyday life. His life—the major portion of it was spent in his atelier. That is how, once the difficult days were overcome, he did not believe any more in the reality of money, no more than he could believe the enormous amounts which were paid for his paintings a few years later. He used money as a form of toy or weapon, as a not very convincing symbol of his domination, of his success, as a standard for comparison which he no longer believed in, but which flattered him. His attitude was complex and often contradictory; but this idea of absence was corroborated by the fact that he never desired to make investments. A man whose life is deeply involved with these problems would try to make his money yield a profit; but Picasso, at the time of a passing crisis with financial difficulties, was capable of buying pieces of gold and then forgetting them; Françoise Gilot saw a box full of gold in the rue la Boétie, and after his death, bundles of bank notes, some no longer in circulation, were found in the drawers and cupboards."[39]

Maître Antébi remembers a case, found under my grandfather's bed after his death, bursting with 500 franc notes. "For bad days, if I ever have to get out in a hurry!"

39 Ibid.

Adrien Maeght, the gallery owner and collector, confided this personal recollection to me: on the occasion of an exhibition organized in spring 1947 by his father Aimé and entitled "On Four Walls," Picasso showed the large canvas *La Toilette* (today, in the Picasso Museum in Paris). Adrien was told to fetch it from the rue des Grands-Augustins. Pablo knew exactly where the painting was, covered in dust. Adrien transported it on the roof of the family's Citroën—even though, in those days, he had no driver's license. The painting was returned after the exhibition in the same way! A little later, Pablo agreed to lend it again and he brought young Adrien to his bank. This was the occasion of a visit to one of Pablo's safes (probably unique for an "outsider") in the BNCI (today, the BNP Paribas Bank) to collect a painting. There, Adrien noticed an infinite number of works, stacked side by side, "including a Cézanne," and, above all, a shelf, two meters long, covered with gold ingots. "I had never seen so much gold in my life!" There were no more ingots when Pablo died but, in the inventory, hundreds of gold coins (US ten and twenty dollar coins, gold francs, sovereigns ...) and franc notes, dating from before 1939, are listed.

Whenever Pablo made real-estate purchases, the space was only bought for the benefit of his oeuvre. These were not investments, he never resold his properties. Even worse, he also paid without canceling the rent of the places (rue de la Boétie and rue des Grands-Augustins), where he never set foot again, and from where he was evicted. At his death, he was in possession of the Château de Boisgeloup close to Paris, the property Le Fournas in Vallauris, the villa La Californie in Cannes, the Château de Vauvenargues near Aix-en-Provence, and the farmhouse Notre-Dame-de-Vie in Mougins. He was never personally involved in these purchases, always having a notary and his banker take care of the price and formalities. Paperwork was a waste of time. He was pleased to have new ateliers and additional space to store his works.

The only exception was the château in Vauvenargues. Of course, this was extremely spacious and very comfortable, but as he said to Kahnweiler with some pride: "I have bought Sainte-Victoire." Here, we was united with Cézanne.

This was, most probably, my grandfather's most impulsive and most sentimental purchase.

A kind of power struggle between Pablo and money has been established, a game ending fatally with a vanquisher and a vanquished.

He could not resolve the misery of the world, but he tried his best.

After the "sumptuous" period in the 1920s following his first marriage, Pablo made few ostentatious expenditures. He ate decently, but did not like large gastronomic feasts. Over time, he did away with his three-piece suits.

Most of the time, on the Côte d'Azur, he wore shorts or boxer shorts and a shirt. Times had changed and he lived in the sun.

He kept his magnificent prewar Hispano-Suiza. Above all, it was the shape of this automobile that he loved. One could impress everybody with it. The automobile fulfilled its mission perfectly, going to and from Spain along the coast, or to Royan at the beginning of the war. The shortage of fuel put an end to this. It was followed by an Oldsmobile until his chauffeur, Marcel Boudin, pulverized it in an accident in 1953. Pablo purchased a 1926 Hispano-Suiza, even larger than the previous one, that seated ten. The ancient engine needed an expert's attention and Adrien Maeght, a neighbor, often came to Mougins to give a helping hand to get it moving. Pablo looked after it like everything else—especially his works—with love.

THE INHERITANCE

This "affective" accumulation of his works was to become the Picasso inheritance. In an official report, Maître Maurice Rheims, the estate expert in charge of the inventory, describes the artistic treasure left by Pablo Picasso in the following manner:

"The group of canvases, preserved by the painter up to his death, appear to us to comprise several types:

– First of all, the paintings of which he was particularly fond. We think particularly of those early works, some of which he repurchased;

– then, those paintings that he kept because of personal memories, or because they bore witness to different stages in his technique or vision;

– finally, those paintings completed during the final years of his life and which he did not feel could as yet be given to his dealers."

It was added that the same procedure was followed in respect to the drawings, sculptures, ceramics, etchings, lithographs, linocuts, tapestries, and books.

After Pablo died on April 8, 1973, there was no doubt that he had left the largest legacy that any painter had ever left behind. Only Jacqueline, his widow, knew the incalculable number of his works—or better, she knew that they were really innumerable.

After the period of identifying the legitimate heirs (Jacqueline, Paulo and then Maya, Claude, and Paloma) the effective succession procedures, in the legal sense, were initiated at the beginning of June 1974. In the initial stages Maître Darmon, a notary in Cannes, opened the succession activities. In response to his request of April 18, 1973, the central register of last testaments confirmed one week later that it did not have a file in the name of the

deceased. There was, therefore, no will and on a strictly legal basis only two heirs to Picasso were recognized—Jacqueline, his widow, and Paul, known as Paulo, his son with his first wife Olga.

After July 1973, Maître Darmon officially requested the financial administration in Cannes to apply the law called *Dation*, dated December 31, 1968, which allows "the waiving of inheritance taxes through the transfer of works of art, with a high artistic value, to the state." At the beginning of August, he deposited a request for an extension of six months for registering the declaration of inheritance with the revenue service. In fact it would take more than four years finally to reach this point.

Maître Darmon acted solely on behalf of Jacqueline and Paulo. He even began with an inventory, without having any real idea of the difficulty of the task: portraits are described as still lifes, a "group of ten paintings" with no further description is mentioned, the location of the works is omitted.

The legal recognition of the filial position of Claude and Paloma, in spring 1974, made it clear that the affair had now become more complicated. Claude and Paloma requested the designation of an official receiver. When Maya was, in her turn, "welcomed" by the judges the following June, she joined in this request.

Pierre Zécri was named official receiver in July with a mandate for one year, which would be renewed annually up to the settlement of all points pertaining to the inheritance, followed by the organization of the jointly held property—that meant up until 1983. Maurice Rheims was named the expert responsible for the procedures of the inventory. Nobody had the slightest idea of the scope of this operation. But, very soon, each of the heirs realized that an official receiver was absolutely necessary. Maître Zécri replaced Maître Darmon, the notary, who still remained with his official title close to Jacqueline. In addition, each of the heirs had a personal notary take part during the discussions, which helped in understanding the complexity of the inheritance being dealt with.

First of all, a list of Pablo's properties was drawn up, containing his houses, studios, apartments, and bank deposits. Then it was necessary to make a list of the movable property—including, of course, his works.

There were around sixty meetings between the heirs and their counselors between 1974 and 1979. I myself took part in the final general meeting dealing with the inheritance, which took place in autumn 1979, attended by all heirs and their lawyers. Everybody was congratulated for having completed a mission, which went beyond individual interests, so successfully. It was like surviving a foreseen shipwreck without getting wet!

On that day, I had the impression of representing, in that large gathering, the future generation, the peaceful generation that would profit from the accomplishments and be able to establish its pleasant future based on the memory of Picasso. It was like after a political revolution and the creation of a new constitution. I was the silent spectator of the great adventure taking place. I was also the link between the artist's family and the men of law: I had already started my legal studies. One group greeted me, the other welcomed me. I saw that as a sign.

On that occasion, the only photograph of the group was taken, in which —as some sort of irony—I also appear, without knowing that I would write my very own story twenty-five years later. This photo, instigated by Maître Zécri and intended to remain private, appeared in the magazine *Paris-Match* the following week, to symbolize "the inheritance of the century."

Media interest in inheritances has always staggered me: more often it neglects the merits of the deceased to exult in the good fortune of the heirs. However, there is really no merit in inheriting. It is only a legal expression. And, this amazement results in the heir feeling the strange sentiment of guilt. In addition, there immediately follows the moral obligation of being worthy of what one receives.

I have the luck of not being an heir and I hope that my parents have an extremely long life. I have been the privileged witness of this inheritance: my situation as a "non-heir" comforted me in my idea that an inheritance is a living thing, an exchange, a transmission of moral values—the taste of work, of merit, the feeling of gratefulness, of esteem for others. My grandfather was part of this heritage of values and I have a different relationship to his oeuvre. It is not merely an inventory number for me.

In Pablo's inheritance, matters took on an unusual dimension due to the works of art. These were not factories or shops that one or the other heir could take over, giving the impression of being one with the patrimony. Among Picasso's heirs, nobody painted, drew, or sculpted and this is what they were going to receive! Of course, Jacqueline, Paulo, Maya, Claude, and Paloma, all sources of inspiration for Pablo's works, have an artistic legitimization in this respect. Even Christine, Paulo's widow (Paulo died in 1975) and their son Bernard inspired him to *Maternités* one creative day. But the heirs had not participated in the creation of their patrimony.

I remember that my mother surprised everyone after the final division by jumping for joy at the thought of getting back this or that work that she had seen as a child and that brought back so many memories. She had led her life convinced that she would not get anything, because that was the law. Her

relationship with her father had been without any "hope" and, consequently, free of any financial interest.

The belated reform on filial recognition had caught up with morality. That this reform took place a few months before Pablo's death allowed Maya to maintain her spiritual relationship with her father. Nobody, absolutely nobody, had ever contested that Maya was her father's daughter. A law had separated them, on paper, but not in reality. But, love has always been more powerful than law.

I never cease saying: there was never any "wrangling" over Picasso's heritage. The advocate Paul Lombard analyzed that "this is where legends begin to express themselves. It has often been said that Picasso's heirs were fascinated by money, that they tore each other to pieces, that there was a long judicial battle, bad blood, etc. That is wrong! From the beginning, when they had gotten over the general shock, one started to see signs of a kind of consensus based on family unity." Jacqueline, Paulo, Maya, Claude, and Paloma had a common cause.

This was to combine the wish to succeed in reaching a peaceful conclusion to the inheritance, and to respect the legal regulations concerning devolution: the situation of Paulo, the oldest legitimate son, and of Maya, Claude, and Paloma, his natural children, as well as of Jacqueline, his widow, whom he married according to the old regime of community of property and movable and acquired property. To this was added Olga's estate, which had not been wound up after her death in 1955, and for which Paulo had not claimed his rights. Olga and Pablo had been married without a contract and fell under the same regime of community of property, and personal and acquired property. It was necessary to settle the accounts.

This complex ensemble of individual aspects could have proven insoluble without the desire of all those involved to keep the peace.

Maître Hini, one of the notaries involved in the inheritance, informed me: "There was a major concern that I saw with Maya and with the others. Jacqueline, Claude, and Paloma, as well as the other members of the family, were fully aware that it was necessary to preserve Picasso's oeuvre, and that the best possibility was to include the major works in the *Dation*. One or the other might have wanted to keep this or that work. There was the willingness to see the work endure. All the parties saw this as an absolute priority"

Paul Lombard gave me the same impression: "Contrary to what one hears, the heirs behaved exceedingly well. I have an advantage over my colleagues in that I have experienced, at close quarters, all the major inheritances.

I have dealt with Bonnard, Dunoyer de Segonzac, Chagall, Maeght.... I really know the milieu, and I consider that making a case of rapaciousness against Picasso's heirs is not honest!" More particularly, the advocate remembers that in the bosom of the reconciled family "there are two persons who emerged strengthened: Paulo for his feeling of solidarity and Maya for her unselfishness, her sense of moderation and wisdom. Paulo, who could have taken a purely retractile and egoistical stance, did not do so."

The famous reunion in Cannes, in spring 1974, just before Maya was recognized by the courts, is a good example, in my opinion. Paulo took Maître Hini aside and said to him: "You should reassure Maya, tell her, I will always give her her share...."

A considerable bonus was that all of the lawyers involved in the inheritance knew each other, corresponded with each other, and in addition, belonged to the same generation: Jean-Denis Bredin, Roland Dumas, Bernard Bacqué de Sariac, Paul Lombard, André Weil-Curiel, Maurice Rheims, and Pierre Zécri—to which must be added the heirs' individual notaries, ministerial officials renowned for their wisdom. As Paul Lombard still recalls: "This became the case of the century for the advocates and one saw the entire French bar trying to get into the fortress!"

The first period began officially at the end of 1973, in effect mid-1974, and finished in June 1975 with the terrible death of Paulo. The handling of the estate of Paul Picasso, known as Paulo, with his three heirs: his widow Christine and their son Bernard, aged only fifteen, and his daughter Marina, aged twenty-four, were added.

On the "folklore" level, the Picasso inheritance also makes us aware of an additional heir in the form of the famous person Eugenio Arias, my grandfather's friend and hairdresser from 1948 until his death. During a visit by the official receiver to Notre-Dame-de-Vie, Picasso's confidant during his late years showed up and declared himself a "spiritual son" of Picasso with the wish of participating in the division. In spite of the sincerity of his attachment, he was politely informed that such a title did not exist under French law and that his wish could not be fulfilled.

Even though, after my grandfather's death, the press made column-long calculations of the value of the inheritance and of the respective shares of those involved, a genuine kind of magic took the place of any mercantile interests within the group. As Picasso's houses were opened in 1974, an entire century returned to life.

Art regained its rights. And each one, Paulo, Maya, Claude, and Paloma, rediscovered memories, often intact—as if time had stood still since their

departure. Jacqueline took on the role of head of the family, or, if you prefer, guardian of the temple. Had she not insulted everyone, at the time when Maurice Rheims, accompanied by his team, the children of her deceased husband, and their advocates visited Notre-Dame-de-Vie in Mougins for the first time in 1974? In spite of her wish to remain calm, she realized that the kingdom, where she had once been the amorous servant, had disappeared. Vanished forever.

It was too much for her. The inventory penetrated the rooms, moving objects that Pablo had arranged or disarranged. Did she not say to Pablo's children, after a meeting with Maître Zécri, that she had raised them! At this, Paulo, with his habitual good humor, replied that she was born in 1926 and he in 1921! Jacqueline was flattered by this indirect compliment.

Maître Hini remembers a visit to La Californie, the villa in Cannes that Pablo left in 1961, where all the studios were closed: "I remember the first major session of inventory taken in La Californie. I was working with Maître Rheims.... It was the opening of the gates. We were dumbfounded. It was like Ali Baba's cave. I saw hundreds of paintings stacked against each other. I saw the studio. Maurice Rheims waxed lyrical because Pablo Picasso did not use a palette and crushed his tubes on newspapers. He said: 'Oh! There! There! That's the hand of the master!' looking at the old newspapers on the ground.'" Paul Lombard recalls: "I had never seen anything like it in my life ... it was strewn with Picassos, with paper all over the floor.... At one instance, I walked on a letter, and bent down and picked it up. If I had been struck by lightning it would not have had a greater effect on me: it was a letter from Apollinaire to Picasso! To this day, I regret not having stolen it. What honesty makes us do!"

For an expert and enlightened collector such as Maurice Rheims, it was nirvana, where work and passion swept aside his habitual reserve. For him, "climbing up the stairs, one after the other, we felt like we were entering into the house of Raphael"

Maurice Rheims had met my grandfather on several occasions during the 1960s. He gave me a rapid, but precise, sketch of this absolutely uncommon man: "He was a prodigious man, the most moving person I have known in my life ...; he remained full of vigor and humor." Concerning the rumors about Pablo that had been making the rounds for several years, he replied simply: "That is really exaggerated. He was not an evil genius. I do not feel that he deserves that.... I believe that, for him, only his work counted, what was going to exist. He had a feeling of obligation towards his oeuvre." When I asked him why Pablo had not made a testament, he replied philosophically: "For Picasso, everything in the universe followed its destiny. The point of departure is in no way important. The arrival is everything. And the arrival—nobody knows it!"

The inheritance was merely one stage more in this fatalistic scheme.

After Jacqueline and Pablo had been set up in Vauvenargues, and later in Mougins, the studios on the ground and first floors in the large villa in Cannes remained closed. The remainder of La Californie had been occupied, since 1968, by Mariano Miguel, a postwar Spanish friend and Pablo's last secretary, who lived there with his wife and their son Alberto. Miguel (everybody called him that after his family name) went to work everyday in Notre-Dame-de-Vie in Mougins, in the small office to the right of the entrance where, due to the layout, he controlled all the supplies (he was to remain Jacqueline's secretary until his retirement in 1980). Lucette, the guardian of La Californie since 1955, lived with her husband Antoine Pellegrino in the small house next to the large entrance gate, unshakable dragons protecting the hoarded treasures. One had the feeling that a great many masterpieces were there, awaiting the return of their creator.

The large house reverberated with the noise and screams of surprise just as during the time when Claude and Paloma spent their holidays there. A feeling of eternity floated above it. A souvenir of simple pleasure, of the postwar period, of *joie-de-vivre*, between brothers and sisters united by the same father. I loved it when my mother, on her return, told us of all the things she had rediscovered. Oh, she hardly even thought about the inheritance! She rediscovered the uncommon way of life that she had chosen to interrupt almost twenty years previously. Even more, Claude and Paloma were, for her, still the children she had known and cared for. She vaguely expected to see her father in this or that doorway, delighted at having been able to trick them about his death....

The inventory on the Côte d'Azur took months. Maître Zécri and Maître Rheims organized two teams: one of researchers and one of packers in charge of security, packing, and transport to Paris. Often, the police, gendarmerie, and private detectives made their rounds. Maître Rheims' colleagues formed a closed guard of six, lodged in the Hotel Carlton in Cannes. Each of its members had a specialty: painting, engraving, drawing.... It was necessary to identify, catalogue, and evaluate the contents of the villa in Mougins, the Fournas atelier in Vallauris, the villa in Cannes and the château in Vauvenargues, and to get back the works that had been displayed in Pablo's last exhibition in Avignon.[40]

40 The last exhibition, prepared with Pablo during his lifetime, took place in the Papal Palace in Avignon (as had been the case in 1970) in May 1973. It was such a success that it was prolonged. In January 1976, the 118 works on display were stolen. They were found by the Marseille judicial police in the following October and the gang of thieves arrested (one of them died of a heart attack at the time of the haul). As we lived in Marseille at the time, Maya was the first to go to identify the rediscovered canvases and to take civil action.

The contents of the vaults of the BNP in Paris have to be added to this. Maître Zécri also took great pains to investigate large-scale dealers and foreign banks, particularly in Switzerland, to find out as far as possible if any works or valuables were deposited there. All replies were negative.

During the inventory, any kind of change to the works, no matter what, had always to occur with a bailiff's affidavit. This meant that there were thousands of these, especially for each workday of Maître Rheims' team as the works were all placed in safes in Paris. On several occasions I accompanied my mother to the BNP, where the experts spent entire weeks in the cellar to make an inventory of what they found, and what was taken back to the houses. They were not safes in the normal understanding of the word: they were large armored rooms with monumental doors.

The technical crew was divided into small groups according to their disciplines. François Bellet, Maître Rheims' assistant, and Brigitte Baer (today, an expert on Picasso engravings) discovered thousands of treasures there. Everybody was frisked daily before leaving the building. In the Odoul warehouse (a storage house specializing in articles of value) an inventory of sculptures and ceramics was made by Werner Spies (who had met my grandfather on several occasions to edit one of the first books on his sculpture, which was published in Germany and Switzerland in 1971), and Christine Piot (who would become a reputed historian on Picasso's oeuvre). Others examined works of reference such as Zervos (painting, drawings, and a part of the sculptures), Geiser (etchings), Kornfeld (etchings, lithographs, linocuts, and ceramics), Duncan (paintings), Georges Ramié (ceramics), and tried to identify which works were already generally known—or "divulguées."

Under "divulged" a distinction has to be made between those works reported to have left the studio, presuming that they had been sold, or were intended to be sold later ... and to be removed from the list of "movable" property in the legal common estate of Pablo and Jacqueline (of which she should legally receive the half).

This painstaking work took close to three years. Maurice Rheims' report is almost a novel—at any rate, it is extremely emotional: "One can have no idea of the state in which we found the rooms filled in La Californie merely by taking a quick glance at the photographs made before the work was undertaken. The word 'disorder' would not be appropriate here. That would be sacrilegious; suffice it to say that during our stay in the Midi, we were confronted with homes lived in, one or the other (Notre-Dame-de-Vie) by a genius, and that the genius had his own concept of order. Scattered around the rooms we found albums containing preparatory sketches for *Demoiselles d'Avignon*; rolled and folded in a bottleneck there was an image

of a bullfight of considerable importance and value; discarded under a pile of old newspapers there were prints, including some of the most rare editions, virtually lost in boxes of drawing, rubbing shoulders with printed posters. In the cellar, buried underneath worthless objects, we found drawings by Degas and Seurat. This way of keeping beautiful things followed a system that only the master could understand, or those living by his side, as we also discovered in Notre-Dame-de-Vie. Between magazines and exhibition catalogues we found bibliophile masterpieces entirely embellished by the hand of the master, and in the garage, under piles of books covered by a tarpaulin, we discovered a very old book of original Chirico sketches."

The inventory lists close to 60,000 objects, each with the probable date of its creation, verified using the impressive bibliography. This also permitted establishing the well-known "non-divulged" works, reported in the final communal estate between Pablo and Jacqueline, and now included to 50 percent into Jacqueline's share. An inventory number, a description of the object with its dimensions, the possible existence of a date or signature, the state of conservation, and all other attributes were written on the back. And finally, the evaluation.

Maître Rheims applied several parameters: the beauty, the rareness, the originality, the dimensions, the prices at public sales, gallery costs, the state of the market, and even the international financial situation. The Japanese market had been shattered since 1973, and Western countries were suffering from the effects of the recession resulting from the oil crisis. In public sales 90 percent of the contemporary works offered remained unsold. The price for a Picasso, however, remained high and stable. One can imagine the impact, hoped to be impossible, which the placing of such a large number of works, by the heirs, would have had on the market. This supply would have greatly exceeded the demand and resulted in an instantaneous plummet in the most cautious estimates.

Finally, this long labor in 1977 produced an impressive list:
- 1,885 paintings
- 7,089 drawings
- 1,228 sculptures
- 6,112 lithographs
- 2,800 ceramics
- 18,095 engravings
- 3,181 prints
- 149 books containing 4,659 drawings and sketches
- 8 carpets and 11 tapestries.

To this had to be added all of the real-estate and movable property as well as bank assets amounting to tens of millions of francs of the period.

In this respect, it should be pointed out that my grandfather showed no interest in such financial matters, which he refused to deal with out of principle, being of the opinion that the only thing that mattered was the fruits of his labor. It was his wish never to touch the dividends and profits on the investments that his bankers made for him!

Maître Rheims, who had made an estimation of all the possessions down to the tiniest object, evaluated, authorized by the official receiver, that the total sum of the estate amounted to exactly 1,372,903,256 francs—the equivalent to around $840 million today. Maître Zécri had advised the heirs to be cautious and use the utmost discretion in their dealings with the media. But this astounding number, supposedly secret, did not remain so. Approximate numbers made the rounds. On July 11, 1977, the magazine *Le Point*,[41] published a stern portrait of Picasso with his signature on its cover and the caption "1,251,673,200 new francs: The Inheritance of the Century" —announcing that the declaration of succession had just been signed. As early as April 1976, numerous newspapers had already spoken of an inheritance approaching five billion francs—a totally fanciful figure. As my uncle Claude declared in 1977: "At the moment, this inheritance is all hot air." He was referring to the fact that all estimations took place at one particular moment, in a fluctuating context faced with a work of the spirit, being the most fragile imaginable.

This is always the case. For more than twenty-five years the media have regularly estimated the value of Picasso's estate. At the beginning of the 1980s they talked about 1.8 billion francs, in the middle of the 1990s, the magazine *VSD* cautiously put forward the number five billion francs, in keeping with the art market. In 2001, the British newspaper *Daily Mail* mentions a Picasso family fortune of six billion pounds (approximately twelve billion dollars) taking speculation on the art market into consideration. These estimates can only be seen as fluctuating as they depend on a large number of parameters and individuals.

A project of division by lots was proposed by Maître Zécri and two "protocols of agreement," dealing with the two inheritances were signed, in March 1976, by the heirs of Pablo and Paulo, defining the modalities for estimating the share of each.

It is here that Maître Ferrebœuf, Marina's young "forgotten" lawyer, made a reappearance, as I have already mentioned. Along with him, the

41 *Le Point*, no. 251 (July 11, 1977).

notary Maître Leplat appeared on the scene. On April 14, Guy Ferrebœuf presented Maître Zécri, in the name of his client (whose official lawyer was still Maître Naud for the interlocutors in the inheritances of Pablo and Paulo) with a bailiff's warrant denouncing that the said "protocols" had been signed by her "under extremely difficult circumstances and in great haste". In addition to her general "protestations" and "reservations," Marina essentially criticized the fact that the end of the common estate of Pablo and his first wife Olga had been fixed on June 29, 1935, and not at Olga's death in February 1955. June 29, 1935 was officially recognized as the date of their judicial nonconciliation authorizing Pablo to proceed with divorce proceedings. Marina and her advocate had absolutely no idea of the ordinance as their appeal for "the separation of goods" remained without effect. They also appeared to be convinced that the couple had remained "together" until 1955 (Olga's death) without Pablo taking the slightest initiative concerning divorce procedures. They seemed to have been ignorant of the final separation judgment, which came into legal effect on the date of the first petition, namely June 29, 1935.

Less than two weeks before, at the beginning of April 1976, Marina had already submitted a complaint to Maître Naud, naming her (half-)brother Bernard as the "adverse party," asking that great caution be placed on the evaluation of the Château de Boisgeloup, which Bernard was to receive from the inheritance of their father Paulo. According to her, it was absolutely essential that the evaluation be reviewed and that the apartment in the rue de Vieux-Colombier in Paris (where Bernard lived with his mother Christine), whose value had been reduced in the inventory, not be forgotten.

She had the habit of calling her stepmother, Christine Picasso, by her maiden name, Christine Pauplin ... except in the official documents circulating between the other heirs and their advisers. This subtlety could only be understood if Christine had met Paulo after he had left Émilenne, Marina's mother.

Marina herself saw the succession as a confrontation and she was the first, and only one, to use the term "adverse party." Moreover, the correspondence of her advocate often includes the reference: Att. Marina Picasso/Picasso Succession or Miscellaneous.

In a written agreement, she had guaranteed Albert Naud, a big name on the Paris bar, three percent of what she received *in fine*, being a much higher amount than the usual percentage of 0.20. If she was going to be rich, why shouldn't he be rich, too?

In addition, she had congratulated Maître Zécri, in March, on the drafting and acceptance of the famous protocols organizing the division, pleased

that this would take place immediately after Maître Naud had settled the signature of all the heirs.

But she indicated, in a telegram to the latter, that she planned to withdraw the defense of her interests from him! This was almost in the final stages of the matter.

In the meantime, Maître Ferrebœuf had sent the unbelievable summons to Maître Zécri, as well as to the BNP, to block all the bank accounts of the heritage. On the following June 1, he transmitted Marina's "reservations" on the evaluation of the works made by Maître Rheims and on the division of the heirs' joint rights.[42]

Curiously, on June 2, the newspaper *Le Figaro* took up Marina's criticism, indicating that she had been poorly advised by Maître Naud and had signed the famous protocols "without being aware of the consequences"—a scathing repudiation for the Parisian advocate. What was the origin of these "flights"? On June 15, Maître Ferrebœuf criticized the legal emancipation of Bernard (then aged sixteen), which had permitted the definitive signing of the "protocols." Finally, a few days later, Marina demanded, in an emergency measure, that the administration be transferred to the tribunal of the county court in Grasse! And this, even though Maître Zécri had been nominated by the Paris tribunal!

In addition, in the complaint made on behalf of his client, Maître Ferrebœuf claimed, that Jacqueline Picasso had moved works of art and funds abroad.

Without any proof! If I am not mistaken, to this day not a single member of our family has ever been suspected of illegally exporting works of art to a foreign country. Except Marina. Life is full of surprises.

The other heirs were in a state of shock, particularly Jacqueline. All the work that had so far been carried out in a positive atmosphere suddenly came under attack on all points, without any justification. What was the origin of this incredible story about the illegal export of artworks and money? How could the painstaking work, over several years, by Maître Rheims, who was to become a member of the Académie Française, be criticized? Maître Zécri was also president of the Society of Receivers and renowned, in this capacity, for his rigor. Was Marina suggesting to start again? All this indirectly put back the establishment of the *Dation* with the representatives of the state!

To top it all, Marina and her (half-)brother both submitted identical claims. Seeing that Bernard was represented by Maître Bacqué de Sariac, our

42 Rights on reproduction and continuing rights managed by SPADEM, the official collection agency at the time.

grandfather's former lawyer, his interests were defended to the utmost. As a symmetrical effect, Marina's were just the same. In any case, these judicial and extra-judicial campaigns were considered "outrageous" by all—and, above all, by Maître Naud, who announced that he was going to get the president of the Society of Advocates to take action against Maître Ferrebœuf for lack of professional ethics. But it was Marina who chose her lawyers.

Marina's complaint was judged inadmissible by the tribunal in Grasse. On July 9, Pierre Zécri and Maurice Rheims were renewed in their functions by the City Court in Paris.

The summer allowed for a cooling down, even though Marina had clearly demonstrated her intentions and that, henceforth, it would be prudent to take this into consideration. She had to backtrack, common interest once again came to the fore. But, without knowing it, she was given an amusing nickname, which I shall remain silent about.

Maître Naud died shortly after. The advocates were moved by the demise of their eminent colleague. They could not let his widow down. Thus, in consensus, the advocates of the other heirs gave her, from their own pockets, his portion of the minimum retainer fee intended to be identical for all the lawyers involved in the affair. Much less than the three percent promised by his client.

Marina has very personal memories about the events of this succession, and declared: "Having understood my problem [which one?], my new advocate [Maître Ferrebœuf] found solutions which ended in a first global agreement at the end of 1979. Some other difficulties [which ones?] however appeared, and it was necessary to wait until the end of September 1980 before a definitive agreement could be agreed on by the heirs and the division carried out." This is an extremely novel résumé.

Allow me to put the record straight: the first global agreement was signed in March 1976 (and not in 1979), a second the following December (concerning preferential choices). The inventory was officially completed at the end of June 1977, the declaration of succession was signed in mid-September 1977 (and not in 1980), the *Dation* was constituted in 1978 and the division commenced at the beginning of November 1979. It was terminated for Marina in September 1981. Concerning Maître Ferrebœuf, among his other merits, he was probably the only one, in everyone's opinion, who was mainly devoted to making criticism or reservations on behalf of his client wherever possible, trying to obtain additional settlement advantages. That was, all in all,

the rational justification for his interventions on behalf of his client and the interest in his return.

Marina was the only one of the heirs to contact Maître Zécri directly on several occasions, demanding that he take care of her personal expenses (of course, to be deducted from her future share). The receiver never did this and he was not empowered to do so. The tone between the two of them was very direct, sometimes extreme, but Maître Zécri remained steadfast, and without making any comments, carried out his mission rigorously. Without exception.

Parallel to the meticulous inventory drawn up by Maître Rheims, the heirs had found some solutions—trying to be as just and humane as possible.

Jacqueline's atypical situation, as my grandfather's widow, is worthy of a separate examination. In principle, she should have received half of the goods of the couple; but, on the one hand, she was born when her husband was already forty-five, their marriage lasted twelve years following a six-year long liaison (amounting to about one fifth of Pablo's life), and, above all, it was necessary to resolve the question of Olga's communal property (who had died in 1955) and the rights of Pablo's four children from his relationships. By common agreement, it was decided logically to take the date of the ordnance of nonconciliation, June 29, 1935 (authorizing divorce proceedings between Pablo and his first wife Olga), as the effective date of the end of this first communal estate. The date of Pablo's second marriage, to Jacqueline, March 2, 1961, was regarded as the commencement of the second communal estate ending in the husband's death. In the second case, the unknown "non-divulged" paintings of the period (included in the communal estate) and those paintings reputedly "divulged" were taken into consideration. To these were added those paintings dedicated to Jacqueline (and given to her and not forming part of the estate) and which should be reported in the case that their total value exceed the portion of the estate of which the testator may dispose at his discretion.

One can understand that all this was extremely complicated. But, it was necessary to respect the rights of all involved. The balance of these fastidious calculations was divided between Paulo, Maya, Claude, and Paloma in accordance with their respective situations with regard to the law: technically speaking, the value of a half of the value of Paulo's (the legitimate child's) share should be divided between Maya, Claude, and Paloma (the natural children). Then, Paulo's estate would be dealt with: his children Marina and Bernard each taking an equal share in their father's inheritance, incorporating, in addition, Olga's estate. Paulo's widow, Christine (married to him

under the terms of the separation of property), received one quarter of the usufruct of her deceased husband's share.

The complex of the works included in the estate were divided into lots of equal value and followed an artistic plan. Each of the lots received a completely equitable number of major works. Maître Rheims organized ten lots (notably for the paintings), occasionally twenty or thirty for the other categories, in keeping with the number of objects, in order to provide a more even balance. A kind of draw was organized: three lots for Jacqueline, one lot for Maya, one for Claude, one for Paloma, two for Marina, and two for Bernard. The two inheritances had been regrouped for this drawing. In the same way, and in order to provide the greatest possible homogeneity, the *Dation*, in keeping with the two inheritances, had been removed in advance.

The properties had been divided in an amicable fashion:

– Jacqueline kept her dwellings (Notre-Dame-de-Vie in Mougins, a property where she was the official tenant, and the château in Vauvenargues, which she also asked to be awarded);

– Maya asked for the atelier in Fournas, the old ceramics factory, which she knew so well;

– Marina requested the impressive villa La Californie, in Cannes;

– Bernard wanted the Château de Boisgeloup, where he had spent his childhood and which his father Paulo had bequeathed to him in his final testament.

The value of these real estate properties was, of course, made as a deduction on their rights on the oeuvre and other assets in their respective parts.

These personal choices formed a part of the "preferential choices." In effect, Marina, the first in line to Paulo's inheritance, had asked that she be granted—what she called—"usual gifts." These were gifts that parents often give their children. She reckoned that she had been deprived during her childhood—except that in her case, as is normal, these presents should have come from her father who, seen soberly, did not really possess very much, and not, posthumously from her grandfather.

Taking her anguish into consideration ... of not having had any "usual gifts," and in order to avoid any tension, the remaining heirs agreed that they be granted to her: a preferential selection, valued at several million francs at that time, from among the items in the succession inventory. It was inconceivable that her (half-)brother Bernard could have received presents worth so much from his father while he was alive.

But what did this matter? It is quite clear that the juridical denomination of these so-called "usual gifts," after the death of the supposed donators and the arbitrary calculation of the extent of their generosity, did not have any legal reality. What is more, Marina never had the juridical qualification for

inheriting from Pablo Picasso, but only from Paul Picasso. Not being part of the legacy or the *Dation*—the amount "offered" was reintroduced into the inheritance assets and granted to Marina, in a transactional manner, via a preferential choice, by deduction from the entirety of the inheritance to be divided.

This original deal had the merit, for the other heirs, of being transparent and respecting fiscal laws, particularly attentive to the spirit of the dossier. And, finally, costing them nothing.

This initiative of Marina's produced an indirectly happy effect, since it activated the allocation to all the heirs, and included, once again for her, an additional "preferential choice." This permitted each one to select those works he or she desired up to an amount of several million francs of the period. This was a good decision, which added some feeling to the general ambience, without being too administrative. Here, as elsewhere, there was not a sordid battle. My mother Maya proposed that we, her children, each select one of our grandfather's paintings of which we were particularly fond: my brother Richard, my sister Diana, and I each chose a work, completely seriously—and absolutely spontaneously.

Finally, Marina redeemed the share of the usufruct of her stepmother Christine, as is often the case in complicated inheritances, which definitely simplified their relationship.

The inventory was completed during 1977 and the preferential choices indicated during 1978. On July 21, 1976, Dominique Bozo, former conservator of the collections of the Musée d'Art moderne, was named director of the future Picasso Museum by Michel Guy, Secretary of State for Culture and the Environment.

The idea of a major Picasso Museum for France had been proposed several years earlier by Georges Pompidou, President of the Republic, on the occasion of the celebrations held in 1971 as an homage to the artist. Besides Pablo's personal collection, expected from the likely donation, France had neither had the opportunity nor the financial means to create an outstanding collection during his lifetime. The nomination of Dominique Bozo coincided with the proposition made by Michel Guy to the heirs to deduct the *Dation* before the division and not, as is ordinarily the case, on the individual shares after the ensemble is broken up. According to Bozo, it was not merely "to bring together the masterpieces, but to create a living museum that would display Picasso's development."[43] The state therefore asked the heirs for selected works, in advance.

43 *Le Point*, no. 251 (July 11, 1977).

The minister approached Jean Leymarie, former director of the Musée d'Art moderne and a close friend of my grandfather's, and finally, in 1978, Michèle Richet, former conservator at the same museum.

Dominique Bozo exclaimed with surprise at the inventory carried out by Maître Rheims: "I was stupefied: it was both the quantity and the quality that I discovered. There were not only unknown, superb works but numerous masterpieces that Picasso had kept. I soon realized that I was not confronted with the leftovers from the atelier but with a genuine collection— one that had been given some thought, and was wanted." In spring 1975, these three governmental experts were able to inspect and select from the works on the inventory. Dominique Bozo and Jean Leymarie had to struggle to remain calm faced with major, popular works from each period and the presentation of all the techniques used, giving greater importance to the ensembles (including preparatory studies), which could never have been realized previously.

The state's list was put together with the list of preferential choices made by the heirs to calculate the arbitration. No difficulties arose, and the heirs even accepted that certain works be taken by the state (on the initiative of Maurice Aicardi, president of the inter-ministerial commission on the protection of patrimony—the so-called *"Dation* commission") to perfect the coherence of the ensemble of the donation. An independent council, drawn from the art market and museums, was finally convened for three days. It consisted of Pierre Daix, Roland Penrose, and Maurice Besset (former conservator at the Grenoble Museum, and professor at the University of Geneva) called together to "substantiate" the official selection.

The works of the future *Dation* were transferred to the Palais de Tokyo at the end of 1978. In a sense, they were putting the cart before the horse by transferring the works before the official agreement had been signed, but there was a perfect osmosis between all involved. The finance minister (and future President of the Republic) Valéry Giscard d'Estaing proclaimed, after Picasso's death: "In exceptional circumstances there have to be exceptional measures!"

The finance minister received the official proposal for the donation at the beginning of 1979. Maurice Aicardi was the official interlocutor in the Picasso inheritance. The financial authority sent him the *Dation* proposal and he then contacted those responsible for culture. A committee of conservators, an artistic board from the society of national museums and an inter-ministerial commission, with Hubert Landais (director of French museums) as *rapporteur*, studied the artistic importance of this *Dation* proposal, put forward officially by the heirs, but planned with other specialists from the same ministry.

All of this "shuttling" appeared complicated, but the coordination was excellent. After a favorable decision by the Ministry of Culture in March 1979, and the confirmation of the commission presided over by Maurice Aicardi, the Ministry of Finance officially agreed to the *Dation* in September 1979. At the end of September the heirs were completely exonerated from penalties occurring as a result of the tardiness in the declaration of succession: more than five years. It would have been impossible to have completed everything within six months in 1974—which everyone, including the state, had foreseen.

Due to lack of space, a small selection from the Picasso donation was shown to the public in the Grand Palais in Paris, in October 1979. On that day, at the time of the opening by the President of the Republic Valéry Giscard d'Estaing and Jean-Philippe Lecat, the new Minister of Culture and Communication, I fully understood the scope and diversity of my grandfather's work.

As for the heirs, Maître Rheims had put together the famous lots and Maître Zécri organized the draw in 1979. With the solution of the distribution, which occurred officially at the end of the year, and came into effect at the beginning of 1980 with the material transfer of the lots to all involved, each heir received his share and started a new life. The two Picasso inheritances—Pablo's and Paulo's—had been settled: the adventure had lasted for four intensive years, and technically almost seven. A record!

Jacqueline Picasso was the main beneficiary of my grandfather's estate. First of all because she retained all the paintings Pablo had dedicated to her, and had escaped inheritance tax (as gifts between spouses); and then because she had to pay absolutely no inheritance tax on her portion of the legacy (being his widow, and married under the law of community of property). She received the most important part both materially and effectively.

Seeing that they were not regarded as the heirs of Pablo Picasso, but solely the heirs of his son Paulo, Marina and Bernard both received one half of their father's share, becoming, in absolute terms, the second beneficiaries, even if they had to settle their father's inheritance tax and then their own. In this way, their respective portions were amputated by approximately 40 percent.

Maya, Claude, and Paloma followed, with equal portions, and lost around 20 percent in taxes. Finally, there was Christine, Paulo's widow.

The French state indirectly figured as one of the major beneficiaries: it received a total of close to 300 million francs (around $180 million today) in inheritance taxes (approximately two-thirds from Pablo's estate and one-third from Paulo's), settled in the form of a single *Dation* of works of art.

I have always been troubled by the medial definition of "principal heir" or "principal beneficiary" beloved of the media when dealing with an estate. Any "principal" quality, resulting from the death of another person, takes on an almost humiliating character. Such a qualification, absurd by nature, shows how ridiculous it is to glorify a legacy merely on its quantitative merits. And, for an heir, the worst thing is only to be able to praise himself for what he has received from another. Concerning our family, in 1977 a journalist wrote: "the beneficiaries of Picasso's estate have, above all, inherited a responsibility: that of managing his fame and his posthumous wealth."[44] She was right.

Now it was essential to show worthiness, and that was quite a challenge.

One can imagine the financial burden on the heirs if the succession had taken place a few years later when the inheritance taxes were increased, at the beginning of the 1980s, to 40 percent for the major portion in direct lineage. This would have provided the state—that is to say, all of us—with a Picasso Museum in Paris so enormous that even the vast Hôtel Salé would not be able to house it.

If the succession had taken place after December 21, 2001—after the reform of family rights in France with the equalization of the rights of all children, no matter of which filiation (legitimate, natural, or adopted)— there would have been no disparity between the descendants, all treated equally by the law. That would have probably permitted the retention of a kind of fraternity closer to the egalitarian ideals of my grandfather and, without doubt, would have created fewer problems.

THE DATION

The marvelous Malraux law, dating from December 1968, organizing the principles of *Dation*, permits the payment, with the agreement of the State Administration, of inheritance taxes through the transfer of works of art. The object of this law was to protect the artistic patrimony of France, and prevent heirs from being forced to sell important works in order to be able to meet their obligations: selling them at cut-rate prices to foreign buyers.

The Succession Picasso was certainly the most emblematic illustration of this law. First of all, without this law, the heirs would have been forced to place works worth about one quarter of the value of the succession on the market, which would have, most probably, led to a dramatic worldwide plunge in the prices of Picassos. Moreover, France, in an unbelievable way,

44 Hélène Demoriane, *Le Point*, no. 251 (July 11, 1977).

had neglected to include works by Picasso in its national collections. The Museum of Modern Art in New York had long been in possession of a priceless collection of close to 1,000 works, including *Les Demoiselles d'Avignon*, not to mention *Guernica*, then in its provisional "political" storage. France had only a few works, scattered here and there, collected essentially on the impetus of Georges Salles, Jean Cassou, and Jean Leymarie. These three men recognized that France had neglected Picasso in an irresponsible manner. They were not heard in their day. Picasso had known many ministers. No one, until Malraux, had understood that priceless treasures were inexorably leaving France.

The interest in the Picasso *Dation* was twofold: to pay taxes and give a Picasso museum to France.

There was an immediate proposal to create a specific museum to house this *Dation*. Among the real estate in its possession, the Paris Council chose the Hôtel Aubert de Fontenay, called the Hôtel Salé—Salted Hôtel— (because of the tax on salt that the farmer general had used to build the hôtel). The state was granted a long-lease of ninety-nine years on the property. A budget of twenty million francs (around $13,2 million today) was made available for its initial restoration, under the auspices of the architect Bernard Vitry. Part of the external restoration was financed by the state.

I accompanied my mother on the first official inspection of the building. That was in autumn 1975. Michel Guy, the minister of cultural affairs, was present. It was an enormous building in a very bad state of repair, but the restoration of the facade had already begun. My mother and Dominique Bozo had become friends and imagined this or that work in this or that place. Claude and Bernard seemed enthusiastic, but paid close attention to all the details. Certainly, this majestic hotel, in pure eighteenth-century style, with its large main courtyard and possibly a future garden in the rear appeared far removed from modern art. But the space was wonderful. Even more, the Marais district was the best preserved in the capital and resembled the old Paris that Pablo had known at the beginning of the century. And again, wasn't he always buying châteaux?

The basement, made up of magnificent vaulted stone cellars and, at that time, in use by a neighboring administration as a canteen, now shelters pictures of Maya, Claude, and Paloma as well as portraits of Marie-Thérèse, Dora, Françoise, and Jacqueline, and the famous sculptures *The Goat* and *Young Girl Skipping*—among other masterpieces. They are presented following a chronological course past all the works in the museum. When going into the upper floors one passes through the youthful period; the portraits of Olga and Paulo, and again Marie-Thérèse. Picasso's entire life and output are covered.

The architect Ronald Simounet was in charge of the interior renovation and produced a work of great modernity—the gentle slopes that he incorporated are a perfect solution—always respecting the past.

I only returned in 1985, when the entire family took part in the inauguration by François Mitterrand, the President of the Republic, and the then minister for culture, Jack Lang.

This magnificent museum houses the famous *Dation*, chosen from the works Picasso himself preserved. In this way, it definitely constitutes the most complete artistic ensemble in the world. There, one can also find exceptional archives, including a major portion of his correspondence.

As I previously indicated, from the initial stages of the Succession, Jacqueline, Paulo, Maya, Claude, and Paloma had the wish that the supreme interest in the *Dation* prevail. They considered it their duty. A duty towards France, a duty towards Picasso. With this spontaneous osmosis, Paulo's heirs formed themselves into a group with a common spirit, in 1975. Nobody had problems with the fact that the state took first place.

Certainly, the events of spring 1976 (Marina's attacks) could have led to inextricable discussions; but the law, good sense, and the judges gave priority to the state. Dominique Bozo made suggestions regarding the general harmony of the future museum. They corresponded, objectively, to the instinctive choice of all.

Since that time, the Picasso Museum has held its treasure. The heirs received theirs.

THE *INDIVISION* OR SUCCESSION

During the settlement of the Succession, the practice of moral rights was also organized. These rights are extremely important. They affect everybody, and not only artists. But, they are often underestimated or misunderstood.

This is what French law says: moral rights are regulated by article L.121–1 of the code on intellectual property:

"The author has full possession in respect to his name, quality, and work.

This right is perpetual, inalienable, and unalterable.

In the case of death, it is transferred to the author's heirs.

The right can be transferred to a third party, in accordance with testamentary arrangements."

Article L.121–2 adds: "The author has the sole right to divulge his work. … This right can be exercised even after the expiration of the exclusive rights on exploitation determined by article L.123–1. This article L.123–1 foresees that 'the author has the right, throughout his life, to exploit his

work in any form whatsoever and to obtain a pecuniary benefit from this. Upon the decease of the author, this right continues, for the benefit of his rightful successors, during the current calendar year and for the following seventy years.'"

These are the fundamental principles which determine moral rights. To sum up, four attributes are included: the divulgence rights, authorship rights, rights in respect of the work, and the repentance rights. Pablo Picasso controlled this during his lifetime. However, these moral rights were now transferred to his descendants (ab intestat), conforming to the law (article L.121–2) in an indivisible manner.

The Succession Picasso, composed of his children Maya, Claude, and Paloma and, after June 1975, his grandchildren Marina and Bernard (assuming the rights of their deceased father Paulo), was formed naturally. As the law here does not recognize any differentiation between legitimate and natural children, using the formulation "descendants," a provisional solution was adopted: the ownership would be composed of the five heirs—namely, Pablo's three children as well as Paulo's two—each receiving an equal portion of the inheritance. Originally, Jacqueline, Pablo's widow, was included in this arrangement on account of the quarter of the usufruct on the patrimonial rights to which she was entitled. This arrangement was in effect until her death in 1986.

Therefore, the Succession Picasso or *indivision* was, collectively and individually, in possession of the moral rights. Moral rights permit the holder (the author or his legal descendants, or their representative) to consider the utilization, reproduction, and representation of his work, in any way deemed appropriate. This also applies to the name and image of the artist, in connection with personality rights.

Of course, moral rights are not attached to an oeuvre. They cover patrimonial, intangible rights. The fact of materially being in possession of a work does not give the owner the right to implement the usage of moral rights. In one sense, moral right applies to the universality of the oeuvre: in the present case, all the works sold, given or retained by Picasso. The indivisible rights ensuing from this moral right include rights on the reproduction and representation of the oeuvre (in books, catalogues, postcards, posters; for television, video, cinema, multimedia, online networks, merchandising licenses ...) and resale rights (approximately two to three percent of the price of a work sold in public auction; only in force in certain countries, and, notably, not in the USA).

These patrimonial rights apply throughout the artist's lifetime and for fifty years (in the United States, for example) or seventy years (in the Euro-

pean Union) after his death, for the benefit of his heirs. In the case of my grandfather, who died in 1973, these rights run until 2043 at the latest.

It is quite evident that this moral right is nontransferable. Because it is a collective right, it is not possible for an individual to cede it to a third party without violating the rights of the others. As an example: imagine that you, along with your brothers and sisters, own a house—within the framework of an inheritance. It is not possible that one of your siblings sells the house without your agreement and that the buyer demands that you move out! A unanimous agreement is essential.

The exercise of moral right, itself, is perpetual. It is applicable particularly within the framework of rights regarding the oeuvre. These same regulations apply to musicians, writers, and, in a more general manner, to all creators of intellectual works—today, this could be the creator of a computer program—with individual practices for each domain of activity. For example, moral rights apply in the case of the adaptation of a work: if someone wishes to modify a work, to change its colors, to modify its integral appearance or proportions, the owner of the moral rights can accept or refuse, without explaining or justifying himself.

In 1973, Picasso's oeuvre was the most reproduced in the world. Pablo himself was aware of the requests for traditional reproductions on postcards, posters, exhibition catalogues, books, and had delegated his rights to SPADEM (Societé de la Propriété Artistique des Dessins Et Modèles), one of the major French copyright organizations. For this type of reproduction, a preestablished scale of charges exists. On the other hand, for more atypical utilization (clothing or tableware, for example) he himself had to accept, modify or refuse the specific requests for licensing.

The same functional scheme was transferred to the successors. Therefore, very quickly, meetings of all the participants were arranged—usually quarterly—initially at SPADEM since they received the requests from the potential users. At the start, unanimous decisions were taken, then majority decisions (to make things easier), since moral law was collectively practiced in these different cases. My mother Maya traveled regularly from Marseille, preferring to take the night train so that she would not be separated from us for too long a time.

In 1976, my uncle Claude Picasso suggested the creation of a nontrading company to manage the entire complex of rights and to found an instrument to which each could make a contribution, and which would serve as a permanent site for meeting and information.

This company made the centralization of an extremely complete documentation of Picasso's oeuvre possible, with a wide range of books, catalogues, and photos as well as a set of the inventory sheets, making it possi-

ble to proceed with verifications and proposals throughout the establishment of the *Dation*. Complementary to SPADEM, this nontrading company was also able to act against forgers and pirates, and against all illegal use, examples of which were starting to appear.

The offices were located on rue de Lille, in the 7th district of Paris, behind the Musée d'Orsay. The name of the company was curiously composed of the names of each of the heirs: "Maya Picasso-Widmaier, Claude Picasso, Paloma Picasso, Christine Picasso, Marina Picasso, Bernard Picasso." After a year, with the departure of Marina who, as always, considered herself a "phantom" associate, it became the "Societé civile Picasso." It appears to me that the general interest is also an individual interest—"phantom" or not.

Unfortunately, despite its innovativeness, the Societé civile Picasso soon reached its limits due to the independence and distance that each of the heirs desired in his or her private life. It remained an interesting endeavor, the prelude to the creation, twenty years later, of a much more useful and efficient structure—the Picasso Administration.

The collective interest faded when faced with the legitimate aspirations of the individuals. Paloma started her personal career in the United States. In 1978, she married Rafael López y Cambil, a playwright-cum-businessman, and began to develop, with him, her own cosmetics business (originally with the American Warner Cosmetics company, later sold to L'Oréal) and jewelry (with Tiffany's New York). As I have said, they became, before the time, the first jet-set couple—in the literal sense, since they spent more time in the air than on the ground.

Bernard, at the ripe old age of eighteen, had already been confronted with adult life and followed his own path. Marina moved to Switzerland with her two children, after becoming separated from their father, and her collection of inherited works was stored in a bonded warehouse at Geneva airport. She trusted the management to the famous Swiss dealer Jan Krugier, who was also the brother-in-law of the then French minister of the interior, Michel Poniatowski. Only Maya and Claude played an active role in the Societé civile Picasso.

Faced with so many difficulties, it became quite clear to Claude that it was necessary to put an end to the adventure. The Societé civile Picasso died without being really born. The meetings with the participants took place as before, on the SPADEM premises, whenever the heirs happened to have time.

In spring 1980, SPADEM, alerted by their sister organization, which was also its American representative, ARS (Artists Rights Society), noticed that numerous products reproducing works by Picasso, all reputedly of Ameri-

can provenance, were on sale in shops, without any prior authorization being requested for their production and distribution.

The great diversity of the products and their simultaneous appearance was strange: furthermore, they were not representative of the usual pirated products such as T-shirts, scarves, and other second-rate trinkets. Was this an organization of particularly powerful counterfeiters? What is more, the various works by Picasso that were reproduced were, strangely enough, all works inherited by Marina!

After swift investigations, various licensees were identified in the United States. They maintained that they had all obtained a licensing agreement from an American organization, Jackie Fine Arts. This organization, managed by William Finesod, was contacted immediately and an explanation demanded. Mr. Finesod claimed that he had purchased the reproduction rights, for the works she had inherited, from Marina Picasso via a Swiss company! Marina, in violation of the rights of the co-heirs and in violation of French law, had therefore sold the reproduction rights to these works, rights supposedly indivisible and nontransferable, since they belonged to the entirety of the Succession. The system worked very slyly within the anonymity of a slew of organizations: Marina Picasso had handed over reproduction rights to the Swiss Paraselenes organization, who had transferred them to Art Masters International (AMI)—established in Delaware in the United States—who had then granted a license to Jackie Fine Arts in New York State who, in its turn, sublicensed them to various American merchandising companies! Under the terms of this agreement, Paraselenes/AMI, representing Marina, was to receive a guaranteed minimum of $22.5 million, divided over fifteen years, notwithstanding the transfer of 60 percent of the revenues obtained from third parties (in this case, Jackie Fine Arts).[45] However, under this agreement, Jackie Fine Arts was permitted to create, at its own discretion, any product imaginable without any constraints. It was at liberty to adapt the images of the works, to possibly modify them, without asking for the least authorization from the common heirs, as no control procedure was indicated in the contract.

In the contract there is one sole reference made concerning moral rights, defining them as: not undermining the name, honor, reputation, or the memory of Pablo Picasso. But there was no mention of submitting projects and prototypes in advance for approval, nor any sanctions in the event of a violation of moral rights. At its discretion, the American organization could

45 This amounted to 100 million francs of the period ($1=4.45 francs in 1980) or 220 million francs revalued at equal parity (around $66 million today, on the entirety of the foreseen period). The total of this transaction was revealed in McKnight 1987, p. 148.

reproduce up to 1,000 images (chosen from the 2,000 at its disposal) of those works by Pablo Picasso that Marina Picasso had received as her part of the inheritance.

Jackie Fine Arts had already signed a series of subcontract licenses with various organizations, one for scarves, another for—reputedly original—reproductions of Marina's works (within the framework of the policy of tax exemptions for American art purchasers).

Not only was the fire lit, it was already spreading with forty or so licenses under contract.

SPADEM declared to the other heirs that it had been informed, some time previously, by Marina's advocate Maitre Ferrebœuf, of the intention of his client to inaugurate merchandising activities in the United States, but that it had not foreseen the illegal and secret set-up. Marina had flung the door wide open to all the possible and imaginable utilizations of the works, and name of Picasso attached to them, without any form of control, risking a radical trivialization. In matters of financial speculation, she had created a precedent and broken records, both in respect to the revenues guaranteed over Switzerland, and regarding the illegality of the operation carried out behind the backs of the other heirs who, incidentally, never wanted to institute such a policy.

This affair, propelled out of necessity, forced the heirs into business, full steam a head.

Maya was informed, at the beginning of September 1980, while we were on vacation in the United States. After having reconstructed the chain of organizations involved in the affair, SPADEM enjoined Jackie Fine Arts to immediately cease all counterfeit activities. In response to this judiciary ultimatum, Jackie Fine Arts pleaded good faith and, at the instigation of its sublicensees who were already operating, the American company officially notified the five heirs of the threat of reclamations amounting to the gigantic sum of $600 million, around 2.5 billion francs at that time (approximately one billion US dollars today), in damages and interest! That would have meant the ruin of the heirs and the selling of all their works if they lost the case. The bankruptcy of the market for Picasso's oeuvre, and for the galleries, as well as the endangerment of museums and collectors was certain.

My mother did not exactly understand what was happening and hid her great anxiety. She later told us she had almost become ill. After her return, she was summoned to a crisis meeting organized in Paris by the group of American advocates representing the interests of William Finesod. My mother immediately demanded that her lawyers Paul Lombard and Marie-France Pestel-Debord accompany her. On the evening before the meeting,

she also asked her notary Paul Hini to join them the following day at the Trianon Palace Hotel in Versailles, where the meeting was to be held.

On October 11, 1980, a marathon began, which was to last fifteen days, without interruption.

The American advocate Leslie Schreyer explained the circumstances of the agreement before the interlocutors, dumbfounded by the recklessness of this enormous transaction. He defended the validity of the agreement in spite of the obvious illegality of the operation. Marina came to this first meeting accompanied by Maître Ferrebœuf, promoted to "business advocate" on the occasion of this "contract." Marina did not say a word. She did not return the next day. She never returned.

The remaining heirs were faced with a conflicting choice: to contest the agreement legally and embark on a flood of processes in the United States without any certainty of being successful faced with American jurisdiction, and incurring the threat of insufferable damages and interest; or to reorganize the agreements by making a selection and reintroducing the absolute respect of the heirs' exercise of moral rights.

Claude and my mother, Maya, had taken control of the discussions to make their interlocutors understand their reasoning. Maître Hini was the first to realize the urgency of working on the legal implications of the agreement. The Americans wanted a closing, that is to say to not leave without an agreement. In addition to the unshakable principle that moral rights could not be ceded, and definitely not in the case of Picasso's works, which it is vital to protect globally at all costs, there remained the problem of the sublicensees of the American organization. If summoned to stop their business, they would obviously process against Jackie Fine Arts, the alleged licensee of the AMI organization, the new "proprietor" of Marina's reproduction rights (I repeat, in reality this was the joint property of all the heirs), and against all of Picasso's heirs who were accused of being parasites.

At the end of fifteen days and fifteen nights, and probably because Claude and Maya had struck up good relations with William Finesod and his lawyers, making them understand reason, a "concord" was arrived at. It was composed of all the juridical and financial elements of a new agreement, and was implemented.

It is evident that Marina's "sale" of the reproduction rights on her works was annulled, seeing that it was illegal. In future, one could speak of a traditional license for the reproduction of images of works from the collection of Marina Picasso, with exclusivity on a specific, and reduced, selection of images. The financial guarantees were drastically lowered. And, above all, the American sublicensees would have to, in future, submit themselves to normal procedures in presenting their requests for the possible validation of

prototypes by the VAGA[46] organization, SPADEM's equivalent in the United States. Maya, Claude, Paloma, and Bernard, the heirs, found themselves forced to organize merchandising activities that none of them wanted. But, at least they could control the situation—with Marina of course. After all, there was an indestructible joint-ownership.

At the heart of these American licensees we found a certain Marilyn Goldberg, who managed the Museum Boutique International (MBI) organization. She had the ingenious idea of amalgamating the other licensees and representing them. And she became the muscled interlocutor with the Picasso Administration.

In spite of the procedure indicated in the transactional agreement with Jackie Fine Arts, she always had problems in adhering to the rules of the Succession. Profiting from the geographic distance, she took almost fifteen years to do so. Even the newspaper *Le Monde* echoed this: "Claude Picasso has tried, in vain, to prevent the American Marilyn Goldberg and her enterprise ... from exploiting the rights sold by Marina Picasso (one of the rights owners) on the paintings bequeathed to her by her father Paul, oldest son of the painter, from duplicating them, in anyway whatsoever...."[47]

Marilyn was a formidable businesswoman, charming, but with a predilection for "redecorating." Had she not declared, in a disconcerting manner, that Claude Picasso made everything more complicated, and that where Picasso took eight colors, she only took four, in order to reduce costs?[48] I was a young, fresh law student at the time, in 1980, and my mother told me about this energetic American woman. I ignored the fact that I would still hear my uncle Claude talking about her fifteen years later!

Because, it took fifteen years of permanent discussions, going back and forth, of regular transgressions, to arrive at an agreement imposed by a judge in New York (who declined to give a verdict himself), in order to stabilize commercial relationships. This interminable process cost the Succession a fortune, both in advocates fees and loss of revenue.

Since 1995, the Succession, via the Picasso Administration, which henceforth represented it, has continued to work with Marilyn Goldberg, under finally stabilized conditions. Having met her personally on several occasions, I can vouch for the fact that this level-headed woman has an almost religious business sense! And she has charm. Finally, with a certain understanding, our relations have become cordial. Part of the Franco-American entente.

46 VAGA (Visual Arts and Galleries Association): this organization has since been replaced by ARS (Artist Rights Society) for the Picasso Administration.

47 Pascal Galinier, *Le Monde* (January 4, 1999).

48 Report on the Capital television program, shown on the French T.V. network M6 in January 1996.

In the concordat, a chapter dedicated to the famous reproductions of "original" works belonging to Marina, and signed in her own hand to "authenticate" them, plays a role. These famous "originals" took advantage of a system of tax shelters for American purchasers within the framework of a policy to assist in the investment in artworks within the territory of the United States. As this was an operation thought up by William Finesod and which, indirectly, was enmeshed with the IRS, it appeared prudent to respect the American taxpayers who were already involved.

The Succession accepted the principal of this enterprise, leaving it up to Marina to take care of hand-signing the thousands of reproductions of her works. An international scandal and legal actions were avoided through the *sang-froid* of all, and the talents of the lawyers.

The press regularly deals with the echoes of this complicated affair.[49] But —to this day—no clarification has been made. Various objects, released under this agreement, have appeared on the market, sometimes with the backing of the organization, often without. This was the case with the Chapeau Bleu perfume, whose bottle represents a portrait of Marie-Thérèse belonging to Marina, transformed unbelievably into three dimensions. It became absolutely necessary to remove this article from commercial distribution.

Maya, Claude, Paloma, and Bernard continued to meet at regular intervals. Marina did not participate in any of the meetings, although she was always invited—in 1981 she indicated that, henceforth, she would be represented by a Parisian advocate, Maître Pierre Hebey.

At that time, without our knowledge, Marina had embarked upon a lengthy psychotherapy treatment.[50]

From 1981 to 1986, my mother kept me up to date with the activities of the organization. I was following my legal studies, without knowing that this training and my professional experience would, one day, help me to understand the magnitude of the task of this organization and to offer them some suggestions. Years passed by. I had graduated with a degree in business and fiscal law—licence and masters—and was about to begin a third specialized field of study. And, to perform my military service in the air force. I was far away from the Picasso universe, I was living my own life. I had taken my articles at a notary's, an auctioneer's, an advocater's, and finally at a fiscal counselor's. The cases I had worked on made me more open for other experiences.

Finally, I understood that it was really television and music that I loved and, through the intervention of a magazine publisher friend Yaffa Assouline,

49 See particularly, VSD, April 1996, and McKnight 1987
50 Marina Picasso and Vallentin 2001, p.12.

I met the producer Jacques Marouani. In France, his name opened many doors in the recording world—a kind of French David Geffen.

I became his legal assistant. This was in 1987. I was about to become acquainted with the adventures of creating a television channel, La Cinq (jointly owned by a certain Silvio Berlusconi), with its Pharaonic contracts and the introduction of commercial television in France, hounding the historic French channel TF1, at the same time as the successes at the Top 50 French Billboard program, with my employer's artists. I learned the ropes. I developed a professional network.

In 1990, I left to set up my own enterprise. I had the opportunity of meeting a talented young journalist, Daniela Lumbroso, with whom I rapidly produced a series of entertainment programs which were broadcast—at prime time—on the public channel Antenne 2.

I was a debutant, a rookie. During the same year, I got to know Yannick Noah, the tennis champion who was in the midst of changing his field. He was a sort of French Arthur Ash, coming from the school of the greats such as Jimmy Connors, Bjorn Borg, and Boris Becker.

This was one of the most wonderful encounters, both on the philosophical and professional level, in my life. His determination, his calming strength, and his feeling for others opened my eyes to what the goal of one's life could really be. One is what one accomplishes, not what one pretends to be. He had already proved this. And he proved it again, as an artist. A few months later, we took part in the adventure of his song *Saga Africa*, which became the summer hit. I had my first golden record on the wall of my office. My very own life began. I had put my postulate into practice: to be able to live without Picasso.

In 1994, in addition to my experience as an audiovisual producer, I started to become interested in multimedia. At this time, CD-ROM technology started to play a role in computing. An enthusiastic friend served as my technical guide. It was necessary to provide content, to develop programs. I thought that there was one subject that would be a natural for me: Picasso.

Faithful to my way of working, I analyzed the market and picked out those partners who could be interested in my project. Specifically, I needed an associate who understood the subtleties of moral rights and had respect for the work. In addition, it would be necessary to have the technical capabilities for producing a CD-ROM, and a publisher's commercial network for worldwide distribution.

My choice fell on the recently formed multimedia division of the Hachette-Filipacchi branch of the Lagardère group. I had made the acquaintance of its artistic director, Jacqueline Le Bot, who had directed the production of the Maeght Foundation's CD-ROM which I found particularly

praiseworthy. She understood the artistic world and I appreciated her mastery of the production process. My meeting with her young boss, Arnaud Lagardère, who had recently become head of the branch, made me completely convinced.

I went to meet Arnaud in Danbury, Connecticut, the home of Grolier, the world's largest publisher of CD-ROMs, which the French group had recently acquired and since resold. There, he learned his lessons and his unexpected enthusiasm resulted in a dynamic management style. He was that rare bird I was looking for, a competent Frenchman with a global network. I was also sensitized to the potential of an up-and-coming communications network called Internet, which appeared to be a marvelous tool for the subsequent development of our project.

It was now necessary to reach an agreement with the Succession Picasso, where my uncle Claude was the administrator. I saw him very rarely at that time. I had a meeting with him a few days before Christmas 1994.

I knew that he was administrator of the Succession, but I was not aware of how he had obtained this official position. In fact, I was unaware that this had occurred as the result of a disagreement with my own mother, Maya, which had taken place in 1988. Until then, the organization had operated through the copyright-protection agency SPADEM. Picasso was, himself, a member of this society during his lifetime. SPADEM managed the monopoly on the artistic copyright of Pablo Picasso's oeuvre, that is to say the famous intangible patrimonial rights. My mother had complained about SPADEM's inefficiency at meetings of the group, which, in view of the time constraints of all involved, were often settled by transferring the matters to be dealt with to the next meeting. Following the events with Jackie Fine Arts in 1980, Marina never attended any of these meetings on account of her lack of interest for the others and what had happened.

The Succession had been organized, after the inheritance had been finalized, by a five-year agreement reached in October 1980 and renewed, provisionally, in 1986. In June 1988, my mother left SPADEM (each heir had had to personally become a member), which blocked the autonomous functioning of the copyright society. Henceforth, it would become necessary to obtain Maya's individual agreement for all requests that it handled. Opposed to this situation, Claude and Bernard demanded that a judge immediately pronounce an interim ruling.

It should be known that, in cases of difficulty, and in the absence of a solution, the members of the Succession had to consult exclusively the judge handling the inheritance, who sat on the High Court. It seemed unthinkable that one or more individual managements could take the place of a sole indi-

visible management. During the proceedings, my mother requested that the judge award each with the totally independent management of the intangible rights for the works, which he or she had inherited individually. This would have amounted to a veritable break-up of the joint ownership stipulated by French law, which foresees that "nobody can be forced to remain in the *indivision* and the partition can be instigated at any time, unless it has been reprieved by judgment or agreement (article 815 of the civil code). However, what about the public works (in museums, galleries, collections...)? Who would manage the rights of these? What about the management of the name and image of Picasso?

It was necessary that a common, collective body survive.

My mother added that she wanted membership of SPADEM not to be obligatory, since she had already resigned from it. She thought that direct administration would be much more efficient and less costly (SPADEM took a fixed commission of approximately 25 percent on all sums collected for its member artists—50 percent on sums collected abroad, including the salary of its local representative). It seemed to her that the Succession would need a considerable amount to protect the name and work of Picasso, faced with the worldwide growth of counterfeit works. The Jackie Fine Arts affair and the multiplication of "authorized" products had attracted the attention of pirates, convinced of the attractiveness of the name and oeuvre of the artist of genius.

My mother was right much too early: this direct, and extremely efficient, form of management was inaugurated only eight years later with the creation of the Picasso Administration.

Claude, Paloma, Marina, and Bernard, through their advocates, reached an undisclosed agreement under which they committed themselves to a joint ownership and to remain together. Marina expressed her reservations about not signing if the judge ultimately announced the division of the Succession. She did not have to do so as the judge ruled out my mother and named my uncle Claude (who had not expected it!) administrator of the indivision, with the simple "option" of becoming a member of SPADEM in its name. This second aspect, finally suggested by my mother, was particularly useful when SPADEM collapsed in 1995, Claude was able to withdraw in time and not see the Picasso Succession also collapse.[51]

I believe that this juridical decision was probably a major step forward, even imagining the deception of my mother. She never mentioned it to us, her children, and this attitude proved to us just how much she was a lady of conciliation and appeasement. She could have told us about her rancor,

51 Cf. p. 272.

transferred her bitterness from one generation to the next, started a vendetta. That is in no way her character.

When I told her that I was going to meet Claude, on the occasion of my CD-ROM project, she approved, without turning a hair.

My reunion with Claude was particularly pleasant. I almost did not expect it. After Paulo's death, he had become and remains my only uncle. This is a particularly important bond. We got to know each other, and I have memories of lively discussions about his activities as administrator and on the major adjustments he wanted to initiate. He explained to me the problems he had encountered in respect to moral rights. I thought I could throw some new light onto the mater and told him about my professional experience with major international groups, in my opinion, interesting interlocutors. Being neither a Picasso heir, nor member of the *indivision*, always allowed me to disregard the constraints and to preserve my independence and a certain pragmatism.

At that time, Claude and I met frequently. In his official function, he managed the indivisible rights pertaining to Picasso's works—that which is called the "monopoly," since these rights pertain to the entirety of his works. He also disposes of a mandate from each member of the *indivision* to act in connection with brand names: this is a question of managing the name Picasso on all labels, both on the level of registration and exploitation. This is a legal obligation.

It was now the beginning of 1995 and, apparently, the Picasso brand name had become a reality—and a real problem. The stocks of illegal merchandise produced by individuals or organizations with bad intentions (or because of a so-called lack of information) had increased worldwide. It was no longer possible to defend oneself merely on the grounds of copyright. The unexpected exploitation of the Picasso brand name was not a family postulate but a consequence!

Pablo Picasso is the most widely reproduced artist in the world, legally ("Picasso" alone accounts for 40 percent of the global market for the reproduction of artists' graphic works) but also the most "pirated" with all the menaces implied both pertaining to the original works (authenticity, colors, and integrity) as well as to the nature of the commercial products (often unacceptable in spirit). Beyond the financial aspect, which is secondary but important, the Succession has always maintained moral ambitions.

Picasso had become a commercial brand name, like Coca-Cola, Disney, or Nike: a brand name immediately recognized and used to sell products far removed from the artist and his reputation. In Taiwan, a catalogue was confiscated that offered a series of household articles stamped "Picasso"—

carpeting, lampshades, curtains, casseroles, fans, shoes, toilet paper … here, reproducing a "simplified" work, and elsewhere, the signature alone in the form of a producer's brand name!

From there, it is a only a short step to thinking that this business took place with the approval of our family. This was often cheerfully passed over.

In numerous legal systems, the mere registration of a brand name is not sufficient. It must be exploited on pain of forfeit. That is the case in France, for instance. It appears logical but can become extremely dangerous in the case of a name like "Picasso," if one is not careful. In addition, in many countries, the judge ruling on "opposition to the brand" can state that we suffer no damage if Picasso fans exist, seeing that we do not produce them ourselves! It then becomes necessary to prove that moral damage has been done to the oeuvre and reputation of the artist, and also to draw attention to the fact that products manufactured by licensees suffer from the existence of pirated products, which interfere with their own distribution.

In addition, there are investment and usage problems for those legal licensees, which largely go past us, but which, in the long run, have an impact on the general economy. This is the same pirate activity that musicians and record producers fight against. Why are Picasso's heirs not permitted to defend their patrimony, which is also the remembrance of Picasso, in the whole world?

In a sense, Picasso's oeuvre (and that of many other artists) suffices in itself, in museums, exhibitions, and books. But the public likes to rediscover this or that familiar object. The success of museum shops and the thousands of published products stemming from artists' works is a clear indication of this. Picasso's popularity is such that it has become a craze that it is necessary to respond to. To do nothing is to leave the way open to those tempted to sink into illegality, severely affecting the reputation of the artist and his work. And not making those who possess his works very happy.

Until the end of 1995, the Succession Picasso, legally administered by my uncle Claude, had been represented by SPADEM. This organization had representatives throughout the world. It managed the rights of around four thousand individual artists. The reproduction rights that they granted for works by Picasso represented an enormous sum: up to 40 percent of SPADEM's annual balance.

In spite of this substantial revenue, in 1995, SPADEM did not pay the artists, or their legal representatives, their collected rights. It was in an extremely grave financial situation, following the acquisition of gigantic computing equipment, which was probably over-dimensioned and ruinous

in maintenance costs. Claude Picasso had resigned from SPADEM prior to this situation. He had the prudence of foresight, at joining, of arranging a notice period of a single month as opposed to the traditional, statutory notice period of six months. He was, thus, able to react rapidly and protect the interests of Pablo's heirs in the best way possible.

My uncle considered that it was now necessary to move on to a new stage. This is how the Picasso Administration came into existence, in order to manage the indivisible rights that he was in charge of administering directly. This was a necessity faced with the global volume of the business to be dealt with and financial fluctuation. A legal entity, a company, was being replaced by the single natural person of an administrator.

The Picasso Administration is an EURL (Entreprise Unipersonnelle à Responsibilité Limitée under French law, a single-shareholder limited liability company) with Claude Picasso, with the title of "judiciary administrator," as the sole shareholder. The Picasso Administration received a mandate from him to operate from the legal authorities and acts in the name of the Picasso Succession—or Picasso *indivision*, although I would personally prefer the "Picasso family" to put an end to this mortifying footnote. None of the heirs, no matter who, evidently had to be a member of the Picasso Administration and had to either accept or refuse to take part. It is a transparent structure. As to the choice of the name Picasso Administration by Claude, it appears absolutely clear to me since it can be understood in all languages.[52]

This step taken by my uncle led to the establishment of a new dialogue between the joint owners, with the traditional exception of Marina. I believe that Maya appreciated it that I revived the dialogue between herself and the others.

The Paris office of the Picasso Administration has become the, previously missing, information center permitting the answering of all questions. Claude Picasso took all the necessary steps to restore the monopoly, that is to say, to organize international representations (with twenty-two correspondents worldwide),[53] and to initiate the appropriate legal action to counter the fraudulent use of the oeuvre and name, or of Pablo Picasso's very image.

An inventory, made in 1998, listed more than seven hundred illegal "Picasso" trademarks throughout the world, concerning all kinds of prod-

52 Concerning the word "administrator": it appears cold but it is the only legal word acknowledged.
53 South Africa: Dalro. Germany: Bildkunst. Argentina: Estudio Jurídico Kiper. Australia: Viscopy. Austria: VBK. Belgium: SABAM. Canada: SODRAC. Korea: SACK. Denmark: Copydan. Spain: VEGAP. Estonia: EAU. USA: ARS. Finland: Kuvasto. Italy: SIAE. Japan: BCF. Latvia: AKKA/LA. Lithuania: Latgaa. Norway: BONO. The Netherlands: Beeldrecht. UK: DACS. Sweden: BUS. Switzerland: Prolitteris.

ucts and services. Can one permit these infringements on property? I do not think so. In this listing, along with the seven hundred pirate brands, the Picasso *indivision* only possessed around ten registrations, in addition to about three hundred for the "Paloma Picasso" brand, which seems logical, and a few for "Marina Picasso" and "Maya Picasso." In this last case, I advised my mother to take this action, as a precaution, seeing that her, very original, first name is also the title of numerous portraits painted or drawn by her father.

Following this, case by case, each illegal brand was taken over—either amicably, or through legal action—by the Succession represented by the Picasso Administration. One opposition against a brand costs around $360 in France but $23,000 in Panama.... But, if one does not take action in Panama one faces the genuine risk of seeing pirated products appear, stamped "Picasso," registered in Panama, taking advantage of a name legally protected there!

The end result is that if there are seven hundred illegal trademarks, it is necessary to remonstrate in seven hundred cases. As there are forty-two classes of products and services, this would eventually lead to the legal registration of the "Picasso" brand in each individual class—that is the situation in France today—and in all countries. A *contrario*, it is not a matter of, henceforth, creating all possible "Picasso" products, in all protected classes. That would represent hundreds of different products, many of them unwanted! Picasso's heirs, never specifically wanted to be involved in merchandising nor, *a fortiori*, authorize all products. It was a matter of proceeding with very specific arbitration.

Merchandising always existed, even during my grandfather's lifetime: postcards and posters are the precursors of modern licensed products. In the 1950s, Pablo himself was amused to see shirts and dresses—individual models—made from cloth reproducing certain of his "multiplied" works.

Today, to my knowledge, there must exist around ten authorized licensing agreements using the name and oeuvre of my grandfather. This is far removed from the fantasies of those who see Picasso everywhere. In comparison, does anyone know that about 250 licenses exist for the name and work of René Magritte? This is not talked about. In Picasso's case, this sensible parsimony is attested through the radical restriction, and strict control, in order to arrive at a balance. Finally, it is the revenue generated by these licenses which permits the financing of the Picasso Administration, more specifically, provides it with the means to protect the name and work of the artist and, where necessary, to undertake any action against infringement on the brand or counterfeit—thus, being able to pay the lawyers' fees and to ensure the ongoing functioning of the authorization for reproduction of the works.

The products, according to the Picasso Administration policy, take advantage of the values of recognition, confidence, and reputation. With the name and oeuvre of Picasso there exists a genuine "imaginary added value," which inspires the public. The recognition of the name is almost universal, with an identification rating approaching 95 percent in most countries. Such fame attracts desires. As a defense measure, and not spontaneous exploitation, the Picasso *indivision* was forced to see marketing as an element of protection. In order to fight against this market, which they had not expected and which they did not feel competent to investigate (with the isolated exception of the Jackie Fine Arts affair of 1980), the heirs began their battle against illegally established conditions, determining a strategy to ward off anything and everything. Starting in 1995, Claude Picasso, the legal administrator of the Succession, was able to proceed actively, at his own discretion, and defined the legal boundaries for the use of Picasso's name (which had become a trademark) and his oeuvre.

The policy of burying one's head in the sand, and the good old days of postcards, were long gone. It had now become necessary for the heirs to face up to the reality of the contemporary world, to become innovative without damaging the reputation of the work and the artist, and to find a kind of equilibrium.

Strengthened by my personal experience with major corporations, often on a global scale, I decided to develop my activities as rapprochement counselor for businesses and adapt them to the family situation. In a certain sense, I tried to unite talents. My activities with the Picasso Administration took place, and still take place, in a way that would be possible for any other contributor. Concerning my remuneration, it is legitimate and, to my knowledge, in keeping with that paid to third parties by the Succession. What is more, it is "proportional" (as a percentage), which is an excellent motivation: each improvement obtained by me benefits everybody: a little like my grandfather and his dealers. Everything is transparent.

After 1996, I suggested a rapprochement with major industrial groups, within the framework of creating products that could legally reproduce the name and oeuvre of Picasso. Some projects were successful, others not. I learned that, in Argentina, the heirs were faced with some disturbing problems concerning the illegal registration of the "Picasso" trademark in class 12 (dealing with land vehicles), for truck trailers. There was also talk of "Picasso" bicycles in China. I therefore conceived an "automobile" project relating to the same class. Once again, this project became part of an active defense strategy.

The existence of an illegal product creates a precedence. If there is no reaction, this trailer or this little bicycle can, legally, open the way for uncontrollable derivatives. It is not financial interest that dictates this, it is, first

and foremost, a moral interest. The automobile is an object that unites inventiveness with modernity: artistic creativity is required for styling and color, and the manufacturing quality must be impeccable. The automobile is the product of the twentieth century. It is a symbol of individual liberty.

The study of this project, tackled on my part in 1995, began actively in March 1997, after determining the candidates for such an operation. It was necessary to take the history of their brand names, their nationality, production potential, their image, the state of their range of products, and their distribution network into consideration, and all of this with the utmost confidentiality. Competition is fierce in the automobile world. There is no room for making blunders and, above all, it was necessary to take the public's reaction to our analysis into consideration. I had to make this project consistent with Pablo Picasso's personal history, and also confirm the pertinence and opportunities arising from the idea. And then, it was necessary for the idea to please a car manufacturer!

At that time, I officially informed the Picasso Administration, giving details of my investigation, its advantages and limitations, and the direction to be taken. I also indicated that the creation of a special "Picasso" series meant an industrial set-up time of around eight to fourteen months, even merely to change or add a detail to an already-existing vehicle.

My final recommendation was for Citroën. I initiated contacts. In June 1998, I presented my ideas, in two separate meetings on the same day; one with the production manager of PSA-Peugeot Citroën, on the personal recommendation of Martin Falz, the recently named president of the group, and the other with Jacques Séguéla, his advertising adviser at Euro-RSCG (a subsidiary of Havas Advertising).

Séguéla advised me to proceed, to risk the exceptional and to christen a vehicle "Picasso"—and not merely a limited edition of an existing model. Risk! That word would have pleased my grandfather. How could we make such audacity become reality without waiting several years in a production process that was scheduled so far in advance? He told me that his client Automobiles Citroën was presenting a new vehicle, the following October, at the World Automobile Fair in Paris. It was to be the unique example of a new model. This new vehicle would not come onto the market until one year later. And, it still had no name! Three months before its presentation! To offer the name of a creator such as Picasso would be an unexpected honor. And, I must admit, an undeniable trump for the constructor.

Within a few minutes, I had just discovered an unnamed car, to be presented as a unique example, like a work of art, at the 1998 automobile salon, the centennial, in Paris. We could call it Picasso, and would have time, in one year, to prepare for its production and communication activities! This rap-

prochement seemed almost inevitable: it was the famous "I do not seek, I find...." Jacques Séguéla himself had found a tremendously revolutionary idea: wasn't this the first time in history that an automobile had borne the name of a painter?

In addition, Citroën is well-known in China.

André Citroën constructed his first prototype in 1907 at the same time as my grandfather was working on *Les Demoiselles d'Avignon*. Both men were, in their individual fields, precursors, visionaries. I do not work for the commercial section of the company, but I believe that Citroën is part of the collective memory of all French people and of many others in foreign countries. I hope I can be forgiven for such enthusiasm. Wasn't André Citroën the man who illuminated the Eiffel Tower, the man who financed, alone, the lighting of the Place de la Concorde in Paris? To talk about Citroën automobiles is to talk about the 3CV goose, the yellow cruiser, the traction, the 2CV, servo-steering, disc brakes, the DS, the Méhari, the SM. Even Americans are aware of these avant-garde creations!

I had often been told about my uncle Paulo's Traction 15CV, an extremely rare model with hydro-pneumatic suspension. And I can still remember his beautiful DS in Boisgeloup.

As the famous sociologist Roland Barthes stressed when speaking about the DS at the time of its introduction: "I believe that, today, the automobile has almost become the equivalent of the Gothic cathedrals: by this, I mean a great creation of the time, conceived passionately by unknown artists, consummated in its image, if not in its usage, by an entire people who appropriate it as a perfectly magical object."[54] The automobile had become a consumer object permitting all kinds of audacity. In this, it no longer seems commonplace and can easily be associated with an *objet d'art*. Its legitimacy, both utilitarian and conceptual, provides it with the capability of being raised to the level of a work of art.

After having discussed the procedures for obtaining a license from the Picasso heirs, represented by the Picasso Administration, with those responsible at Citroën, I left the entire project to the final agreement of Claude Picasso, seeing that he had all the legal powers of decision. I had to present the whole dossier to the Picasso Administration, including all those parameters and financial aspects that I had negotiated. And to know what the vehicle would look like.

A visit was organized to Automobiles Citroën's styling center. I, who had always had a passion for cars, was about to come face-to-face with a top-secret prototype!

54 Roland Barthes, "La nouvelle Citroën," in *Mythologies,* Paris 1957; English edition: Barthes 1997.

Claude Picasso organized several meetings with all the interlocutors. Between July and September 1998, an agreement was rapidly reached. On September 15, the vehicle was presented to the international press at the Stadium of France (where the national soccer team had become world champion two months previously) by Claude Satinet, general manager of Automobiles Citroën. It was concealed behind a large blue curtain. There were two hundred journalists in the conference room. The secret had been well kept. Nobody had seen the vehicle, nobody knew its name.

The blue curtain rose. A huge photograph of my grandfather appeared. My heart was beating. What would be the reaction to our audacious gamble? There was silence, nobody understood. Then, the photo was raised, revealing the car which only had the "Picasso" signature on both sides. Nothing else. This was homage paid by a great French automobile producer to the greatest modern artist.

The impact was enormous. Picasso's name, unexpected on this automobile, made an immediate impact in the media. Surprisingly, the national radio news channel France Info, announced the launch of the vehicle in its daily news broadcast. The respected *Le Journal des Arts* echoed: "In the artistic sphere those who regard Picasso as the painter of the twentieth century are legion. In the automotive sector, Citroën is universally recognized as an original and innovative brand…. Should one be astonished at the association of these two names…?"[55] The reactions were positive, even enthusiastic. It was the kind of shock my grandfather would have liked.

It was also a precursory act, a pioneering act. Jacques Séguéla and Yves del Frate, responsible for the Citroën brand at the Euro-RSCG agency, chose a slogan obvious in its simplicity: "The imaginary, first of all"! After its presentation the Citroën Xsara Picasso became a prestigious success. The unification of the two names had not resulted in the slightest feeling of vampirism; both coexist to the benefit of each other .

Today, this minivan is a considerable commercial success, much greater than hoped for. In addition to the obvious technical and aesthetic qualities of the car—which would probably have been sufficient to guarantee its success—the name Picasso intensified the image of the vehicle. The automobile press congratulated. It is the most-sold middle-sized minivan in Europe. The publicity spot, "The Robot," is such a graphic and emotional hit, that it is shown in all countries—a rare thing, considering the differences in mentality and advertising from one country to the next. It has obtained an unprecedented level of recognition and satisfaction. The spot's music "Je ne veux pas travailler" (I don't want to work) by the American group Pink

55 *Le Journal des Arts* (December 18, 1998–January 7, 1999).

Martini has become a hit. And this, everywhere; as the vehicle is sold in more than fifty countries (except—for the time being—in North America)! It is constructed in Spain, as well as in Brazil, and even in China! It is a global car. In the image of his name.

Many journalists have asked me what Pablo would have thought. Without wanting to take his place, I replied that, in view of his career, with the exception of the political intentions of his art, innovation and experimentation with new techniques had always aroused his curiosity. My grandfather never stopped breaking out of all confines. He led real revolutions (Cubism, collage, sculpture, ceramics, linocuts, metal). Naming a car after an artist was something that had never been done before. It is quite a little revolution. It would have made him "purr" He would have been amused to see his name on a car; he who had arrived in Paris, unknown and penniless, at the beginning of the twentieth century, to attend the Exposition Universelle. It is his name that has, since, become universal. Could he have imagined that, today, there would be more than one million vehicles on the road bearing his signature?

I recently visited the Citroën factory in Vigo, on Spain's Atlantic coast near the Portuguese border. More than ten thousand people work there in a huge, ultramodern plant. I followed the production process, step by step, of hundreds of Picassos in all colors. During the assembly, there is a very special moment: the application of his signature to the car. Even with the participation of thousands of persons on a technological object, finally, it is one man who provides the unexpected "plus." Would he have believed it himself?

There is also a large wall where all the workers are free to express themselves—a real *dazibao*—and I was surprised to see hundreds of thoughts, suggestions and, above all, works of art inspired by the car and also largely by my grandfather's works, on it. I was content.

Wasn't it in 1961 that Pablo called Jacqueline to show her enthusiastically what he had just drawn in a bullfight arena? "Look! I have made a car." The first and only one we know of.

In addition, when I consider the use he himself made of advertising posters and trademarks (Pernod, Kub, Bass, Le Bon Marché, Suze) in his Cubist works, I realize that he participated as a spectator in the birth of a new activity, and appreciated its colorful creativity. He did not turn away from it. Isn't publicity often at the forefront of a creation? Today, the great poster artists are exhibited in museums. Picasso's name on a car is merely an episode. The Paris Musée d'Art Moderne spontaneously chose to reproduce a photo of the front wing of a red Citroën minivan, with Picasso's signature,

as its official greetings card for the year 2000. This was sent to its thousands of cultural contacts throughout the world.

Here, I saw a kind of consensus.

On the financial level, taking into account the magnitude of the collaboration with Automobiles Citroën, the revenues from this license are very important for the Picasso Administration and, therefore, for the joint owners. It is not my position to reveal this amount: I am bound by a commitment to confidentiality, as is common practice in the business world. Without dealing with the taboo attached to money, a French tradition, it is normal that each person reaps the benefits of his labors.

The Succession Picasso continues to control all uses of the name and oeuvre of Pablo Picasso, but now has the support of a powerful partner. This is a useful trade-off. The revenues from this uncommon license also permit us to cover the costs necessary to protect the name and memory of Picasso.

At last, even automobile manufacturers have overcome the distance separating them from the world of art and from artists. How many advertising campaigns have been created for Daimler-Chrysler, especially its Mercedes-Benz division, General Motors and Saab, Peugeot or even Volkswagen, using famous artists: James Dean, Andy Warhol, Marilyn Monroe, Toulouse-Lautrec, John Lennon, Steve McQueen, Salvador Dalí. Exactly!

There were scarcely any hostile reactions to the presentation of the Citroën Picasso. Those who were upset were principally preoccupied with the financial arrangements. The French trait of being jealous of "suspect" profits? Some spoke of the "sale" of Picasso's name—which is false seeing that this license is solely for the utilization of the name. There was no transfer of property, the *indivision* remains the proprietor of the Picasso name.

In fact, it will always be difficult to understand that normal people can be the heirs of an exceptional man. With Picasso, one enters into the domain of the irrational, the affective. His fortune is based on emotion. It is intangible, immediate, spontaneous. A personal relationship has been established between his works and his public. As I have so often said, Picasso belongs a little to his family and, in large measure, to the public.

Knowing that only a few people are in the possession of a very important portion of this relationship to the public, both in the quantity of the works and their power to reproduce them and use his name and image, is a disquieting feeling. I understand it. This ownership appears unjustified, exaggerated—unpardonable. Because it is art. Because it is Picasso! Picasso turned everything upside down, his oeuvre is almost intolerable!

Let's be frank. Very little criticism resulted from the launch of the Citroën Picasso, but my cousin Marina can be counted among the rare detractors. It is her right. She went to the press to declare just how greatly she was offended by that utilization of the Picasso name, made "banal" in her words—and Le Parisien[56] announced that she was planning to take legal action.

I asked myself about this recourse of making the public a witness via the media. Didn't Marina state in 1997, in the French magazine Gala,[57] totally without foundation, that the Picasso Administration was bankrupt!? Could she not estimate the consequences resulting merely from this absolute dishonesty? It was necessary to reassure the partners and associates of the indivision. Didn't she repeat, on several occasions, that she had "refused to participate" in the structure of the Picasso Administration, disgusted with its activities and its name? She never showed any interest in participating in it as a shareholder (it is a "transparent" structure, under the EURL statutes, with a mandate by Claude Picasso, the legal administrator and sole shareholder), but she remains a natural member of the indivision that is simply represented by the Picasso Administration.[58] Why did she refuse to come and express herself at these meetings?

Doesn't Marina remember that she illegally sold reproduction rights belonging to the Succession, in December 1979, causing a real disaster, which was brought under control only after fifteen years? She had totally forgotten our grandfather and washed her hands of the future of his work, his name, his image. Marina never appeared at any of the Succession's meetings after this period. Why? Each of the four other heirs made suggestions and everybody discussed them. Claude has the reputation of being extremely attentive in his mission as administrator. However, Marina appears to have a selective memory.

In conformance with what was announced in Le Parisien, Marina later initiated legal proceedings. This was certainly not to attack or renounce the benefits of the license that she criticized publicly: quite simply, to contest my intervention and, above all, my remuneration, declaring that my participation had "impoverished" her! I thought I had worked in the interests of all—including the protection of our grandfather's name. According to Marina, the name of Picasso in no way needed "marketing," everything fell from heaven and, above all, I had absolutely no qualifications or professional experience to manage this kind of business. There had been a vile complot!

56 Le Parisien (January 29, 1999).
57 Gala (October 23–29, 1997).
58 See the website picasso.fr for information on the Picasso Succession and the Picasso Administration.

She demanded that the contract linking me to the Succession Picasso, via the Picasso Administration, be "revoked" (jurists will appreciate this juridical innovation). It should also be noted that this action was managed by Maitre Ferrebœuf, the famous advocate involved in the "offensives" of 1976 and the Jackie Fine Arts events of 1980. This was the occasion of his grand homecoming to Marina, after almost twenty years of official absence.

Of course, Marina did not demand that the principal licensee's contract be cancelled; she expected some advantages from it.

She was turned down in court, but continued to claim in the media that she was the victim of the other heirs—without being more precise that her displeasure was aimed solely at me and the remuneration of my organization, which she wanted to have annulled (she even demanded reparation of her "losses" from Claude Picasso and the Picasso Administration).

This is quite different from the version presented to the journalists. It is called "taking the people for a ride."

After that, things returned to normal. The Picasso Administration continued to do its best in the interest of Pablo's memory.

To be truthful, the returns on the licensing policy are almost marginal, in comparison with the time spent collaborating with interlocutors throughout the world on entirely cultural matters. The everyday activities tend to favor projects with book publishers, television programs, and, currently, multimedia support, in providing an ever-increasing access to images of Pablo Picasso's works. The Picasso Administration acts as a communications center between these different demands and those in possession of information and documents (including images). Those working with Claude, the administrator, both in Paris and abroad as his representatives, increasingly offer and assist to an extent far beyond the commercial character. It suffices to check out the official website *www.picasso.fr* dealing with the activities of the Picasso Administration. Everyone can easily appreciate its soul and conscience! There, everything is concrete.

A particularly interesting Internet website is *picassomatisse.org*[59] which accompanied the impressive exhibition "Picasso and Matisse" held at the Grand Palais in Paris in autumn 2002, and which, organized by the Union of National Museums and the cultural sponsorship of the LVMH group, provides an exemplary illustration of the engagement of the Succession Picasso, via the Picasso Administration, and the Succession Matisse, in an unprecedented pedagogical and scientific enterprise, to offer a greater understand-

59 See also the site *picassomatisse.com* (dealing with the exhibitions in the United Kingdom, France, and the USA).

ing of the works of both painters. I took part in the first presentation of the site and its content, which perfectly conveyed the logistical and cultural assistance necessarily accompanying the simple authorization of reproducing images of the works and the control of the name and image of Picasso. Once again, one can judge the results.

Picasso's heirs are closely involved with the majority of exhibitions organized throughout the world. Many of the works, and often the masterpieces, are noted as coming from a "private collection," and often originate from the collections in the possession of Maya, Claude, Paloma, and Bernard Picasso. Only Marina's works appear with the mention "Collection Marina Picasso, Courtesy Gallery Jan Krugier [henceforth, Krugier & Ditesheim] Geneva."

The heirs are particularly sought after: everybody knows that Pablo preserved many works, considered essential, which are now divided between these heirs. To these, must be added the works in the possession of his widow Jacqueline, which her daughter Catherine Hutin-Blay inherited. Each heir, and this is not a secret, also made personal purchases, to complement the quality of his or her own inheritance.

The representative, itinerant Picasso exhibitions that have taken place over the past years permit us to rediscover unknown, or little-known works: "Picasso and the War Years," "Picasso and the Portrait," "Picasso and Ceramics," "Picasso the Sculptor," "The Erotic Picasso," ... or the major retrospective exhibition "Picasso and Matisse" (in Paris, London, and New York). In autumn 2003, the Picasso Museum in Paris showed the public, for the very first time, an important part of my grandfather's archives, entrusted to the state by his heirs within the framework of the Succession. In spring 2004, it was the Picasso-Ingres exhibition. In addition, a new Parisian museum—the Pinacothèque—opened with the exhibition "The Intimate Picasso: Jacqueline's Collection" (which then traveled to Japan and the United States).

In 2004, there is a retrospective in São Paulo,[60] a ceramics exhibition in Canada,[61] an exhibition of Cubist portraits of Fernande Olivier in Dallas,[62] and "Picasso: Surrealism and the War Years" in Baltimore,[63] among others.

Organizing these exhibitions entails considerable work for the donors, spanning several years. Here, I would like to take the opportunity of thanking

60 "Picasso, Una retrospectiva" in the OCA, São Paulo.
61 "Picasso and Ceramics" in the Musée des Beaux-Arts in Quebec, then at the University of Toronto Art Centre in Toronto.
62 "Picasso: The Cubist Portraits of Fernande Olivier" at the Nasher Sculpture Center in Dallas.
63 "Picasso: Surrealism and the War Years" at the Baltimore Museum of Art, Baltimore.

the conservators, who exert themselves without counting the costs, for a passion that has become their second nature. Their engagement enables us to obtain a better impression of the life and oeuvre of Pablo, complementing the memories and the, almost innate, knowledge that, particularly, his children Maya, Claude, and Paloma have. Finally, Picasso's heirs have often initiated more modest exhibitions, permitting the public to discover the more intimate or specific aspects of his art (drawings, etchings, thematic exhibitions). Here, I am thinking particularly about the exhibitions organized from the collections of Maya and Marina, or more recently, Bernard and his mother Christine. The initiative of these last mentioned, in collaboration with the Junta de Andalusía, leading to the opening of the Museo Picasso in Málaga, is a demonstration of this family spirit.[64]

Actually, there are so many events and exhibitions throughout the year that it is almost impossible to document them all.[65]

In a certain way, we have come full circle: Picasso's art is entwined with Picasso's money and that, conveniently, brings us back to his art. Reason has a heart.

64 The opening of the Museo Picasso in Málaga on October, 27, 2003 by the King and Queen of Spain was marked with the first exhibition "El Picasso de los Picassos," uniting little-known or unknown works lent by members of the Picasso family, with the exception of Marina.
65 Up-to-date information is provided on the website www.picasso.fr.

Death

"Everything approaches on its own, including death."[1]

Pablo Picasso

Of all the various reputations attributed to my grandfather, the one he truly deserves is that of being superstitious. He was born into that nineteenth-century Spain that was so steeped in and loyal to the most medieval form of Catholicism that went far beyond the precepts of the Vatican. This rigid Spain had been molded by the Inquisition. The very values of Spanish society were those of the Church itself; and the threat of being condemned to Hell for the least discrepancy was taken more than seriously. Royalty, the aristocracy, the bourgeoisie, and peasants alike all dwelt in a permanent relationship of sub-mission under the supreme—albeit not always indulgent—surveillance of God and of His representative on Earth, the almighty Church.

Although the Ruiz y Picasso family were not exactly devout, practicing Catholics, they could scarcely avoid the national tradition, which often replaced daily church-going with a whole ritual array of superstitions and precautionary measures. Everything was seen in terms of good or evil, aus-picious or ill-omened, devil or angel! For my grandfather, religion had never provided answers to metaphysical questions. He never considered praying or turning to God for the answer to the anxieties of the human condition. When confronted with death or with the horrors of life, he expressed his queries through the medium of his work.

1 Malraux 1976.

He was born among the dead. Shortly after 11 p.m. on the night of October 25, 1881, Doña María gave birth to a still-born son. After attempting to revive him for several minutes, the lifeless little body was placed on a table. His uncle Don Salvador, an experienced doctor, cast a suspicious eye on the child and, strangely enough, decided to place his still-burning cigar next to the face of the new born infant, who suddenly sprang to life with a "roar of rage," as historian Josep Palau i Fabre later recounted.

Was it a miracle? Or was it a beyond-the-tomb signal from his other uncle, Don Pablo, a doctor in theology and Canon of Málaga Cathedral, who had died precisely three years previously that October? The family had literally worshipped him, and decided to pay him homage by naming the little stranger Pablo—the first male heir of the Ruiz family.

They didn't then realize that Pablo's gratitude would exceed their wildest dreams, nor that he would cast off the yoke of the late Canon's precepts.

Two weeks later, on November 10, 1881, Pablo was baptized at the church of Santiago, in Málaga, and there received enough names to satisfy a congregation of saints: Pablo Diego José Francisco de Paula Juan Nepomuceno María de los Remedios Cipriano Santissima Trinidad Ruiz y Picasso! Later, "Pablo Picasso" would be more than enough to assure his fame.

Throughout his life, so many official documents would chant the litany of his rosary-like identity before other equally official ones, tired of reciting this seemingly interminable name, would impose their own authority and abbreviate the identity of this Mr. Picasso.

Pablo's first true encounter with death took place on January 10, 1895. His little sister Conchita died of diphtheria at the age of eight. Pablo was then thirteen, and hadn't yet fully decided to become a painter. He didn't really care much for school and quite frankly preferred the punishments he would receive, which consisted of being put into a little solitary confinement "cell" —there, at least, he had some peace and quiet, and could spend his time drawing. Just before his sister's death, however, he challenged the Heavens: he would sacrifice his talent and give up the idea of becoming a painter if little Conchita were to get well again.

But Conchita didn't get well. God had been heartless. Furthermore, by blasphemously equating his sister's life with his mere talent, he had surely invoked the Creator's wrath. He, Pablo, had been responsible for her death. On the other hand, it was perhaps a sign that God wanted him to be a painter, and this predestination placed him above all other people, as it had already placed him above the life of Conchita. In lieu of a divine gesture, a

certain magic could possibly be detected behind all this, and Pablo was perhaps the appointed alchemist.

Jean Leymarie, art critic and friend of my grandfather, whom I consulted at length, confirmed the importance of this painful episode: "He who had already felt an irrepressible calling, and who was seen as a prodigy to whom even his father yielded, had vowed that if she survived, he would give up painting. This was a most extraordinary thing. However, she died, his wish had not been granted, and from that moment on he became 'committed.' That's how I see it, for whether or not he was Faustian or agnostic, he had a deeply religious spirit. And because of that, his commitment was total. A will power beyond himself was at work. In the typically Spanish manner, he engaged his entire fate, and what he loved the most in life. Heaven didn't grant his wish and thus confirmed his vocation of becoming a painter. And he had absolutely no right whatsoever to misuse his power."

This superior, quasi-divine decision to practice his talent as a painter could account for the fact that Pablo felt entrusted with a true mission. How could anyone then be surprised that from that moment on he placed his art above all else—even before all other people?

And from this fundamental anecdote also stems his particular fatalism— his life-long refusal to take any initiative, and to allow fate to work itself out. "In other words," Leymarie went on, "once invested with this supernatural power of his at the age of thirteen, Picasso already knew what he had to do. Later, when he went to Paris, he had several friends who committed suicide, or who fell victim to drugs or alcohol. But he had already submitted himself to an iron discipline from which he never swerved. He would eat soup, and always adhered to a light diet to maintain his strength for his work. That's how I understood it when he didn't want to entertain his friends: in fact, he adored them and was dying to. And his friends all thought he was being capricious, or mean. But he absolutely couldn't, for he was absorbed in his work. And I believe that is fundamental for understanding Picasso."

Max Jacob had been struck by this asceticism. Despite the fact that from 1910–12 on Pablo was able to enjoy the comforts of life, he remained quite detached from all material objects. Aside from his time with Olga, he led a simple, frugal existence that focused on a goal that was spiritual, "committed," and always artistic.

The mere influence of Spanish traditions had already made him superstitious, but Pablo saw the death of his sister as a call from Providence. Even if he didn't believe (or at least not for very long) in an almighty God who turned out to be incapable of curing Conchita, an exterior divine force seemed to be encouraging him in his creative desires, and was irresistibly

driving him towards his mission as messenger, and as an intermediary. Was he already wondering about the meaning of his talent? Was he seeking a sign, or an answer? Could his little sister's death have been the price that had to be paid? None of those around him could answer such questions. Even later, no one ever could. He was convinced of his own personal intuition, and of the spontaneous, even supernatural organization of things.

Pablo made the distinction between God and the divine. Although he always claimed to be an atheist, he often evoked religious themes in his work. In spite of all his resistance to "oppression," the academic training he received in Spain throughout his adolescence had an undeniable impact on his work. Goya, El Greco, or Velázquez, who all painted innumerable religious scenes, also contributed to guiding his painting toward Christian themes.

Thus, just after arriving in Barcelona, he produced a drawing of Christ blessing the Devil—an obvious expression of the conflict that raged deep within him. Several other religious subjects were to follow: *The Flight into Egypt, The Altar of the Blessed Virgin, Christ Appearing to a Nun, Christ Being Worshiped by the Angels, The Annunciation, The Resurrection,* etc.

These paintings go beyond mere academicism. They comprise an initiatory path, and a form of exorcism. Admittedly, religious themes were an essential part of the famous fine arts academies' examinations, and it would have been suicidal not to have mastered them. The spiritual goal was thus opportunely subordinated to the more practical objective.

With all its rules and regulations and threats, Catholicism seemed more like a stranglehold of constraints to him than a source of hope. Pablo was filled with an overwhelming passion for freedom. After the Academy, he also had to defy the Church and refuse to become spiritually bogged down.

Here the struggle was much more grueling. But Pablo came up with a sharp maneuver. When in the fall of 1896 he completed his huge *Science and Charity* painting, he had perfected a certain form of academicism and had opened a door. He was fifteen years old at the time. The ambiguity of the theme—between a nun's prayer and the knowledge of a doctor (whom he portrayed with his father's face)—was in itself quite daring. The impious comparison of hope with certitude was a declaration of faith, or rather of non-faith, as the case may be. It would then appear that prayer was no longer the last resort, but that science could at long last provide the miracle of healing.

But his revolt against tradition was limited by his obligation (a horrible word) to produce large-scale conventional canvases, as the only ones capable of making him stand out at the exhibitions. Pierre Daix spoke accurately of "the big academic machine."

From then on Pablo launched into a subversive, beyond-the-fringe and resolvedly innovative form of expression ... and one that was hardly understandable to his contemporaries, who felt threatened in their beliefs.

The political situation in Barcelona in late February 1899 led him to paint morbid subjects. Death prowled the riot-torn streets of the city. The surge of the anarchist dream combined with the rebellion against the needless war fought in Cuba against the United States. Henceforth Pablo would be discussing mature topics with his friends in the cafés and bars. His reply to the prudishness of the Church was to frequent the brothels regularly, and to experiment with more licentious forms of activity. But he also became interested in the philosophy of Nietzsche. He had yet to read him, but was listening carefully to those around him. He had retained the essential: "the Nietzschean principles of the death of God and the birth of the Superman, that extraordinary being who, alone upon his mountain summit, was able to survive the death of God. Yo—'I,' or the ego—was the key word which, among all the young artists and intellectuals of the Quatre Gats, summarized the cult of the Superman for whom anything was permitted. 'I myself am my own destiny, and I have fashioned my existence for all eternity,' Nietzsche had stated, and Picasso was ready to reply to that declaration of absolute liberty. Nietzsche's will to power had found an echo in his own heart. Power was the one and only value promoted by Nietzsche which could take the place of love and of other basic values which had lost all meaning for modern man. And Picasso, for whom all transcendental values were associated with the repressive Spanish Church and who thought that he had tried love and failed, found that this philosophy corresponded wonderfully to his needs and to his dreams of power."[2] His weapons, however, consisted of nothing more than a brush and a pencil, and the field of his victory would be a blank canvas.

As to his failure at love, up to then, the only form of love he had known was in the fixed-price embraces of the "ladies of the night," an essential part of the rites of passage from adolescence to adulthood. There had been nothing very promising on the emotional front.

Pablo was in Madrid in February of 1901 when he was informed that his friend Casagemas had committed suicide in Paris. The young man hadn't been able to stand the idea of being rejected by the lovely Germaine, who was both indifferent, and already married. He had wanted to kill her, before taking his own life. He managed to miss her, but he didn't miss himself.

2 Stassinopoulos-Huffington 1988.

Pablo was shattered by the news, and immediately returned to Paris to exorcise his pain and remorse at having been helpless. He had seen his friend suffer so much for that inaccessible woman! This drama inspired his highly symbolic painting *The Burial of Casagemas*. Here he was exorcizing his own morbid ideas, which affirmed the close thematic connection of life, death, childhoods, and love—and the inevitable reality of prostitution as the heart's assassin.

Picasso's 1903 painting *Life* symbolized the miracle of creation, which lay at the very heart of the desolation that human beings passed through. This was the final Blue painting. As I mentioned earlier, Pablo had a very hard time parting with his works. But he sold this one immediately, as if to close the door on a disastrous bygone period. He was now ready to take up new challenges. As well as new colors.

Four years later, he had an overwhelming mystical encounter at the Trocadero Musée de l'Homme in Paris. It was there that he discovered African sculpture and African masks.

For several years already, there had been a keen interest in African art, particularly among artists. Vlaminck, his neighbor at the Bateau-Lavoir, owned several pieces of sculpture from Dahomey and the Ivory Coast. He sold a mask to their friend Derain, who then showed it to Matisse and to Picasso. Matisse then enthusiastically bought an African statuette (which he took to be Egyptian) and showed it to Gertrude and Leo Stein. Which is how Picasso discovered it.

The debate is already familiar: did Pablo discover the African masks and statuettes before painting *Les Demoiselles d'Avignon*, or after he had finished it? I'd take his own version, given to Malraux in *Picasso's Mask*: "People are always talking about the influence of the 'Africans' on me. What do they mean? We all loved fetishes. Van Gogh said: 'We all had Japanese art in common.' For us it's 'African.' Their forms didn't have any more influence on me than on Matisse; or on Derain. But for them, the masks were sculptures just like the others. When Matisse showed me his first African bust, he was telling me about Egyptian art.... The masks were not at all pieces of sculpture like the others. They were magical items. And why not the Egyptians, and the Chaldeans? We hadn't really perceived it. Primitive, but not magical. The Africans were 'intercessors'—and I've known that word ever since that time. Against anything; against unfamiliar or threatening spirits. I was always looking at the fetishes. And I understood: I'm against everything myself. I, too, think that anything unknown is an enemy. Everything! Not the details! Women, children, animals, tobacco, gambling ... but the whole thing! I understood what the 'Africans' used their art for. Why sculpt like that and not any other way. You can't call them

Cubists…. But all the fetishes were used for the same thing. They were weapons. To help people from being subjected to spirits, and to be independent. Tools. If you are able to give spirits a form, then you become independent."[3]

Pablo thus gave an intellectual explanation of that influence, whereas other painters had simply experienced an artistic emotion. And doesn't Pablo say of his friend Braque: "He doesn't understand these things at all— he's not superstitious."

The word was finally blurted out.

At another point in his interview with André Malraux, Pablo affirmed that he had produced his "first exorcism painting" with *Les Demoiselles d'Avignon*. He went on to add: "Nature has to exist, for us to be able to rape it."

From then on, Picasso appeared liberated from the usual artistic constraints; and even the expression of his religious fantasies were freed without ever approaching blasphemy. Already a rebel in his anarchist political convictions, he now became so in his art, upon which he imposed no rules at all. But he remained indestructibly attached to various grigris and other superstitions. According to Patrick O'Brian, his opposition to the Church wasn't all that clear: "He maintained a deep sense of the divine; deep, but also rather obscure, dualistic and, in so many ways, about as far away as you can get from what could be called 'Christian.'"[4] He specified that Pablo hated people making "the slightest allusion to the fear of his demise, even though his least ailment seemed to preoccupy him greatly. As for death itself, he avoided evoking it as much as possible, except in silence, in his work and, often, he would take refuge in anger. When he was bed-ridden with illness in the final weeks of his life, one of his close friends—a Catalonian—urged him to make out his will. 'Doing things like that just attracts death,' he cried out furiously, and shortly thereafter ordered him to leave."[5] Roland Dumas confirmed to me the fact that for *Guernica*, a will and testament was out of the question. Pablo informally designated Roland Dumas, just in case. He had managed to evoke the inevitable without actually pronouncing the word "death." He had also managed to write his "last will and testament" without using those words!

As for his defiance of God, he made a few concessions, either due to a fleeting sense of joy, or to one more of his many superstitions: "Receiving the promises of eternal love from Françoise Gilot in a church, with the bless-

3 Malraux 1976.
4 O'Brian 1976, p. 35.
5 Ibid., p. 36.

ing of holy water, or else pointing out to Matisse that in troubled times, it was comforting to have God on your side."[6]

Didn't he once tell Hélène Parmelin: "A truly good painting is that way because it was touched by the hand of God"? But he quite regularly took the trouble to deny His existence.

As for the traditional Catholicism in which he'd been raised, the most revealing aspect was the silence he maintained about it.

And yet on June 21, 1942, Pablo became the godfather of his daughter Maya (who had been born on September 5, 1935). Even if the religious procedure and Maya's enrollment in a Catholic school on Île Saint-Louis in Paris were mostly the ideas of Marie-Thérèse, it was also a way for Pablo to make his paternity official. Despite his legal impossibility of divorcing and of recognizing Maya, Pablo was trying to create a link, be it as fictitious a one as a baptism. The Church came to the rescue. It should also be pointed out that Maya's name was actually quite religious—Maria de la Concepcion—and was ample proof to the Spanish side of the family of his great affection for the Church.

Seemingly so.

Even more disturbing was the fact that it was Maya's second baptism. For, like her father, Maya was "still-born." At the Belvedere Clinic in Boulogne-Billancourt, childbirth took place under general anesthetic— such was the dangerous medical practice of the times. Marie-Thérèse never felt a thing; but suddenly there were complications, and Maya seemed to come into the world lifeless. Pablo was terrified and proceeded to give his daughter an emergency baptism, sprinkling water on the inert little body like a priest giving the first and last rites of the Church. And suddenly Maya sprang to life!

In emergencies, and in spite of his distrust of religion, he could neither avoid ancestral traditions nor deprive his child of a path towards that "elsewhere," to which he held the official key, in the ritual of the sacrament.

Pablo was terribly upset by all this. He refused to pay the 2,500 franc fee to the doctor in charge, who was one of the most famous in Paris, by the way. It was his fault! And as for God....

Shortly after the second, and official, baptism, Pablo attended Maya's first communion, then her solemn holy communion in 1947. Each time the hard-headed freethinker seemed to betray a most singular awareness of the liturgy, in spite of his apparent wariness.

6 Ibid., p. 37.

In his work, as Patrick O'Brian specified, "aside from a few standard pieces from his childhood, such as *First Communion* and *The Old Woman Receiving the Holy Oils from the Hands of an Altar Boy*, or else several biblical scenes from his adolescence (particularly *The Flight into Egypt*), or a few vaguely hagiographic paintings, he produced practically nothing with a pronounced religious character prior to the drawings of the *Crucifixion* (1927), his strange *Calvary* (1930), and the 1932 drawing inspired by the Isenheim Altarpiece. Then once again there was silence until the silhouettes of Christ in the bull-fight engravings (1959), while so many other painters—atheists, agnostics, Jews, lukewarm Christians, or ardent Catholics—were producing religious works commissioned by the Church. Several art authorities saw no religious significance in *Calvary*; others accused him of blasphemy... Picasso's statement concerning the *Crucifixion* seems to me to be well-founded and quite moving—a fierce protest cry, and the expression of a most powerful emotion which does not over-step the broad boundaries of Catholicism."[7]

And what is one to make of the portrait *Young Nicolas Poussin* painted in 1971 in the image of an unacknowledged Christ crowned with a halo of celestial light, as if he saw his admiration for the painter as something sacred? It is true that this late work appeared at a moment when, for my grandfather, there was no escaping the idea of an imminent death. Is this flamboyant portrait a kind of discreet homage? Or a confession? In March 1973, he himself chose the work for the catalogue cover for the Palais des Papes exhibition in Avignon, which was to open the following May. He was never to see it.

My grandfather always remained cautious. Although he had lost his basic beliefs, he was unable to escape from the demands of form, or from its most superstitious expressions.

Pablo had also been the godfather of Max Jacob, his very first French friend. Jacob had been born into a Jewish family and wanted to convert. Pablo gave him one of his numerous names—"Cyprien," from the Spanish Cipriano— as his confirmation name.

The ceremony took place on February 18, 1915, and Pablo was overjoyed to be able to show off his knowledge of ecclesiastical protocol. His friend's unexpected conversion certainly didn't fail to interest Pablo, who was ever torn between the answers on this earth, and the promises of Heaven.

Pablo was only married once in a religious ceremony. But not according to Catholic ritual. This was to Olga Khokhlova, on July 12, 1918, at the Ortho-

7 Ibid., p. 36.

dox Church on rue Daru in Paris. Their son Paulo was born in 1921, and was baptized and raised as a Catholic. Claude and Paloma, Pablo's youngest children, are agnostic, as is their mother Françoise Gilot. Pablo never had any particular requirements as to his children's religion, and as usual just left things up to circumstances—and to their mothers. And finally, if he only married Jacqueline in a civil ceremony, it was because she had been divorced from a first husband and, in the eyes of the Church, was "lost."

For Pablo, communion with other human beings never happened through prayer; but through his work. It was up to the works to express humanity's ills; and to pass on a message of hope and peace. He held his creations in high esteem, which went beyond himself. Sooner or later every true creator sets a challenge: "Down with style! Does God have a style! He created the guitar; the harlequin; the basset hound; the cat; the owl and the dove. Like me. The elephant and the whale, right; but the elephant and the squirrel? A real bazaar! He created what didn't exist. So do I. He even did painting. So do I."[8]

He "deified" his work—in a secular fashion. Justice won out over morals; equality and liberty over the Judeo-Christian principles of our civilization. Pablo translated the indescribable, the appalling. He was the witness of a reality, and not of a celestial ideal. Like God, according to him.

From which stems the transcription of both beauty and horror in all things.

Even the famous *Doves of Peace,* which appeared in the hopeful postwar period as a wonderful allegory of an ideal world in which peace would regenerate humanity, are a weapon, a last bastion, a call to human beings to reason at the very moment when reason is disintegrating. They are not meant to lull the viewer to sleep, but rather to wake him up.

That is the weapon of a pacifist, the only weapon an artist can use.

This religion that he had received, then rejected, except for its superstitious elements, made him all the more suspicious since he had known the strictest form of Catholicism in his native Spain. But this religion, this Church, instead of providing a true aid, would suggest a whole series of quasi-pagan images based on immemorial beliefs. The most innocuous superstitions terrorized Pablo, according to what my mother has told me. A black cat crossing your path, opening an umbrella inside the house, putting a pair of scissors on the bed, or receiving a gift made of cloth ("that's for drying your tears ..."), he saw so many things as threats. Françoise Gilot also recalls his superstition about placing a loaf of bread upside down on the table.

8 Malraux 1976.

Among his fetish objects Patrick O'Brian assigns a special role to keys: "Keys, for Picasso, had a certain amount of vague importance. He carried a heavy key-ring and when the keys tore his pockets (because he'd never been lucky enough to find a wife who could sew), he would tie them to his belt with a piece of string."[9] "I love keys," he told Antonina Vallentin, "it's very important to have one. It is true that keys have often haunted me. In the series I did of bathers, there's always a door they're trying to open with a huge key."[10] Apparently, those who are outside and who wish to come in use a key, possibly the wrong one, in the same way that those who want to communicate with others use a language, sometimes poorly understood, or even incomprehensible. Isn't his art a kind of key?

Maya often told me that even if her mother, Marie-Thérèse, could sew very well, her father "never wanted anyone to touch his trousers. It was forbidden to clean them: he was so afraid that everything in his pockets would get lost—including his keys."

Pablo regularly sent his nail parings or his hair to Marie-Thérèse so that she could keep them and prevent them from falling into the hands of black magic or voodoo practitioners! In 1977, when her mother died, Maya discovered these relics affectionately wrapped in tissue paper.

Françoise Gilot confirmed Picasso's superstition: "The best thing was to take the hair clippings in little bags to a secret place to dispose of them safely. Pablo went around for months with his hair much too long, unable to go to a barber. If anyone made the least mention of it, a drama ensued."[11] This fear lasted till he found Eugenio Arias, a barber he could trust, and signed him on for life ... and the barber would get rid of the cut hair each time! Françoise Gilot also recounts the ceremonious departures from the house: "Each time we'd leave on a trip, however brief, we all had to gather in a room, and sit there silently for at least two minutes—then we could leave with a clear conscience. If, however, in the course of this ritual, one of the children (Claude or Paloma) started laughing or talking, we had to start all over. Otherwise Pablo refused to budge. He would laugh: 'Oh! I don't take this seriously, I know it doesn't really mean anything, but just the same ...'."[12]

Even more surprising were the séances Pablo would attend by himself. This is probably one of the least known aspects of my grandfather, which Adrien Maeght told me about: "In 1947, Marguerite Ben Houra, the wife of a well-known Algerian politician close to General de Gaulle, moved into Vallauris to help a talented young Berber artist named Baya to make ceramics.

9 O'Brian 1976, p. 350.
10 Vallentin 1957.
11 Gilot and Lake 1964.
12 Ibid.

Pablo, whom I addressed as Monsieur Picasso, was still living in Golfe-Juan (with Françoise, at the Fort family home). Marguerite was a friend of my mother's, and she organized séances during which she made saucers turn in circles! Pablo was both frightened and impressed by these séances, of which Marguerite gave detailed accounts. I was seventeen years old, I didn't yet have my driver's license, but I would drive the car—a Citroën Traction— and serve as chauffeur. That's how I got to spend several evenings with Picasso.... It was no longer the great Picasso nor the little Adrien Maeght— we were all just watching the saucer turn. Pablo was fascinated."

The ultimate superstition was his refusal to make out a last will and testament: "That attracts death," he would say to those unwary people who dared speak to him about it. To his lawyer, or to anyone who brought up the subject of his successors, he angrily ordered them to be silent.

This hatred of official "acts" revealed itself in another way. Pablo could never bring himself to sign a marriage contract, either with Olga or with Jacqueline: a marriage contract implied that following the marriage—a positive act *par excellence*—there could be a divorce. And so here, as elsewhere, it was best to leave things alone so as not to bring bad luck, or invoke a separation. Pablo's wonderful optimism! Not concluding a marriage contract was the same as hoping that everything would remain well.

It should be noted that this superstition would then nullify the obsession with material things of which my grandfather has been accused. By not signing a marriage settlement for the separation of properties, he was accepting the general settlement whereby only goods acquired since the marriage are deemed to be held in common. Thus, his fortune could be shared in case of separation. This did happen, by the way, and he never questioned it or tried to avoid it. In all this, Olga proved to be just as disinterested.

For *Guernica*, as I have said, Roland Dumas carefully avoided the word "testament." Pablo had warned him: "No will and testament. If it's like in Balzac, I'll be dead the next day!" In fact, Picasso hated all procedures and preferred to say: "Don't touch a thing! While you're here, alive, things last; successors are for when I'm dead, but I don't want to die!" According to Roland Dumas, Jacqueline followed Pablo's philosophy, and didn't want to hear anything about what would happen afterwards. "She shared that superstition. I think she loved him deeply, and she wanted to spare him the pain of growing old."

Pablo spent his final years living outside time—with no material worries. Aside from Catherine, Jacqueline's adolescent daughter, Pablo saw no other children, who could have served as a cruel reminder that each day carried him further away from his youth.

"Inheritance," explains Pierre Daix, "implies death, and what interested him was being alive.… To those who asked questions, his response was: 'I've made enough so that there'll be plenty for everybody!' When I went to see him regularly each month, he would always say: 'You see all this work—it's for my little family!' And it's true he had made hundreds of engravings, drawings and paintings.… It was obviously a joke, because he wasn't doing that for his children, but in order to express what he had to express."

Ernst Beyeler, the big Swiss art dealer and collector, told me he had also brought up the fate of all the works that Pablo had been keeping: "As he never mentioned death, nor talked about his successors or his testament, which, by the way, he didn't have, Picasso once told me: 'You're not the first person to tell me: "Oh! that's for the family," or "There's enough for the family." No, those are friends, they're family portraits,' but he didn't say they were for the family."

And above all, never speak of his death.

At the same time, Pablo stared death in the face. In the final months of his life he painted a series of self-portraits, the eyes of which expressed all the power that death inspired in him, like some terrible private battle. This staring death in the face is a very Spanish attitude—the positive side of machismo. Death is a reality that you must know how to confront, while still refusing to give in to it.

Pierre Daix is one of the people who spoke to me the most about my grandfather's relationship with death, surely because he had spoken with him at length in the late 1960s, for the preparation of his catalogues raisonnés.[13] He recalled a visit to Mougins in June 1972. Pablo stood him in front of the famous *Self-Portrait* in colored crayons. What you see is a human skull with two magnified, astonished eyes staring out, seeking life, in a final burst of pastel color: Daix had the impression that Picasso was staring his own death in the face. The *Self-Portrait* was placed on an armchair in his studio. When Daix returned in October, it was still there. Pablo had kept on working with, as his only company, this *Self-Portrait* in the form of a *memento mori*. Once again he stood Daix in front of the drawing: "It was truly then that I had the feeling that I was seeing him for the last time." Daix had found him somewhat "dulled," but suddenly Pablo snapped out of it in order to discuss the subject of the day, which was the Cubism of 1913 and the various cut and paste problems necessary to the work of the historian.

In fact, my grandfather was fleeing death. He wanted to understand it, without drawing its attention. From which stemmed the almost childlike superstition that made him exhaust the subject in every way possible.

13 Daix and Boudaille 1967; Daix and Rosselet 1979.

Photographer Luc Fournol recalls that a mutual friend went to see Pablo. He found him looking at the heads of dead goats that were rotting away on a railing. "I think he was very interested in death." Even more striking is what I was told by Francis Roux, the owner of La Colombe d'Or in Saint-Paul-de Vence. After World War II, his father had been a friend of so many artists and intellectuals, and at his place you could run into Braque, Miró, Chagall, or Sartre. "There was an artistic atmosphere which my father maintained, and that's how they met. Picasso had come by chance." In 1953, when his father died, Francis set the casket in an alcove, towards the front of the bar, by the door to the restaurant: "I was alone next to the casket, and the only other person I saw there was Picasso. He stood ten feet away, still, silent, for twenty minutes or so, staring at his dead friend's casket."

It was an homage; but it was surely an analysis as well. As if Pablo wanted to feel, to experience death.

It has been persistently rumored that my grandfather never went to funerals, for fear of death. And yet there are many funerals he attended in the most spontaneous way. He went to his father Don José's funeral in Barcelona, and for that occasion made a portrait of his father using cuttings from the May 3, 1913, edition of the newspaper *Excelsior*—the date of Don José's death. He cut out the letters SIOR from *monsieur*, proving that he wasn't afraid of paying posthumous homage. There was also the painful ordeal of the burial of Éva, his fleeting love, who passed away in 1915. Then his friend Guillaume Apollinaire died of the Spanish flu in 1918. He was unable to attend his mother's funeral in 1939 as General Franco had come to power, and the siege of Barcelona was taking place. And one shouldn't forget the funeral vigils for his Communist comrades Jean-Richard Bloch in 1947, or Paul Éluard in 1952. And in 1958 he made a formal homage at the death of the Party's historic leader Marcel Cachin. He had said to his friend, photographer André Villiers, on the subject of death: "I think about it from morning till night—it is the mistress that never leaves you!" This fatalism also comes across in his statement to Malraux: "There comes a time in life, after you've worked very hard, when forms appear all by themselves, paintings appear all by themselves—you don't even have to think about it. Everything comes naturally, all by itself. Death as well."[14]

Weren't bullfights the most immediate representation of the struggle against death? Weren't they his first sources of inspiration when he drew as a child? Aren't they still the most epic representations of his own battle? He was fascinated by bullfights, for they symbolized the supernatural power of death:

14 Malraux 1976.

man dominates the bull, which is an instrument of death. Man kills death. Of course it all depends on the talent with which the matador sizes up his adversary, charms him, deceives him, then conquers him. Couldn't it be the same thing with death?

The motor of Pablo's existence was his creative power and drive. His hidden reserves of energy kept fatigue at bay, and masked any feeling of aging, or of having said enough already. As a tiny child, he demanded crayons and pencils by shouting: "Piz, piz" (from the Spanish word *lapiz*, for crayon)—even before he was able to say "Mama!" Even on the morning of his death, he asked his secretary for paper and pencils. Art is life; and that means expressing yourself, fighting against time, and never wasting time. Then expressing yourself even more.

Concerning this ongoing game, in which he observed death without actually speaking about it, Heinz Berggruen told me an amusing anecdote. Pablo had become friends with a certain Lionel Prejger, the owner of an aluminum factory in Vallauris since 1943, and a true handy-man. Pablo was interested in this metal business for the material it could supply him for his sculptures, particularly for his folded sheet metal, and other metallic constructions. Prejger also specialized in hearses, for his own pleasure. My grandfather loved this unexpected, quixotic side. "If you wanted to give him a treat," Berggruen explained," you had to come up with something unusual, or give him something like a 1870 horse-drawn hearse, and he'd be overjoyed!" No one knows if Pablo ever actually dared climb into a hearse, but just being around such an object was a daunting experience—and a symbolic victory over death.

Lionel Prejger became Pablo's close friend and their collaboration transformed the businessman's life, for he then became Pablo's executor. Pablo wanted to make a toy for his grandson Bernard—and thus in 1960, the horse on wheels came into existence, made up of conical tubes produced by one of Prejger's factories (for televisions, tables and chairs of the period). Prior to this there had already been the celebrated Picasso sheet metal sculptures, produced by the famous Mr. Tiola in his Vallauris studio, which Lionel Prejger subsequently bought. While the work was going on, Prejger would visit my grandfather daily in Mougins to let him know how his sculptures were coming along. Pablo had previously supplied him with cardboard or folded paper models to go by. Pablo was so enthusiastic about these visits! Even though he was in his eighties.

Pablo never tried to imagine the future. He dwelt in the present. Inasmuch as this present inspired either joy or sorrow, he would accordingly throw one emotion or the other onto the canvas. Pierre Daix told me how this fatal-

istic side had surprised him so much, from the very first time they met at the end of World War II: "I was struck by how pedagogical he was with me. He 'taught' me. There were paintings he had done before, of things like a coffee pot, or a skull, and all the still lifes produced during the war. But what struck me most about my first meeting with him in late 1945, at Éluard's initiative, was the fact that we both shared the same anxiety. I was not an optimistic person. Pablo viewed the coming times with apprehension. For him, *The Grave* (*Le Charnier*) was the expression of what he feared. Later there was the "Art and Resistance" exhibition, including *Homage to the Spanish Who Died for France*—which was a sarcastic homage.[15] In fact, there was a sort of communion between us; we were on the same wavelength—as opposed to the Communist Party members who didn't appreciate these dark works." A few months later, Pablo would recover *La Joie de Vivre*.

Wasting time made him sick. Although death was waiting there at the end of the line, illness, or rather the fear of illness, had long been a daily obsession. That panic dated back to his childhood, and to the death of Conchita. In the Spain of yesteryear, fatal contagious illnesses were the common lot. Epidemics brought family mourning. Death was present on a daily basis. Fernande Olivier, his companion at the turn of the century, deplored the fact that Pablo got so gloomy when he saw her sick and bed-ridden. Hadn't they immediately fled the idyllic little village of Gosol in Spain because the innkeeper's daughter had come down with typhoid fever? Terrified of an eventual epidemic, which could possibly spread throughout the entire Iberian Peninsula, Pablo insisted on returning to Paris that very same day.

According to Pierre Daix, each time he had any little ailment, it took on Dantesque proportions! "One day he burned his eye slightly. He'd been working on some copper in the sun, and his cornea was slightly damaged. For the next ten days, life was infernal for Jacqueline, and for everyone else. For him, anything concerning his eyes became very dramatic. But he was very rarely sick. He couldn't even stand the fact that my wife had a headache. He said to me one day: 'You see—she's younger than you and she's got a headache!' Absolutely unexplainable!"

Aside from his gall bladder operation towards the end of his life, he never really had any health problems. On that occasion, he was operated on at the American Hospital in Neuilly, under a false name so as not to be "recog-

15 "Art and Resistance," exhibition, Feb. 15–March 15, 1946, at the Musée National d'Art moderne de la Ville de Paris, under the auspices of FTP (Francs-Tireurs et Partisans). The Picasso works exhibited there were *The Grave* and *Homage to the Spanish Who Died for France*.

nized" by journalists. Ever since Françoise Gilot's book had come out in France in 1965, he had been the prey of the paparazzi, and of rumors—so often unfounded—both of which he always detested. His art itself was an affirmation, not a rumor.

According to Roland Dumas, Pablo had once again become conscious of his appearance ever since his marriage to Jacqueline in 1961. He took great pride in being "impeccable," especially with regard to his physical condition. With such an attitude, a stay in the hospital was like a visit to death's waiting room, or to its very doorstep.

In spite of his advanced age and the inexorable feeling of getting older, Pablo was always very lively. He kept everything under control. When Ernst Beyeler came to talk to him about an exhibition project of "ninety works for his ninety years," my grandfather told him as he was leaving: "We'll put a hundred sculptures together for my one hundred years." They had both evoked the time that was passing: "We spoke of Max Pellequer, whom I'd known. I'd been able to buy the Picasso works that he'd owned. Pellequer was Picasso's banker and adviser, and Picasso said of him: 'You know, we're both getting old (he and Pablo)—if we discuss tax or financial questions, I have to shout like a madman, so all the neighbors must be getting an earful of all the figures and details!'" Beyeler added: "When Picasso felt depressed, about age and all that, he kept it to himself." And changed the subject, as usual.

My grandfather, who was never ill, was a chronic hypochondriac. From the natural anxieties of his youthful years, to the obsessions of old age, he had forged a disciplined lifestyle for himself, based on a dietary asceticism, the virtues of which he preached incessantly to others—don't eat too much, don't drink, but he probably overdid it with cigarettes, though miraculously it didn't affect him, until the very end of his life.

In the fall of 1972, Pablo was coughing regularly and managed to catch a bad cold, which turned into bronchitis. An artificial respirator had to be kept near him. The mobile contraption followed him everywhere. He even had to interrupt his work for several weeks, before he started to feel better around Christmas time.

His final spring was soon approaching.

On April 8, 1973, his body left him. He immediately swung from life into immortality. And in so doing, he had finally managed to conquer death.

Eternity

*"I paint as others would write
their autobiographies ...
the future will select the pages it
prefers."*[1]

Pablo Picasso

Ah, the Faust myth! To become immortal! To be able to prolong life in order to know ever more, to perpetuate happiness. Why should one be contingent upon time, on the ephemerons?

Picasso conquered the ephemerons. He entered eternity as a living being.

My grandfather lived for almost ninety-two years. Pablo is dead, Picasso is eternal. "Le roi est mort, vive le roi." He is beyond time. Almost three decades after his death, there isn't the shadow of a doubt that his name and his work will survive for centuries to come. He who had fought against time in order to prolong his art to the utmost finished by melting into the collective memory of humanity and, in so doing, his own mortal being managed to survive.

In the very last years of his life, he confided to his friend Hélène Parmelin: "I feel like I'm getting somewhere ... I've only just begun."[2] He just had to have more time—to finish one more painting, then go on to another, and another. His world was his canvas.

And he went on to rejoin it. Today he exists in that work to which his fame has granted immortality. He owes that fame, above all, to his work, and to his constant probings—as if he had been entrusted with a mission of

1 From Gilot and Lake 1964.
2 Parmelin 1994.

refusing the order of the world, the static and inflexible, ordinary arrangement of things. What order? For Picasso, there is no such thing as order. He must impose his own language in order to rewrite the world. Some will see a mystical aspect in this quest: the absolute necessity of revealing a new reality. He has a bit of the messiah in him. "What you need is to attain the natural.... Painting must be so intelligent that it becomes the same thing as life."[3]

The daring spirit of this work fascinated his contemporaries, and those who came later, and will fascinate future generations.

I use the word "work" because Pablo Picasso never spoke of his art as an entertainment or a diversion. For him, it was only work.

When the Succession began after my grandfather's death, we discovered the whole submerged quantity of this work. Once all his houses had been explored and inventoried, a true treasure trove was revealed to the entire world: thousands of works from all his various periods, classified in that superior form of order that we commonly refer to as chaos, or disorder. These "treasure caves" depicted a genius to the world.

The difference with an ordinary individual dreaming about immortality is that Pablo Picasso never dreamt of becoming famous. Of course, according to family legend, as a little boy he was supposedly impressed by the return from Italy to Málaga of one of his father's close friends, a painter by the name of Antonio Munoz. It took place on the very same day as the visit of King Alfonso XII to Málaga. The whole city was draped with flags, and the joyous crowds stood waiting excitedly for the king to pass. Antonio showed up just as the procession of royal carriages carrying important officials was going past. Pablo thought they were celebrating the return of the painter, and was convinced that a painter could thus attain glory!

Si non è vero... No, my grandfather never sought fame. Above all else, he needed to fulfill himself. And this irrepressible need made him accept poverty, or, even worse, sumptuousness and ostentatiousness. And this is a lesson for me, and for us all: we are only what we do. To act is to become what we truly are.

When he rejected the destiny that his father had planned for him in Barcelona—to become an art teacher and talented portraitist—little did he think that the "art market," as we know it today, would make a celebrity of him. At the turn of the century, the art market didn't exist—especially in Spain. In the Iberian art world of those years, 1880 to 1900, the various academies or patrons of the arts would award any artists of merit with hon-

3 Ibid.

orary tokens of recognition. Outside the official institutions there was no salvation. Few artists dared deviate from the system, and none of them really dreamed about making a fortune. They were indebted to several salons and a handful of patrons.

The Impressionists were the precursors of a new art form, a new economy, and, quite obviously, a new form of notoriety. Courbet, Manet, and Renoir became the new references. Art dealer Paul Durand-Ruel was their mentor, with his vast network of art collectors and critics. Fortune and fame went hand in hand. By the end of the nineteenth century, the big galleries were dictating their terms. By the twentieth century, artists were to be kings.

Picasso, or rather Pablo Ruiz y Picasso, could feel that the world was changing.

The turn of the century was effervescent with excitement—people felt that something wonderful was about to happen. And it was as an adventurer that Pablo left for Paris, the city of promise, and began the life of a poor artist, whose only treasure was his rather vague sense of hope. In that Paris of 1900, the great Exposition Universelle sparked the interest of both the public and the artists. Great currents were flowing, and Picasso wanted to get into the swim of things as soon as he could.

One has to plunge into the spirit of the times in order to understand them. Trying to judge a particular moment at the turn of the last century with today's way of thinking is a mistake that quickly leads to erroneous conclusions about the facts and the participants. Pre-World War I Europe was still entrenched in the repressive traditions of the nineteenth century. France was probably the most reform-minded and the most advanced. The Spain that Pablo came from was monarchist, Catholic, and severely strict. He had been raised in a highly patriarchal family environment. He lived surrounded by women—his mother, sisters, and aunts—but his father made the decisions and laid down the law. Women were celebrated but submissive, and men enjoyed the divine right of kings. In that rigid social universe, the old caste system still thrived.

My grandfather had his first success following an uncompromising series of steps, which forged his reputation in artistic circles. But he wasn't known outside the small group of initiates, painters, and dealers. Then came the drastic changes of a century marked by technical progress, which included the press, radio, and television. The society of spectacle was born. Up to 1945, Pablo could stroll the streets and enjoy a drink on the terrace of the Café de Flore, in St Germain-des-Prés, without being recognized. Following the liberation, such insouciance was a thing of the past: he had become

Picasso. Of course, so many people had been aware of his name and his work, as far away as the United States, since the early 1930s. But who knew his face? As my grandmother often said, she had never even heard of Cubism in 1927. She came from that middle-class category of trades people for whom modern art is just not a suitable topic of conversation: "Nice girls don't read the newspapers." Pablo could in no way be accused of abusing his celebrity in his younger years (he was already 65 in 1945!), nor of being in full control of his situation. He hadn't experienced the planetary glory of a twenty-year-old rock star as so many do fleetingly today. That very maturity even enabled my grandfather to combine personality and sudden media renown. He created a "precedent": only movie stars become the object of such fascination, thanks to the efforts of the production studios. Picasso had no press agent. Nothing was programmed. But he instinctively knew how to charm the media. To paraphrase one of his statements, he "found" material for self-promotion where other, more experienced artists had only "sought" it. He opened the way for the great specialists of media exposure, such as Dalí, Warhol, César, and so many others.

Just how aware of his own fame was he? And when exactly did he become aware of it? I've mentioned the visit that a number of American soldiers paid him at the liberation of Paris. He was, at the time, with my grandmother Marie-Thérèse and their daughter Maya, at home on the Île Saint-Louis. As soon as the barricades had been crossed and the snipers all arrested or killed, American GIs were running all over Paris with a list of famous monuments—including a visit to Picasso. While still a soldier, Marlon Brando is said to have come by; and Ernest Hemingway, not finding him at the rue des Grands-Augustins studio, left him a box of hand grenades as a souvenir!

My mother has a wonderful photo of a GI's helmet placed on a chair in front of the famous portrait of her in a red apron.[4] The soldiers all insisted on having a souvenir of their meeting with Picasso.

It was at that critical time that Pablo rose to the special status among world celebrities so cherished and highlighted by the media. He had always been able to maintain the privacy of his world, with all its joys and sorrows—but now he could no longer remain incognito.

Pablo's life contained all the ingredients that make for popular success: love, children, glory, wealth, originality, and in place of beauty in the strictest sense of the term, an undeniable charm and charisma. On top of that, he had a superhuman quality: the power to create, to inspire, to

4 See photo in center of book.

trouble, to release emotions, and, at the same time, to transform any object into gold. He knew both the value and the price of emotion.

Although Picasso was able to recognize his "magical" power (as in the aforementioned anecdote of the 500 franc bill), he in no way abused it. Even if a piece of his work was simply four lines drawn in a few seconds, it shouldn't be seen as a source of income, but as a mission. Otherwise, we wouldn't have found nearly half of all his works in his homes. He had to realize himself and to accomplish his mission, even if that meant going faster than time would allow, to say more and more, even just for a few more seconds.... Until time finally caught up with him.

As I pointed out earlier, Picasso refused to speak of "periods" or of evolution in his work. Everything was integrated into a continuity, a language. He didn't lock anything up in pre-established categories—even to the point of shocking: "Cubism? Never heard of it! African art? Never heard of it."

Just as surprising was the care he always took to put certain works aside throughout his whole life—which would then comprise the treasures of the Succession and, in part, that of the Picasso Museum in Paris. He only released the others, most parsimoniously, in order to make a living, support a family and continue to work—and skillfully to maintain his celebrity status and his popularity. He knew, and he would let that be known.

Before attaining fame, Pablo had first acquired a certain notoriety in the art world, which wasn't yet called a "market." In this world, Picasso was to become the rising asset, then the ultimate reference, and finally the refuge. He created his dealers just has he had created himself. He was as dreaded as he was appreciated by his original dealers, whether it be Vollard, Kahnweiler, Rosenberg, or Wildenstein. Having become an absolute master, he had the power to make the career, the reputation, and the fortune of Berggruen, or of Beyeler, without even mentioning their successors. Notoriety had become reputation.

How does one become famous? First, by having a familiar name that can be easily retained by the media, then by the public. Then, by shocking. And finally, by polishing up your image. Picasso was appealing! He led his life just as he wanted to. He was an example. He was the multicolored alternative to a world of gray certitudes. He was politically active, and as a revolutionary—but he didn't destroy anything, except for commonplace ideas and social conventions.

Who would imagine such energy and mischievousness in this already mature man seen playing on the beach with his family in the period just after the war? Without actually realizing it, my grandfather was a great "communicator." He was instinctive, and knew how to play with the

photographers, and how to give them just what they were looking for: something spectacular. For Robert Doisneau, he lined up some bread rolls so that they looked like fingers; for André Villers, he pulled out a revolver and a cowboy hat; for Robert Capa a parasol; and for Edward Quinn, a matador's hat and cape to which he added a red nose. And he always seemed to be wearing his signature sailor jersey. Communicating, he taught us, is doing the essential, with accessories. What fleeting magic; and what eternity!

He wasn't fond of his own voice, and dreaded making a mistake in French. Pierre Daix told me of his anxieties: "Towards the end of his life, when I was with him and journalists were pursuing him, my biggest problem was telling them: 'Don't put a microphone in front of him; it'll cause trouble!' He never wanted to be recorded. One day Jacqueline's daughter Cathy had a little belt-driven portable tape recorder. It was one of the first portables ever made, and it had broken down. I wanted to try and fix it, but Pablo told me: 'Go ahead and fix it if you like, but I don't want to see that thing around here!'"

My grandfather had suffered too much from things he had been purported to have said, and from words that had been misunderstood. Daix added: "He adored jokes, and playing tricks. But they were always blown out of proportion and word would get around. Then there'd be trouble, and he hated stirring up trouble, either in political matters, or in his personal life. There was the problem of his accent, which is true, and in front of a microphone, he probably felt a certain inferiority."

He didn't like his voice, but he managed to make films without words, or almost. In one, with Paul Haesaerts in 1950, he painted on a transparent pane of glass, but no one really understood the mastery of his stroke. For a documentary with Luciano Emmer in 1953, Pablo moved about silently, but with a mischievous eye turned toward the camera, and drew the famous vault of the Temple of Peace in Vallauris. And especially, he composed a sculpture made up of random objects he had picked up that formed the elements of a puzzle to which he had the key. This was done on the floor of one of the big rooms at the Fournas studio—which I know so well, having played there as an adolescent before the property, which my mother inherited, was renovated. Then, when Henri-Georges Clouzot offered to shoot *Le Mystère Picasso* (*The Picasso Mystery*) in 1953, expecting to discover the artist's secrets, Pablo took hold of the camera in order to avoid revealing anything and, if possible, to increase the magic and the secrecy surrounding his talent. This would capture his genius once and for all. Clouzot's documentary won the special prize of the jury at the 1956 Cannes Film Festival, then the gold medal for best documentary at the Festival of Venice in 1959. I think that if my grandfather hadn't been so old at the time when television was

really coming into its own—in the 1970s—he would have "found a way" to make use of it ... not to mention the various means of virtual reality today.

In a sense, this talent as a great communicator consisted in not communicating. Towards the end of his life, when he began to consider the passing years as a sort of countdown, he would refuse visits. He was the one who decided, but Jacqueline was the one held responsible for that isolation. He maintained the prestige, while she suffered the resentment. And yet, everyone I spoke to assured me that she was innocent—except perhaps for the fact that she carried out her husband's orders too perfectly. She was the soldier of a general who was permanently in a crisis conference. She had decided to take the initiative in preventing any unpleasant incidents. Jacqueline possessed the flaws of her own qualities: she wasn't the mother of any of Pablo's four children, and wasn't competing with any of his companions. She didn't have to be accountable to anyone, except to her husband. And, whatever authority she may have had over him, Pablo's decisions were veritable orders. He wanted peace and quiet, and she guaranteed it.

Would he have achieved the same glory and the same posterity in these more media-oriented times? I don't believe so. Owing to his mystery, and to all the legends both true and false that he maintained, often unwillingly, he was a star. Once again, I think that all came naturally, and with no "marketing" strategy, for neither the word nor the thing it designates existed in his lifetime.

Nevertheless, he couldn't discount the fact that his work benefited from his notoriety, and what's more, from his popularity. Certainly it was the art professionals—the collectors and the gallery owners—who had picked him out, praised him, and backed him, but he most naturally connected with the public. Just as he had declared himself a man of the people and in sympathy with the people, he was a public figure, and close to the public. And with the support of the public, he was able to escape from the "professionals of the profession," which is a rare event for an artist. He had almost managed to escape from the price quotations, as each new sale took on record proportions.

My mother recalls hearing him say: "Whether they say good things or bad about it doesn't matter; just as long as they talk about it!" Of course he was talking about his work, and nothing else. The rest was to be kept in the family, including politics.

From celebrity to scandal is only one short step and, under the guise of nonchalance and prospecting, my grandfather prepared and served up juicy little items for the scandal-mongers. On the one hand, it amused him. On the other, he knew that it helped to maintain the myth. By an almost physical

necessity, he had created *Les Demoiselles d'Avignon*. Despite the sarcasm, including that of his friends, he had persevered in his own artistic direction, and he had won. He was both the inventor of modern art, and its main destroyer. His one big scandal was to have shaken up hearts and minds.

The countdown of time forced him into other scandalous and necessary explorations. His aversion to revelations about his private life is well known. He had no patience for scandal at his own expense. I see this as Picasso's own special limit, for here the life of the man and that of the artist were always inextricably linked. By separating the man from the artist, you can usually admire the artist and denigrate the man. "Picasso, creator and destroyer": this is a biographer's fabrication, which doesn't quite work. In him, there was no dissociation between the life of the artist and the life of the man. Could he have possibly created the sublime portraits of Olga, or of Marie-Thérèse without experiencing their sweetness and composure in the flesh? Could he have contrasted them without having lived through the wrath of the wife, and the refuge of the muse? Don't both the French Riviera and Françoise represent the dazzling reality of *La Joie de Vivre*? Could he have grasped the reality of childhood if he'd been deprived of the joy of being the father of Paulo, Maya, Claude, or Paloma?

He painfully experienced the slings against his right to privacy. Born in a time of family secrets, when there were no scandal newspapers, he always thought that everything should be settled within the family, or the clan, whose solidarity he esteemed so much. What's more, he worked at taking care of his family, and providing for them materially, of course, but also he sought to give intelligently, and with discretion. And that's a far cry from manipulation, or control.

On the other hand, could he have forbidden others from having their own memories of him, or from speaking about him, considering the importance he had assumed in their lives and the things they had mutually shared? In my opinion, it all depends on the timelessness of the relationships, be they only material.

The memoirs of Fernande Olivier, his companion at the Bateau-Lavoir at the turn of the century, infuriated him and he vainly sought to have them suppressed.[5] Looking through the book, you can understand why it didn't appeal to readers. On the other hand, it provides interesting details on a critical period of Picasso's life. Oddly enough, it was Olga who found it the most appealing. It should be mentioned that excerpts of the book had been previously published in the daily newspaper *Le Soir*, which gave quite a public character to the most commonplace revelations: at the time, they obviously

5 Olivier 1964.

didn't have the historical interest that we find in them today. Pablo and Olga had been married since 1918 and, even though the couple's relationship had ineluctably broken down, particularly in 1933, Olga had made a point of honor of preserving the reputation of her marriage in polite society.

Fernande's account of Pablo's bohemian lifestyle wasn't respectable, in spite of the fact that it concerned a bygone period that she hadn't known or shared with Pablo. If Fernande had rubbed elbows with the turn-of-the century artists, it was because they were a gathering of boon companions. She had never truly understood their aspirations, nor their talent. These memoirs were then harmless, but useful.

But for my grandfather, it was unacceptable on the grounds of principle —despite the fact that Fernande was free, and had not been dependent on him for a long time.

The publication of Françoise Gilot's book, *Life with Picasso*, provoked the same fury. Françoise was his companion from 1943 to 1953 and is the mother of Claude and Paloma. In 1964, she recounted her long relationship with Pablo. I believe she had the right to do it. She was no longer living with him, and had refused any form of alimony from him. My grandfather, who was already nearly eighty-four years old, persisted in wanting to have the book banned by the French courts, although it had already been out for several months in the United States. Having been harassed by Olga thirty years earlier, he felt obliged to react in the same manner on account of Jacqueline this time. Roland Dumas confirmed that he had absolutely advised him against any legal action. In his opinion, that could only give the book all the more publicity. And he was right. Pablo, particularly prompted by his wife, insisted. They had even drawn up a manifesto, signed by their friends, which had no effect: "There's no point in exalting the painter if you destroy the man." Even the Communist Party lent its voice to oppose the book (out of friendship for Pablo many denounced the book, while admitting that they hadn't read it).

On March 22, 1965, Pablo's suit against Françoise was dismissed. In early April he lost the lawsuit against the publisher. Then he lost his appeal.

In my opinion, this book had actually become something forbidden, like a taboo. I hadn't read it until recently and I'd been expecting to discover some horrible revelations. I went through it cautiously, but attentively, and came to the conclusion that there had been much ado about nothing, and that Pablo, by over-reacting as he had, had triggered an over-blown controversy. It is also true that the work is particularly well documented, which makes any objections quite difficult. Perhaps my feeling as a reader comes from my generation, or from our period in time. But I saw nothing more than a love story, with all its ups and downs, and tenderness, and disputes.

Dumas was right. Only one point really caught my attention. In fact, the book had originally been written in English, with the collaboration of Carlton Lake, journalist and art specialist. It had first come out in the States in 1964, then in France in 1965. One passage of the French edition was the basis for the dispute, in that it revealed Picasso to be extremely violent—the one and only testimony of this sort in all the writing that was ever devoted to him: "He [Pablo] took the cigarette he was smoking and stuck it into my right cheek [Françoise's]. It was terribly painful, but I was determined not to give him the satisfaction of seeing me scream. After what seemed to me a very long moment, he pulled it away. 'No,' he said, 'it's not a good idea. After all, I may still feel like looking at you.'"

I was astounded by such a cruel act! So astounded, in fact, that I referred back to the American version.

And what did the original text say? "He took the cigarette he was smoking and touched it to my right cheek and held it there. He must have expected me to pull away, but I was determined not to give him the satisfaction. After what seemed a long time, he took it away. 'No,' he said, 'that's not a good idea. After all, I may still want to look at you.'"

The scene took place in late summer of 1946 during a heated argument concerning the possibility of Françoise coming to live in Paris with Pablo, which she was still refusing to do.

The use of the word "touched" is unclear—and it was probably chosen for that reason. It could mean "pointed at," or "touched with the unlit end," but it does not mean "stuck into," or "pushed into." Then: "he must have expected me to pull away" was replaced by "it was terribly painful," which is obviously not the same thing at all! Furthermore, of all the people I've met who knew Françoise during that period, no one ever remembers having seen the least scar or blemish on her cheek.

And yet, Françoise had never called the French text into question.

The trial for libel took place, and Pablo lost. In the judges' opinion, Pablo's memories were also those of Françoise's, and if one person wanted to stifle them, the other had the right to speak of them freely. She stuck pretty much to what was already known, even if only by a chosen few.

The book appealed to an audience of unimaginable proportions for the times. Either in spite of himself, or because of his reaction to it, Pablo got his dreaded scandal. Unfortunately, their children Claude and Paloma suffered the consequences in their relationship with their father. Much ado about nothing. Rather, much pain about nothing.

Towards the end of his life, my grandfather had a hard time with his celebrity. From 1954 on, because of the Cold War and the overexposure of

his political involvement with the communists, he gave fewer interviews. He restricted himself to his professional activities and to his art—drawing and painting—and to donating works.

His retreat coincided with the dawn of his new life with Jacqueline—and this new lifestyle continued to grow. From 1965 on, he hardly went out: he was growing old, and in particular, ever since the scandal caused by Françoise's book, he had become the prey of photographers. Any sneak photo of Picasso was a godsend for all the world's editors-in-chief. The village of Mougins was from then on his official address. Often hanging around in front of the villa Notre-Dame-de-Vie (purchased several years earlier) were gawking tourists and journalists or just visitors, occasionally friends, who were always turned away. "The master is very old, very old, and he is working...."

It's quite evident from the photos taken towards the end of his life that he had physically declined. His mind was impeccably intact, but he had gotten thin, and his face was deeply lined, with a huge liver spot on his left cheek. In the numerous photos of Lucien Clergue, you could see that he was no longer the same man, and that in gatherings he was more of an onlooker than a participant.

There were moments of nostalgia, such as listening to Manitas de Plata, the Spanish gypsy guitarist, who had come to see him in 1968. Then silence once again. He seemed almost absent: was he bored, or was he thinking, or was he simply observing the enthusiasm and youthfulness about him, poignant reminders of his present condition?

When you think of my grandfather, in general, I suppose you remember especially the joyous man on the beach at Golfe-Juan, wearing a bathing suit and sailor shirt, in the very prime of his life (as the standard expression goes), the valiant father of Claude and Paloma. Those wonderful, sun-filled photos from the 1950s established the Picasso legend: Françoise and the children, the older children Paulo and Maya at the restaurant Tétou in Golfe-Juan, *Le Mystère Picasso* by Clouzot, the Cannes Film Festival with Pablo wearing a derby hat, while the market value of his works was already stratospheric. Then the communist years, international celebrity, and the historic photos by Doisneau, Duncan, Villers, Quinn, or Clergue, with Jacqueline and her daughter Cathy on the beach as ever. And there was Pablo, in full sunlight, as ever. Always so visible.

In his later years Pablo would wear glasses, but he never wore sun glasses. Ever since childhood, his eyes had become accustomed to looking straight into the sun. Did his talent for striking colors stem from that? In a certain sense he was a rival of the sun.

Ten years after that stormy period, life had gotten quieter. Pablo was no longer as available as before, for he was no longer so physically fit. Being importuned tired him out. Boring him was a way of killing him. He had everything organized. He had given his orders. They just needed to be carried out.

The image that Picasso projected was dangerous in spite of himself: his fame and fortune were a fatal attraction. Getting close to him was a way of cashing in on some of the celebrity; but not being able to detach oneself from him was the best way to destroy one's own ambition. For that meant doubting your own abilities, while reproaching him for creating obstacles. It meant both loving and hating him. Being the relative or the friend of a famous man (especially one who is wealthy) is a real challenge for both parties. And it is even more difficult if you add to that the incomprehensible, untouchable power of creation. Pablo had already given enormously of both his time and his money. He had always proved himself to be available and dependable—and always spontaneously. He had the look of a god, who can create all, and can change everything, but that was an illusion. Life is the result of adjustments, between human beings and things. And Picasso accelerated the particles.

In the final decade of his life, his mind was focused on the essential— which was his work. He was entirely free from material constraints, and what he requested of those around him was an extra degree of stimulation. The friends of his final years, such as Hélène Parmelin, her husband painter Édouard Pignon, the journalist Georges Tabaraud, or Zette and Michel Leiris, kept the fires of controversial conversation alive, which so wonderfully stimulated Pablo's mind. The only reservation one could have was that they all shared the same opinions, or at least pretended to, for they had long before understood that Pablo didn't appreciate sterile conversations on boring subjects. Boredom meant death. With them, Pablo could engage in some true intellectual jousting. Roland Dumas was the Parisian correspondent, the official tattler of the homage and tributes in which Pablo no longer participated, but which still interested him greatly. As family representative there was Paulo, with the lovely Christine and their son Bernard. For the administration and the handling of problems, Paulo was in Paris, attorney Antébi in Cannes, and Miguel, the faithful secretary, at the house. And for the regency, there was Jacqueline. She was the constant connection for everything, and for everyone. Pablo was protecting himself, and did not want to see a living soul. At times like that he spoke only to his canvas. He barely said a word to Jacqueline or to any of the others.

August 1972. Pablito, Paulo's eldest son, regretting the fact that he couldn't see our grandfather as often as he wanted to, showed up one day unan-

nounced and rang the doorbell at the gate, but was not allowed in. He was in his twenties, and Pablo was nearly ninety. He climbed over the daunting barbed wire fence and got into the garden. This set off the alarm, and aroused Mr. Barra, the caretaker, Mariano Miguel, the secretary, and the guard dogs. Consternation reigned. Inside the house, Ms. Studer, the governess, was puzzled. No one had ever seen the young man before.

Although Pablito showed them his identity card, he was led to the door in strict military fashion. Miguel had been given orders by Jacqueline.

Pablo was then informed of it all. What disturbed him the most was that someone had been able to break into the property. Furthermore, the incident had caused a bit of scandal in the neighborhood ... and he despised scandal. From that moment on, the villa was to become impregnable. Pablito was merely an example—what really worried those around Pablo was the possibility that other much less well-intending visitors could follow his lead. Picasso's fame, and presumed wealth, made him the perfect prey—and an easy one, at that.

Pablo and Jacqueline reprimanded Paulo, which strained the already tense relationship between Paulo and Pablito. As Marina later recounted: "Jacqueline always made my parents [Émilienne and Paulo, divorced since 1953] responsible, even though they weren't responsible parents."[6] Lawyer Antébi, for his part, thought that Pablito's irrational initiative, which had caused a sensation in the village, seriously worried the authorities who feared some new incident on the dreaded day of the painter's death. This fear contributed to the "scheduled delayed" announcement of his passing away, at the request of the district attorney of Grasse.

When he was ninety years old, my grandfather found himself alone, illustrious, isolated by his age, and a sort of voluntary prisoner of his talent, which always demanded him to achieve more and more. He was also a prisoner of time, which was passing too quickly.

When he passed away, a tidal wave of media interest swept over the entire world. The press unanimously honored the extraordinary biography of the artist with special editions, and unmasked the man. Due to the new reform, the proceedings that recognized the filiation of Maya, Claude, and Paloma had only just started and coincided dramatically with the death of their father. Everything was in the public eye.

Losing "the painter of the twentieth century" led the whole world to pay homage. Even Spanish television, under General Franco, announced, albeit

6 McKnight 1987.

briefly, the death of the "brilliant Spanish painter, Pablo Ruiz Picasso," Pravda limited itself to an eighteen-word dispatch from the Tass news agency, on the inside pages, mentioning the death of the "world-famous Spanish painter." Only Soviet television stated he was a communist. Rumors started to circulate, even of the most sordid nature, but the legend of Pablo Picasso had already protected him from them. In today's world, where the celebrated "fifteen minutes" of media fame predicted by Andy Warhol has become a reality, where appearing is more important than doing, an advertising specialist might say: "Picasso's done a good job in pulling off his publicity stunt."

Except "a stunt" does not last. In Picasso's case, it is a life's work.

THE NAME

A few months ago, a journalist from a well-known daily newspaper asked me about the name Picasso. It was while France's parliament was reforming the law on surnames. From that time onward, a child could bear the surname of his father or mother, or both, in one order or another, even for those children up to thirteen years of age born before the law was passed. It is a logical piece of legislation keeping within the spirit of equality between men and women. To tell the truth, France was curiously an exception, since this type of issue had, for a long time, ceased to be a problem in other European countries. Now, freedom prevails everywhere when choosing a surname. It is a notable step forward for the psychology of the child, who no longer has the feeling that the mother's identity is 'swept away' with her family name. Since the 1972 reform on filiation, biological (so-called natural) children receive the name of the parent who acknowledges them first, the father or the mother (and this applies even if the father or mother were married to different partners at the time of conception or birth). Ironically, natural children benefited unexpectedly from the parents' choice, while the legitimate child could only, until today, bear the surname of the father. The phrase "born of adultery" was then suppressed and the term "father unknown" was no longer obligatory.

After 1972, it was no longer legally forbidden for a married father (or a married mother) to declare a child born out of wedlock. Moreover, with the 1972 reform, if a father, married or unmarried, does not acknowledge his child at birth, the child can try to prove who the father is using different means, including the help of recent advances in DNA testing.

Since the introduction of the French law in 2001, the same thing goes for the equality of the rights of children, natural or legitimate, regarding inheritance. Before, a natural child received half the share of a legitimate child.

The Succession Picasso has embodied this distinction between natural and legitimate children. What is more, a natural child even received half the share of an adopted child from their deceased common parent! What a to-do!

There was therefore scope for reform. Lawyers supported this necessary reform, and several of them confirmed to me, during the settling of numerous successions, that legitimate sons and daughters had asked to receive the same share as their natural half-brothers or sisters, since they were all the children of the deceased parent. This ghastly "half" was finally done away with. When introducing members of the Picasso family, should I have to say "This is my half-uncle Claude and my half-aunt Paloma" or "my half-cousin Bernard and his half-sister Marina"?! Are they just half-people? Well, in these matters as in others, I don't have any half-sentiments.

My grandfather had taken the decision to choose the surname that he liked. Spanish tradition has it that a child's surname is composed partly of the father's family name and partly of the mother's. In this case, the spouses Don José Ruiz Blasco and Doña María Picasso López gave birth to Pablo Ruiz y Picasso, becoming Pablo Ruiz Picasso.

It is interesting to note that the double "s" in Picasso is an uncommon spelling in Spain.

The journalist who was interviewing me asked me why my grandfather had chosen his mother's name alone to sign his works. Was it because "Picasso" was much more original than "Ruiz," a very common Spanish surname? It is likely that this was the main reason, and indeed, the only name people retained was "Picasso." It sounded good. It was original. My grandfather found that "Ruiz" was not, phonetically speaking, very pleasing, but that "Picasso," with its double "s" was, he would say, "more exotic, more resonant." He said to Brassaï: "Haven't you noticed the double 's' elsewhere in the name of Matisse, Poussin, Douanier Rousseau?" His friend Sabartès had immediately called him "Picasso" since the first time they met in Spain. Didn't Gertrude Stein find this name catchy? Braque only addressed his friend as "Picasso," and not Pablo!

Despite the love that Pablo had for Doña María Picasso, I do not think it was an oedipal problem that led him to suppress his father's name. Pablo was always full of respect when he spoke of his father, and has reproduced his "appearance" many a time on numerous canvases, whenever he needed to represent a man, a real one. He had also written to his mother to ensure that his choice to use her name alone, Picasso, would not be misinterpreted by his father, and to ask her to reassure his genitor of his respect and affection for him.[7]

7 The notoriety act established by Cannes notary Monsieur Darmon on May 3, 1937, includes Pablo's various official names: somtimes Ruiz y Picasso, often Ruiz-Picasso, and more frequently Picasso.

On a legal level, he did not give it the slightest consideration. There was the law and there was his life. His official papers had "Pablo Ruiz Picasso" written on them, but from the beginning of his career, he signed his works "Picasso." He signed himself with the name "Pablo Picasso" on his pass to get into the Exposition Universelle in Paris in 1937, where *Guernica* was unveiled. That was his choice. Later on, Paloma was known everywhere as Paloma Picasso, likewise my cousin Marina Picasso.

My case is atypical. During my school years, I used only my father's family name, Widmaier (which comes from the *département* of Territoire-de-Belfort, close to the Alsace), but from 1973 onwards and from the start of the Succession, I stood out and was labeled "Picasso's grandson" in my secondary school. This gave me a double identity, which I incorporated without any difficulty. The 1985 French law regarding which surname one uses allowed me to make my belonging to my mother's and father's pasts official, by becoming Olivier Widmaier Ruiz Picasso. Sometimes I prefer to use Widmaier, while other times, and more often, Picasso. The unfortunate name Ruiz, and I say that with affection, has disappeared because the use of other names predominates. In our family, I know how often my uncle Claude or my cousin Bernard, for example, use the "Ruiz" in their name. Everyone has got their own way of adjusting it, which is another success of this spirit of freedom that helped Pablo triumph.

The most atypical case is that of Émilienne, Marina's mother. Divorced from Paulo since 1953, she asked, twenty-three years later, to replace the name Ruiz Picasso (her ex-husband's name) with her maiden name, Lotte— she found herself with this patronymic name after the divorce, and wanted to give it up again. There was, after all, another Madame Paul Ruiz Picasso, through marriage: Christine, the widow of Paulo, a position that was not easily reconcilable.

However, before the arrival and evolution of the recent law, many people were astonished by this feminine ascendance in our family. Pablo used his mother's name, I also use that of my mother; Gaël and Flore, Marina's children, have only their mother's name. It is a type of liberty that has probably given each of us a sense of balance, even if it is not just a name that determines the individual. But it does contribute to it. The name Picasso made so famous by Pablo is always immediately recognized. A "Picasso" is never anonymous. Personality is something else altogether.

Faced with the force of such a name, along with the advantages come the responsibilities. And respecting them. Being the heir, in the broadest sense of the word, of Pablo Picasso means having rights as well as obligations. I feel entrusted with a duty to preserve the memory of my grandfather and the truth, even if it means protesting against the abuses, the contradic-

tions, and the lies. You really have to be vigilant, and keep an eye on what you say.

A name can be a heavy burden to carry. The person who had the worst experience of this was my cousin Pablo Picasso, whom we had to start calling "Pablito" very quickly. Naming Pablo Picasso after Pablo Picasso was an homage to the grandfather, as is the tradition in numerous families, but also a crushing weight to carry. The young man, who was never able to live with it, couldn't bear, among other things, the obligation of surviving his grandfather.

A final episode was added to this subject. At the beginning of 2003, France's Prime Minister, Jean-Pierre Raffarin, decided, on the proposal of the Minister of Justice at our behest, that our name Widmaier Ruiz Picasso would become the definitive family name of my brother Richard, my sister Diana, and myself. From now on, it's our responsibility to live with it and use all of it or part of it, without any question.

A name is not everything, it is a means of identification. I am Pablo Picasso's grandson, I am one of Pablo Picasso's grandchildren. I share this ancestry without any difficulty. It is a genetic fact. I could call myself Mr. Thingy and still have the legitimacy to talk about my grandfather. Defining my identity in relation to Pablo Picasso, as I said earlier, compels me to observe a rigor in the face of historical reality. I am not going to rewrite his story on the pretence that I would have preferred a more pleasant or more comfortable scenario.

A last word on this subject. Generally, after the period of mourning, the ancestor's place gradually fades and disappears. The handing down has been done. In the case of Picasso, it carries on. Whatever the efforts and merits of each one of us, Pablo's presence and image continue to make a mark on our destiny. We cannot escape from it. The eternity of this artist means that each new generation faces the same dilemma. Living with Picasso, living next to Picasso, living without Picasso.

Maya is one of the most competent experts in the world on the works of her father Pablo, so much so that it is difficult for an auction house or a gallery to refrain from asking for her opinion, as a genuine guarantee, if ever there is one, of the origin of a work. She does this as though it were a mission and is also dedicated to carrying out considerable research. She is the eldest and has complementary and irreplaceable memories and personal archives. She was born in 1935 and has been, in everyone's opinion, the person who has spent the most time with Pablo. She enjoys the privilege of age. She goes about her work, as an expert, with no venality whatsoever. She staunchly maintains her reputation of being the "incorruptible Maya," in

spite of the incredible financial propositions that she is sometimes offered to sway her opinion, or even to extort her consent on works of dubious origin.

Inspired by her determination, my sister Diana, a lawyer by vocation and an art historian out of passion, decided to create a reference work on Picasso's sculpture, an inventory comprising photos, cross-references, and analyses on everything that could be included under this heading, such as his collages, sheet metal sculptures, installations, and our grandfather's three-dimensional work. This vast enterprise took several years to complete, and required the support and collaboration of our family, giving us another opportunity for reunions.[8]

My cousin Bernard, who came into his inheritance early following his father, Paulo's, death, is now an art book publisher and dynamically manages his inheritance, a part of which, by way of loans and gifts, contributed to the opening of a Picasso Museum in Málaga in October 2003. This was the fruit of a collaboration between the Christine, Bernard, and Paul Picasso Foundation and the Picasso Foundation Museum of the Andalusian Region (Junta). Installed in a renovated seventeenth-century palace linked to several old buildings in the area where Pablo lived as a child, the museum is an exceptional place. For its inauguration, Bernard asked all of our family to loan him key works that complimented his own and those of his mother. It was a lovely family reunion for Picasso's return to his place of birth—only Marina declined the invitation. The king and queen of Spain, Juan Carlos and Sofia, came to open the museum—Pablo's childhood dream had come true!

Evidently, everyone has thus found their own sense of balance, and given a meaning to their destiny. They have succeeded in combining Picasso with their own lives.

Marina speaks of serenity. She has lived in Switzerland for over twenty years and, as I mentioned earlier, has published two books. At the end of the second one, she maintains: "Through the prism of my father [Paulo], he [Pablo] was contemptuous and miserly. Through the prism of my mother [Émilienne], he was insensitive and perverse.... Everything was his fault...."[9] It would have been better, to my mind, to have started with this and to have avoided writing, or rewriting, the rest.

8 As a prelude to the undertaking of this new reference work, Diana created a first retrospective exhibition of "The Sculptures of Picasso" with the American gallery owner Larry Gagosian, presented at the Gagosian Gallery in New York, in fall 2003. Some very important works, taken from diverse collections, had not been exhibited for several decades.

9 Marina Picasso and Valletin 2001.

Thirty years ago, there was only the copyright law to protect artists and give them exclusive rights to their work, whether written, musical, or graphic. France, a pioneer in this field, had given the artist a lot of security, passing laws in 1957 and 1985. French copyright organizations (such as SACEM for music, ADAGP, or the late SPADEM for the fine arts) took charge of representing artists, looking after their rights, and collecting their royalties.

If you wish to reproduce an artist's work, you have to get permission beforehand. And so a whole system is in place and most artists are usefully represented by these organizations.

In the case of emblematic artists, a new, unexpected aspect of their personality has taken on great importance: their name. The name of Picasso has become a brand, particularly since the 1980s. It is only the natural extension, to modern-day consumer products, of what was and moreover remains the signature of an artist at the bottom of a painting, whether it is genuine or fake: Rembrandt, Renoir, Van Gogh, Miró, Dalí, or, indeed, Picasso. This confirms, verifies, authenticates, authorizes, and stands up for itself.

In the middle of the 1980s, the power of a name was exemplified by a certain Kiki Picasso. I informed my mother of my astonishment, not so much at the "funny" pseudonym, but more by the way in which he was capitalizing on the name. Kiki Picasso, whose real name is Christian Chapiron, was one of the first graffiti artists, a graphic designer who used colored spray paint to highlight printed photos. His pseudonym created confusion on the Parisian scene and many thought he was a relative of Pablo.

A feeling of amused indifference prevailed in our family. Kiki became an illustrator for jingles and TV show themes. He reproduced on video what he had done with the photos, this time making use of early computer graphics. His notoriety grew the more he was seen, to such an extent that one evening, at the Palace (a famous Parisian discothèque at the time), one of the barmen informed me that my cousin was there. I therefore went off to look for Bernard, my only cousin who was of age, and instead came across Kiki. I invited him to a beer, clinked glasses, but did not say anything, sure that his joking about would soon come to an end.

However, this appealing artist with the damaging pseudonym actually started to include himself as a descendent of Pablo Picasso in a way that was unacceptable. Besides the occasional appearance of his work in the press, he had just edited a biography, packed with fanciful suggestions.[10] In it, he reproduced works that he covered in graffiti, or redepicted photos that had already been published. One of these was a portrait of Paloma's marriage in

10 Kiki Picasso, *Les Chefs-d'œuvre de Kiki Picasso*, Paris: Éditions le Dernier Terrain Vague, 1981.

1978, given the new, crude title *The Mongoloid of the Family gets Married at Church*. He spoke of Jacqueline being "the old sow" and put a caption next to another work: "Although Pablo Picasso painted like a donkey's tail, he was still a good grandfather!"

His work otherwise showed some talent, though other users of computer graphics around the world eventually caught up with him, and his days as an artist were numbered. Was that why he went from originality to excess? Playing on a useless and dangerous confusion, he joked: "When his father [Pablo] went and drank, Kiki Picasso stayed on his own in the workshop. He amused himself by daubing Pablo's canvases. None of this was ever noticed and a good number of canvases touched up in this way were sold to wealthy collectors."

At the end of their patience, and after discussing it at great length since 1985, Paloma, Claude, and Bernard issued a writ in 1988 for usurpation of name and identity, and demanded that he cease using the name Picasso. They also asked for 1 franc (about 20 cents at that time) for damages. The tribunal granted their request on May 31, 1989. Kiki lost his pseudonym. His works did not last much longer either.

As I mentioned, "Picasso" has become a brand to be reckoned with. It was under the constraints of multiple fraudulent usage that my family was forced to patent the name and the signature "Picasso." This was never conditional, it was consequential. It is important to emphasize this.

Claude, the administrator of the Estate, was the one who noticed the extent of the disaster throughout the world. Traditional forgery specialists in the Far East, and also numerous European and American countries, were obtaining illegal patents. Along with this were the patents where the name closely resembled "Picasso," or which meant something in the local language: *picazo* in Japanese ("flash" on a camera), or *picaro* for a car manufacturer, for example. In total, there were more than seven hundred different Picasso brands in 1998. We therefore had to intensify the objection in order to recover the name and prevent any undesirable use of it, and also to protect, if the occasion should arise, the small number of official licensees. But I have already given the details of that battle.

If the celebrity of my grandfather's name has made a brand out of it, the arrival of the Internet has propelled it. The brand makes you buy, the domain name makes you click. About a thousand website addresses contain the name "Picasso." Some of these sites are by genuine admirers of Picasso, who want to show such and such an interesting painting scanned from a book, or merely to declare their passion. Legally, the reproduction is banned, but morally it is a question of leniency, and I know how much my

uncle Claude, in his capacity as administrator, knows how to tell the difference between aficionados, students, researchers, and the real swindlers. Other clever rascals have gone about it more simply: nearly fifty thousand sites over the world mention Pablo Picasso, and search engines list hundreds of them. It is such a godsend having that reference, where someone curiously surfing the Net clicks on it and then generates some business. It is in this way that an address "picasso-for-life" could lead you directly to an advert for a life insurance agency.

Besides these editorial "curiosities," the Picasso Administration has had to, and will continue to, retrieve, one by one, the Internet addresses that have hijacked the name. It has firmly intervened to have the legitimate www.picasso.fr, necessary for its own site, to give information to the public and specialists as well as for its relationship with its representatives. It is this unremitting crusade undertaken by the Picasso Administration that conjoins prevention and repression, so that the artworks of Pablo Picasso can live on, in tranquility.

Who could have imagined that the young Spanish emigrant would leave his name on twentieth-century art, before becoming a brand, then an actual form of media, by the next century?[11]

[11] It is this exceptional impact that is encountered again in a comedy entitled *Picasso at the Lapin Agile*, released in 2003: a journey through eternity bringing together Albert Einstein, Elvis Presley, and Pablo Picasso, played by such renowned actors as Steve Martin and Kevin Kline as well as Juliette Binoche. What a sight

"What a
Holy Devil!"[1]

As I close the story of my grandfather's life for the time being, I do wonder if the complexities of his life and work were really only the reflection of his complex personality. Was Picasso's life simply the fatalistic sum of chance happenings? As a spontaneous person, didn't he himself also push the wheel of fortune as it presented itself to him? There is one point that I haven't touched upon so far, and yet which forms an integral part of all the themes I've discussed, dominating Picasso's image, and that is manipulation.

What hasn't already been said about this charmer, manipulating and breaking hearts? Didn't Picasso also manipulate his art dealers? When all is said and done, might it be said that he manipulated the general public too? To adopt such a stance would be to belittle the reality I've just been reliving. Have people forgotten that he arrived penniless in Paris, and spent years living from hand to mouth? Several thankless years went by before the sky brightened. Had he been the enthusiastic lover of Fernande and Éva because he was a rich and famous painter? No. He had married Olga—so he thought —for life. Marie-Thérèse, my grandmother, didn't even know who Picasso was! Did he employ means other than his innate charm to win them over? Picasso's behavior begs a lot questions, but it was he who supplied many of the answers. Is it really fair to accuse him of having manipulated his

1 Pierre Cabanne 1974.

mistresses? The question is definitely worth a closer look. Picasso seems to have taken great care not to hurt anyone—which some people put down to deft maneuvering.

It *is* true that he concealed his fleeting and intermittent affair with Madeleine from Fernande, but that was before he and Fernande were officially living together as a couple. He fell in love with Éva only after breaking up with Fernande—nothing really happened before.

The marriage with Olga was kept artificially alive, partly thanks to Marie-Thérèse. But having a new woman in his life didn't make it any easier for him to leave the previous one. He also wanted to protect the interests of Paulo. What's more, my grandfather was trapped, as divorce didn't exist in Spain. He would always end up by doing the sensible thing and coming home. That's what Olga wanted, turning a blind eye to what had been going on for nearly eight years. And that was only half of it.

Passion won over reason. Pablo was always sincere about his feelings. As soon as the Spanish Republic instituted divorce, he asked for a separation from Olga, whatever the terms. She refused however. Reason triumphed, all the more so as divorce would then be definitively abrogated under Franco. Never having wished this double life to continue, Pablo found himself trapped once more. Was it because he wanted to collect another trophy that he allowed Dora into his life, or was it she who had forced her way in? Either way, Pablo couldn't get a divorce and, whether he liked it or not, Olga remained his wife on paper whilst Marie-Thérèse had just given birth. That was how it was. What a mess for a manipulator to deal with!

Was it then that Picasso had to come clean to Marie-Thérèse? In fact, she already knew he was married "forever" when they met in 1927. He gave her the official files for divorce as soon as it was legally possible, even though she had never asked him for a thing. "We were happy just as we were," she said. Marie-Thérèse found herself in the midst of a turbulent existence over which she had no real control. The situation was impossible until Olga left in 1935.

What's more, Marie-Thérèse's status had changed—she had become the mother of their daughter Maya and would remain so. Improbable ties on paper were replaced by blood ties. Between 1935 and 1941, however, a lot of events took place. Dora appeared, followed by the Spanish Civil War and then worldwide conflict. The relationship with Marie-Thérèse fizzled out. In a situation analogous to that of a divorced couple, their daughter Maya gradually became the sole reason for Picasso's visits.

It was Dora who was the most aware of the emotional tangle, and of what her fate would be—it was up to her to choose. I think that a distorted image

of what was going on inexorably took root. As each woman was replaced by another, a wife remained.

Above all, manipulation is the result of calculation, and of reason. The facts show that it was the heart—albeit the heart of an artist—that dictated Picasso's actions.

It would be wrong to think that my grandfather took exception to the almost unbelievable turn that events successively took. He had the material means and the strength of character to take it all on board. He was genuinely fond of all the women who crossed the path of his destiny. They stimulated and inspired his work. Besides, wasn't it there that they were portrayed in their most flattering light—Olga pensive, Marie-Thérèse languid, Dora in tears, Françoise intrepid and Jacqueline imperious? They were all silent and complementary.

What happened was out of Picasso's control—or so he maintained.

Even the money that was required to maintain this labyrinth of confused emotions—exacerbated all the more by the children's presence—wasn't a problem for him.

If my grandfather's inevitable unfaithfulness started out as a result of his artificially permanent marriage to Olga (which ended with her death in 1955), Picasso was no less considered a lying womanizer. The legend lingers on. In a sense, such times have always been referred to in the past tense, never in the present, because Picasso never sensationalized his personal life.

Unfortunately, his fate was inescapable. In one way, the fact that he continued to meet the needs of all those women can be seen as a form of loyalty. Committed to a life of wandering, never able to settle down properly, he was forced to remain financially faithful to each of them—with the exception of Françoise, who chose to regain her independence and win another's affections.

"Friendship is the gift that love offers," my grandfather used to say—and that had its highs and lows.

Whichever way you look at it, Picasso was an interesting individual and he was fortunate in that his companions were women devoid of ulterior motives. They had all fallen in love with him at one time or another. They were fascinated by him too. Who wouldn't have been? Jacqueline nevertheless managed to organize their relationship and sometimes demanded her husband's undivided attention. That was another stroke of luck.

However, in view of so many passionate affairs in the course of a love life that lasted half a century—Pablo became a father at sixty-eight, after all—it's easier to understand how the image of Picasso the manipulator might

have become embedded in people's minds. Nothing had been planned in advance however. He didn't manipulate people. He was ruled by his emotions and nothing else; sometimes conflicting and often complex as they were, his emotions were never conventional.

The only one who was able to analyze the situation objectively, in her book *Life with Picasso*, was Françoise. She knew the script and the characters of whom there were too many for her to hope that she might feature in the closing embrace. Pablo would not have stuck to his role. She left the set. She didn't like that film. She even bumped into Jacqueline, a promising beginner, on her way out.

By dint of trying to protect herself, Françoise ended up by muffling her step and lending an almost formal tone to their relationship. She acted partly out of decency, but it also reinforced the idea that Pablo liked teaching people a lesson. Typical of someone of his age. But the impression he gave was deceptive, because that particular young woman really affected Pablo and was able to have quite a special hold over him. If he had only meant it to be a game, his opponent got the better of him. It became impossible to work out who was manipulating whom. As for wanting to have a child, then two children, that seemed to provide a cure for their strife, and stood as a sign that the heart had triumphed over reason.

The difference in age stood in Jacqueline's favor. She arrived just as a number of people were leaving the stage. Whatever the extent of her love, and her "notorious" devotion to Pablo, the word "manipulation" cannot be applied to their relationship. They really lived together.

Why, in that case, was so much said about my grandfather wanting to dominate women? As far as the women were concerned, he knew what he was letting himself in for and he really wanted them—one by one and then, inevitably, all of them together. It was there on the canvases. He needed them. He told them so, and showed it in his drawings. There was a certain charm to it all. And affection too. It could even be termed romantic!

Nevertheless, it's clear that Pablo was a jealous and possessive man, even if he never admitted it. Besides, even if he was *the* companion for his amorous conquests, he was also the man of their dreams, which was a very flattering state of affairs. Only Françoise "threatened" his position, and this must have exacerbated the anger of a man who realized he could be replaced.

I understand this Latin temperament because I have inherited it and behave similarly in relationships myself. Isn't being a little bit jealous also a sign of affection, which the other person should appreciate?

As far as his treatment of art dealers is concerned, the audacity with which he controlled what happened to his work seems to me quite legitimate. Today, such behavior would simply be called sensible management.

My grandfather worked his fingers to the bone, forced into leading a daunting existence in order to give to others. Such reckless, generous abandon deserves consideration, and has a price to it. And if money was the yardstick, he made sure things were measured properly. If he is recognized as probably having initiated the modern art market and of having amassed quite a fortune in the process, he was also able to learn from his personal experience and share that lesson. Many remember this. Others will now be aware of the situation. As for his stinginess, there's nothing to be said!

Was Picasso able to escape fate? Or was he the master of his destiny? This question is ultimately beyond me. His fatalistic personality leads me to believe that he just let things happen. He followed his instinct. He must have caused sadness to those around him by not bothering to explain. He sinned by omission. There were, of course, mitigating circumstances.

His life can be seen as the most accomplished and extraordinary example of such a series of events. It stands as the nirvana of chance. My grandfather himself made a lot of declarations of this sort; he even went as far as not deciding what would happen to a work he had nevertheless carefully preserved. In a way, instead of searching blindly for something or somebody, he realized that it was better to give himself up to unexpected and felicitous encounters, to what is known as "serendipity." Think of the famous line "I don't seek, I find!" Wasn't this fatalism simply a form of hope?

Finally, Picasso can be described as being a man of several women and the father of four children—all of whom inspired him—but he remains our grandfather and, as such, a vast portion of our joyous collective memory.

Writing about Picasso is a seemingly endless task. Over the last few decades, extra details, anecdotes and revelations—most with their share of calculation and lies—have progressively fleshed out the picture. I got to the stage where I was dreaming about spending a few moments with my grandfather just to understand the inexplicable. I wanted to be able to talk to Pablo in the present if only to grasp a gesture, a reassuring word, even if Picasso himself remained an enigma; I wanted to go away again feeling satisfied having learnt nothing, but having dreamt. For the capacity to dream is what is most essential in life.

Like many artists, my grandfather took us into a parallel universe. He gave us his vision of the world through the material objects he explored and the intangible emotions that suddenly took form in his works. No matter

that the rest seems so difficult to understand and to accept. Picasso reveals us to ourselves. He instills in us the essence of who we are, both good and bad. Our emotions. Life itself.

Pablo is dead! Long live Picasso!

As my grandmother Marie-Thérèse put it, Pablo was a "holy devil," but he was also "a most wonderful terror"!

A most wonderful terror....

Appendices

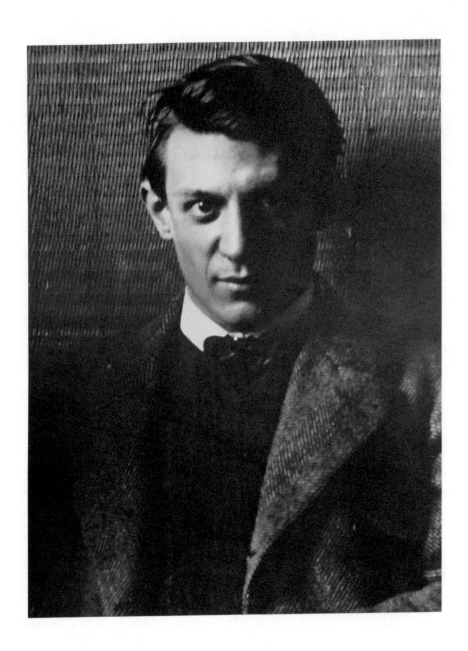

Chronology

1881 October 25: Birth of Pablo, son of José Ruiz Blasco and María Picasso López, in Málaga, Andalucia.

1884 Birth of his sister Lola.

1887 Birth of his sister Conchita (who was to die of diphtheria in 1895).

1891 The family moves to La Coruña, Galicia.

1896 The family moves to Barcelona permanently. Pablo enters the La Lonja Fine Arts Academy after successfully completing the entrance exam. He lives on his own in la Calle de la Plata.

1897 Pablo moves to Madrid on his own. He intermittently takes courses at the Academy of San Fernando, then returns to Barcelona.

1898 After suffering from scarlet fever, he convalesces for several months at Horta de Ebro, the home of his friend Manuel Pallarès, then returns to Barcelona.

1899 Meets Jaime Sabartès.

1900 Moves into a large studio in Barcelona with his friend Carles Casagemas. First exhibition at the café *El Quatre Gats*. In October, leaves for Paris along with Casagemas and Pallarès, for the Exposition Universelle. First meeting with Germaine. Meets a Catalan by the name of Manyac, who introduces him to art dealer Ambroise Vollard and gallery owner Berthe Weill, who buys three paintings from him. Returns to Barcelona at Christmas, then leaves for Madrid, where he contributes to the magazine *Arte Joven*, while Casagemas returns to Paris.

1901 Exhibition at the Vollard gallery. Meets critic, poet and writer Max Jacob. Casagemas commits suicide in Paris. Pablo returns to Paris. Beginning of the "Blue Period." Returns to Barcelona.

1902 Returns to Paris with painter Sebastia Junyer-Vidal, in materially difficult conditions.

1903 Returns to Barcelona.

1904 Moves to Montmartre, into a studio in the Bateau-Lavoir, at 13, rue Ravignan. Meets Fernande Olivier.

1905 Takes an active part in Parisian art life: frequently meets Guillaume Apollinaire, André Salmon, Juan Gris, Marie Laurencin, Léo Stein. Evenings at the cabaret Le Lapin Agile and in the restaurants of Montmartre. Journey to Holland in the summer.

1906 Brief stay with Fernande, at his family's home in Barcelona. Journey to Gosol with Fernande. Introduced to Matisse by Gertrude Stein. Begin-

ning of the representation of desire in his work. Discovery of tribal art and sculpture. *Portrait of Gertrude Stein* and first studies for *Les Demoiselles d'Avignon.*

1907 *Les Demoiselles d'Avignon*. Meets Daniel-Henry Kahnweiler. Cézanne retrospective at the Salon d'Automne.

1908–09 Work on geometric forms and discovery of works by Braque during the summer at L'Estaque. Art critic Louis Vauxcelles speaks of "cubes." Adoption of thirteen-year-old Raymonde. Fernande takes the girl back to the orphanage on rue Caulaincourt after only a few days.

1910 Moves to 11, boulevard de Clichy. Journey to Cadaqués, Spain, with Fernande.

Returns to Paris in September.

1912 Breaks up with Fernande. Meets Éva Gouel (real name: Marcelle Humbert). Moves to Montparnasse, rue Schoelcher. Journey to Céret with Éva. Death of Don José Ruiz Blasco, Pablo's father. Funeral takes place in Barcelona.

Summer in Avignon with Éva and friends. Declaration of war between France and Germany. Pablo, as a neutral Spaniard, remains in Paris.

Baptism of Max Jacob. Pablo is godfather. Meets Jean Cocteau and Eugenia Errazuriz. Is initiated into social life. December: Éva dies of cancer.

1916 Moves to Montrouge in October.

1917 January: brief stay with his family in Barcelona. Helps design stage sets and costumes for Jean Cocteau's ballet *Parade.*

Journey to Rome with Cocteau to join Serge de Diaghilev and his Ballets Russes, as well as Igor Stravinsky. Meets Olga Khokhlova, one of the dancers in the troop.

Visits to Naples and Pompei.

Return to Paris at the end of April.

On May 18 the curtain goes up at the Chatelet theater on *Parade*, which provokes a scandal.

Leaves in May for Madrid, and Barcelona, with the Ballets Russes.

Introduces Olga to his mother, Doña María.

Returns to Paris in November and moves into Montrouge with Olga.

1918 "Neoclassical" period.

Marries Olga on July 12. The witnesses are Guillaume Apollinaire, Jean Cocteau and Max Jacob.

Honeymoon in Biarritz, at the home of Eugenia Errazuriz, who introduces him to art dealer Paul Rosenberg.

November 9: Death of Apollinaire.

At the end of November, moves into 23, rue la Boétie, Paris. Has two floors: his studio is located just above the cozy apartment.

1919	Spends three months in London with Olga in order to work on Diaghilev's *Le Tricorne*.
	Vacations in St. Raphaël with Olga during the month of August.
	Exhibition at Paul Rosenberg's.
1921	Birth of Paul—known as Paulo, on February 4.
	First monograph.
	Pablo, Olga, and their son Paulo move to Fontainebleau in July.
1923	Tour of Cap-d'Antibes with Olga and Paulo, then of the Riviera. Olga is depicted as "pensive."
	Meets Sara Murphy.
1924	Friendly relationships with the Surrealists, who publish an homage to Picasso in *Paris-Journal*.
	The family stays in Juan-les-Pins in June.
	Purchases a car and hires a chauffeur.
1925	Leaves for Monte Carlo in the spring with Olga and Paulo for the season of the Ballets Russes.
	Moves to Juan-les-Pins during the summer.
	Takes part in the first Surrealist exhibition, in November.
1926	Exhibition at the Paul Rosenberg gallery during June and July.
	Meets Christian Zervos.
	Travels to Juan-les-Pins and to Antibes for the summer, then to Barcelona in October with Olga and Paulo.
1927	Meets Marie-Thérèse Walter in Paris on January 8.
1928	Summer vacation in Dinard with Olga and Paulo. Marie-Thérèse's presence is kept secret.
	Starts sculpting again, along with sculptor Julio González.
1929	A stay with the family in Dinard. Marie-Thérèse is secretly nearby.
	Meeting with Dalí.
1930	Purchases the Château de Boisgeloup in the Eure *département* of France in June.
	Stays in Juan-les-Pins with Olga, Paulo, and Marie-Thérèse during the summer.
	In the autumn, Marie-Thérèse moves into 40, rue la Boétie.
1931	Stays at Boisgeloup with Marie-Thérèse.
1932	Summer with the family at Boisgeloup.
	Departure of Olga and Paulo for a vacation in Juan-les-Pins in August.
	Retrospective exhibition at the Georges Petit gallery, Paris, where the untitled portraits of Marie-Thérèse are revealed.
	Publication of the first volume of the catalogue raisonné compiled by Christian Zervos, covering the period 1895 to 1906.
	Votes on the divorce law in Spain, which has become a Republic.

1933 Publication of the original French edition of Fernande Olivier's book *Picasso and His Friends*, which Pablo, at the behest of Olga, unsuccessfully tries to have banned.

Meets lawyer Henri Robert to discuss the possibility of a divorce.

1934 Pablo travels to Madrid, Toledo, and Saragossa with Olga and Paulo, during the summer.

Trip to Barcelona with Marie-Thérèse.

Announcement of Marie-Thérèse's pregnancy on December 25.

1935 Pablo requests a divorce from Olga.

Non-conciliation hearing in the spring.

Non-concilation judgment, June 29.

Olga, with Paulo, leaves 23, rue la Boétie and moves into the Hôtel California, rue de Berri.

Birth of Maya on September 5.

Beginning of Pablo's friendship with Paul Éluard.

1936 In March, Pablo leaves for Juan-les-Pins with Marie-Thérèse and their daughter, Maya.

Design of theater curtain for Romain Rolland's *14 juillet*.

In July, the Spanish Civil War breaks out.

In August, Pablo leaves to join Paul and Nusch Éluard in Mougins.

In Saint-Tropez, meets Dora Maar again, first introduced to Pablo the previous spring by Éluard, in Paris.

Discovery of Vallauris, a historic potters' village.

In the autumn, Pablo definitively leaves Boisgeloup, now the official residence of Olga—who never visits it.

With Marie-Thérèse and Maya, he settles in Tremblay-sur-Mauldre, in a house and studio lent him by Vollard.

1937 In January, Pablo moves into a new studio in Paris, at 7, rue des Grands-Augustins.

In February and March, regular visits to Trembly-sur-Mauldre. Creation of a series of portraits of Marie-Thérèse.

In April, the Spanish Republican government requests Pablo to create a mural for the Spanish Pavilion at the Exhibition Universelle in Paris in July.

From April 26 on, the Basque town of Guernica is under bombardment.

Creation of *Guernica*, from May 1 to June 4.

On July 12, inauguration of the Spanish Pavilion at the World Fair.

Request for an inquiry in the proceedings of the divorce from Olga.

1938 Trip with Dora Maar to Mougins during the summer.

Return to Paris at the end of September.

1939 In January, death of Doña María, Pablo's mother, in Barcelona.

Franco's troops enter Barcelona.

Large retrospective, including *Guernica*, first in the Museum of Modern Art, New York, then in ten other U. S. cities, at the initiative of Alfred Barr.

Death of Ambroise Vollard, in July.

Annulment of the divorce in Spain. Request for legal separation from Olga.

War is declared between France and Nazi Germany in September.

Pablo leaves for Royan, to join Marie-Thérèse and Maya. Dora accompanies him secretly.

1940 Legal separation from Olga awarded in February; she appeals against the judgment.

The Armistice is signed, ushering in the Vichy government.

Pablo travels between Paris and Royan.

In the autumn, he leaves the apartment on the rue la Boétie—while retaining possession of it—for the duration of the war. He moves into the studio and small flat on the rue des Grands-Augustins.

1941 *Desire Caught by the Tail*, a theatrical play published by Gallimard.

Marie-Thérèse and Maya return to Paris, where they live on the boulevard Henri-IV.

The Court of Appeals upholds the legal separation from Olga.

1943 Meets Françoise Gilot in May.

Olga's appeal is refused.

1944 The liberation of Paris.

Pablo joins the Communist Party.

He takes part in the Salon d'Automne.

1945 First lithographs with Fernand Mourlot.

1946 In March, Pablo travels to the Côte d'Azur and in Provence together with Françoise.

Takes up residence with Françoise in April.

Works exhibited at the Museum of Antibes, on loan from Jules Dor de La Souchère.

New retrospective at the Museum of Modern Art, New York.

Françoise's pregnancy is announced.

1947 Birth of Claude on May 15.

Moves to Golfe-Juan with Françoise and their son in June.

Beginning of intense period of activity in ceramics with Suzanne and Georges Ramié in Vallauris.

Winter on the Côte d'Azur.

1948 Move to the villa La Galloise, in Vallauris.

Creation of *The Dove of Peace*, as a poster for the Congress of Intellectuals for Peace, held in April in Paris.

Visits to Cracow and Auschwitz.

	Return to Vallauris in September.
	Françoise's second pregnancy is announced in October.
1949	Birth of Paloma on April 19.
	Purchase of the Fournas studios in Vallauris.
1950	Second Peace Conference, in England, in October.
	Pablo receives the Lenin Peace Prize, in November.
1951	Pablo leaves the apartment in the rue la Boétie in Paris, and buys two apartments in the rue Gay-Lussac.
1952	Creation of the work *War and Peace* in a disused fourteenth-century chapel near the marketplace in Vallauris.
1953	Cubism exhibition: 1907–1914 in the Musée d'Art moderne, Paris; *Les Demoiselles d'Avignon* is shown. Death of Stalin. Scandal within the Communist Party over a portrait of Stalin requested of Picasso and published in *Les Lettres françaises*.
	Françoise leaves for Paris with their two children. They settle in the rue Gay-Lussac.
1954	Retrospective in Rome and Milan.
	Meets Jacqueline Roque at the Madoura gallery in June.
1955	Death of Olga.
	Claude and Paloma made wards of Pablo.
	Retrospective in Paris at the Musée d'Arts décoratifs.
	Pablo buys the villa La Californie in Cannes, where he is joined by Jacqueline and Maya, followed by Claude and Paloma during their school holidays; filming of *Le Mystère Picasso*, directed by Henri-Georges Clouzot, in July and August.
1958	Pablo buys the château in Vauvenargues, Provence.
1959	Pablo petitions the Minister of Justice to give his name to his children Maya, Claude, and Paloma, with Paul's consent.
1961	Marriage to Jacqueline on March 2, in Vallauris.
	Pablo buys the country house Notre-Dame de Vie, in Mougins.
	Celebrates his eightieth birthday in Vallauris.
1962	Pablo receives his second Lenin Peace Prize.
1963	Opening of the Picasso Museum in Barcelona (artworks donated by Sabartès). Collaboration with the Crommelynck brothers, who set up their copperplate workshop in Mougins.
1964	Publication of the original French edition of Brassaï's book, *Conversations with Picasso*.
	Publication of Françoise Gilot's book *Life with Picasso*, in the U. S.
1965	Publication of the French edition of Françoise Gilot's book, *Vivre avec Picasso*; legal steps to have it banned fail.
	Retrospectives in Canada and Japan.

1966 Pablo celebrates his eighty-fifth birthday.

Retrospectives in Paris in the Grand Palais and the Petit Palais in November, at which numerous new sculptures are shown.

1967 Expulsion from the studio and apartment in the rue des Grands-Augustins, under the unoccupied dwellings law.

Pablo turns down the Légion d'Honneur.

1968 Death of Sabartès.

1970 Donation of works created during his childhood and youth to the Picasso Museum in Barcelona.

Exhibition of most recent works at the Palais des Papes in Avignon.

Bateau-Lavoir is destroyed in a fire.

1971 Pablo celebrates his ninetieth birthday.

Exhibition of eight canvases in the Grande Galérie at the Louvre, Paris.

1972 Reform of the paternity law in January, then promulgation in August.

Request for recognition of paternity of Maya, in December.

1973 Request for recognition of paternity of Claude and Paloma, in February.

Death of Pablo April 8 at Notre-Dame de Vie in Mougins.

Burial at the château in Vauvenargues.

Exhibition in the Palais des Papes, Avignon, in May.

Donation to the State of Pablo's personal collection of works by other artists: including Cézanne, Matisse, Rousseau, Balthus.

Opening of Probate.

1974 Definitive judicial decision officially recognizing Maya, Claude, and Paloma as the natural children of Pablo Picasso.

Nomination of a judicial administrator, Maître Pierre Zécri, and an expert, Maître Maurice Rheims. Beginning of the inventory.

1975 In June, death of Paulo, leaving three heirs: his wife Christine, their son Bernard (born in 1959), and Paulo's daughter Marina (born in 1950).

Opening of Probate for Paulo's estate.

1976 Inheritance agreements signed in March (followed, in December, by "preferential choices").

1977 Completion of inventory and simultaneous declaration of the legacies of Pablo and Paulo.

Suicide of Marie-Thérèse in October.

1978 Official deposition of the proposal for a *Dation* (a gift of artistic works made in lieu of inheritance tax, combining the legacies of Pablo and Paulo).

1979 Official presentation of the works in the *Dation* (exhibited in part at the Grand Palais in the autumn). The heirs begin the process of dividing their legacies.

1985 Opening of the Picasso Museum in Paris.

1986 Suicide of Jacqueline, in October.

Bibliography

Pierre ASSOULINE. *An Artful Life: A Biography of D. H. Kahnweiler, 1884–1979*. New York: Grove Press, 1990.

Nicole AVRIL. *Moi, Dora Maar*. Paris: Plon, 2002.

Brigitte BAER. "Seven Years of Printmaking: The Theatre and Its Limits." In *Late Picasso: Paintings, Drawings, Prints, 1953–1972*. Exhib. cat. London: The Tate Gallery, 1988.

Anne BALDASSARI. *Picasso photographe, 1901–1916*. Paris: RMN, 1994.

—. *Picasso and Photography: The Dark Mirror*. Paris and New York: Flammarion, 1997.

—. *Picasso: Papiers journaux*. Exhib. cat. Paris, Musée Picasso; Paris: Éditions Tallandier, 2003.

Alfred H. BARR, Jr. *Picasso: Forty Years of His Art*. Exhib. cat. New York: The Museum of Modern Art, 1939.

—. *Picasso: Fifty Years of His Art*. Exhib. cat. New York: The Museum of Modern Art, 1946.

—. *Matisse: His Art and His Public*. Exhib. cat. New York: The Museum of Modern Art, 1951.

Roland BARTHES. *Mythologies*. New York: Hill and Wang, 1997.

Heinz BERGGRUEN. *Highways and Byways*. London, 1998.

Marie-Laure BERNADAC and Michael ANDROULA. *Picasso: Propos sur l'art*. Paris: Gallimard, 1998.

— and Paule du BOUCHET. *Picasso: Master of the New Idea*. New York: Harry N. Abrams, 1993.

—. Laurence MARCEILLAC, Michèle RICHET, Hélène SECKEL. *The Picasso Museum, Paris: Paintings, Papiers collés, Picture Reliefs, Sculptures and Ceramics*. Paris, Picasso Museum; New York: Harry N. Abrams, 1986.

—. Isabelle MONOD-FONTAINE, and David SYLVESTER. *Le Dernier Picasso*. Exhib. cat. Paris: Centre Georges Pompidou, February 17–May 16, 1988; Paris: Gallimard, 2000.

— and Christine PIOT (Eds.). *Picasso: Collected Writings*. New York: Harry N. Abrams, 1986.

BRASSAÏ. *Conversations with Picasso*. Chicago: University of Chicago Press, 1999.

Pierre CABANNE. *Pablo Picasso: His Life and Times*. New York: Morrow, 1977.

Douglas COOPER. *Picasso Theatre*. New York: Harry N. Abrams, 1968.

—. *The Cubist Epoch*. Oxford: Phaidon, 1971.

Pierre DAIX. *Picasso*. Paris: Somogy, 1964.

—. "Picasso et l'art nègre." In *Art nègre et civilisation de l'universel*. Dakar-Abidjan: Les Nouvelles Éditions africaines, 1975.

—. *La Vie de peintre de Pablo Picasso*. Paris: Le Seuil, 1977.

—. *Picasso créateur*. Paris: Le Seuil, 1987.

—. *Picasso, la Provence et Jacqueline*. Arles: Actes Sud, 1991.

—. *Picasso: Life and Art*. New York: Harper and Row, 1993.

—. *Dictionnaire Picasso*. Paris: Robert Laffont, 1995.

—. *Tout mon temps: Mémoires*. Paris: Fayard, 2001.

— and Georges BOUDAILLE. *Picasso: The Blue and Rose Periods, A Catalogue Raisonné, 1900–1906*. London: Evelyn Adams & Mackay, 1967.

— and Joan ROSSELET. Picasso: The Cubist Years, 1907–1916—A Catalogue Raisonné of the Paintings and Related Works. London: Thames and Hudson, 1979.

Roland DUMAS. *Le Fil et la Pelote: Mémoires*. Paris: Plon, 1996.

Douglas D. DUNCAN. *Picasso's Picasssos: The Treasures of La Californie*. London: Macmillan, 1961.

—. *Picasso and Jacqueline*. New York: W. W. Norton & Company, 1988.

Paul ÉLUARD. *À Pablo Picasso*. Geneva: Trois Collines, 1944.

Michael C. FITZGERALD. *Making Modernism: Picasso and the Creation of the Market for the Twentieth Century*. Berkeley, Los Angeles, and London: University of California Press, 1995.

Edward FRY. *Cubism*. New York: Oxford University Press, 1978.

Pierre-Yves GAUTIER. *Propriété littéraire et artistique*. Paris: Presses Universitaires de France, 1991.

Henry GIDEL. *Picasso*. Paris: Flammarion, 2002.

Françoise GILOT and Carlton LAKE. *Life with Picasso*. New York: McGraw Hill Company, 1964.

—. *Vivre avec Picasso*. Paris: Calmann-Lévy. 1965.

Ernst H. GOMBRICH. *Picasso: Fifty Years of His Art*. New York: The Museum of Modern Art, 1946.

—. *The Story of Art*. London: Phaidon, 1950.

—. *Reflections on the History of Art: Views and Reviews*. Berkeley: University of California Press, 1987.

Gérard GOSSELIN and Jean-Pierre JOUFFROY (Eds.). *Picasso et la presse: Un peintre dans l'histoire*. Exhib. cat. Paris, Fête de l'Humanité; Paris: Cercle d'Art, 2000, with the following contributors and their essays:

— Raymond BACHOLLET. "Picasso à ses débuts."

— Pierre DAIX. "L'Art dans la presse."

— Gérard GOSSELIN. "Picasso: La Politique et la presse."

— Jean-Pierre JOUFFROY. "Un Fondateur de la deuxième renaissance."

— Georges TABARAUD. "Picasso et *Le Patriote*."

Max JACOB. *Souvenirs sur Picasso contés par Max Jacob*. Paris: Les Cahiers d'Art, 1927.

Jean-Pierre JOUFFROY and Edouard RUIZ. *Picasso, de l'image à la lettre*. Paris: Messidor, 1981.

Daniel-Henry KAHNWEILER. *My Galleries and Painters*. London: Thames & Hudson, 1971.

—. *L'Art dans la pub.* Exhib. cat. Paris: Musée de la publicité; Paris: Union centrale des arts décoratifs, 2000.

Geneviève LAPORTE. *Sunshine at Midnight: Memories of Picasso and Cocteau*. New York: Macmillan, 1975.

—. *Un Amour secret de Picasso.* Revised and expanded edition. Monaco: Éditions du Rocher, 1989.

Brigitte LÉAL. *Picasso et les enfants*. Paris: Flammarion, 1996.

Jean LEYMARIE. *Picasso: The Artist of the Century*. New York: Viking, 1962.

Marylin McCULLY. *El Quatre Gats: Art in Barcelona around 1900*. Exhib. cat. Princeton, NJ: The Art Gallery, 1978.

—. *A Picasso Anthology*. London: Art Council of Great Britain, 1981.

—. "Picasso und Casagemas: Eine Frage von Leben und Tod." In *Der junge Picasso*, exhib. cat. Bern: Kunstmuseum Bern, 1984.

Gerald McKNIGHT. *Bitter Legacy: Picasso's Disputed Millions*. London: Bantam Press, 1987.

André MALRAUX. *Picasso's Mask*. London: Macdonald and Jane's 1976.

Fernand MOURLOT. *Picasso: Lithographs*. Boston, MA: Boston Book and Art, 1970.

Steven A. NASH and Robert ROSENBLUM (Eds.). *Picasso and the War Years 1937–1945*. London: Thames & Hudson, 1999, with the following contributors and their essays:

— Michael C. FITZGERALD. "Reports From the Home Fronts, Some Skirmishes Over Picasso's Reputation."

— Robert ROSENBLUM. "Picasso's Disasters of War: The Art of Blasphemy."

— Steven A. NASH. "Picasso, War and Art" and "Chronology."

— Gertje R. UTLEY. "From Guernica to the Charnel House: The Political Radicalisation of the Artist."

Patrick O'BRIAN. *Pablo Ruiz Picasso: A Biography*. London: Collins, 1976.

Fernande OLIVIER. *Picasso and His Friends*. London: Heinemann, 1964, revised edition: 1996.

—. *Souvenirs intimes, écrits pour Picasso*. Ed. Gilbert Krill. Paris: Calmann-Lévy, 1988.

—. *Loving Picasso: The Private Journal of Fernande Olivier*. New York: Harry N. Abrams, 2001.

Josep PALAU I FABRE. *Picasso: The Early Years, 1881–1907*. New York: Rizzoli, 1981.

—. *Academic and Anti-academic (1895–1900)*. Exhib. cat. New York: Yoshii Gallery, 1996.

Hélène PARMELIN. *Picasso sur la place*. Paris: Julliard, 1959.

—. *Picasso says...* London: Allen & Unwin, 1969.

—. *Voyage en Picasso*. Paris: Christian Bourgeois, 1994.

Roland PENROSE. *Picasso: His Life and Work*. London: Gollancz, 1958.

—. *Picasso at Work: An Intimate Photographic Study by Edward Quinn*. London: W. H. Allen, 1965.

—. *Picasso*. Paris: Flammarion, 1982.

Picasso and Braque: A Symposium. Organized by William Rubin, chaired by Kirk Varnedoe, and edited by Lynn Zelevansky. New York: The Museum of Modern Art, 1992.

Les Picasso de Dora Maar, Estate of Mme Markovitch. Auction cat. Paris, 1998.

Picasso: Documents iconographiques. Ed. Pierre Cailler, with a preface by Jaime Sabartès. Geneva: Pierre Cailler, 1954.

Picasso œuvres des musées de Leningrad et de Moscou. With an introduction by Vercors and a conversation between Daniel-Henry Kahnweiler and Hélène Parmelin. Paris: Le Cercle d'Art, 1955.

Picasso et le portrait. Ed. William Rubin. Exhib. cat. Paris, Grand Palais; Paris: Flammarion-RMN, 1996, with the following contributors and their essays:

— Brigitte LÉAL. "Per Dora Maar tan rebufon/Les portraits de Dora Maar."

— Michael C. FITZGERALD. "L'Art, la politique et la famille durant les années d'après-guerre avec Françoise Gilot," and "Le Néoclassicisme et les portraits d'Olga Khokhlova."

— William RUBIN. "Réflexions sur Picasso et le portrait."

Diana Widmaier PICASSO. "La Rencontre de Picasso et Marie-Thérèse: Réflexions sur un revirement historiographique." In *Picasso et le femmes*. Ed. Ingrid Mössinger. Exhib. cat. Chemnitz: Kunstsammlungen Chemnitz, 2002.

—. "Marie-Thérèse Walter et Pablo Picasso: New Elements on a secret love." In *Pablo Picasso and Marie-Thérèse: Between Classicism and Surrealism.* Exhib. cat. Münster: Graphik Museum Picasso, 2004, pp. 27–36.

Marina PICASSO. *Les Enfants du bout du monde.* Paris: Ramsay, 1995.

— and Louis VALLENTIN. *Picasso: My Grandfather.* Trans. Catherine Temerson. London: Chatto & Windus, 2001.

Georges RAMIÉ. *Céramique de Picasso.* Paris: le Cercle d'Art, 1974.

—. *Picasso's Ceramics.* New York: Viking Press, 1976.

John RICHARDSON. *Picasso: Watercolours and Gouaches.* London: Barrie and Rockliff, 1964.

— and Marylin McCULLY. *The Life of Picasso.* Vol. I: *1881–1906,* vol. II *1907–1917.* London: Pimlico, 1992 and 1996.

William RUBIN. *Picasso in the Collection of the Museum of Modern Art.* Exhib. cat. New York: The Museum of Modern Art, 1972.

—. *Pablo Picasso: A Retrospective.* Exhib. cat. New York, The Museum of Modern Art; Munich and New York: Prestel, 1980.

—. "Picasso." In *Primitivism in 20th Century Art: Affinity of the Tribal and the Modern.* New York, The Museum of Modern Art; Munich and New York: Prestel, 1984.

—. "La Genèse des Demoiselles d'Avignon." In *Les Demoiselles d'Avignon.* Vol. II. Exhib. cat. Paris, Musée Picasso; Paris: RMN, 1988.

—. *Picasso and Portraiture: Representation and Transformation.* New York: The Museum of Modern Art, 1996.

Lydie SALVAYRE. *Et que les mangent le bœuf mort.* Paris: Verticales, 2002.

Hélène SECKEL. *Max Jacob et Picasso.* Paris: RMN, 1994.

Jules DOR de la SOUCHÈRE. *Picasso à Antibes.* Paris: Fernand Hazan, 1960.

Werner SPIES. *Pablo Picasso: Eine Ausstellung zum 100. Geburtstag—Werke aus der Sammlung Marina Picasso.* Exhib. cat. Munich, Haus der Kunst; Munich and New York: Prestel, 1981.

—. *Pablo Picasso on the Path to Sculpture. The Paris and Dinard Sketchbooks of 1928 from the Marina Picasso Collection.* Munich and New York: Prestel, 1995.

—. *Picasso's World of Children.* Munich and New York: Prestel: 1996

— and Christine Piot. *Picasso: The Sculptures.* Ostfildern-Ruit: Hatje Cantz, 1984.

— and Dupuis-Labbé. *Picasso sculpteur.* Exhib. cat. Paris: Centre Georges Pompidou, 2000.

Arianna STASSINOPOULOS-HUFFINGTON. *Picasso: Creator and Destroyer.* New York: Simon and Schuster, 1988.

Georges TABARAUD. *Mes annés Picasso.* Paris: Plon, 2002.

Antonina VALLENTIN. *Picasso.* Paris: Albin Michel, 1957.

Berthe WEILL. *Pan! Dans l'œil, Ou trente ans dans les coulisses de la peinture contemporaine 1900–1930.* Paris: Librairie Lipschutz, 1933.

Christian ZERVOS. *Catalogue général illustré de l'œuvre de Picasso.* 33 vols. Paris: Cahiers d'Art, 1932–75.

—. *Dessins de Picasso, 1892–1948.* Paris: Cahiers d'Art, 1949.

ARTICLES FROM JOURNALS AND NEWSPAPERS

Joseph ALSOP. "The Art of Collecting Art." *The New York Review of Books* (December 2, 1982).

Pablo PICASSO. "Lettre sur l'Art." *Ogoniok,* no. 20, Moscow (May 16, 1926), from the Russian by C. Motchoulsky, in *Formes,* no. 2 (February 1930).

"Picasso at Auschwitz." *Art News* (September 1993).

Interview with Georges SADOUL, *Regards* 187 (July 29, 1937).

John RICHARDSON. "Picasso's Apocalyptic Whorehouse." *The New York Review of Books* (1987).

Efstratios TÉRIADE. "En causant avec Picasso." *L'Intransigeant* (June 15, 1932).

Christian ZERVOS. *Les Cahiers d'Art,* no. 10, Paris (1932–75) (Éditions Cahiers d'Art).

RADIO, MULTIMEDIA, AND VIDEO

Interview by Pierre Cabanne with Marie-Thérèse Walter, in *Présence des Arts,* France-Inter, April 13, 1974.

Picasso, un homme, une œuvre, une légende, CD-Rom, interactive co-production Welcome-Grolier, by Olivier Widmaier Picasso (appointed producer), Anne-Sophie Tournier (executive producer), and Claude Picasso (editorial adviser), 1996.

Treize journées dans la vie de Pablo Picasso, film by Pierre Daix, Pierre-Philippe Boutang, and Pierre-André Boutang, directed by Pierre-Philippe Boutang, DVD, issued by Arte Vidéo-RMN, 2000.

Photo Credits

Front cover: © Edward Quinn Archive. Zurich-Berlin-New York: Scalo Publishers.

Front flap: *Marie-Thérèse with a Garland of Flowers*, 6 February 1937, oil on canvas, 61×46cm, private collection (Duncan 106 P), © Succession Picasso, 2004; (left) Pablo Picasso with his children Paloma, Maya, Claude, and Paolo, © Edward Quinn Archive, Zurich-Berlin-New York: Scalo Publishers; (right) portrait of Pablo Picasso (detail), © André Villers, 1955.

Back flap: Olivier Widmaier Picasso in front of *Three Figures under a Tree* (c. 1907–08), oil on canvas. Musée Picasso, Paris, © Succession Picasso, 2004.

Page 169: (top) Private collection, © Succession Picasso, 2004; (bottom) © photo RMN.

Page 170: (top) Photo RMN, © Succession Picasso, 2004; (bottom) © photo RMN.

Page 171: (top) Photo by J.G. Berizzi/RMN, © Succession Picasso, 2004; (bottom) © Paris: Man Ray Trust/ADAGP, 2004.

Page 172: (top) Private collection, © Succession Picasso, 2004; (lower left) © Collection of Maya Picasso; (lower right) © Collection of Maya Picasso.

Page 173: (upper left) © Collection of Maya Picasso; (upper right) photo of Marie-Thérèse Walter, © Collection of Maya Picasso; (bottom) Private collection, © Succession Picasso, 2004.

Page 174: (upper right) photo of Marie-Thérèse Walter, © Collection of Maya Picasso; (left) Collection of Maya Picasso; (lower right) © Collection of Maya Picasso.

Page 175: (top) © Collection of Maya Picasso; (bottom) © Collection of Maya Picasso.

Page 176: photo by J.G. Berizzi/RMN, © Succession Picasso, 2004.

Page 177: (top) Private collection. Courtesy Thomas Ammann Fine Art, Zurich, © Succession Picasso, 2004; (bottom) © Edward Quinn Archive. Zurich-Berlin-New York: Scalo Publishers.

Page 178: (top) © Succession Picasso, 2004; (center and bottom) © Edward Quinn Archive. Zurich-Berlin-New York: Scalo Publishers.

Page 179: (top) Private collection, Bridgeman Library; © Succession Picasso, 2004; (center left and right, lower left) © Collection Maya Picasso.

Page 180: (top) © Collection of Maya Picasso; (center) © Edward Quinn Archive. Zurich-Berlin-New York: Scalo Publishers; (bottom) © René Burri/Magnum Photos.

Page 181: (top) © Paris: Man Ray Trust/ADAGP, 2004; (center left) photo of Maillat, D.R. © Collection of Maya Picasso, (bottom right) © Collection of Maya Picasso; (lower left) © Collection of Maya Picasso.

Page 182: (top) photo by J.G. Berizzi/RMN, © Succession Picasso, 2004; (bottom) © Collection of Gérard Sassier.

Page 183: (from top to bottom) © Collection of Gérard Sassier; © Collection of Gérard Sassier; © Collection of Maya Picasso; © James Andanson Corbis-Sygma.

Page 184: (top) Collection of Pierre Zécri, © Eric Beaudoin/D.R., (center) © Corbis/Sygma; (bottom) © Steve Lyon.

Page 332: Pablo Picasso, detail of a photo by Joan Vidal Ventosa, Barcelona, 1906, D.R.

Captions to page XVI

Top :

Members of the Pablo and Paul Picasso Successions (top): From right to left (standing): Me. Rheims, Me. Magnan, Me. Rivoire, *Claude*, M. Geraudie (Me. Lefebvre's clerk), Me. Zécri, Me. Lefebvre, Me. Hini, Me. Bredin, Me. Verdeil, Me. Claire. From left to right (seated): *Paloma*, Me. Leplat, *Marina*, Me. Ferreboeuf, Me. Weil-Curiel, Me. Dumas, Me. Darmon, *Maya*, Me. Lombard, Olivier, *Bernard, Christine*, Me. Bacqué de Sariac. Names of the heirs are given in italics.

Center:

Inauguration of the retrospective Picasso et le portrait

From left to right: Gaël (Marina's eldest son), Bernard (Paulo's youngest son), Olivier (Maya's elder son) and Alice Evans, Paloma and her husband Eric Thévenet, Marina (Paulo's daughter) and her three children Florian, May, and Dimitri, Philippe Douste-Blazy (Minister of Culture) and Jacques Chirac, Sydney (wife of Claude), Maya, Claude, Hélène and Bernard Arnault (President of the LVMH Group, patron of the exhibition), Christine (Paulo's widow and Bernard's mother). The following were absent: Richard and Diana (Maya's children), Jasmin (Claude and Sydney's son) and Flore (Marina's daughter).

Acknowledgements

I would like to thank all of those who granted interviews for their time, and for helping to keep alive the memory of my grandfather. They provided invaluable information, and some of them were able to shed light on the story of his legacy, which is, above all, his artistic work.

Armand Antébi (†)
Heinz Berggruen
Ernst Beyeler
Pierre Daix
Roland Dumas
Luc Fournol
Paul Hini
Jean Leymarie
Paul Lombard
Adrien Maeght
Alberto Miguel Montanés
Lucette Pellegrino
Alain Ramié
Maurice Rheims (†)
Mstislav Rostropovitch
Francis Roux
Gérard Sassier
Inès Sassier (†)
Werner Spies
André Villers
Pierre Zécri

and most especially my mother, Maya, who added the sincerity of her feelings to the accuracy of her memory.

Many thanks also to the following for their help:

Theres Abbt, Scalo, Zurich
René Abguillerm
Claudia Andrieu
Doris Ammann
Anne Baldassari
Jean-Paul Claverie, LVMH
Anne Davy
Odile d'Harcourt, RMN
Catherine Hutin
Anne-Marie Levaux
Isabelle Maeght
Yoyo Maeght
Kamel Mennour
Solange and Daniel Mossé
Marie-France Pestel-Debord
Noëlle Prejger
Christine Picasso
Christine Pinault
Diana Widmaier Picasso

The Archives of the Conseil Général of the Alpes-Maritimes and the Musée Picasso, Paris

as well as all the well-known authors, historians, and biographers whose writings have allowed me to complement family memories and archives and carry out my research.